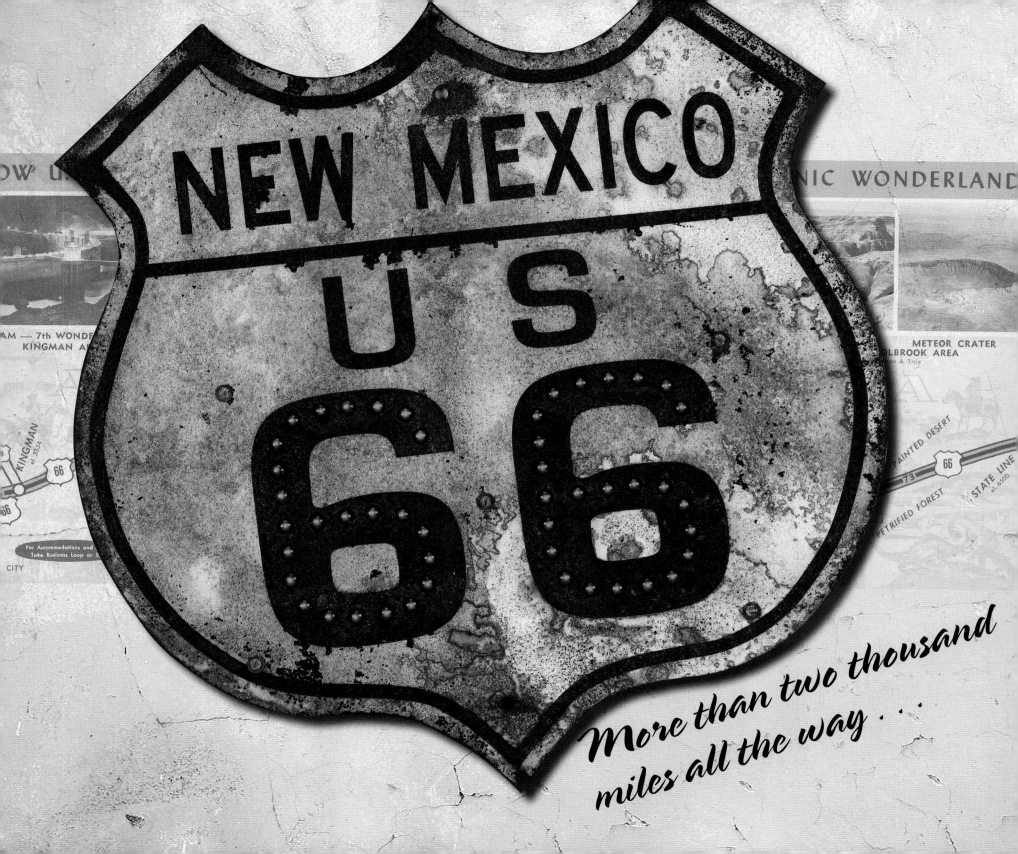

NEW MEXICO

US

66

More than two thousand
miles all the way . . .

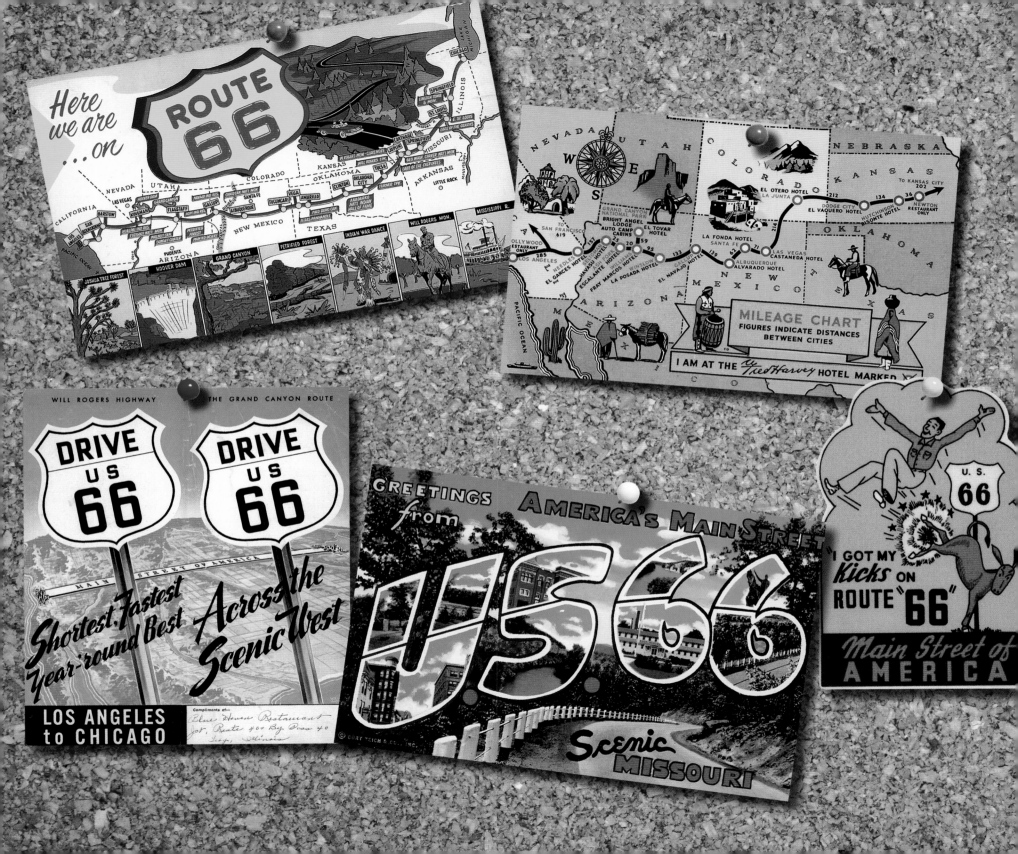

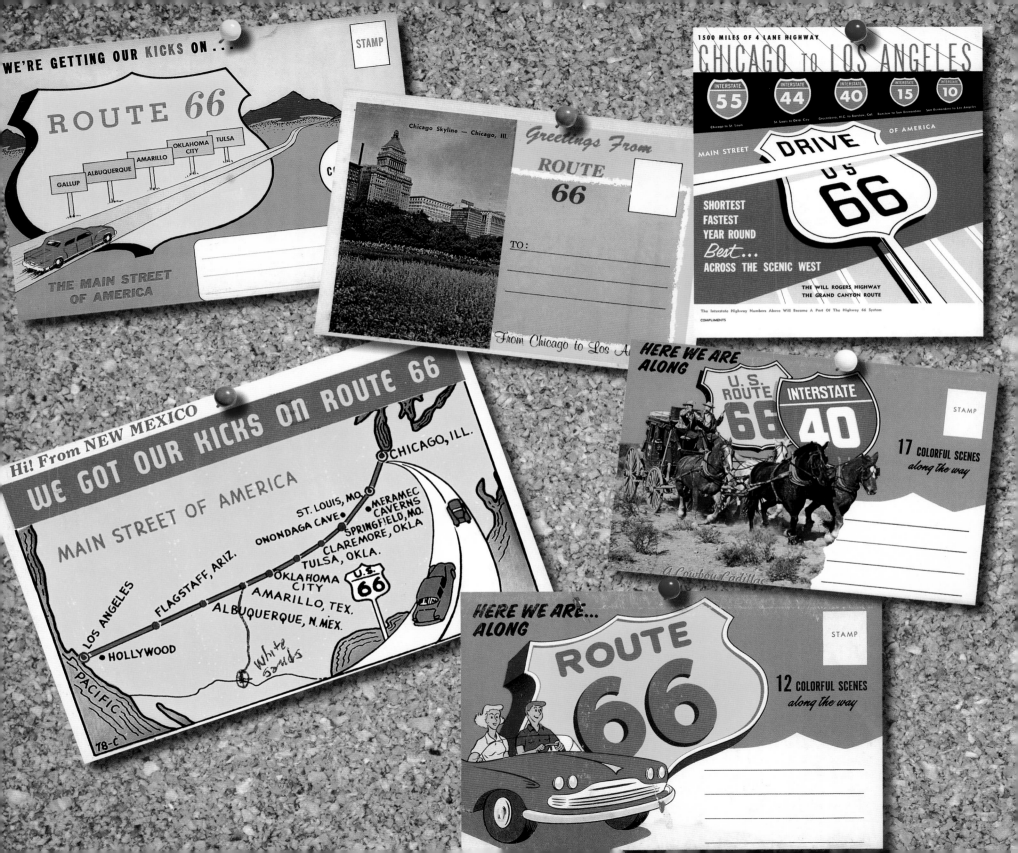

Route 66 Facts

French Fries as you like them
FRENCH FRIES

- Route 66 was commissioned by the U.S. Government in 1926, with the goal of picking up as many bits and pieces of existing road as possible to save on construction costs.

- In 1926 just 800 miles of Route 66 were paved. Only in 1937 did Route 66 get paved end-to-end.

- Route 66 was 2,448 miles long, or about 4,000 km. This is a rough approximation as the road has had many different alignments over the years.

TELEGRAM POST-CARD

No. 1 | Time Sent July 5 | July 5 1908
Arrived safely — Am feeling well — Miss You awfully — Will write soon
J. A. D.

P.J. PLANT PUB WASHINGTON D.C.

- Route 66 crossed eight states and three time zones. The states that the Mother Road ran through are: Illinois, Missouri, Kansas, Oklahoma, Texas, New Mexico, Arizona, and California.

- As a publicity stunt in 1928, promoters of Route 66 held a coast-to-coast foot race that included all 2,448 miles of the Mother Road and then some. The race kept right on going far beyond Chicago, all the way to New York City.

- Throughout its life Route 66 continued to evolve, leaving many abandoned stretches of concrete still waiting to be found by the more adventurous traveler.

- In his novel, *The Grapes of Wrath*, published in 1939, John Steinbeck was the first to refer to Route 66 as "Mother Road."

- Cyrus Avery, the father of Route 66, was the first to refer to Route 66 as "the Main Street of America" in 1927.

- Bobby Troup wrote the song "Route 66" in 1946. It has been recorded by numerous musicians over the years, including Nat King Cole, who first recorded it in 1946, scoring a major hit; Chuck Berry; the Rolling Stones; Depeche Mode; Asleep at the Wheel; and the Replacements. Yet only Perry Como ever recorded the full song with all of the original lyrics.

George Maharis and Martin Milner were the stars of the CBS television series *Route 66*, which debuted on October 7, 1960. In the show, the stars drove brand new baby-blue Corvettes, though the audience didn't know that because the show was in black and white. The show continued for 116 episodes, finally ending on March 13, 1964. Ironically, the show was filmed on locations all around the USA, but rarely near the real Route 66.

Cowboy Punching Cattle ON A JACK RABBIT

Kansas has the shortest section of the Mother Road with only thirteen miles. However, three historic Route 66 towns are located on this short segment, including Baxter Springs, Galena, and Riverton.

Oklahoma has more miles of the original Route 66 than any other state.

In Texas, ninety-one percent of the original Route 66 is still in use.

Adrian, Texas, is said to be the geo-mathematical center of Route 66. However, many argue that this title actually belongs to Vega, Texas. They're probably both right, depending upon which alignment a traveler might have taken.

Because of a change in alignment of Route 66 in 1937, there is an intersection where Route 66 crosses itself at Central Avenue and Fourth Street in downtown Albuquerque, New Mexico. Here, you can stand on the corner of Route 66 and Route 66.

Arizona has the longest stretch of the historic highway still in use today.

The last original Route 66 road sign was taken down in Chicago on January 17, 1977.

In 1984 Route 66 was officially decommissioned as a federal highway. However, daily use of the road had already been gradually replaced by interstates in earlier years. The road was decommissioned due to public demand for better transportation as the old road deteriorated after World War II.

Some eighty-five percent of the original Route 66 is still drivable today.

The last stretch of old Route 66 disappeared from most "official" road maps in 1984.

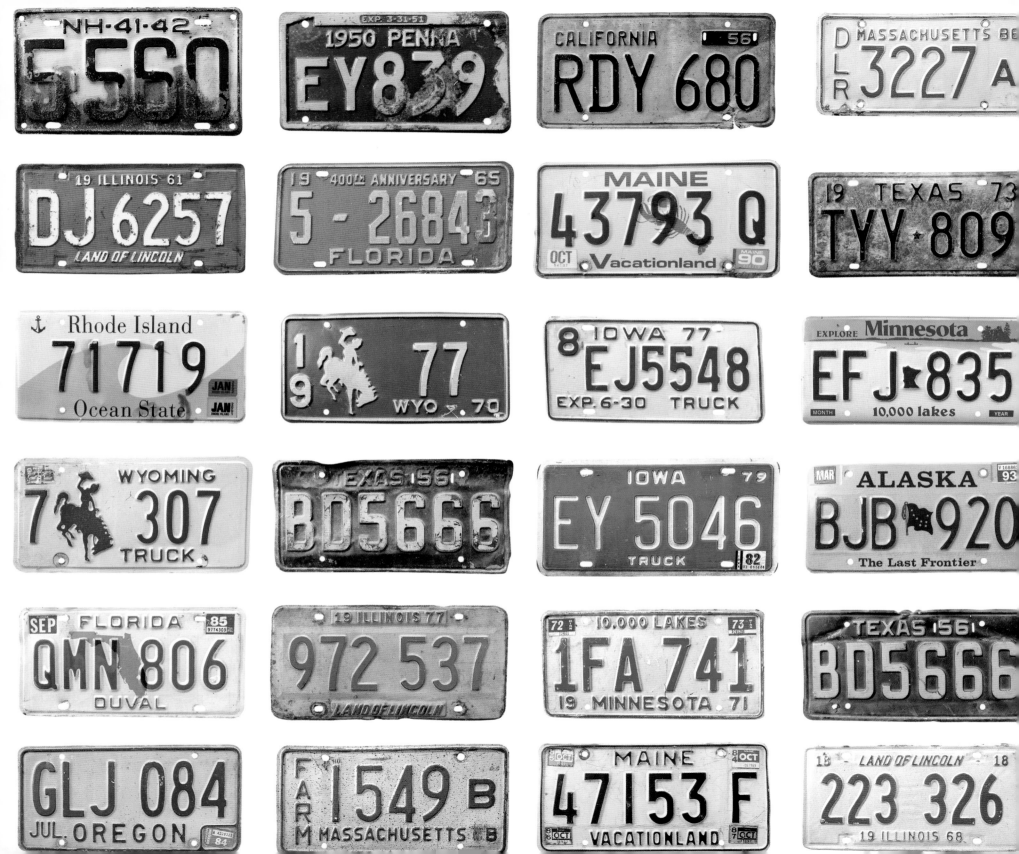

19 ILLINOIS 63
255 540
LAND OF LINCOLN

MISSISSIPPI
41D 998
OCT. LEE 73

75 LIVE FREE OR DIE N.H. OCT 78
DK345
NEW HAMPSHIRE

FLORIDA
5V - 6451
19 SUNSHINE STATE 62

19 ILLINOIS 77
972 538
LAND OF LINCOLN

LAND OF LINCOLN
970 892
19 ILLINOIS 78

MAINE AUG
NTBELL
Vacationland YEAR

Minnesota
02587
JULY ALL STAR 1985

19 ILLINOIS 69
165 060B
LAND OF LINCOLN

WASHINGTON
A 10449

SANTA FE
334 DPZ
New Mexico USA
Land of Enchantment APR

36· 136
MONTANA 62
PRISON MADE

N.DAKOTA N.D.72 N.D.73 70
TRUCK 86-173
PEACE GARDEN STATE

MAINE SEP
10708 K
VACATIONLAND

DEC 87 NORTH DAKOTA 80
TRUCK TAE370
PEACE GARDEN STATE

19 SUNSHINE STATE 63
5W-28775
FLORIDA

UFU·867
.COLORADO.

Wyoming
1 388 C S
LAND OF LINCOLN
JJ5069
19 ILLINOIS 64

MAINE
7650
VACATIONLAND

EXPLORE CANADA'S ARCTIC
000
NUNAVUT

MAINE
2101 CU
APR Vacationland MAINE 00

MICH 65
TD·8859
WATER - WINTER
WONDERLAND

MAINE 72 MAINE 73
503-141
MAINE 71 VACATIONLAND 70

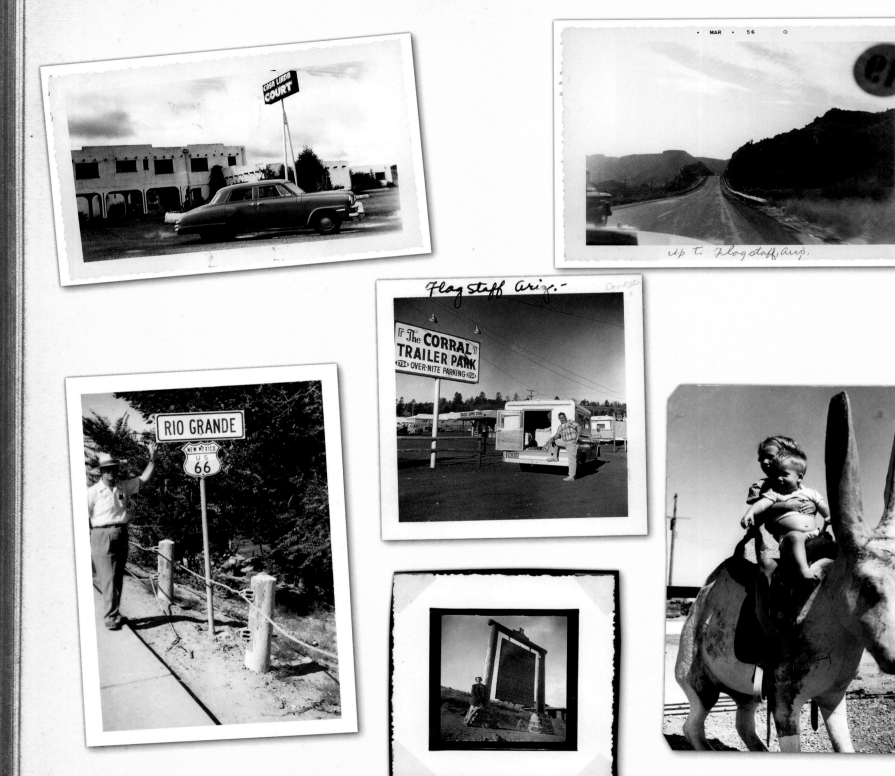

MAR · 56

Up to Flagstaff, Ariz.

Flagstaff Ariz.-

The CORRAL
TRAILER PARK
OVER-NITE PARKING

RIO GRANDE
NEW MEXICO
US
66

Pony at Gingko Petrified Forest

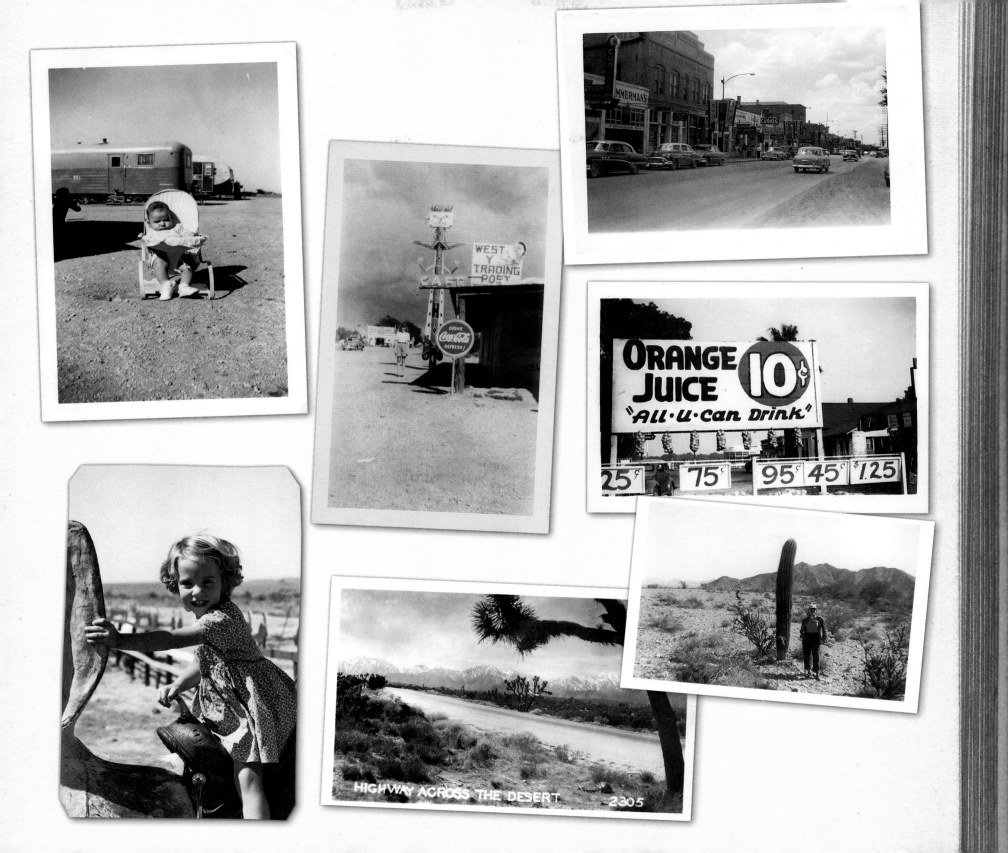

HIGHWAY ACROSS THE DESERT 2305

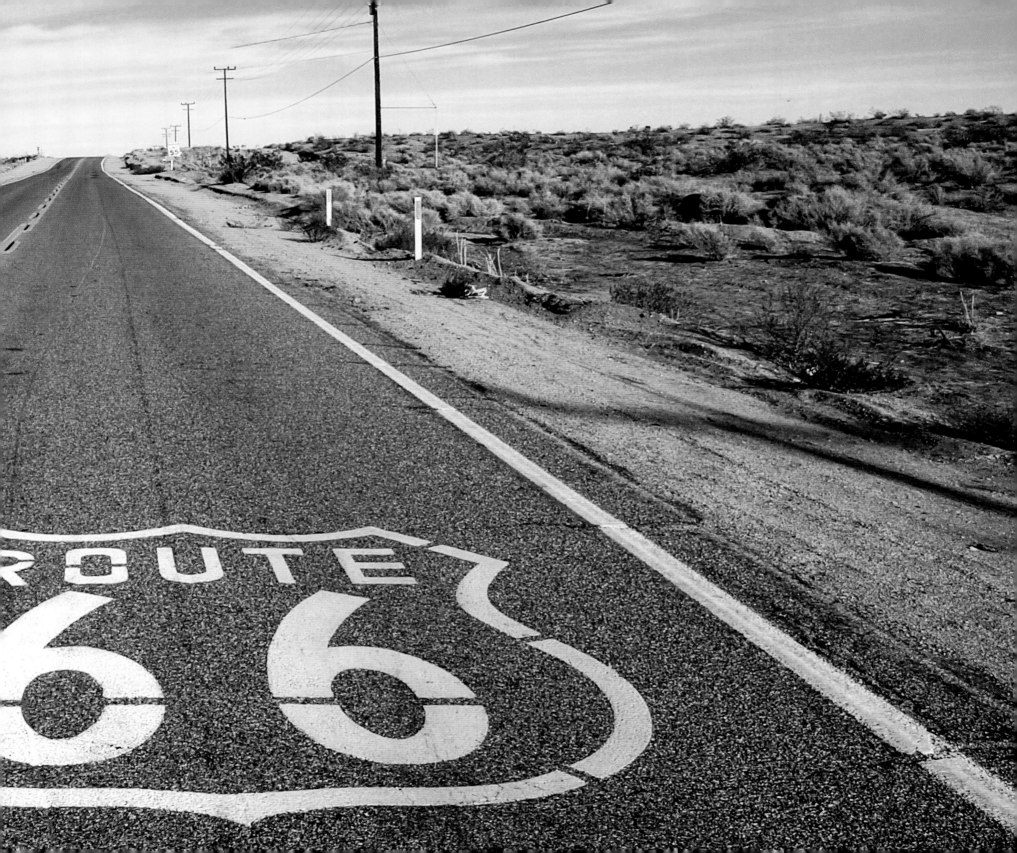

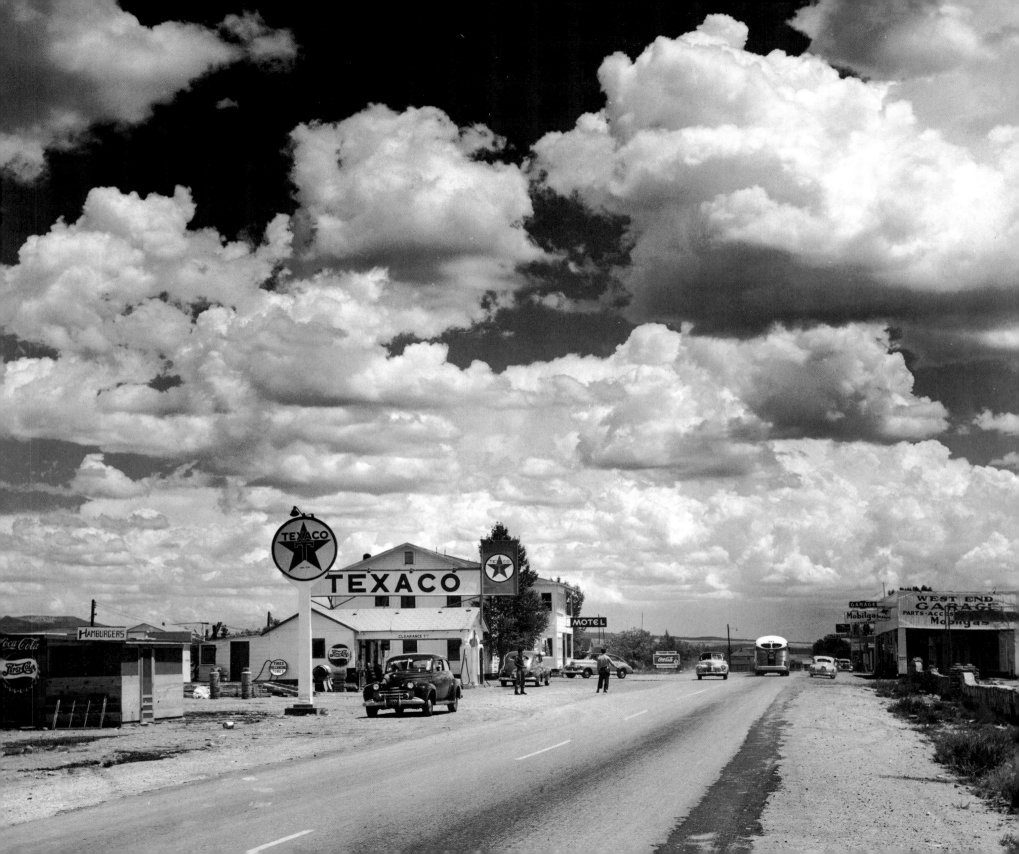

GREETINGS *from*
ROUTE 66

The Ultimate Road Trip

BACK THROUGH TIME ALONG AMERICA'S MAIN STREET

Voyageur Press

First published in 2010 by Voyageur Press, an imprint of MBI Publishing Company, 400 First Avenue North, Suite 300, Minneapolis, MN 55401 USA

Voyageur Press titles are also available at discounts in bulk quantity for industrial or sales-promotional use. For details write to Special Sales Manager at MBI Publishing Company, 400 First Avenue North, Suite 300, Minneapolis, MN 55401 USA.

To find out more about our books, visit us online at www.voyageurpress.com.

ISBN-13: 978-0-7603-3885-8

Editor: Michael Dregni

Design Manager: Katie Sonmor

Designed by: John Barnett/4 Eyes Design

Layout by: Mandy Kimlinger

Cover designed by: Matt Simmons

Printed in China

On the title page: Cumulus clouds billow over a Texaco gas station and a motel as cars and a bus travel along a stretch of Route 66 through Seligman, Arizona, in 1947. *Andreas Feininger/Time Life Pictures/Getty Images*
Inset: Tailfin on a classic pink Cadillac. *Len Green/Shutterstock*
Opposite page: A teepee at the Wigwam Motel in Holbrook, Arizona. *Michael Karl Witzel collection*
Pages 10–11, 12–13, and 240: *Shutterstock*

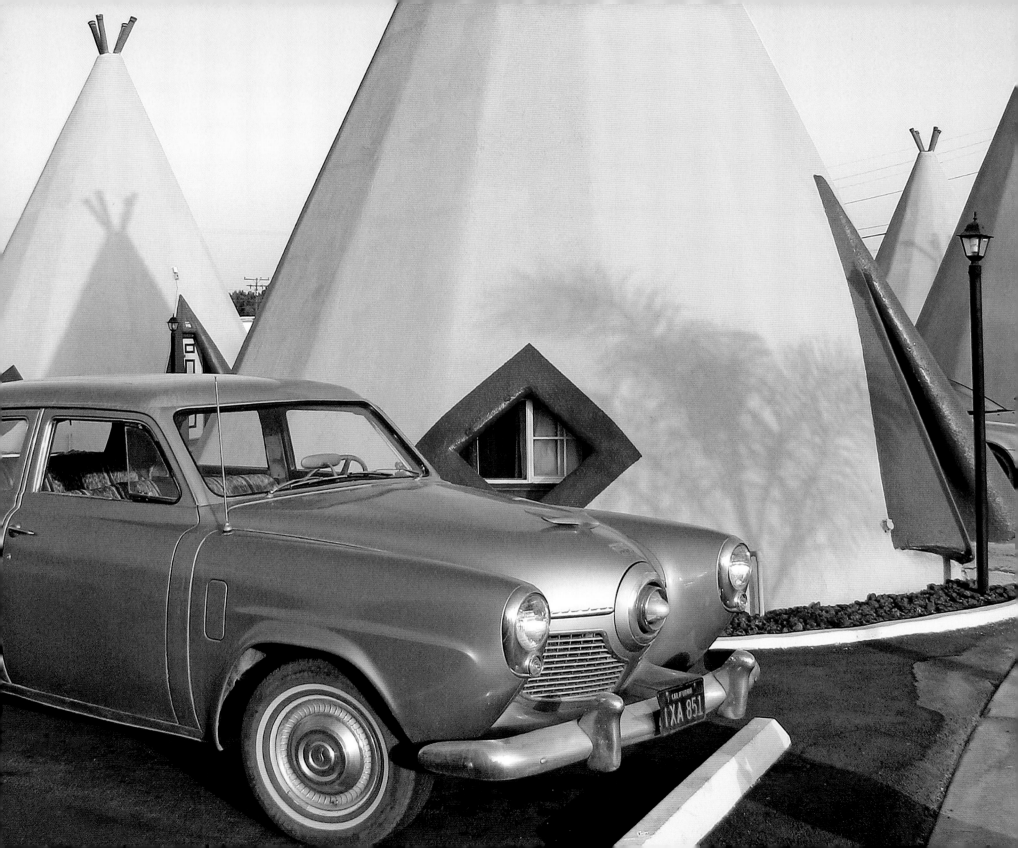

The
ROUTE
TRAVEL US 66
America Travels

CALIFORNIA
LASSEN VOLCANIC NAT'L. PK.
REDWOODS
SACRAMENTO
SAN FRANCISCO
YOSEMITE NAT'L. PARK
KINGS CANYON NAT'L. PARK
SEQUOIA NAT'L. PARK
DEATH VALLEY
LOS ANGELES
SAN JUAN CAPISTRANO
Summertime — all the time

210

A-2
ARIZONA

168

NEW MEXICO

130

BLUE BONNETS
THE STATE FLOWER
TEXAS
AMARILLO
TEXARKANA
BIG SPRING
ABILENE
DALLAS
FORT WORTH
TYLER
WACO
EL PASO
EL CAPITAN PEAK
AUSTIN
SAN JACINTO MONUMENT
RANDOLPH FIELD
HOUSTON
SAN ANTONIO
THE
LONE STAR
STATE
THE ALAMO
LAREDO
CORPUS CHRISTI
GULF OF MEXICO
McALLEN
BROWNSVILLE

110

CONTENTS

1 Illinois
The Journey Begins

Jim Hinckley

Greetings from ILLINOIS

© C. T. & CO.

Long ago Route 66 transcended its original purpose as a transportation corridor to become an internationally recognized American icon that continues to grow in popularity with each passing year. Attesting to this is the fact that in Illinois the Old Double Six consistently rates as one of the state's largest tourist attractions.

From all over the world, people come to pay homage to this unique ribbon of asphalt and to immerse themselves in the American experience, both real and romanticized. They are seldom disappointed in their quest, as Route 66 in Illinois—from Grant Park in Chicago to the Chain of Rocks Bridge on the Mississippi River—is an endless string of time capsules from when it was the Main Street of America and the minivan had yet to replace the station wagon.

Often overlooked in the quest for the Route 66 experience is the rich, diverse history found with each passing mile that transforms this highway from a neon-lit Disneyland into a link that ties the distant past to the present and future. Decades before the designation of U.S. 66, or even the establishment of a federal highway system, there was a busy thoroughfare, a modern incarnation of the Native American trails and frontier-era trade routes that linked the river port of St. Louis and the fast-growing, future metropolis of Chicago.

This highway was known by a variety of names—Mississippi Valley Highway, Greater Sheridan Road, and Chicago Trail to name but a few. The most popular name, Pontiac Trail, hinted at the Native American origins of the route and became the roadway's official designation in 1915.

In 1918, as the state of Illinois initiated construction to transform the historic trail followed by Marquette and Joliet more than two centuries earlier into a modern, all-weather highway, the highway's official designation changed to SBI 4. By 1924, two years before the advent of Route 66, virtually the entire route was paved with concrete, making it one of the first highways in the nation specifically designed to accommodate automotive traffic.

The state again assumed leadership in highway development in 1943 with the passage of a bill to fund transformation of Route 66 into a limited-access four-lane

highway. The completion of the project in the mid-1950s became a model for the modern interstate highway system.

Fittingly, the eastern terminus for Route 66 is Grant Park, a foundational element of the city of Chicago. The park, dedicated as Lake Park in 1844, expanded in 1871 with the filling of a lagoon with debris from the Great Chicago Fire; it became a cultural center for the city through the efforts of leading citizens such as Aaron Montgomery Ward.

From the park to the Mississippi River, landmarks chronicling the evolution of Route 66 abound. Many, such as Lou Mitchell's Restaurant at 565 South Jackson Street in Chicago, which opened in 1923, have celebrated the old highway to become icons recognized throughout the world.

Similar roadhouses and restaurants, little changed from an era when the tail fin represented the latest in automotive styling and the minivan had yet to dethrone the station wagon as the vehicle of choice for the family road trip, create the illusion of time travel on the drive through Illinois.

In Willowbrook there's Dell Rhea's Chicken Basket, a former Blue Bird bus stop that has been serving fried chicken dinners to Route 66 travelers since the 1940s. Wilmington is home to the Launching Pad, with its towering Gemini Giant—another time capsule from the highway's glory days that dates to the early 1950s.

The Polk-a-Dot Drive In in Braidwood has changed little since its opening in 1956, and the Old Log Cabin Restaurant in Pontiac dates to the year Route 66 was commissioned, 1926. Springfield is home to the legendary Cozy Dog Drive In; Litchfield has the Ariston Café, which opened in 1924; and in McLean you'll find the Dixie Travel Plaza, one of the oldest truck stops in the nation, dating to 1928 when it opened as the Dixie Truckers Home.

Interspersed among the relics of the modern era are a multitude of historic landmarks that provide windows into a world now long past. More than a few offer clear indications as to why this state proclaims itself "the Land of Lincoln."

In Joliet there's the stunning "jewel of Joliet," the Rialto Theater; it's consistently listed as one of the most beautiful theaters in the nation. Maple sirup production put Funks Grove on the map as early as 1824. Near Collinsville are the Cahokia Mounds State Historic Site, ghostly vestiges of a city and forgotten culture that vanished almost a century before Christopher Columbus' voyage.

The state of Illinois is host to a wide array of sites associated with the nation's sixteenth president, Abraham Lincoln. However, it is in Springfield where the presence of this great man seems most prevalent.

The only home Lincoln ever owned is preserved as he left it after winning the presidency in 1860. His law office on Sixth and Adams Street is another Lincoln-era time capsule.

There's the train station at Tenth and Monroe Street, virtually unchanged since he departed the city, and the Abraham Lincoln Presidential Library & Museum, a stunning multimedia immersion in the America of the early 1860s. However, no visit to Springfield and the world of Lincoln is complete without a stop at the somber Lincoln Tomb State Historic Site.

To drive Route 66 through Illinois is to rediscover (or discover) the joy of a uniquely American adventure, the road trip. This, however, is merely an introduction for the grand adventure only found by following the Main Street of America all the way to the sand and surf of the California coast. ◎

The oldest hotel on Route 66 is the Eagle Hotel in Wilmington, Illinois. Though sitting empty today, the 1836 hotel that once serviced stagecoach travelers has plans for restoration.

When is a corn dog not a corn dog? When you're at the Cozy Dog Drive In along Route 66 in Springfield, Illinois. This first fast food of the road was introduced by Ed Waldmire at the 1946 Illinois State Fair. In 1950, he opened the Cozy Dog Drive In. This Mother Road icon still stands today at 2935 South Sixth Street in Springfield, Illinois, but when you try their Cozy Dog, don't call it a corn dog, or you might be met with little more than a steely-eyed stare.

Chicago
The Starting Point

By Kathy Weiser

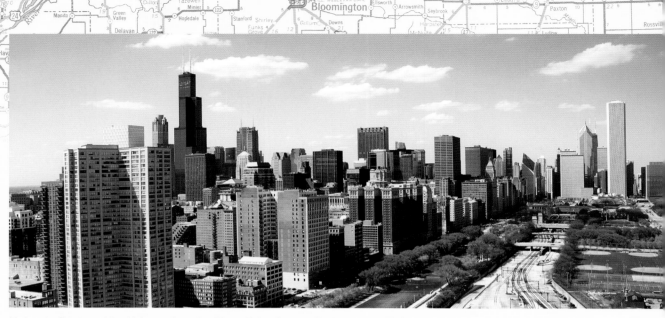

Modern-day Chicago and the old-time starting point of Route 66, heading west. The downtown is viewed here from the South Side with Grant Park at right. The park is bisected by East Jackson Drive, the beginning of the original Mother Road. *Henryk Sadura/Shutterstock*

Route 66 begins in Chicago, Illinois. The city lived a long and rich life along its way to becoming the third largest city in the United States today. Many of its vintage icons have been obliterated with urbanization; however, it still has a few, especially along the outskirts of the city, and downtown Chicago provides a rich view of historical buildings at the very place where Route 66 begins.

The first settler in the Chicago area was a man by the name of Jean Baptiste Point du Sable, an African American from Santo Domingo. In 1781 he chose a location at the mouth of the Chicago River for its strategic value as a trading post. Later, in 1802, the same site was occupied by Fort Dearborn, which was regularly attacked by Native Americans until Chief Black Hawk was defeated in 1832. One year later, Chicago was officially incorporated as a town and by 1837 it boasted more than four thousand residents.

In 1848, the first railroad reached Chicago and the town really began to boom. By 1860 it had a dozen railroad lines into the city and a population of more than a hundred thousand. Incredibly, just ten years later, this number had tripled and Chicago was on its way to becoming one of the biggest cities in the nation.

In 1871 disaster struck the city with the Great Chicago Fire covering the town in ashes. Raging for two days on October 8 and 9, the fire destroyed 3.5 square miles, 17,450 buildings, and killed as many as 250 people. Sparks from the fire were so bad that they destroyed more than a million acres of Michigan and

Wisconsin timberland. However, Chicago endured, and just six weeks after the fire construction of more than 300 buildings had begun.

Continuing to grow at a rapid pace, Chicago developed "the El," its first elevated railway, in 1891. Circling the city's downtown area, it was soon called "the Loop." Though obviously not powered by the same engines of the nineteenth century, the El and the Loop continue to service Chicago commuters today.

It was also this same year that saw Chicago's first skyscraper, the sixteen-story Monadnock Building at 53 West Jackson Boulevard.

In 1893 Chicago hosted the World Columbian Exposition, which commemorated the discovery of America by Columbus some four hundred years earlier. Staging this magnificent event cost more than twenty-seven million dollars. Hosted from May through October of 1893, the fair covered 633 acres and attracted twenty-seven million visitors, almost half of the U.S. total population at that time.

Several firsts were introduced at the fair including Cracker Jacks, Aunt Jemima syrup, diet soda, and Pabst beer. It was here that the carnival concept was born, the hamburger was introduced, and the United States unveiled its first commemorative stamp and coin sets.

During the exposition, *New York Sun* editor Charles Dana, tired of hearing Chicagoans boast of the world's Columbian Exposition, dubbed Chicago the "Windy City," a name which has obviously stuck to this day.

Before the advent of Route 66, there was already a popular road from Chicago

Chicago, old and new: The skyline today is a jumble of classic buildings in the world-renowned Chicago architectural style blended with modern-day skyscrapers. *Shutterstock*

to St. Louis called the Pontiac Trail. In 1918 Illinois began to pave the road, and by the time Route 66 was instituted it was entirely paved. By 1927, the Route 66 signs were visible all along the Illinois route, and Chicago sported numerous services to accommodate travelers. It was during this time that Louis Armstrong, as a member of King Oliver's Creole Jazz Band, became a mainstay in Chicago, helping to usher in the Jazz Age.

By 1929 Chicago had become a dangerous place, with several gangs competing for the lucrative illicit bootleg liquor trade. Reaching its peak on February 14, seven members of the George "Bugs" Moran gang were killed in a North Clark Street garage when rival mobsters ambushed them. The police suspected that Al Capone and his gang were responsible for the eight-minute-long St. Valentine's Day Massacre, but could never prove it. Instead Capone was prosecuted for tax evasion and sentenced to eleven years in prison on October 24, 1931.

In the meantime, hundreds of travelers streamed through Chicago on their journey along Route 66. One icon that remains today is Lou Mitchell's Restaurant, located at 565 West Jackson Boulevard, which has been serving up coffee and home cookin' since 1923. Nearby is Chicago's Union Station, once home to one of the many Harvey House Restaurants; it's been preserved and still serves Amtrak passengers today. The designated official beginning of the Mother Road begins at Grant Park on Adams Street in front of the Art Institute, where you'll find the "Begin Route 66" sign.

⫶ Old Route 66 originally began in Chicago at Michigan Avenue and Jackson Boulevard. After the 1933 World's Fair, the terminus of the road was moved to Lake Shore Drive at the entrance to Grant Park.

⫶ Lou Mitchell's Café has been providing breakfast for those beginning the long journey on Route 66 since the beginning. Opened in 1923 at 565 W. Jackson, breakfast is still served all day at Lou Mitchell's in Chicago.

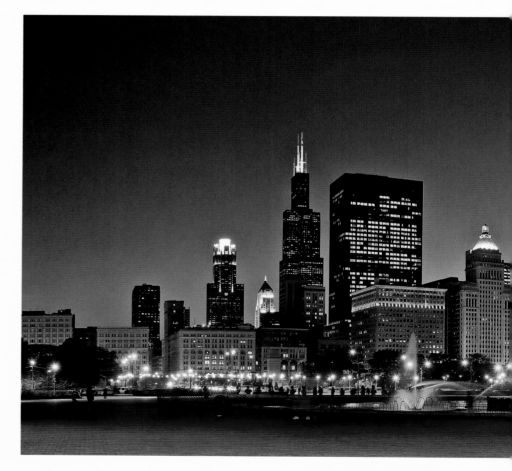

From here, take Adams Street west for about 2.5 miles then make a left onto Ogden Avenue, which leads you into an older, seedier part of town. After you pass through one of Chicago's oldest parks, Douglas Park, you will see the Castle Car Wash at 3801 West Ogden on your left. Long closed, the carwash now tends to serve as a parking lot for the fire station across the street.

Entering the suburb of Cicero, which was the one-time base of Al Capone's infamous operations, you can see several Route 66-era buildings, including the Cindy Lyn Motel at 5029 West Ogden and Henry's Drive In just a bit further down.

Route 66 then rambles through the Chicago suburb of Berwyn, where there is not much to see other than aging strip centers; however, at the Cermak Plaza Shopping Center parking lot, there is a tall piece of artwork called "the Spindle," a forty-foot spike with nine cars skewered on top of it.

Here there is also the Pinto Belt, which displays the flattened bodies of cars and something called the Bee Tree.

It's about here that old Route 66 gets a little hard to follow as the signs are not as prevalent and two alignments occur as you enter Lyons. Get a few good maps and keep your eyes open as you continue your journey through the small towns of McCook and Plainfield on your way to Romeoville and Joliet. ◉

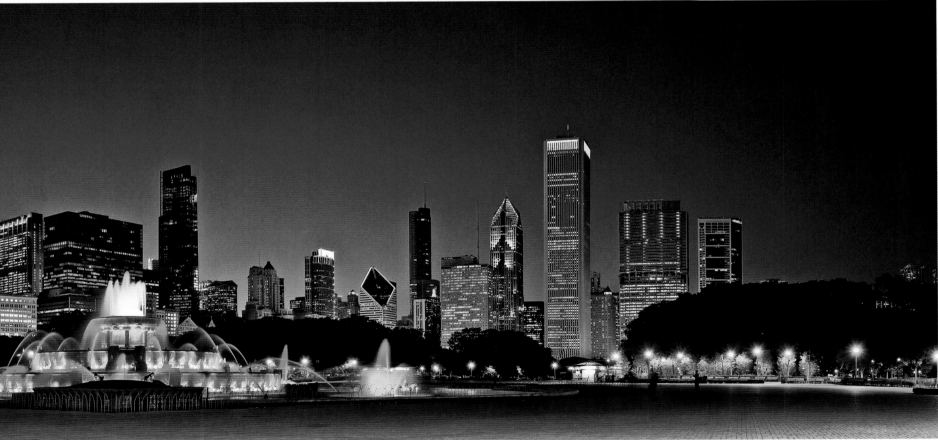

Buckingham Fountain in Grant Park lies near the starting point of old Route 66 at Chicago's waterfront. *Kevin Tavares/Shutterstock*

Early method of laying macadam. *Michael Karl Witzel collection*

VOICES FROM THE MOTHER ROAD

Horatio Sawyer Earle: The Father of Good Roads

By Michael Karl Witzel

A good many years before

Route 66 was enshrined as the Main Street of America, the system of American roads and highways was nothing more than an idea. It took men of vision to change that paradigm into a viable transportation system, men like Horatio Earle, the man who came to be regarded as the father of good roads.

Horatio Sawyer Earle was born in Mt. Holly, Vermont, on February 14, 1855, in an age devoid of automobiles. There he attended school and graduated from the Black River Academy in Ludlow, Vermont. Since his family couldn't afford to send him to school, he worked as a gopher in a pulp mill, then as a lumber hauler, and finally as a traveling salesman selling agricultural implements. His mode of transportation: horse and buggy.

By the time he turned twenty, he had traveled enough to know that there had to be a better way. Roads of the day were dismal. But first he moved to Detroit, Michigan, and worked as a salesman with the North Wayne Tool Company. He invented an improved sickle that he called Earle's Little Giant Grass Hook and became quite successful with it. He zoomed up the ranks to company president and later became the owner.

A salesman and businessman by day, Earle was also an avid bicyclist in his spare time. A vocal proponent of improving conditions for cycling, he came to be known as someone who was interested in advancing the current status quo in roads. In 1899, he was named the chief consul of the Michigan Division of the League of American Wheelman (LAW), a group that was dedicated to the furtherance of the cycling arts.

At the time, the league spent much of its efforts on holding bicycle races and such. But the forward-thinking Earle thought this was a rather frivolous direction for the group, and proposed that they focus their energies on more serious matters. Bicycling would stall without decent surfaces to travel upon, so he pushed for a vote to shelve racing activities and replace them with events relating to good roads.

By 1900, Earle had galvanized the bicycling masses. That year he called the first International Good Roads Congress to order in Port Huron, Michigan, and hooked together a "good roads train" to garner publicity. The wheeled caravan consisted of forty motorized vehicles, including a traction engine, road roller, sprinkler, and dump wagons. Heading for a sample road built just for the occasion, the train was loaded to capacity with two thousand attending delegates and accompanied by hundreds of bicycles. The media took notice: after the event, Earle was known as "the Father of Good Roads in Michigan."

Earle kept the momentum going, subsequently founding the Michigan Good Roads Association and serving as its first president. But he had even higher aspirations: In 1901, he was also elected as the LAW candidate to the Michigan State Senate. For him, the political post was a perfect platform from which to promote his vision. "The Legislature of 1901 became my constant good roads convention; and, it was reported, that I found a rule that permitted of my making a good roads speech on every bill," Earle later wrote.

Horatio Sawyer Earle cartoon. *Michael Karl Witzel collection*

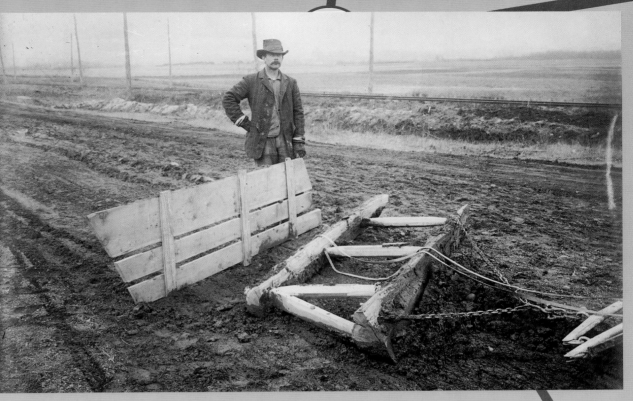

A Good Roads scraper. *Michael Karl Witzel collection*

A Good Roads gathering. *Michael Karl Witzel collection*

Better Roads and Streets magazine. Michael Karl Witzel collection

National Old Trails Road map. Michael Karl Witzel collection

While serving his first term, Earle introduced a resolution to create a state highway commission. With bipartisan support, the resolution passed the senate the same day and was fast-tracked through the house, where it was signed by the governor. In 1902, the Michigan state legislature passed a law to create the Highway Educational Department, whereupon Michigan governor Aaron Bliss appointed Earle commissioner of the highways.

Earle continued to follow his good roads agenda by drafting the State Reward Road Law, which was passed by the legislature in 1905. His efforts were well-received and he was officially appointed the constitutional state highway commissioner of the State Highway Department, the precursor to the Michigan Department of Transportation.

In 1909, Earle managed an important project undertaken by the State Highway Department and the Wayne County Road Commission, one that would change road history forever. Upon completion, Detroit would boast the nation's first mile of concrete highway, a prototype for all roads to come. Built for a total cost of $13,537, the city's future cruising strip was named Woodward Avenue and located between Six and Seven Mile roads.

After its completion, Earle's smooth concrete road was viewed as nothing less than a modern marvel. Early automobile owners loved it, as did bicyclists pedaling on two wheels. In stark comparison, most of the roads around Detroit and Michigan proper were sad examples of transit—horrific pathways riddled with sand, mud, and clay that trapped both horse-drawn and motorized vehicles with their devilish flaws.

As the news of Earle's pristine stretch of concrete spread, he continued to speak up for good roads nationally. In 1902 he founded the American Road Makers and continued his battle against what he called the "mighty monarch mud, who rules the road to the exclusion of everyone." In 1910, his group was renamed the American Road Builders Association, which in 1977 became the American Road and Transportation Builders Association.

Earle continued to work for the creation of good roads until his death in 1935. By that time, the continent was laced with countless concrete highways—segments of Route 66 included. Of course his life's work was honored with monuments in Cass and Mackinaw City, Michigan, but that wasn't at all what Earle was about. In his autobiography, he wrote that "The monument I prize most is not measured by its height, but its length in miles."

Earle's words proved to be prophetic, as he eventually received the honor he desired: By 2004, America counted more than forty-seven thousand miles of interstate highways nationwide, a fitting tribute to one of America's unsung highway heroes. ◉

Wilmington

The Gemini Giant of Wilmington, Illinois

By Kathy Weiser

Wilmington, Illinois, is home to some five thousand people, but its most photographed citizen isn't a person at all. Rather it is the Gemini Giant, a large fiberglass "muffler man" built in the 1960s. During this time, these colossal men could be found all over America, holding all manner of "tools" in their hands, from mufflers, to hot dogs, to axes, and more. In this case, the Gemini Giant sports a rocket ship, a remnant of our fascination with outer space. Most of these very tall men lost their lives as America began to move faster and faster. But here in Wilmington, the large green man hangs tight, along with several other historic icons of the past.

Wilmington was born in 1834, when Thomas Cox acquired four hundred acres of land from the government and built a sawmill. He later added a corn cracker, a gristmill, and a carding machine, and the enterprise took on the name Cox's Mills. Patronized by settlers from as far as fifty miles away, pioneers brought their corn and wheat to the Wilmington mills to be ground.

By the time Route 66 pushed through, Wilmington responded with services for the many travelers of the Mother Road. The Eagle Hotel, having served the stagecoaches of the past, now served those traveling on the new trail to the west. In 1937, the Mar Theatre opened at 121 South Main Street with five hundred seats. The Launch Pad Drive-In opened in 1960, at first selling only hot dogs and ice cream, but soon expanding to a full-service menu. It is at the Launch Pad Drive-In on 810 East Baltimore Street that the vintage green Gemini Giant stands, welcoming travelers to the restaurant. All three of these icons can still be seen in Wilmington today.

Having had a fine time in Wilmington, head on down Route 66 through the old coal-mining communities of Braidwood, Braceville, and Gardner. ⊙

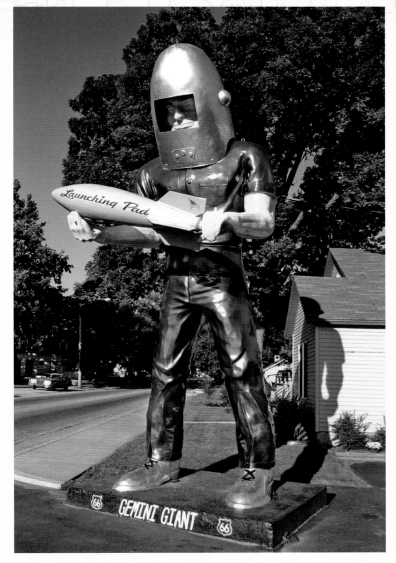

Wilmington's famed Gemini Giant. *Michael Karl Witzel collection*

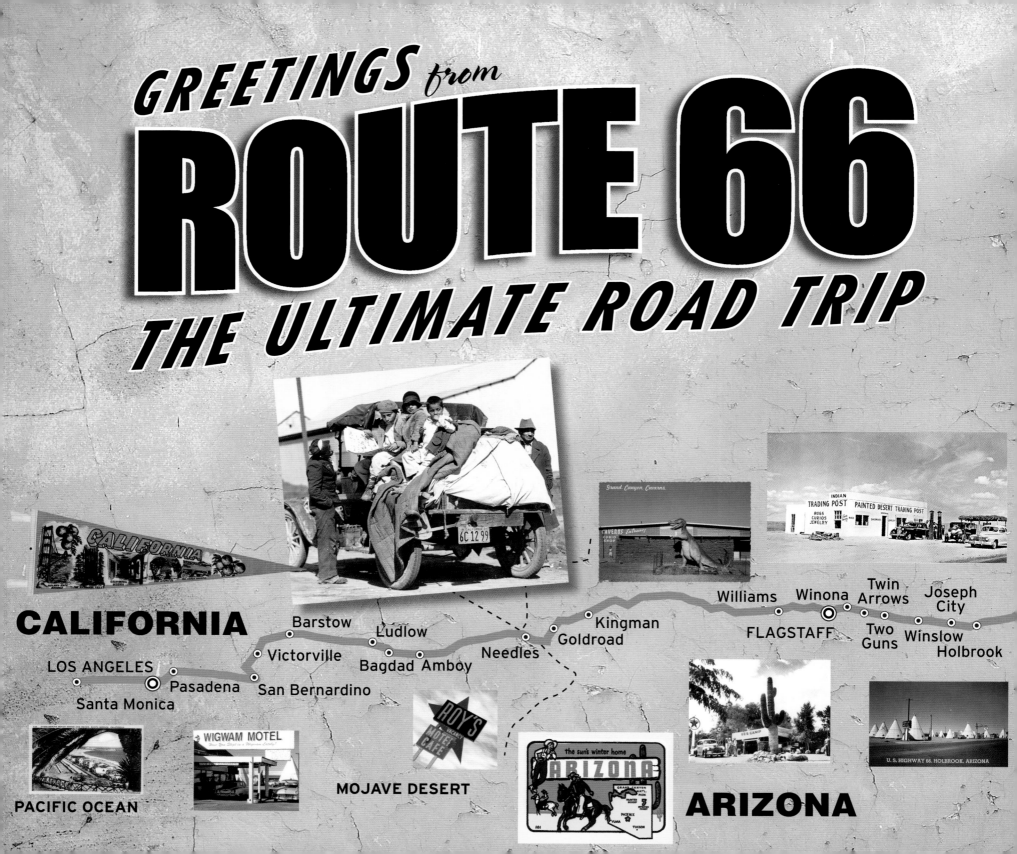

GREETINGS *from* ROUTE 66
THE ULTIMATE ROAD TRIP

CALIFORNIA

Barstow
Ludlow
Victorville
Bagdad Amboy
LOS ANGELES
Pasadena
Santa Monica
San Bernardino

Needles

Kingman
Goldroad

Williams Winona Twin Arrows Joseph City
FLAGSTAFF Two Guns Winslow
Holbrook

Grand Canyon Caverns.

INDIAN TRADING POST PAINTED DESERT TRADING POST
RUGS CURIOS JEWELRY

CALIFORNIA

ROY'S MOTEL CAFE

the sun's winter home
ARIZONA

WIGWAM MOTEL

U.S. HIGHWAY 66, HOLBROOK, ARIZONA

PACIFIC OCEAN

MOJAVE DESERT

ARIZONA

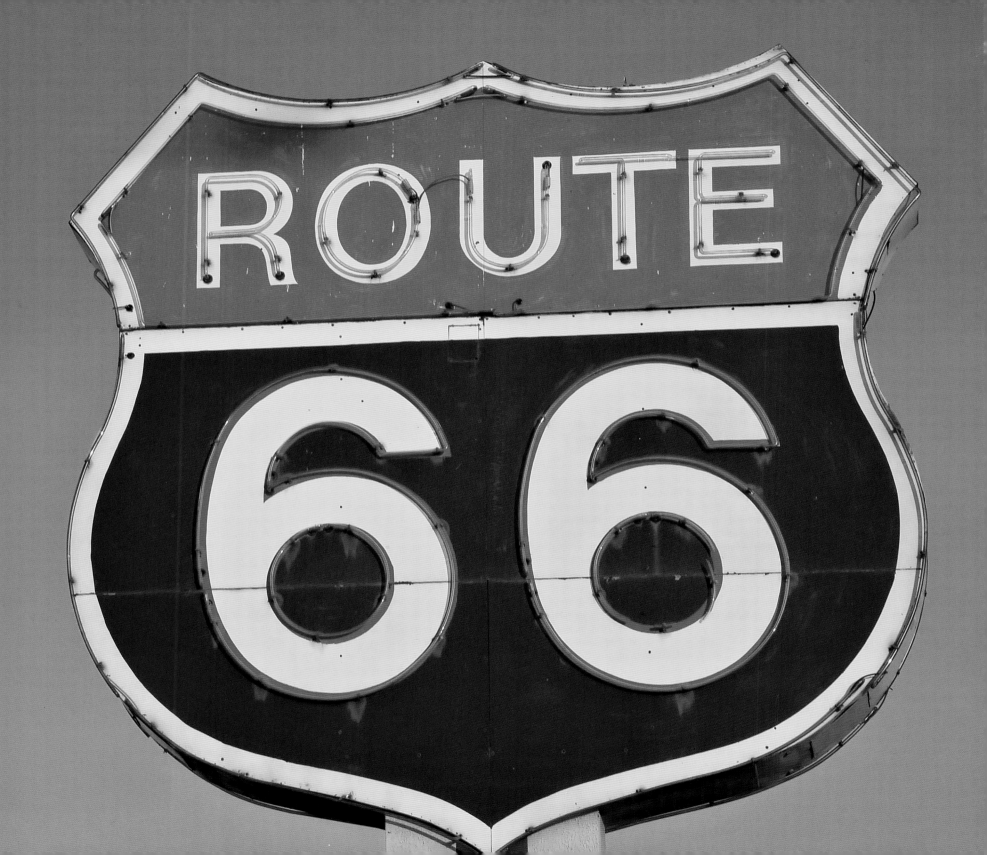

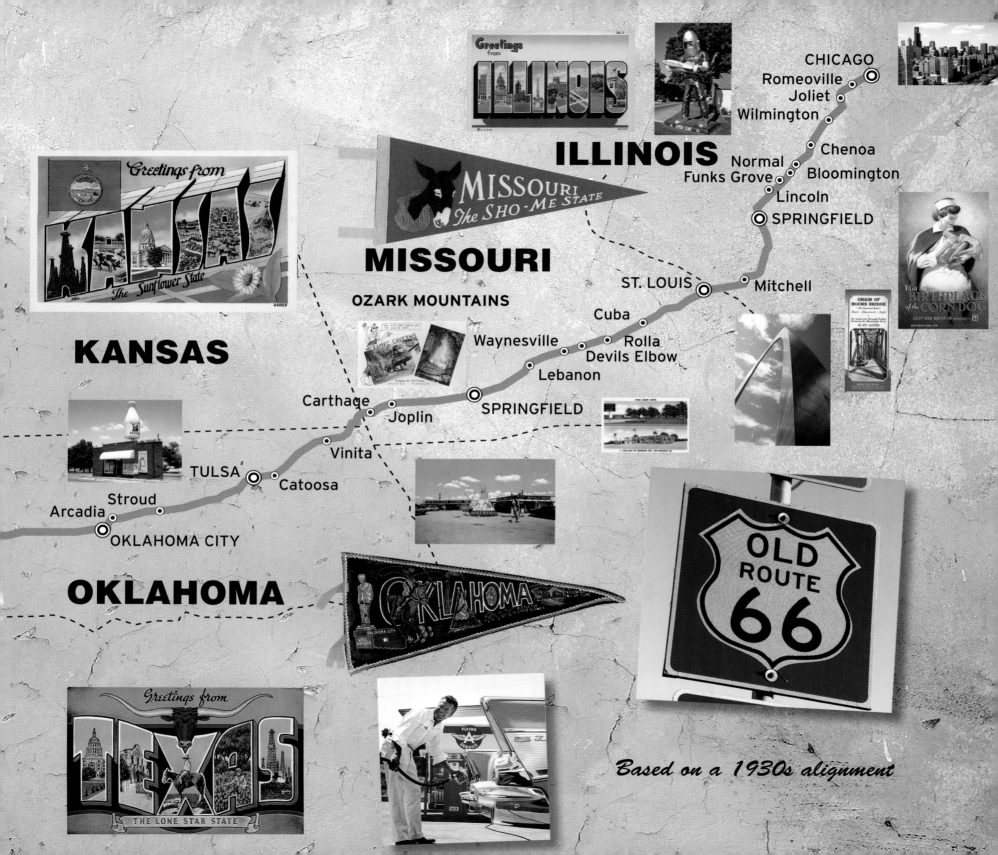

Greetings from **ILLINOIS**

CHICAGO
Romeoville
Joliet
Wilmington

Chenoa

Normal
Funks Grove
Bloomington

Lincoln

SPRINGFIELD

ILLINOIS

MISSOURI The SHO-ME STATE

MISSOURI

ST. LOUIS
Mitchell

OZARK MOUNTAINS

Cuba

Rolla
Waynesville
Devils Elbow
Lebanon

Greetings from **KANSAS** The Sunflower State

KANSAS

Carthage
Joplin
SPRINGFIELD

Vinita

TULSA
Catoosa

Arcadia Stroud

OKLAHOMA CITY

OKLAHOMA

OKLAHOMA OKLAHOMA CITY WILL ROGERS

OLD ROUTE 66

Greetings from **TEXAS** THE LONE STAR STATE

Based on a 1930s alignment

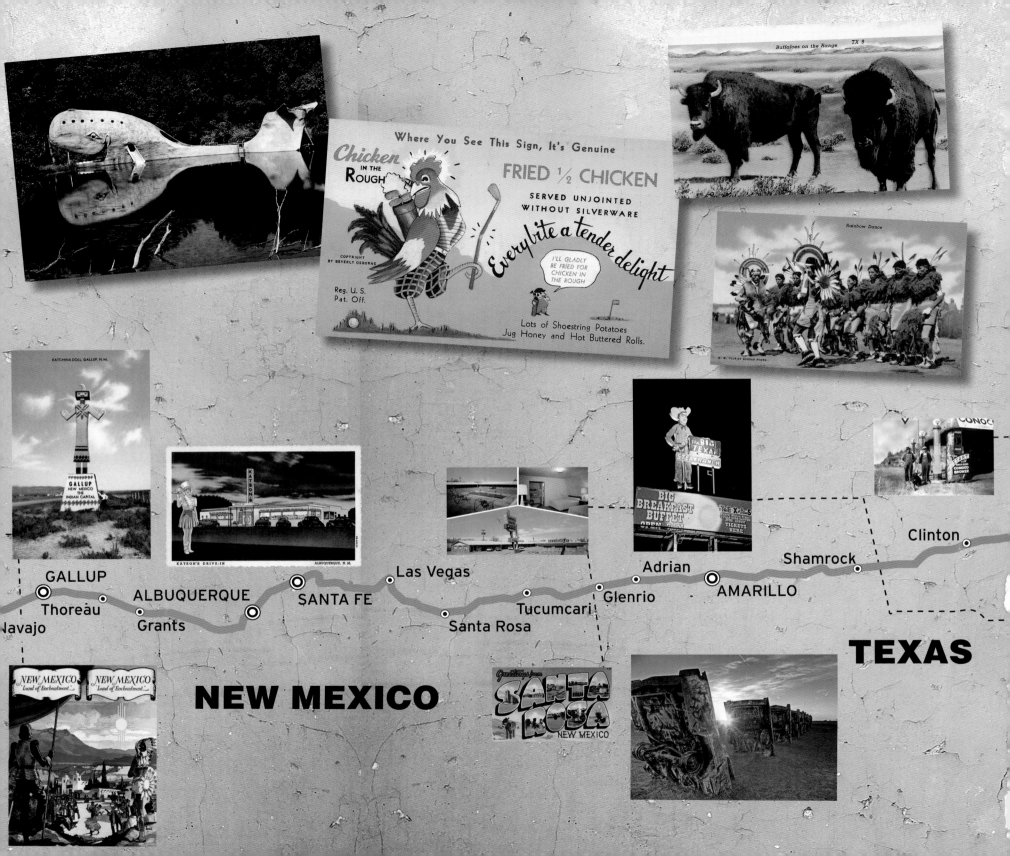

Buffaloes on the Range TX 9

Where You See This Sign, It's Genuine

Chicken IN THE Rough

FRIED ½ CHICKEN

SERVED UNJOINTED
WITHOUT SILVERWARE

Every bite a tender delight

COPYRIGHT
BY BEVERLY OSBORNE

I'LL GLADLY
BE FRIED FOR
CHICKEN IN
THE ROUGH

Reg. U. S.
Pat. Off.

Lots of Shoestring Potatoes
Jug Honey and Hot Buttered Rolls.

Rainbow Dance

KATCHINA DOLL, GALLUP, N. M.

GALLUP
NEW MEXICO
THE
INDIAN CAPITAL

KATSON'S

BIG TEXAN
STEAK RANCH

CONOCO

BIG
BREAKFAST
BUFFET

TEXAS

Clinton

Shamrock

KATSON'S DRIVE-IN ALBUQUERQUE, N. M.

Las Vegas

Adrian

AMARILLO

GALLUP

Thoreau

ALBUQUERQUE

SANTA FE

Glenrio

Navajo

Grants

Santa Rosa

Tucumcari

TEXAS

NEW MEXICO

NEW MEXICO
Land of Enchantment

NEW MEXICO
Land of Enchantment

Greetings from
SANTA
ROSA
NEW MEXICO

EXIT

THIS EXIT FOR ANOTHER ROADSIDE ATTRACTION . . .

Romeo and Juliet of the Illinois Plains: Romeoville and Joliet

By Kathy Weiser

Romeoville, Illinois, some thirty miles southwest of Chicago, was first called Romeo when nearby Joliet was still called Juliet. At this time, the settlement was a twin and rival community of Juliet, unlike the romantic pair of Shakespeare's era. Founded in the 1830s, the area was home to abundant farmlands and stone quarries. A post office was established on October 29, 1833.

In 1845, the city of Juliet's name was changed to Joliet to honor the famous explorer Louis Jolliet. When this happened, Romeo acknowledged the busted romance by becoming Romeoville.

Located on the west bank of the Des Plaines River, Romeoville supplied Chicago with produce sent to the city along the historic Illinois & Michigan Canal System, which was opened to commercial traffic in 1848. However, its main economic assets were the numerous limestone quarries in the area, soon gaining it the nickname "Stone City." In its heyday, two trainloads of limestone were shipped from Romeoville every morning on the Chicago Rock Island and Pacific Railroad. One of the most famous buildings constructed with Romeoville limestone was the Illinois State Capitol Building in Springfield.

During the early 1900s, Romeoville thrived as a resort town for wealthy Chicago-area residents who flocked to Isle La Cache and Romeo Beach.

Joliet originally bore the name Juliet, which was probably a corruption of the of French Canadian explorer Louis Jolliet's name. Jolliet first explored this area in the fall of 1673, describing the game as abundant and the prairies wide, surrounded by lush forests.

The Joliet Historical Museum at 204 North Ottawa Street includes a Route 66 Welcome Center. ◉

WHOOPEE Auto Coaster JOLIET ROAD 10¢ 213402
WHOOPEE Auto Coaster JOLIET ROAD 10¢ 213403
WHOOPEE Auto Coaster JOLIET ROAD 10¢ 213404
WHOOPEE Auto Coaster JOLIET ROAD 10¢ 213405
WHOOPEE Auto Coas JOLIET ROA 10¢

The Whoopee Auto Coaster on Route 66 on the way to Joliet was one of the first roadside attractions to tempt travelers once upon a time. Located on Lawndale Avenue South of 47th Street in McCook, Illinois, the amusement ride did booming business from the late 1920s through the mid-1930s. For a 10-cent ticket, you could drive your car along a wooden-plank road of hills—and chills!

The Wishing Well Motel, just 15 miles outside Chicago at La Grange, Illinois.

Buffaloes on the Range TX 9

Rainbow Dance

WHOOPEE
Auto Coaster
JOLIET ROAD
10¢

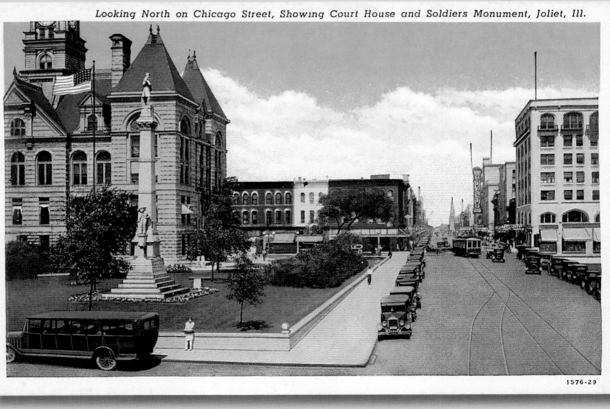

Looking North on Chicago Street, Showing Court House and Soldiers Monument, Joliet, Ill.

1576-29

Downtown Joliet, Illinois.

ROUTE 66 MYTHS AND LEGENDS

Those Famous Old Burma-Shave Signs: "No One Could Read Just One"

By Kathy Weiser

Though most people of today's generation have never heard of Burma-Shave, ask anyone who lived from the 1920s to the early 1960s, and you will most likely bring up a few memories and tales from that vintage era.

Burma-Shave was a brand of brushless shaving cream that was sold from 1925 to 1966. The company was notable for its innovative advertising campaigns, which included rhymes posted all along the nation's roadways. Typically six signs were erected, with each of the first five containing a line of verse and the sixth displaying the brand's name.

Burma-Shave was the second brushless shaving cream to be manufactured and the first one to become a success. The product was sold by Clinton Odell and his sons Leonard and Allan. They formed the Burma-Vita Company, named for the liniment that was the company's first product. The Odells weren't making money on Burma-Vita, and wanted to sell a product that people would use daily. A wholesale drug company in Minneapolis, Minnesota (where the company was located), told Clinton Odell about Lloyd's Euxesis, a British product that was the first brushless shaving cream, but was also of poor quality. Clinton Odell hired a chemist named Carl Noren to produce a quality shaving cream and after forty-three attempts, Burma-Shave was born.

To market Burma-Shave, Allan Odell devised the concept of sequential signboards to sell the product. Allan Odell recalled one time when he noticed signs saying Gas, Oil, Restrooms, and finally a sign pointing to a roadside gas station. The signs compelled people to read each one in the series, and held drivers' attention much longer than a conventional billboard. Though Allan's father Clinton wasn't crazy about the idea, he eventually gave Allan two hundred dollars to give it a try.

In the fall of 1925, the first sets of Burma-Shave signs were erected on two highways leading out of Minneapolis. Sales rose dramatically in the area, and the signs soon appeared nationwide. The next year, Allan and his brother Leonard set up more signs across Minnesota and into Wisconsin, spending $25,000 that year on signs alone. Orders poured in, and sales for the year hit $68,000.

Burma-Shave sign series appeared from 1925 to 1963 in all of the lower forty-eight states except for New Mexico, Arizona, Massachusetts, and Nevada. Four or five consecutive billboards would line highways so they could be read sequentially by passing motorists.

This use of the billboards was a highly successful advertising gimmick, drawing attention from passersby who were curious to discover the punchline. Within a decade, Burma-Shave was the second-most popular brand of shaving cream in the United States.

The first set of slogans was written by the Odells; however, they soon started an annual contest for people to submit the rhymes. With winners receiving a $100 prize, some contests received over fifty thousand entries.

At their height of popularity there were seven thousand Burma-Shave signs stretching across America. They became such an icon to early travelers that families eagerly anticipated seeing the rhyming signs along the roadway, with someone in the car excitedly proclaiming, "I see Burma-Shave signs!" Breaking up the monotony of long trips, someone once said, "No one could read just one."

Burma-Shave sales rose to about six million by 1947, at which time sales stagnated for the next seven years and then gradually began to fall. Various reasons caused the drop, the primary one being urban growth. Typically Burma-Shave signs were posted on rural highways, and higher speed limits caused the signs to be ignored. Subsequently, the Burma-Vita Company was sold to Gillette in 1963, which in turn became part of the American Safety Razor Company and Phillip Morris. The huge conglomerate decided the verses were a silly idea and one of America's vintage icons was lost to progress.

By 1966, every last sign disappeared from America's highways. A few ended up in museums, including a couple of sets that were donated to the Smithsonian Institute. Here are two of them:

Shaving brushes
You'll soon see 'em
On a shelf
In some museum
Burma-Shave

Within this vale
Of toil and sin
Your head grows bald
But not your chin
Burma-Shave

A vintage Burma-Shave sign still standing along Route 66 in Arizona. *Carol M. Highsmith's America, Library of Congress*

Clinton Odell, founder of the company, died in 1958. Allan Odell, who came up with the sign idea, passed away in 1994, his brother Leonard in 1991.

Philip Morris sold the Burma-Shave brand name to the American Safety Razor Company in 1968, but the name remained dormant until 1997, when it was reintroduced for a line of shaving cream, razors, and accessories. Although the original Burma-Shave was a brushless shaving cream, the name currently is used to market a soap and shaving brush set. ⊙

Normal and Bloomington

The Heart of Illinois

By Kathy Weiser

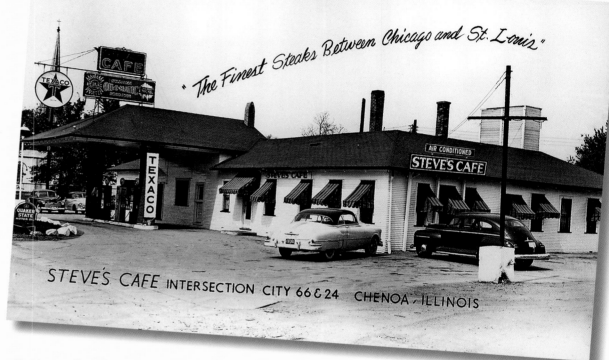

"The Finest Steaks Between Chicago and St. Louis"

STEVE'S CAFE INTERSECTION CITY 66 & 24 CHENOA-ILLINOIS

As you travel Route 66, you'll have to watch carefully to observe where Normal ends and Bloomington begins.

In 1854, the town of North Bloomington was platted in an area that was commonly known as the Junction, at the intersection of the Illinois Central and the Chicago & Alton railroads. Though platted, the town was not developed until three years later when Jesse Fell began to build in an area that lay northeast of the original plat. Fell is referred to as the "founding father" of Normal, as he soon became a central figure in the town's development.

In 1857, Governor William Bissell signed a bill to create a "normal" school, a term used for schools established as teachers' colleges. Jesse Fell took up the campaign for Bloomington and obtained financial backing for the school. Abraham Lincoln, in his capacity as an attorney, drew up the bond guaranteeing that Bloomington citizens would fulfill their financial commitments. The college was named Normal University, and held its first classes in Bloomington while the campus was being built north of the town.

Old Main, the all-purpose building for the university, was completed in 1861; the state's first college was established. Four years later, in 1865, the town was officially incorporated under the name of Normal.

In the 1920s buses began to replace the streetcar lines in Normal and Bloomington, and when Route 66 was designated, the area began to sprout all types of new businesses to accommodate the many travelers of the road. Gus and Edith Belt attached a dining room to the side of their Shell Gas Station and called it Shell's Chicken. However, Gus soon realized that central Illinois had plenty of chicken restaurants and wanted to do something different. With a little help from his friends, Gus began to sell a unique product to the many travelers of the Mother Road: the steak burger. In February 1934, the first Steak 'n' Shake was opened in Normal, Illinois.

Normal continued to grow in the mid-twentieth century, and by 1950 its population was nearly ten thousand. In 1964, Normal University officially became

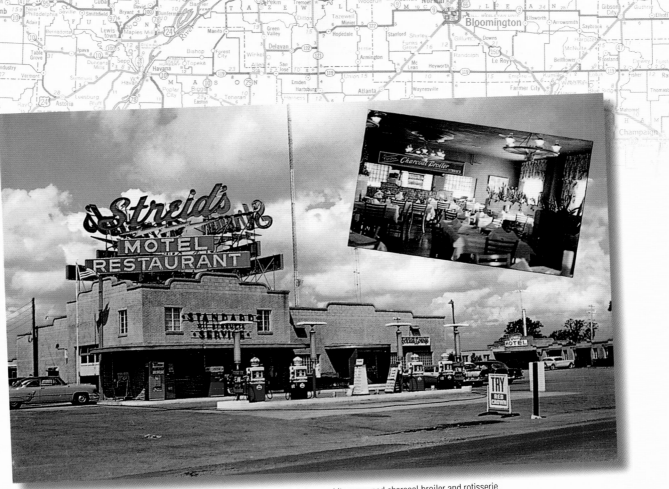

Streid's famed Motel and Restaurant in Bloomington, Illinois, offered gas, lodging, and its renowned charcoal broiler and rotisserie.

Illinois State University, no longer serving as just a teachers' school, but as a multipurpose institution of higher learning.

Today Normal supports a population of nearly fifty thousand residents. While driving Route 66 through Normal, which is primarily a residential section of town, look for several homes that were one-time popular gas stations along the Mother Road. The historic Normal Theater can be seen at 209 North Street.

Seamlessly you enter Bloomington, a city founded decades before the town of Normal was born. In its early years, the settlement was formed near a large grove of trees used by the Kickapoo tribe before white settlers began to arrive in the early 1820s. Before a settlement was established here, several trappers hid a keg of liquor in the grove. However, when a Kickapoo band found it, they drank it, and the stand of trees took on the name Keg Grove. Later, when the first settlers began to build on the land, they changed the name to Blooming Grove due to the many flowers in the area.

When Route 66 came through in 1926 along the Chicago & Alton Railroad corridor, numerous businesses sprouted up along the route and in the heart of Bloomington's downtown district. Unfortunately, when superhighway I-55 replaced Route 66, it bypassed downtown Bloomington and its historic businesses began a quick decline.

Today, this city of some sixty-five thousand people has made a dedicated effort to restore its historic downtown area, which continues to display much of its nineteenth-century charm in its restaurants, shops, and galleries.

Continue your journey down old Route 66 to the ghost town of Funks Grove and more vintage sites at McLean and Atlanta, Illinois. ◉

THE MOTHER ROAD LOST & FOUND

Chenoa, circa 1927

By Russell A. Olsen

Then: Chenoa, Illinois.

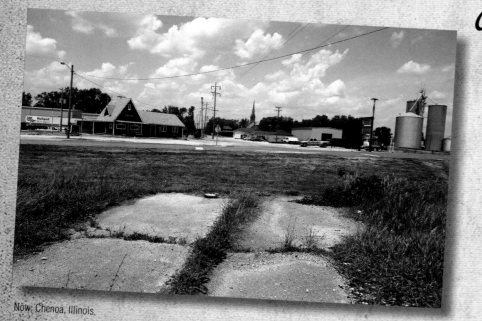

Now: Chenoa, Illinois.

Chenoa had its humble beginnings

in 1854, when Mathew T. Scott acquired thousands of acres of prairie wilderness in the area. He proceeded to lay lots and streets for the yet unnamed town. It was prime property, located at the intersection of the Toledo, Peoria & Western, and the Chicago & Alton railroads. The town's first building was the Farmers Store, built in 1855 by J. B. Lenney, who is often referred to as the Father of Chenoa. By the time the town was founded as Chenoa (a native word meaning "white dove"), the thousands of Indians who at one time made the region their home had long since been removed by the U.S. government to areas west of the Mississippi River.

Chenoa has seen several routings of Highway 66 over the years, including a four-lane version with a railroad crossing that caused long traffic jams as travelers in both directions waited anxiously to proceed. Chenoa has long catered to Route 66 travelers. During the highway's heyday, gas stations, motels, and cafes (including the famous Steve's Café, which can be seen in the vintage photo on page 36) lined the town's streets.

Land for a tourist park, at first simply called Tourist Park (presently known as Red Bird Park), was donated by Scott. The park is a testament to Chenoa's early desire to attract and serve automobile travelers. Tourists were allowed to camp free of charge in the park until the land was leased and a tourist court was built on the property. Many original, vintage buildings remain there, including a structure that has continuously housed a pharmacy (now Chenoa Pharmacy) since 1889.

Like many of the small communities located along this stretch of Route 66, the citizens of Chenoa are proud of their Route 66 heritage and truly make an effort to make you feel welcome in their community. ◉

Recipe for: Sugar Cookies
Funks Grove Pure Maple Sirup, Funks Grove, Illinois

Funks Grove is a historic center for the production of maple sirup along Route 66 in Illinois.

1 cup butter
1 cup granulated sugar
½ cup powdered sugar
¾ cup corn oil
½ cup maple sirup

2 eggs
1 teaspoon baking soda
1 teaspoon cream of tartar
½ teaspoon salt
4 cups flour

Cream the margarine and sugars together. Add the corn oil, maple sirup, and eggs and cream well. Sift together the soda, cream of tartar, salt, and flour. Knead dry ingredients into creamed mixture to form dough. Chill dough for 1 hour. Drop dough by teaspoonful on a cookie sheet and press with a glass dipped in sugar to flatten. Bake in preheated 350 F oven for 12 minutes or until browned.
Yield: 7 dozen cookies.

THIS EXIT FOR ANOTHER ROADSIDE ATTRACTION . . .

Funks Grove: The Home of Maple Sirup

By Kathy Weiser

Some 15 miles south

of Bloomington, Illinois, on Route 66, a rustic sign stands on a grassy embankment with the simple words "Maple Sirup." Here, amongst the prairie grasses, sits a natural maple grove dominating the landscape and filled with sugar and black maples of record size.

In 1824 a man named Isaac Funk became the pioneer founder of Funks Grove when he chose to homestead this location for its water supply, fertile soil, and timber. The fact that the timber was primarily maple was a bonus for Funk, as he and his sons began to make maple sirup and maple sugar for their personal use.

During this time, maple sirup was the only source of sweetener in the area, and Arthur Funk, Isaac's grandson, capitalized on this when he opened the first commercial sirup camp at Funks Grove in 1891. In 1896 Arthur's brother, Lawrence, took over the operation and in the 1920s the sirup operation was passed to Hazel Funk Holmes.

When Route 66 came through about this time, the maple sirup business boomed and the sirup could hardly be made for the season before it was already sold out.

When Aunt Hazel was ready to retire, she asked her nephew, Stephen Funk, and his wife Glaida, to take over the grove and the surrounding farm in 1947. However, before transferring the operation, she arranged for a trust insuring that Funks Grove Pure Maple Sirup would be around for generations to come. Although the trees are worth millions, the trust stipulated that they would never be used for anything other than making maple sirup. The trust also stipulated that the spelling of the word "sirup" remain the same.

As to the spelling of the word, a sign at Funks Grove has this to say:

Historically, according to Webster's Dictionary, "sirup" was the preferred spelling when referring to the product made by boiling sap. "Syrup" with a "y," however, was defined as the end product of adding sugar to fruit juice. Though the "I" spelling is no longer commonly used, the United States Department of Agriculture and Canada also still use it when referring to pure maple sirup. Hazel Funk Holmes, whose trust continues to preserve and protect this timber for maple sirup production insisted on the "I" spelling during her lifetime. It's another tradition that will continue at Funks Grove.

In 1988 Stephen Funk retired, and his son Michael and wife Debby took over the business. Today, a seventh generation of Funks continue to make sirup at this historic place that feels as though it stepped right out a century ago, yet is just miles off of busy Interstate 55. ◉

THIS EXIT FOR ANOTHER ROADSIDE ATTRACTION . . .

Broadwell, Illinois: Home of the Pig-Hip

By Kathy Weiser

When traveling Route 66,

some eight miles south of Lincoln, Illinois, you will come to the tiny little town of Broadwell. Established in 1869, the community now supports only about 150 souls. Here in this small farming town sits one of the Mother Road's more famous icons: the old Pig-Hip Restaurant.

Ernie Edwards and his wife served thousands of barbeque sandwiches and fries at the Pig-Hip to travelers of the road from 1937 until 1991 when the couple retired. Ernie and Frances first opened a small, three-table cafe they called the Harbor Inn. The next year, when a hungry farmer pointed to a steaming pork roast and blurted out that he wanted a sandwich "off that pig hip," Ernie liked the sound of it and soon changed the name of the cafe to the Pig-Hip.

Over the years the restaurant expanded; Ernie's brother, Joe, built a filling station next door; and sister Bonnie Welch and her husband added a motel. Suddenly Broadwell was a full-service stop, and business was booming on the Mother Road. In the 1960s, when Broadwell was bypassed by the interstate, Route 66 fell into disuse and disrepair. Eventually the filling station and motel were sold and closed. By the early 1980s, the handful of other businesses left in Broadwell shut down, leaving the Pig-Hip as the sole commercial business. In 1990, the Edwards retired and, unable to find a buyer for the restaurant, closed the business. Today, with the help of the Illinois Route 66 Association Preservation Committee, the old Pig-Hip has become a Route 66 Museum. ◉

⊲⟫ Did you know Lincoln, Illinois, is the only town named for Abraham Lincoln with his knowledge and consent?

Springfield
Home of Honest Abe

By Kathy Weiser

The pioneer settlement of Springfield began when John Kelley, his wife Mary, their five children, and John's brother, Elisha, arrived in the area in the spring of 1819. The next year, they built the first cabin at what is now the northwest corner of Second and Jefferson streets. Other pioneers from North Carolina, Virginia, and Kentucky followed, taking advantage of the area's fertile soil and trading opportunities.

In 1832, Senator John C. Calhoun, for whom the settlement was named, fell from public favor and the town's name was changed to Springfield. The town was officially incorporated on April 2, 1832.

In 1837, due in large part to the political maneuverings of a young politician named Abraham Lincoln, the state capital was moved from Vandalia to Springfield. On April 15 of that year, Lincoln moved to Springfield from nearby New Salem and began practicing law with John T. Stuart, a prominent Springfield attorney.

Before Lincoln moved to Springfield, the young man had tried his hand at a number of endeavors, including clerking at Denton Offutt's store in New Salem, becoming a postmaster, a surveyor, and a law student, before running for the state legislature in a losing campaign. In 1834 he was elected to the legislature on his second try. It was during this term in office that he influenced the placement of the State Capital in Springfield.

In 1840 Lincoln met a Kentucky belle named Mary Todd, and after a stormy, sporadic courtship, the couple was married by the Reverend Charles Dresser in 1842. Their first son, Robert Todd Lincoln, was born on August 1, 1843. The next spring, Lincoln bought the Reverend Dresser's home on the corner of Eighth and Jackson streets for $1,200 cash and a small lot worth $300. The Lincolns occupied this brown frame house for the next seventeen years.

While practicing his profitable law career, Lincoln continued to be active in politics and on November 6, 1860, he was elected president. On February 11, 1861, Lincoln stood on a platform in the Springfield train station and, in a voice filled with emotion, gave his parting words for the town to the large crowd that had gathered: "My friends: No one, not in my situation, can appreciate my feeling of sadness at this parting. To this place, and the kindness of these people, I owe everything. Here I have lived a quarter of a century and have passed from a young

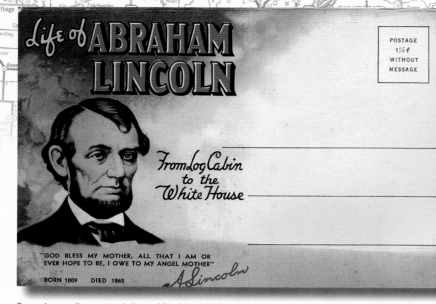

Souvenir accordion-postcard album of Abe Lincoln's life.

to an old man. Here my children have been born and one is buried. . . . To His care I am commending you, as I hope in your prayers you will commend me. I bid you an affectionate farewell." He left Springfield that day and would never return during his lifetime.

Though the Civil War took many men from Springfield in the fight for the Union, it also boosted Springfield's economy with numerous new industries and businesses. With its state capital status, the town continued to grow.

When the Mother Road came through Springfield, the town responded with even more businesses targeted to the many travelers of Main Street U.S.A. Gas stations, cafes, and motels began to spring up overnight.

When the Route 66 signs came down in January 1977, many of these long time businesses died the inevitable death of being bypassed by a super highway. However, many of its old icons still stand in this proud city, and Springfield is dedicated to the memory of its rich history, including the Mother Road.

When you first enter Springfield on the north side of town, you'll see the Pioneer Motel on the north side of the Route at 4321 North Peoria Road. Still open today, the old motel continues to cater to the many travelers of Route 66.

Next, look for Shea's Gas Station Museum, which was at one time an original Texaco station. Owner Bill Shea, a Route 66 Hall of Fame member, will be happy to give you a few stories of the Mother Road. Welcoming visitors from all over the world, the old gas station contains over a half century of gas station memorabilia. The museum is located at 2075 Peoria Road.

The vintage Coney Island Restaurant at 210 South Fifth Street is located downtown. As you continue on you'll pass Sunrise Donuts, long out of business at 1101 South Ninth Street. The Bel Aire Manor Motel, still catering to weary travelers, is located at 2636 South Sixth Street.

When is a corn dog not a corn dog? When you're at the Cozy Dog Drive In along Route 66 in Springfield, Illinois. This first fast food of the road was introduced by Ed Waldmire at the 1946 Illinois State Fair. In 1950, he opened the Cozy Dog Drive In. This Mother Road icon still stands today at 2935 South Sixth Street in Springfield, Illinois, but when you order their Cozy Dog, don't call it a corn dog, or you might be met with little more than a steely-eyed stare.

Recipe for: Batter Dipped French Toast
Inn at 835, Springfield, Illinois

The historic Inn at 835 is listed on the National Register of Historic Places.

1 cup sifted flour

1 teaspoon baking powder

1 teaspoon salt

2 eggs

1 cup milk

2 tablespoons vegetable oil

6 slices cinnamon raisin bread

Beat the eggs, milk, and oil. Add the flour and baking powder and stir until thoroughly combined. Dip cinnamon raisin bread into mixture as needed and deep fry until golden brown. Serve with warm maple syrup.

Fleetwood Restaurant

SPRINGFIELD, ILLINOIS

If you travel the older alignment (pre-1930), you will see the Route 66 Drive-in at 1700 Recreation Drive.

As you travel on down the Mother Road you'll pass over Lake Springfield. A man-made lake built in the 1930s, it now covers parts of the original two-lane alignment of Route 66. When the water level is low, glimpses of the old road can still be seen.

As you continue your travels southwest along the Mother Road out of Springfield, you will have to choose one of two alignments that are both still intact today. The first alignment (1930–1977) begins as a four-lane road in Springfield closely following I-55; it will take you to Glenarm, Divernon, Farmersville, and Litchfield. The pre-1930 alignment, a two-lane road, will take you through Chatham, Auburn (where you can see a piece of brick alignment), Virden, Carlinville, and numerous other small towns before the two alignments rejoin near Staunton, Illinois. ◎

THE MOTHER ROAD LOST & FOUND

Cozy Dog Drive In, Springfield, circa 1950

By Russell A. Olsen

Then: The Cozy Dog Drive In, Springfield.

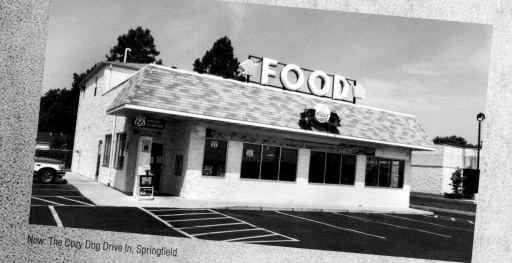

Now: The Cozy Dog Drive In, Springfield.

Ed Waldmire Jr. and

his friend Don Strand developed the Cozy Dog while stationed in Amarillo, Texas, during World War II. To earn extra money, Ed sold the new-fangled food—a delectable hot dog on a stick, dipped in special batter and French-fried—at the USO club and the base PX. The "Crusty Curs," as they were first known, quickly became a local favorite. After Ed's discharge from the military he introduced the dogs to the public at the 1946 Illinois State Fair; they were such a hit that Ed decided to sell his new fast food in his hometown of Springfield, Illinois.

The first Cozy Dog stand was opened at the Lake Springfield beach house on June 16 of that same year. At the insistence of his wife Virginia, who wondered who would eat something called a Crusty Cur, Ed began kicking around ideas for a new name. After much painstaking thought, "Cozy Dog" was settled upon. A second Cozy Dog stand was opened on Ash and MacArthur in Springfield, and in 1950 Waldmire moved into a building that shared seating with the local Dairy Queen. In 1976, Ed's son Buz and daughter-in-law Sue leased the restaurant from Ed. After their divorce, Buz sold his half to Sue, who has run the restaurant ever since. The Cozy Dog moved to its current location at 2935 South Sixth Street in 1996 and sits partially on the property of the former Route 66 landmark Lincoln Motel. ◉

Service With a Smile

ALL NIGHT LONG... *You're Welcome*

Remember that late drive home in a blinding rain, with the gas gauge creeping toward "empty"? Remember how one service station after another was blacked-out, closed? Remember worrying about the long, wet walk home?

* * *

But that needn't happen to you this summer. Once more Texaco Dealers have pioneered! They now offer you all-night-service on every main highway in America throughout the summer touring season.

No matter how late the hour or how bad the night...a Texaco Dealer is ready to supply you with either of those two famous Texaco

Gasolines, *Fire-Chief* or *SKY CHIEF*. He will give your motor needed protection with Insulated Havoline, or Texaco Motor Oil. He will clean that rain-blurred windshield, offer you the shelter and convenience of his *Registered* Rest Room, send you safely on your way. Yes! Day or night... *You're Welcome*

TEXACO DEALERS

TUNE IN: "Millions for Defense" All Star Radio Program every Wednesday Night—Columbia Broadcasting System—9:00 E.D.T., 8:00 E.S.T., 8:00 C.D.T., 7:00 C.S.T., 6:00 M.S.T., 5:00 P.S.T.

Mitchell
Leaving the Land of Lincoln

By Kathy Weiser

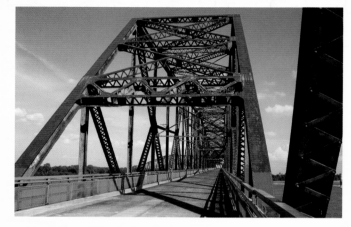

The Chain of Rocks Bridge. *Shutterstock*

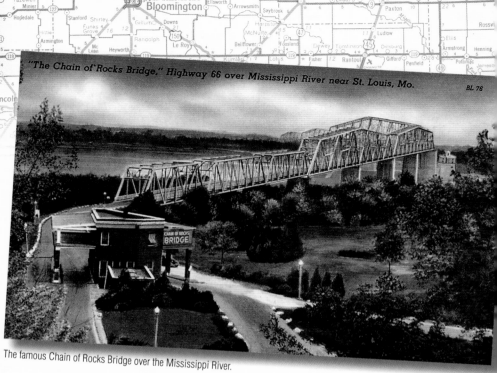

"The Chain of Rocks Bridge," Highway 66 over Mississippi River near St. Louis, Mo. BL 76

The famous Chain of Rocks Bridge over the Mississippi River.

As you near the town of Mitchell, you'll begin to notice you've left the quiet farms of southern Illinois and are entering the suburbs of St. Louis. However, here on the outskirts of the sprawling metropolitan city, you will still find numerous peeks of the old Mother Road.

As you near Mitchell, begin to watch for the old Bel-Air Drive-In sign on the right side of the highway just after crossing Route 111. Opened in the 1950s, this old theater played to travelers along Route 66 up until 1987. Over the years its old screen has fallen down and its parking lot has been reclaimed by the prairie, but its sign continues to stand as testimony of better times.

Beyond the Bel-Air you will pass a number of old motels on the left before coming to a Route 66 classic—the Luna Café. Built in 1924, the cafe also hosted a gambling operation and provided "ladies of ill-repute" during its early days. Furthermore, like many other places along Illinois' ribbon of the Mother Road, the cafe was once said to have been frequented by Al Capone, as well as a host of other mobsters. At one time the cafe was a fine-dining establishment, and so expensive that most law-abiding citizens couldn't afford to eat there. Today it is more of a working-class establishment, catering to the locals and a new generation of Route 66 travelers.

At one time an enormous neon moon graced the top of Luna's building; however, it was taken down and destroyed when the building was re-roofed. With help from Friends of the Mother Road, the neon moon will rise over the Luna again and its neon sign will be restored to its former luster.

Beyond the Luna Café old Route 66 splits, with one alignment headed into the central city of St. Louis via Granite City, Madison, and Venice. This alignment, most often referred to as City 66, then passes through some confusing neighborhoods in East St. Louis, which today is a rough part of town.

The other alignment, referred to as the Beltline Route, used to cross the Mississippi River via the old Chain of Rocks Bridge. The bridge, constructed in 1929, was financed by tolls. In 1967 a new bridge along I-270 was constructed over the river, and the old bridge was closed. After sitting abandoned for more than three decades, it was restored and is now the longest strolling and biking bridge in the world. This alignment passes through the north edge of the city, then turns south through Kirkwood, rejoining City 66 at a point twenty-six miles from the Chain of Rocks Bridge. Today, Route 66 deadends at the Chain of Rocks Bridge, where you will have to backtrack to the new overpass on I-270 to continue your journey along the Mother Road.

You can also reconnect to City 66 by exiting in downtown St. Louis and traveling along Tucker Boulevard. This way you won't miss some of the city's most fascinating sites, such as the Gateway Arch, the historic Union Station, and the famous Route 66 icon Ted Drewes, as you begin to move on into the suburbs.

Welcome to Missouri! Enjoy the sites and flavors of the Show Me State! ◉

Map of St. Louis and Vicinity

U.S. 66 The Will Rogers Highway

US.66, US.40 BY-PASS

VIA

CHAIN OF ROCKS BRIDGE

RECOMMENDED
AAA
ROUTE

Chain of Rocks Bridge Connecting Madison County, Illinois, with St. Louis, Missouri
Carries the two principal East and West National Highways entering St. Louis and avoids all congested metropolitan areas.

HIGHWAY U. S. 66
Is the shortest and fastest route and connects with U. S. Highways 40, 50 and 67 in Illinois, and U. S. Highways 40, 50, 61 and 67 in Missouri.

U. S. 66 and BY-PASS 40
Connects with all St. Louis boulevards and Business Sections.

Owned and Operated by STEPHEN MAERAS
CITY OF MADISON, ILLINOIS Mayor

Presented by

★ **BRIDGE TOLL RATES** ★
Passenger Automobile and Driver 25c
Trucks—40c · Low Commutation Rates

CHAIN OF ROCKS BRIDGE

"The Boulevard Route"

Fast · Shortest · Safe

•

For Local and Through Traffic
Crossing the Mississippi River

At ST. LOUIS

BRIDGE TOLL RATES
Passenger Car and Occupants - 25c
Trucks - 40c - Low Commutation Rates

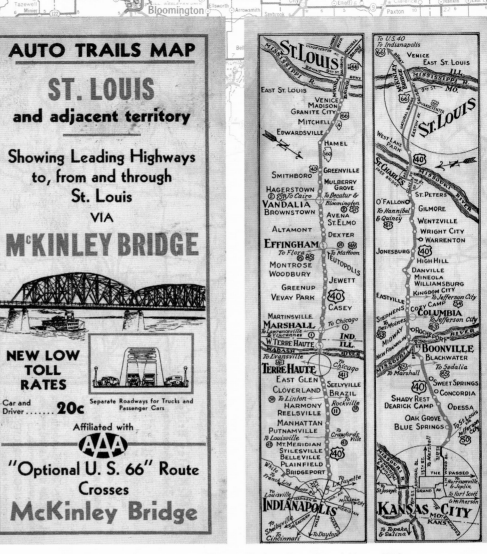

AUTO TRAILS MAP

ST. LOUIS
and adjacent territory

Showing Leading Highways
to, from and through
St. Louis
VIA

McKINLEY BRIDGE

NEW LOW TOLL RATES

Car and Driver 20c

Separate Roadways for Trucks and Passenger Cars

Affiliated with

AAA

"Optional U. S. 66" Route
Crosses

McKinley Bridge

Vintage map for the McKinley Toll Bridge between Illinois and Missouri. "New low toll rates: Car and driver . . . 20¢."

Did you know the Luna Café in Mitchell, Illinois, dates to 1924, two years before the commissioning of Route 66? Did you know the cafe was once a front for an illegal casino in the cellar and a prostitution business on the third floor, or that this illegal operation was part of Al Capone's syndicate?

2 Missouri

Across the Ozarks

Jim Hinckley

0 YEARS' OLD FORMATIONS

AMERICA'S MOST BEAUTIFUL

ONONDAGA CAVE

ONONDAGA CAVE

MAGNIFICENT...AWE INSPIRING

U.S. HIGHWAY 66 NEAR
LEASBURG, MISSOURI

DISCOVERED BY DANIEL BOONE

OPEN EVERY DAY ALL YEAR

Boots Drive-in & Gift Shop
At the Crossroads of America
Junctions U. S. 66 - 71 Carthage, Mo.

The many Mississippi River crossings utilized by Route 66 over the years are now a tangled web of inner-city and semi-rural roads intermingled with dead ends, truncated roads, and bridges that are forgotten engineering marvels. Scattered all along these routes, like dusty gems and tarnished silver, are ghostly vestiges from a time when traffic flowed in an endless stream from east to west and west to east.

Perhaps the most famous river crossing associated with the highway is the Chain of Rocks Bridge, with its twenty-two degree turn in the middle. Built in 1929, the bridge became a component of Route 66 after the realignment of 1936 and continued in this capacity until its abandonment in 1968. Today it is only open to bicyclists and hikers.

Following the twisted and confusing path of Route 66 through the urban wilderness of St. Louis can be daunting. However, for those who persevere, the reward is a true treasure: Ted Drewes Frozen Custard at 6726 Chippewa, where travelers and locals alike have beaten the heat with signature frozen treats since 1941. The roots for this icon of the highway reach even further back in time, to the opening of the original establishment in 1931 on an earlier alignment of Route 66.

The landscapes west of St. Louis are a mind-boggling blend of delightful natural scenery, vintage roadside Americana, and modern urban sprawl. Framing the first twenty-five miles or so is the Henry Shaw Gardenway, a corridor of native trees and shrubs planted before World War II in honor of Henry Shaw, founder of the Missouri Botanical Gardens.

From St. Louis west into the Ozarks, I-44 replaced Route 66 just as the Double Six supplanted the Old Wire Road, which represented an improvement over the Great Osage Trail. In Missouri, as in Illinois, Route 66 is but one manifestation of a transportation corridor in use for centuries.

For early explorers, established routes such as the Great Osage Trail presented the only viable access to what was the western frontier in the closing years of the eighteenth century. During the Civil War, the trail became an important military supply route paralleled by a vital telegraph line that connected St. Louis with Springfield. Vestiges, remnants, and ghostly ruins hidden amongst the vines along Route 66 reflect this long and colorful history.

In Pacific, a town almost erased from the map by Confederate troops in October 1864, Route 66 masquerades as Osage Street, where architectural styles representing more than a century cast long shadows on warm summer afternoons. In Cuba, the Hotel Cuba (established in 1915) represents the world of the traveler before Route 66, while the Wagon Wheel Motel (built around 1936) embodies that of the new breed of adventurer loosely labeled "motorist."

Route 66 State Park, on the banks of the scenic Meramec River, is an idyllic oasis that masks the tragic tale of Times Beach, a small resort community turned ghost town as a result of dioxin contamination. In its day, Meramec Caverns near Stanton was as famous as Rock City, and painted barns proclaiming its wonders were found all along the roads that twisted through the scenic and colorful Ozarks and beyond.

GREETINGS FROM MISSOURI

A tire-scarred remnant of old Route 66. *Kerrick James*

Just a few miles to the west of Rolla is Martin Springs, now smaller than a spot on the map. It was here that an enterprising pioneer built a cabin and provided services to travelers and teamsters on the Wire Road. Shortly before the shield that bore two sixes appeared along the old roadway, the Old Homestead, one of the nation's first truck stops, opened on the site of the old cabin.

Doolittle, with its tattered remnants from the glory days of the highway, seems an unlikely place for a celebration that garnered international media attention; but that is what happened here on October 10, 1946. On that date, Medal of Honor-winning hero and aviation pioneer Jimmy Doolittle flew in for the official dedication ceremony that transformed Centerville into the rechristened Doolittle.

Springfield, "the Queen of the Ozarks," was the western terminus for the Wire Road. Here, on August 10, 1861, twenty-five hundred men died in the battle of Wilson's Creek. Here, in 1865, "Wild Bill" Hickok had his first gunfight. Here the candlelit past blends seamlessly with the neon-lit present.

Carthage is a veritable treasure trove of historic architecture, with the turreted 1895 Jasper County Courthouse as the crown jewel. Founded in 1842, the hometown of legendary Civil War spy, Belle Star, was the scene of the first land battle of the Civil War in 1861, the site of numerous skirmishes throughout the war, and in 1864 was burned by Confederate raiders.

As Joplin has served as the outfitting center and jumping-off point for adventurers headed west for more than a century and a half, it is quite fitting this old mining town marks the end of the line for westbound travelers on Route 66 in Missouri. Vestiges from every step in the town's evolution—outfitting center, mining town, and Route 66 boomtown—abound.

There are also a few ghosts and mysteries here. Southwest of Joplin is a little spot known locally as Spookesville, an area where since at least 1886 a mysterious light that bounces over the hills has startled (and even terrified) travelers. This area is also accessible from Quapaw in Oklahoma. ◉

BREAKFAST SUGGESTIONS

Chilled Fruits and Juices

Orange Juice	.20	Fruit Cocktail	.25
Grapefruit Juice	.20	Stewed Prunes	.20
Tomato Juice	.20	Half of Grapefruit	.20
Grape Juice	.20	Pineapple Juice	.20
Cantaloupe (In season)	.25		

INDIVIDUAL CEREALS

Fresh Sanitary Package of Kellogg's and Post's Cereals

With Milk25 With Cream40 With Fruit40

Hot Cereal25

GOLDEN BROWN TOAST

Buttered or Dry — Rye or Wheat10 Cinnamon .15

French Toast45

Milk Toast30

FRESH COUNTRY EGGS AND OMELETTES

2 Eggs, Any Style, Toast with Butter	.40
Bacon and Eggs, Toast with Butter	.85
Ham and Eggs, Toast with Butter	.95
Plain Omelette, Toast with Butter	.65
Cheese Omelette, Toast with Butter	.75
Western Omelette, Toast with Butter	.85
Ham Omelette, Toast with Butter	.85
Sausage and 2 Eggs	.85
Country Ham and 2 Eggs	1.35
Scrapple and 2 Eggs	.75
Country Style Potatoes	.65
Chip Beef on Toast	.65
Jelly Omelette	.65
Chicken Liver Omelette	1.00
Bacon Omelette	.85
Home Fried Potatoes, Extra	.10

DELICIOUS LIGHT HOT CAKES

Hot Cakes, Syrup, Butter	.40
Blueberry Pancakes	.65
Hot Cakes, Sausage	.85
Hot Cakes, Ham	.90
Hot Cakes, Bacon	.85
Hot Cakes, Scrapple	.75
Hot Cakes, Country Ham	1.35
Hot Cakes, Eggs	.80

CRISP SALADS

Chicken Salad	.60	Sliced Tomatoes, Lettuce	.25 & .40
Tuna Salad	.60	Fresh Vegetable Salad	.25 & .50
Potato Salad	.25 & .45		
Hard Boiled Egg Salad	.25 & .45		
French Fried Potatoes	.25		
Home Fried Potatoes	.20 & .40		

Route 66 café menu—"Now Serving Food Where Prices Appear."

SANDWICHES - LUNCH - PLATTERS

Now Serving Food Where Prices Appear

— SANDWICHES —

Hot		Cold	
Hamburger	.30	Chicken Salad	.65
Cheeseburger	.40	Tuna Fish Salad	.60
Club Hamburger	.45	Egg & Olive	.60
Sausage Sandwich	.60	Ham Salad	.60
Grilled Cheese	.30	Bacon, Lettuce & Tomato	.60
Grilled Ham and Cheese	.60	American Cheese	.50
Grilled Bacon and Cheese	.60	Baked Ham	.30
Ham or Bacon and Egg	.60	Ham & Cheese	.60
Fried Egg	.25	Swiss Cheese	.60
Fish Sandwich	.60	Cold Beef	.60
Crab Cake Sandwich	.60	Sliced Chicken	.60
Oyster	.60	Liverwurst	.60
Western Egg	.60	Cube Steak	.50
Hot Beef, 1 Vegetable	.95	Pork Club	.70
Hot Chicken, 1 Vegetable	.95	Hard Boiled Egg	.95
Grilled Ham	.60	Egg Salad	.35
Bacon	.60	Lettuce & Tomato	.35
Chicken Club	1.00	Peanut Butter & Jelly	.30
Ham Club	.95		
Country Fried Ham	.80		
Fried Ham	.60		
Hot Dog	.25		

Sandwiches on Toast — .05 Extra

FRESH SEA FOODS IN SEASON

Oyster Stew			.60 & .80
Fish Sticks			1.35
Combination Sea Food Platter			1.45
Crab Cake Platter	1.35	Deep Sea Scallops	1.35
Filet of Haddock	1.35	Fried Shrimp	1.35
Oyster Platter (4)			

Above Platters include Two Vegetables, Bread and Butter

Small Fry Oysters (5) Cole Slaw, Bread and Butter			1.30
Large Fry Oysters (8) Cole Slaw, Bread and Butter			
Plain Stew		Milk Stew	1.70
All Meat Crab Cake, with Cole Slaw			.60
Mountain Trout, 2 Vegetables			.75
			1.45

STEAKS AND CHOPS

Hamburger Steak	.95		
Roast Beef	1.25	Grilled Cube Steak	1.25
Pork Chops (2)	1.45	T-Bone Steak	1.75 & 2.50
Country Sausage	1.25	Ham Steak	1.35
Country Fried Ham Platter	1.45	Veal Cutlet	1.25

Above Platters include Two Vegetables, Bread and Butter

ALA CARTE

Cold Cut Platter	1.25
Shrimp Salad Platter	1.25
Combination Salad Platter	1.25
Cottage Cheese and Fruit	.65

St. Louis
Gateway to the West

By Kathy Weiser

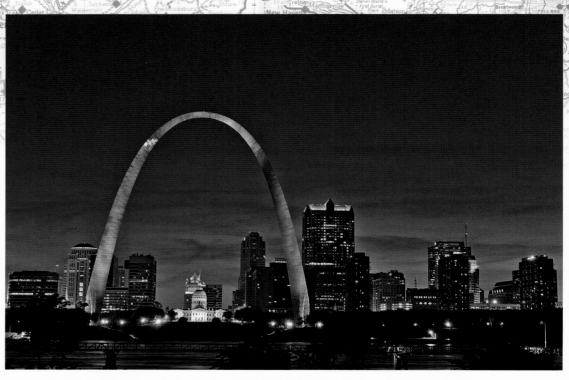

The awe-inspiring St. Louis Arch, the symbolic gateway to the West. *Carlos E. Santa Maria/Shutterstock*

St. Louis, one of the oldest cities in Missouri, began when a man named Pierre Laclede Liguest discovered the perfect place for a trading post on a high bluff of the Mississippi River in 1763. Early the next year, Leclede sent his stepson, along with thirty men, to begin clearing the heavily forested land for a new town, of which Laclede declared, "This settlement will become one of the finest cities in America."

Referred to as Laclede's Village by its new residents, Laclede himself pronounced the settlement St. Louis, in honor of King Louis IX of France.

By 1766, the burgeoning village had about seventy-five buildings built of stone (quarried along the river bluff) or timber posts, and was called home by about three hundred residents. Maintaining steady growth through the end of the century, St. Louis boasted almost a thousand citizens by 1800, mostly French, Spanish, Indians, and both black slaves and freemen.

In 1804, when the Louisiana Purchase was officially transferred to the United States, the settlement included a bakery, two taverns, three blacksmiths, two mills, and a doctor. Several grocers also operated from their homes, selling merchandise at outrageous prices due to high transportation costs. From St. Louis, Thomas Jefferson sent Lewis and Clark to explore the new Louisiana Territory in May 1804. When the explorers returned in September 1806, the city became the "Gateway to the West" for the many mountain men, adventurers, and settlers that followed the path of Lewis and Clark into the new frontier.

The first steamboat arrived in St. Louis on July 27, 1817, beginning the boomtown days of St. Louis as an important river city. Before long, it was common to see more than a hundred steamboats lining the cobblestone levee during any given day.

The 1830s were a decade of growth and prosperity in the burgeoning river city. Many new churches were built at this time, a public school system was started, and the city implemented a new water system. By the 1840, St. Louis was home to almost seventeen thousand residents.

By 1850, river traffic had increased to such an extent that St. Louis was the second largest port in the country, with commercial tonnage exceeded only by New York City. It had also grown to be the largest city west of Pittsburgh. On some days, as many as 170 steamboats could be counted on the levee, some of which were literally "floating palaces," complete with chandeliers, lush carpets, and fine furnishings. It was also during this time that travel to the vast West began in earnest after gold was discovered in California the prior year. St. Louis saw additional prosperity as the gateway to the west, outfitting many a wagon train, trapper, miner, and trader.

By 1890 the U.S. Census declared that the frontier had closed, and America held no more unexplored and undiscovered lands. After this declaration, St. Louis grew at a more leisurely pace, having some 575,000 residents by the turn of the century.

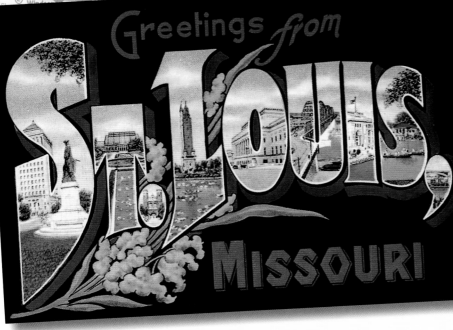

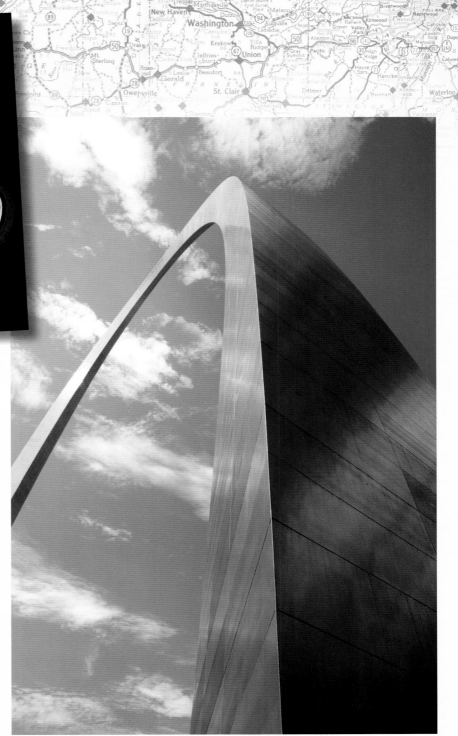

In 1904, St. Louis hosted the World's Fair, the greatest event in its history. Covering more than a thousand acres in the vicinity of west Forest Park, the fair attracted more than twenty million visitors to the glittering expanse of white palaces and lagoons. That same summer, on the fairgrounds, the United States became the first English-speaking country to host the Olympic games. Bringing worldwide attention to the city, another wave of growth continued in St. Louis, which lasted through World War I.

When Route 66 came through the city, St. Louis was already more than 150 years old, with well-established streets and neighborhoods. Due to the city's continued growth and expansion during the life of the Mother Road, the route was changed in St. Louis multiple times. With so many alignments through the metropolis, you'll need a few good maps to navigate St. Louis in search of search of vintage Route 66 icons. Start your journey on the Mother Road through Missouri on the old Chain of Rocks Bridge, located north of downtown. Crossing the Mississippi River from Illinois to Missouri, the bridge was constructed in 1929 as part of the original Highway 66 project. Initially financed by tolls, the bridge carried passengers over the Mighty Mo for the next thirty-eight years until a new bridge was constructed in 1967.

Then, for more than three decades, the bridge sat closed and abandoned. However, in 1999, the bridge was renovated and reopened as a bicycle and pedestrian bridge. Today, the one mile-long Chain of Rocks Bridge is the longest strolling and biking bridge in the world.

St. Louis's famed archway. *Shutterstock*

WAYSIDE AUTO COURT City Route U. S. 66 1½ miles West of St. Louis, Mo.

After viewing this historic viaduct, head to downtown St. Louis, where you can see the Gateway Arch, the Museum of Westward Expansion, and the historic Union Station. Before leaving downtown, be sure to grab a bite at the Eat-Rite Diner at 622 Chouteau Avenue. Constructed in 1908 before Route 66 was even conceived of, this long enduring eatery first served as a coffee and doughnut shop for railroad crews.

In 1940, it became the Eat-Rite Diner and coined its motto "Eat-Rite or don't eat at all." Today, you can get a great burger at its chrome bar that will make you feel as if you've taken a forty-year step back in time.

Another must-see along the way is Ted Drewes Frozen Custard at 6726 Chippewa, which has been serving up frozen "concretes" to hungry travelers since 1931. Just across the street from Ted Drewes is another old Route 66 landmark, the Donut Drive-In, which also continues to cater to Mother Road travelers today.

At the National Museum of Transportation in southwest St. Louis, you can view a unit of the Coral Court Motel. Moved brick by brick to the museum, this motel once gained a reputation in St. Louis as a "no-tell motel." Though the historic motel is gone, the museum brings at least a piece of it back to life.

Continue to follow the Route 66 markers along Chippewa and Manchester Roads through the St. Louis suburbs to see numerous vintage motels and diners scattered between busy modern shopping areas. ◎

Hi Bill
What a life
It sure is a long
Drive.
Ed.

1515

RT66.

JOPLIN
AUG 11
1 30 PM
1949
MO.

HIRE THE HANDICAPPED
ITS GOOD BUSINESS

Post Card

UNITED STATES POSTAGE
1 CENT 1

WAYSIDE AUTO COURT
Ultra Modern. One of the Finest in the Midwest. On U. S. Highway No. 66 City Route, 1½ miles West of St. Louis City Limits and 3 miles East of intersection of By-Pass Hys. 61-66 and 67. Thirty five rooms. Brick cottages with private tiled bath in each unit, hot and cold water, maid service. Beauty-Rest mattresses, hot water heat and 24 hour service. (Mailing address No. 7800 Watson Road, St. Louis, 19, Mo.) Phone WE.4373

We stopped here

═MWM═

Blue Bonnet
Court
4½ Miles West of
St. Louis
Missouri
AAA

SLEEP AND REST

IN THE BEST

210 Rooms
Restaurant
Cocktail Lounge

On U. S. City 66 - One half Mile East of By pass at Junction of U. S. 66 and 61

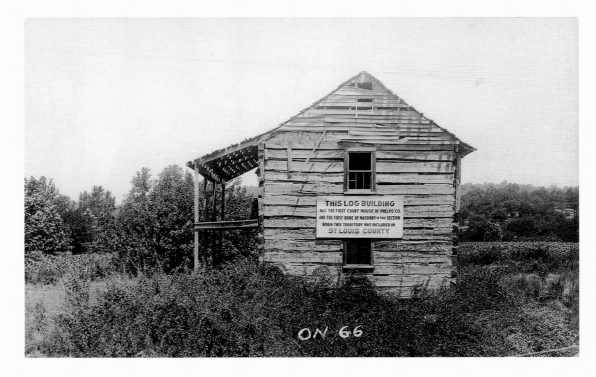

THIS LOG BUILDING
WAS THE FIRST COURT HOUSE OF PHELPS CO.
AND THE FIRST HOME OF MASONRY IN THIS SECTION
WHEN THIS TERRITORY WAS INCLUDED IN
ST LOUIS COUNTY

ON 66

THIS EXIT FOR ANOTHER ROADSIDE ATTRACTION . . .

Meramec Caverns: The Hideout of Jesse James

By Kathy Weiser

Meramec Caverns is a

set of natural limestone caves that features beautifully sculpted stalactites and stalagmites. Formed more than four hundred million years ago, the caverns have a long and rich history. First used by local tribes as a shelter, a French miner stumbled upon them in 1720. Discovering saltpeter (used for making gunpowder) in the cave, Renault named the caves Saltpeter Mine and mined this resource until 1742. Later, Spanish miners used the caverns as a base of operations for lead mining.

During the Civil War, saltpeter mining was revived in the cavern, and Union troops used it as a munitions powder mill from 1862 to 1864. However, when William Quantrill and his irregular band of Confederates discovered it, they destroyed the mill. One member of Quantrill's band, namely Jesse James, would remember the location of the caves and use them later during his outlaw years. It was also during this time that the caves were said to have harbored runaway slaves on the Underground Railroad.

In 1874, Jesse James, along with the James-Younger gang, robbed the Little Rock Express on its way from St. Louis, Missouri, to Little Rock, Arkansas, at a small town called Gads Hill. Pursued by a posse, the gang escaped seventy-five miles northeast to the caves. The sheriff and his men soon tracked the James-Youngers, deciding to starve them out of the caves. However, after three days, the gang had not emerged. The lawmen entered the caves only to find the gang's horses. It has been long believed that the outlaws escaped by swimming from a shallow underground stream to the Meramec River outside the cave.

By the 1890s the caves were owned by a man named Charley Rueppele, who was interested in prospecting it. However, Rueppele also allowed some of Missouri's elite to use part of the caves for ballroom dances. During the hot Missouri summer months in the days before air conditioning, the caves provided a wonderful respite. Today the same area of the caves can still be rented for special events.

In the 1930s, a local cave enthusiast by the name of Lester Dill leased the caves from Rueppele with an option to buy. Along with partner Ed Schuler, they built the access road and entrance to the caves, renamed them Meramec Caverns, and opened them to the public in 1935.

Dill uncovered miles of new passages and spectacular views, and began to heavily market the cave to the many travelers of Route 66. Marketing efforts included the use of "bumper signs" before the advent of bumper stickers, as well as painted signs on the sides and roofs of barns all along Route 66. Soon the cave became known as one of the most famous stops along the Mother Road.

Today Meramec Caverns include tours through seven underground levels, a restaurant, and a museum that features the life and times of the caverns. Outside the caverns, a campground and motel are available along the banks of the Meramec River. For outdoor enthusiasts, canoes and rafts can be rented for float trips, a tour boat is available for a scenic trip along the river, and visitors can pan for gold at the Meramec Mining Company. Open year-round, Meramec Caverns can be reached by I-44 exit 230, in Stanton.

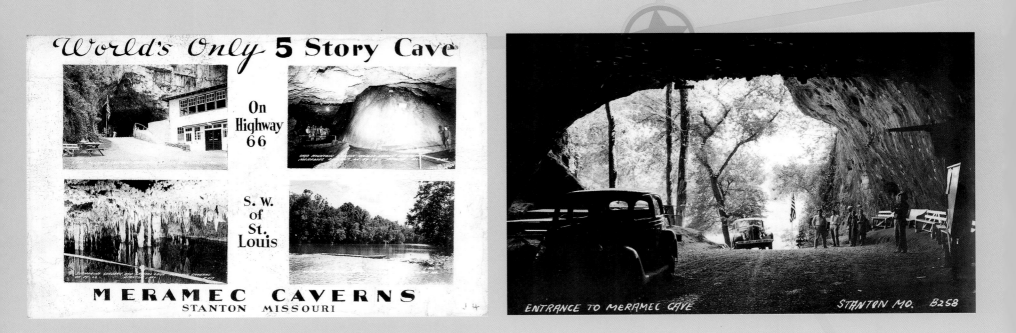

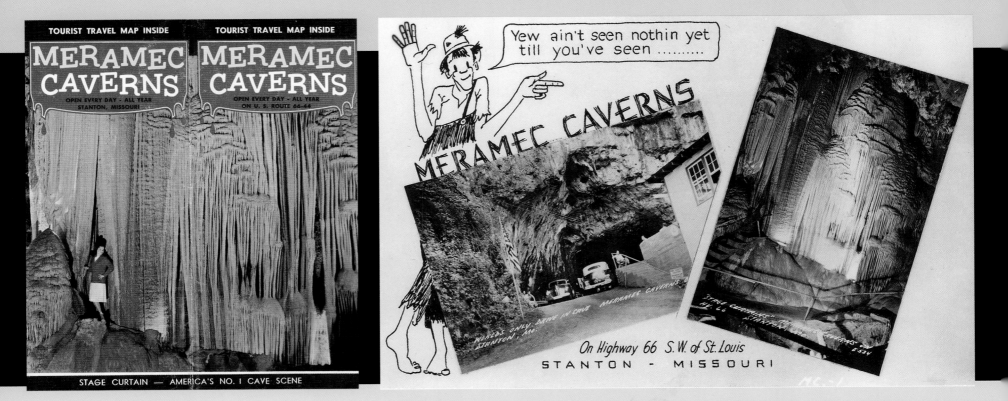

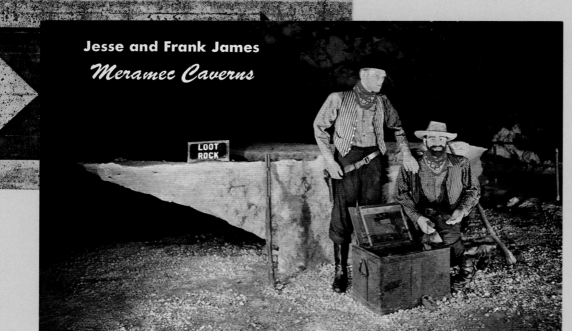

Jesse and Frank James
Meramec Caverns

LOOT
ROCK

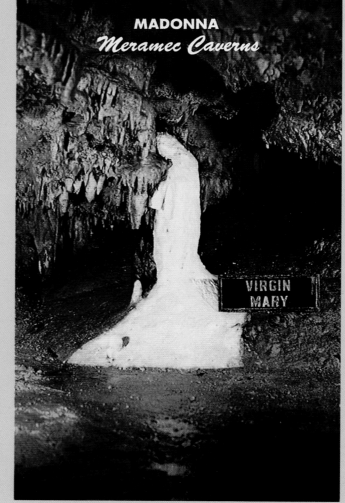

MADONNA
Meramec Caverns

VIRGIN
MARY

On your way to Meramec Caverns, you will pass by the Riverside Reptile Ranch, where you can see the largest collection of snakes in the state of Missouri, from pythons to boas, cobras, rattlesnakes, and more. Not limited to snakes, you can also get a scary look at alligators, scorpions, and tarantulas inside the complex. The outdoor view provides glimpses of foxes, turtles, goats, emus, and Leo the Lion.

Back in Stanton, the Antique Toy Museum is on the south frontage road at exit 230, where you will see thousands of toy trucks, cars, planes, trains, and more. Right next door is the Jesse James Museum, a Route 66 icon for almost 40 years. Here you will hear the story of how Jesse James wasn't really shot to death in 1882—instead, this place will convince you that he died of old age in Granbury, Texas, in 1952.

Other signs of a more prosperous Route 66 are the aging Delta Motel at 2420 South Service Road and the Stanton Motel at 2497 North Service Road East, both of which still serve Route 66 customers today.

Continue your journey on Route 66 on Springfield Road, through the small hamlet of Oak Grove Village, before reaching Sullivan. ◉

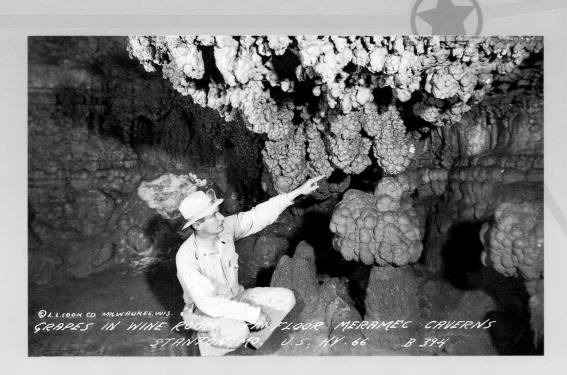

GRAPES IN WINE ROOM 5TH FLOOR MERAMEC CAVERNS
STANTON, MO. U.S. HY. 66 B 394

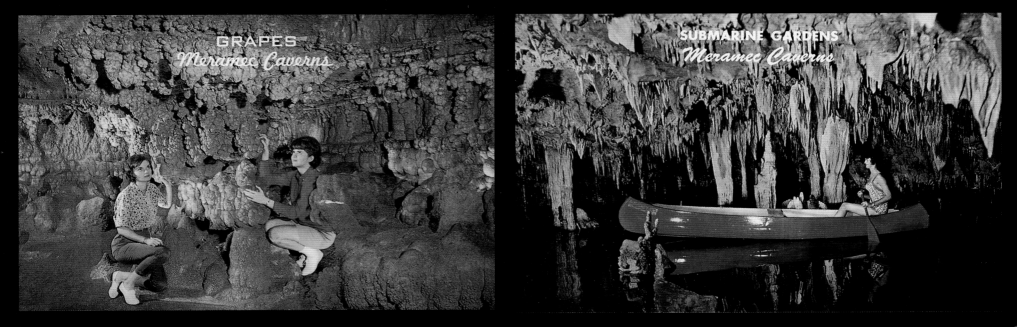

GRAPES
Meramec Caverns

SUBMARINE GARDENS
Meramec Caverns

VOICES FROM THE MOTHER ROAD

Wally Byam: The Man Who Put a Home on Wheels

By Michael Karl Witzel

Wally Byam didn't grow up

with a silver spoon in his mouth. As a boy he worked as a shepherd and lived out of a donkey-powered, two-wheeled wagon. Covered with tattered cloth, it wasn't much, but it had all the necessities: a mat for a bed, a kerosene cook stove, food, water, and a wash pail. It was literally the first travel trailer, although Byam never dreamed that people would want to use something similar for recreation.

Despite these humble beginnings, Byam lifted himself from his circumstances and graduated from Stanford in 1923 with a law degree. He never used his training, failing to apply for a board examination or practice law in any form. Instead, he took his skill for making a case with words and went to work for the Los Angeles Times as an advertising copywriter. Unfortunately, his ability to work for a boss was not as well developed.

So Byam opened his own agency. To generate some cash, he published a handful of how-to magazines for home carpenters and builders. At the time, the do-it-yourself craze was sweeping the nation, and car owners were experimenting with ways to have fun via the automobile. Naturally, many of the magazines' projects involved the automobile.

During the 1920s, there were no established accommodations along our nation's roadways; in fact, the term "motel" (a combination of "motor" and "hotel") had not even been coined yet. Auto camping was fun, but a major hassle. People lugged their supplies with them in their cars and along the roadside and set up elaborate tents and other structures for sleeping—some connected to their cars.

Byam knew there had to be a more satisfying way for motorists to travel, with complete independence, wherever the road might lead. So he published an article that was submitted to him on the construction of a do-it-yourself travel trailer. Unfortunately, his readers wrote in with a variety of complaints! It seemed that the plans were impractical to build, making the trailer unsuitable for people who were serious about long-distance travel by car. In response, Byam decided to design his own version.

A short while later, he had drafted improved plans and penned his own article outlining the assembly of an inexpensive, $100 trailer. He sold the story to *Popular Mechanics* magazine. Byam wrote later in his book, *Trailer Travel Here and Abroad*, that it was a "crude, boxy structure which rested none too easily upon a Model A Ford chassis." It was simple, a "little more than a bed you could crawl into, a shelf to hold a water bottle, a flashlight and some camping equipment . . . protected from the elements."

Next, he sold the plans through his own magazine and got more requests than he imagined possible. Eventually he was busy assembling pre-built units and made-to-order versions of his trailer in his backyard. It was a small operation, and sometimes the customers even came by to help! With the success of a teardrop-shaped, thirteen-foot, canvas and Masonite marvel that he dubbed the Torpedo, he dropped his career in the advertising game and jumped into the trailer manufacturing business. Believing that his aerodynamic trailers slipped along the byways "like a stream of air," he adopted the Airstream name in 1934.

Wally Byam and his early torpedo trailer. *Michael Karl Witzel collection*

Around the same time, aeronautical guru William Hawley Bowlus was developing a radically new trailer concept in the San Fernando Valley. As head of Ryan Aircraft's shop in 1927, he gained valuable expertise working on the *Spirit of St. Louis*. By the thirties, he had perfected a streamlined, monocoque fuselage—applying aircraft design principles to the art of trailer construction. He called it the Bowlus Road Chief. Most trailers had a bulky superstructure, but the Bowlus used exterior skin panels to distribute the stress loads. The result was increased resistance to vibration, improving both mileage and "tow-a-bility."

In 1936, the January issue of *Trailer Travel* magazine featured a full-color illustration of the Road Chief on the cover. Speeding through a desert landscape, it was a preview of recreational vehicles to come. Its polished aluminum shell, Streamline Moderne windows, and aerodynamic rooster-tail embodied the future. The only thing odd about it was the placement of the door: front and center, right above the trailer hitch area.

The model failed to sell very well, and Byam bought out the remainder of the Bowlus inventory. After moving the entry to the side of the trailer, he reintroduced it

An early Airstream Clipper trailer. *Michael Karl Witzel collection*

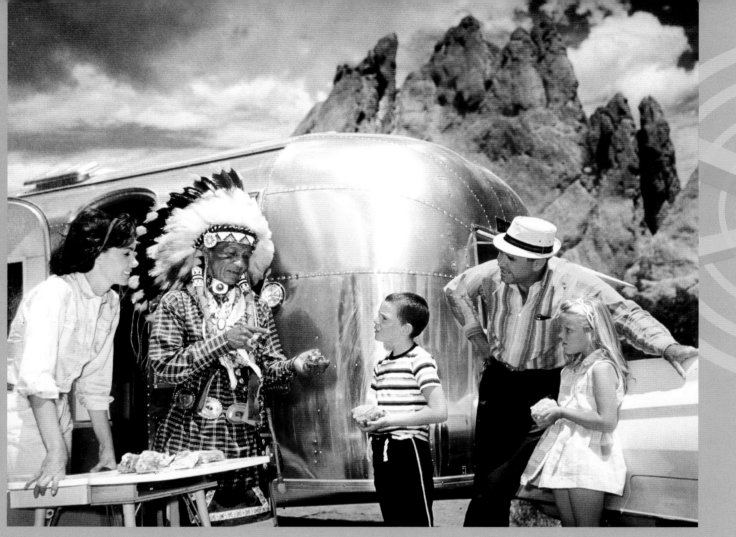

Airstream tourists. *Michael Karl Witzel collection*

as the Airstream Clipper. Inside, the sleeper was built to accommodate four, and the seats converted into beds. A tubular-frame dinette set and a diminutive galley were used to prepare food. An advanced heating and ventilation system (augmented by insulation) increased comfort, along with electrical lights, storage cabinets, and eight fully opening side windows. A luxury version included an experimental dry-ice air conditioner.

When World War II came, parts became difficult to obtain and aluminum a critical war material. In 1942 the War Production Board decreed "house trailers shall not be made for the duration of the war, except by manufacturers making them for the government or recognized and approved governmental agencies." Byam suspended Airstream operations and began work for a Los Angeles aircraft contractor. After the war, Airstream re-emerged and continued to build the gleaming classics that made it unique.

Today the original Clipper (or "Old Grand-Dad" as it is now called) occupies a place of prominence at the company's headquarters in Jackson Center, Ohio. The graceful Airstream is a true survivor, one of only a handful of trailers made in America with the same standards of quality instituted over sixty years ago. No doubt inspired by his early years of living in a crude donkey wagon, Wally Byam's vision of taking your home with you on your travels to "wherever you go" is still rolling down highways like Route 66.

As Byam himself said: "Don't stop. Keep right on going. Hitch up your trailer and go to Canada or down to Old Mexico. Head for Europe, if you can afford it, or go to the Mardi Gras. Go someplace you've heard about, where you can fish or hunt or collect rocks or just look up at the sky. Find out what's at the end of some country road. Go see what's over the next hill, and the one after that, and the one after that." ⊙

The Missouri Ozarks

SCENIC **MISSOURI** AND U.S. HIGHWAY

POSTAGE 1½¢ WITHOUT MESSAGE

MISSOURI U.S. 66

In the BEAUTIFUL OZARKS

A Tour Through The **MISSOURI OZARKS** ON U.S. HIGHWAY

MISSOURI US 66

Interstate 44—U. S. 66 In the Scenic Missouri Ozarks

Greetings from **MISSOURI**

Route 66

GREETINGS FROM The OZARKS

© CURT TEICH & CO., INC.

The Famous Route 66 and 44

READ ALL OF THIS FOLDER
FOR GREATER ENJOYMENT

"MISSOURI, THE CAVE CAPITOL OF THE NATION"

MILEAGE
(approximate)

St. Louis	60	Chicago	345
Springfield	145	New York	1160
Tulsa	320	Los Angeles	1720
Dallas	640	Memphis	195

WRITE—ONONDAGA CAVE, Dept. 6, Leasburg, Mo., for information and literature on group rates for schools, churches and organizations.

THIS EXIT FOR ANOTHER ROADSIDE ATTRACTION . . .

EXIT

Onondaga Cave: Missouri's Famed Show Caverns

By Kathy Weiser

About seven miles

beyond Bourbon is the turnoff for Leasburg, Missouri, where you'll have the opportunity to take a side trip to a spelunker's paradise: Onondaga Cave State Park. Considered to be one of the nation's finest "show" caves, due to its onyx formation, the Onondaga Cave is designated a National Natural Landmark. The park is also home to Cathedral Caves, also well decorated with many formations. Aboveground there is also plenty of natural beauty. The Vilander Bluff Natural Area provides visitors with a panoramic view of the Meramec River, in which canoeing and fishing abounds. The state park is seven miles southeast of I-44 at the Leasburg exit. Along this road can be seen several painted barns for the cave, similar to those for Meramec Caverns.

Returning to Route 66, the old highway travels through one of Missouri's finest wine- and grape-producing regions. Some vineyards can be observed from the road, and several roadside stops sell grapes, grape juice, wine, honey, and other locally produced products in the summer and fall months. ◉

THE TWINS ONONDAGA CAVE LEASBURG, MO. NO. A183

Mysteries & Beauties of

ONONDAGA CAVE

NEAR LEASBURG, MO.
ON HIGHWAY 66 — 85 MILES S.W. OF ST. LOUIS

THE CAVE WITH THE
BOAT RIDE ENTRANCE

64

THE MOTHER ROAD LOST & FOUND

Devils Elbow, circa 1939

By Russell A. Olsen

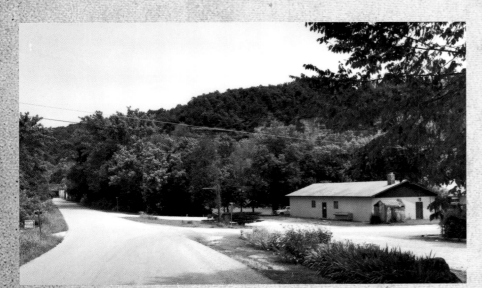

Then: Devils Elbow, Missouri.

Now: Devils Elbow, Missouri.

Devils Elbow is a quiet,

picturesque village on the Big Piney River about twenty miles west of Rolla. Listed as one of Missouri's top scenic spots, this Ozarks town was named by lumberjacks who floated logs down to this treacherous portion of the river. The logs would often jam at the bend and cause long delays, leading the rafters to comment that the river at this point had a "devil of an elbow."

A block east of the bridge leading into Devils Elbow sits the Elbow In (originally the Munger-Moss Sandwich Shop). Across the bridge is the site of the old Devils Elbow Café and the Conoco station built by Dwight Rench in 1932. The cafe and station were at one time affiliated with the nearby Cedar Lodge, ten cabins boasting private cooking facilities. The cafe housed the local post office from 1931 to 1941, and in later years was transformed into a tavern called the Hideaway, which burned to the ground in the late 1950s. A block from the cafe was McCoy's Store and Camp, an old-fashioned general store built by Charles McCoy in 1941. In addition to selling fishing tackle and sporting goods, McCoy's rented boats for use on the Big Piney, as well as six small sleeping rooms upstairs; the owners lived in a four-bedroom apartment downstairs behind the store. In 1948 seven small cabins were added, but McCoy's closed in 1954 and was turned into an apartment building.

That year, McCoy's son-in-law, Atholl "Jiggs" Miller, and his wife Dorothy built Millers Market; they sold camping essentials, dry goods, and gasoline. Jiggs was the postmaster until 1982, when he sold the market to Terry and Marilyn Allman. The Allmans operated the store as Allman's Market until October 2001, when the property was sold to Phil Sheldon. ◉

Rolla

The Middle of Everywhere

By Kathy Weiser

The famous Wagon Wheel Motel neon sign along Route 66 in Cuba, Missouri. *Kerrick James*

Among rivers, forested hills, and bubbling springs, you will find Rolla, Missouri—a haven for outdoor fun.

The first settlers of the area were farmers who began arriving in 1818, building along the riverbanks. Though the town wouldn't be formed for several more years, a man named John Webber built the first house where Rolla would be in 1844.

When Route 66 came through it replaced Route 14, a gravel road that was difficult to travel in anything but good weather. Work began on the concrete slab in 1928, and the stretch from Rolla to Lebanon was the last piece in Missouri to be paved, because of its harsh surface. The completion was cause for a huge celebration. Rolla further improved its image by completing the paving of city streets, which connected with the highway. In no time, Rolla became a vacation playground as tourist cabins motels, trading posts, and fishing camps sprang up.

For views of Route 66, be sure to check out the Mule Trading Post just as you enter the east side of town. On the west end is the Totem Pole Trading Post, opened in 1933 and offering gas and novelties to cross-country travelers. Located at the corner of Route 66 and Martin Springs Drive, the vintage store sells antiques to new adventurers on the Mother Road. Also check out Zeno's Motel and Steak House at 1621 Martin Springs Drive, which has been serving up fine food and accommodation since 1957.

Rolla also has an auto museum called Memoryville USA, which includes a gift shop offering antiques and collectibles and an automobile restoration shop where visitors can view restorations in progress. The museum is located at 2220 North Bishop Avenue. For an interesting look at something else altogether, visit the Rolla Stonehenge. Built by students at the University of Missouri at Rolla, it's a partial reconstruction of the ancient megalith.

Just a bit further down the road at exit 172, you can see the remains of the Stony Dell resort. This exit will also take you to Larry Baggett's Tribute to the Trail of Tears. This interesting property, decorated with a stone archway, statues, stone walls, and rock gardens, was built by the deceased Larry Baggett to honor Native Americans who suffered along the Trail of Tears. ◉

The historic Route 66 Drive-In movie theater in Carthage, Missouri. *Hobart Design/Shutterstock*

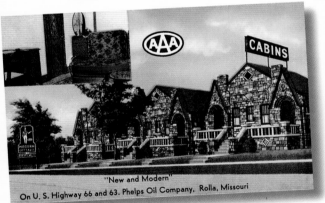

"New and Modern"
On U. S. Highway 66 and 63. Phelps Oil Company, Rolla, Missouri

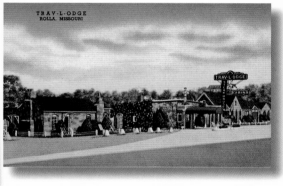

TRAV-L-ODGE
ROLLA, MISSOURI

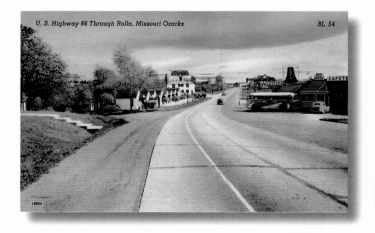

U. S. Highway 66 Through Rolla, Missouri Ozarks BL 54

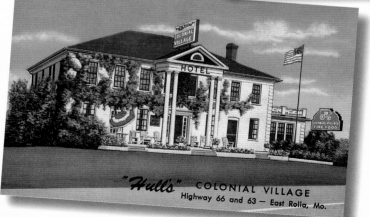

"Hull's" COLONIAL VILLAGE
Highway 66 and 63 — East Rolla, Mo.

HWY. 66
WEST
ROLLA,
MO.

Please Close Cover Before Striking

Springfield

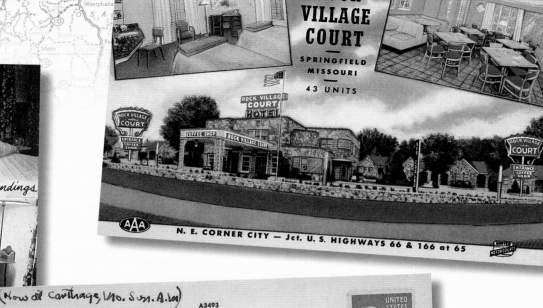

ROCK VILLAGE COURT
SPRINGFIELD MISSOURI

43 UNITS

N. E. CORNER CITY — Jct. U. S. HIGHWAYS 66 & 166 at 65

AAA

Real home like surroundings

Rail Haven Motor Court Springfield, Missouri

NEW HAVEN COURTS ON U. S. 65 AND 66 SPRINGFIELD, MO.

AAA

(Now at Carthage, Mo. Sun. A. m.)

A3493

NEW HAVEN COURTS - SPRINGFIELD, MO.
Located on U. S. 65 and City Route U. S. 66,
3 blocks south of intersection. All strictly modern,
fireproof, steam heated hotel cottages. Sleep Safely.
Phone and Western Union Service. Owned and
operated by Mr. and Mrs. Otis C. Duggins.

We stopped here. Sat. night.

POST CARD

UNITED STATES POSTAGE
1 CENT 1

nice place - 2 beds, shower, toilet bath -
garage in next room, very fancy
lots of motels, neon lights make
quite a sight. Made good time after
carburetor was checked, etc.
Expect to hit Okla. City today -
maybe to Elk City beyond. Sunny -
but cool last night. Roads good -
little traffic - do 50 m.p.h our easy.
Flat farm country - poor except in
big towns. Bye. V — Haven

The Cat and Fiddle Restaurant
1932 South Glenstone, Springfield, Missouri

Otto's Motel Courts

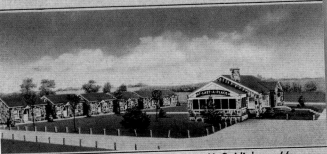

3 Miles East of Springfield, Mo., on U. S. Highway 66
Steam heated, Otto's Motel Court - Fine Foods

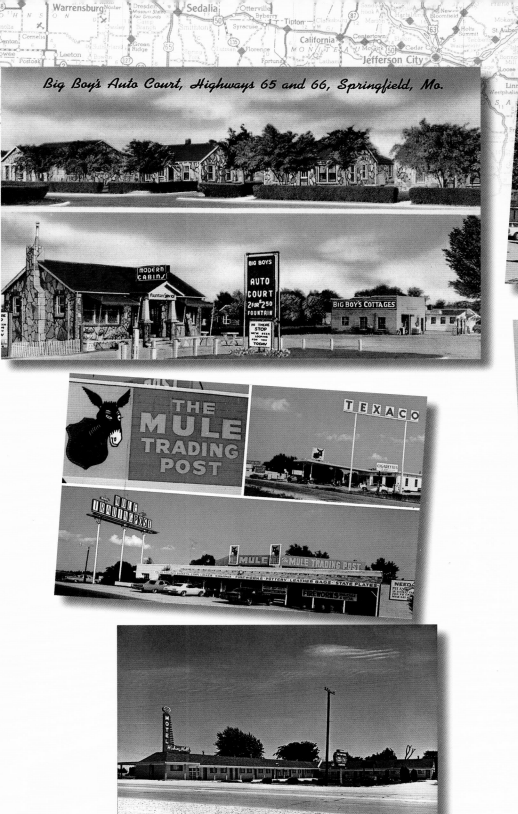

Big Boy's Auto Court, Highways 65 and 66, Springfield, Mo.

MODERN CABINS
BIG BOYS AUTO COURT 2 for $2.50 FOUNTAIN
BIG BOY'S COTTAGES

THE MULE TRADING POST

TEXACO

MULE TRADING POST

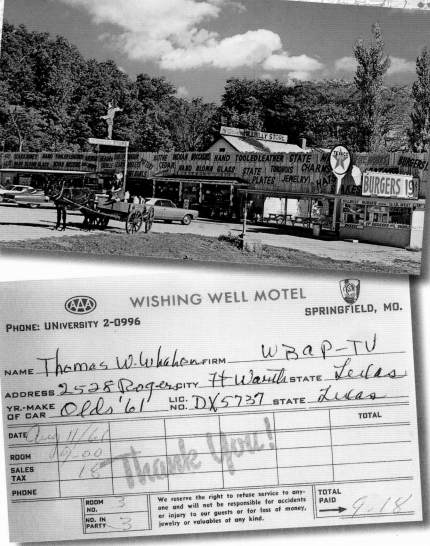

HILLBILLY STORE

BURGERS 19¢

ROCK COURT MOTEL

½ MILE EAST OF LEBANON, MO., ON HIGHWAY 66

BL 59 U. S. Highway 66 Bridge Crossing Gasconade River between Lebanon and Waynesville, Mo.

Joplin
The Miner's Town

By Kathy Weiser

"RECOMMENDED BY DUNCAN HINES"

KORONADO HOTEL KOVRTS
AAA
JOPLIN, MO.

60 ROOMS
BATHS
GARAGES

KORONADO HOTEL KOVRTS ARE LOCATED IN JOPLIN, MO. — SAN ANTONIO, TEX. AND CORPUS CHRISTI, TEX.

Trout Fishing at Bennett Spring State Park, near Lebanon, Missouri and U.S. Highway 66

THIS SPACE FOR WRITING MESSAGES

POST CARD

UNITED STATES POSTAGE
2 CENTS 2

The first settler in the Joplin area was the Reverend Harris G. Joplin in 1839. The minister held church services in his home for other area pioneers long before the city of Joplin was formed. Before the Civil War, lead was discovered in the Joplin Creek Valley, but mining operations were interrupted by the war.

In 1870 a large strike occurred, which brought many miners to the area and caused numerous mining camps to spring up. Soon a man named John C. Cox filed a town site plan on the east side of the valley, which was quickly populated by many businesses. In 1873, the city was incorporated.

With the large influx of miners Joplin was a wild town, filled with saloons, dancehalls, gambling establishments, and brothels. By the turn of the century, the town had become a hub of the region, with fine hotels and restaurants replacing many of these bawdier establishments. Soon Joplin became the self-proclaimed lead and zinc capital of the world, and was filled with many fine homes built by successful businessmen. As you head out of Joplin, you will glimpse several old pubs along the short drive to the Kansas State line. ◉

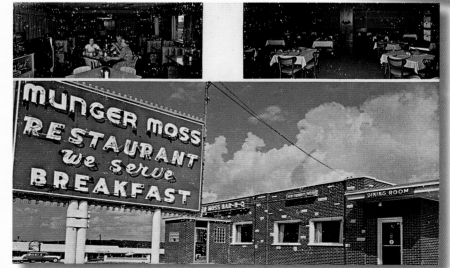

MUNGER MOSS RESTAURANT
We Serve BREAKFAST

DINING ROOM

MOSS BAR-B-Q

ELECTRICAL AND MUSICAL FOUNTAIN

NELSON DREAM VILLAGE — U. S. HIGHWAY No. 66 AND No. 5 — LEBANON, MO. 6A-H772

KORONADO HOTEL KOVRTS JOPLIN, MISSOURI OUR ROOMS AND COFFEE SHOPS ARE AIR CONDITIONED BY REFRIGERATION

KORONADO HOTEL KOVRTS ARE LOCATED IN JOPLIN, SAN ANTONIO, CORPUS CHRISTI!

Little King's HOTEL COURT HOT WATER HEAT

U.S. Highway 66 WEST OF MAIN STREET JOPLIN, MO.

OZARK ROCK CURIOS

OZARK ROCK CURIOS ST. CLAIR, MO.

"It's New" MOTEL TELEVISION

ON HIGHWAY 71, 1 BLOCK SOUTH JUNCTION 66 & 166 .. Phone 9-334

Joplin, Mo.

Bob Cummings Bob Cummings Inc. YOUR HOLLYWOOD AND JOPLIN HOST

MOTOR HOTEL

NIGHTLY ENTERTAINMENT

Please Close Cover Before Striking

PHILLIPS 66 SATELLITE CAFE

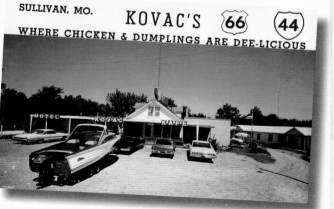

SULLIVAN, MO. KOVAC'S 66 44

WHERE CHICKEN & DUMPLINGS ARE DEE-LICIOUS

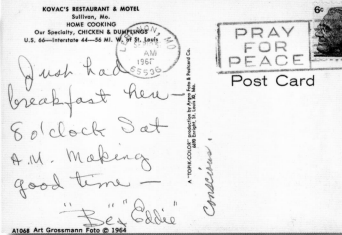

KOVAC'S RESTAURANT & MOTEL
Sullivan, Mo.
HOME COOKING
Our Specialty, CHICKEN & DUMPLINGS
U.S. 66—Interstate 44—56 Mi. W. of St. Louis

PRAY FOR PEACE

Post Card

Just had breakfast here — 8 o'clock Sat A.M. Making good time —

"Ben" Eddie

A1068 Art Grossmann Foto © 1964

Did you know the famous photo of Bonnie Parker (one half of the bandit duo Bonnie and Clyde) with a cigar was found amongst undeveloped film in a camera left behind after a shootout at 3347 1/2 Oak Ridge Drive, a few blocks from Route 66 in Joplin, Missouri?

Did you know Route 66 in Miami, Oklahoma, also has a link to Bonnie and Clyde? In November of 1933 they abandoned a stolen car here, and in April of 1934 they killed a constable.

WANTED FOR MURDER
JOPLIN, MISSOURI

F.F.C.25 — BYL X
26 U 00 6

CLYDE CHAMPION BARROW, age 24, 5'7", 130#, hair dark brown and wavy, eyes hazel, light complexion, home West Dallas, Texas. This man killed Detective Harry McGinnis and Constable J.W. Harryman in this city, April 13, 1933.

BONNIE PARKER CLYDE BARROW CLYDE BARROW

This man is dangerous and is known to have committed the following murders: Howard Hall, Sherman, Texas; J.N. Bucher, Hillsboro, Texas; a deputy sheriff at Atoka, Okla; deputy sheriff at West Dallas, Texas; also a man at Belden, Texas.
 The above photos are kodaks taken by Barrow and his companions in various poses, and we believe they are better for identification than regular police pictures.
 Wire or write any information to the

Police Department.

Wanted poster for Bonnie and Clyde, issued in Joplin, Missouri.

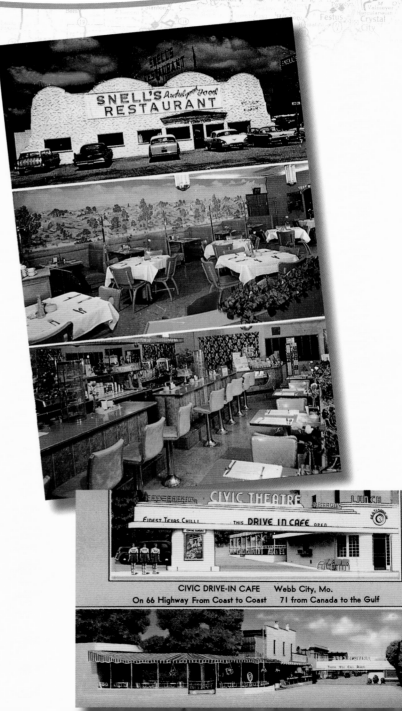

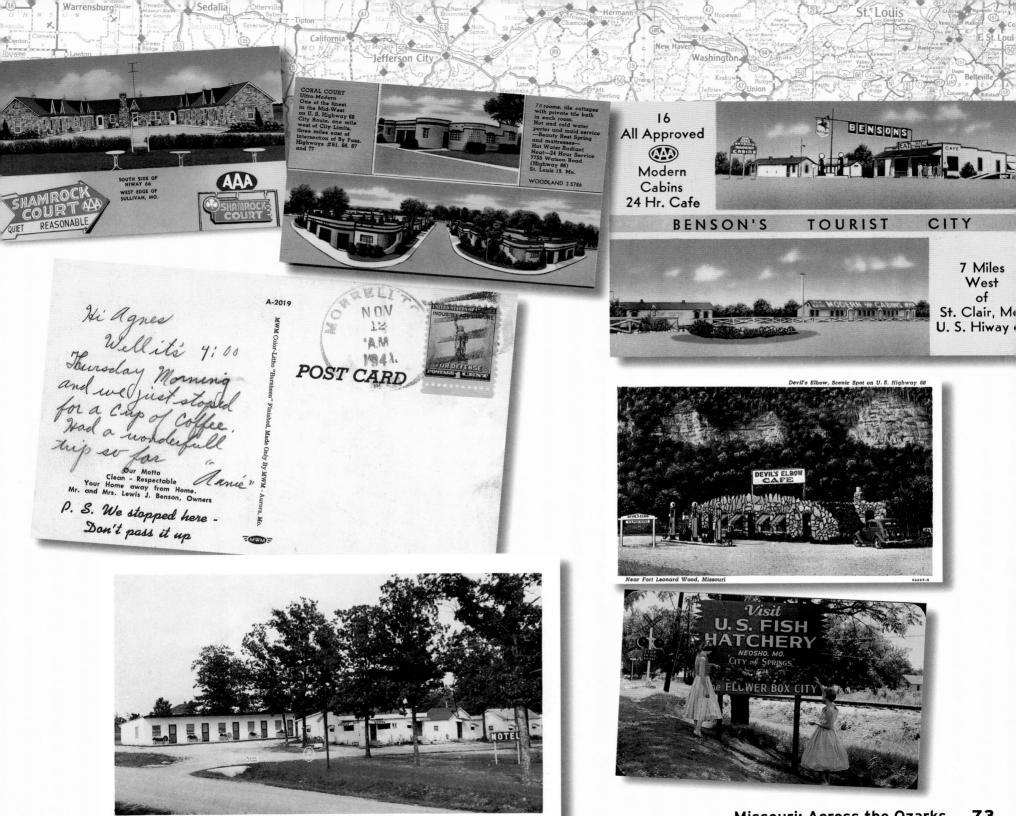

SOUTH SIDE OF HIWAY 66 WEST EDGE OF SULLIVAN, MO.

SHAMROCK COURT AAA
QUIET REASONABLE

AAA
SHAMROCK COURT

CORAL COURT
Ultra-Modern
One of the finest
in the Mid-West
on U. S. Highway 66
City Route, one mile
west of City Limits,
three miles east of
intersection of By Pass,
Highways #61, 66, 67
and 77

70 rooms, tile cottages
with private tile bath
in each room.
Hot and cold water
porter and maid service
—Beauty Rest Spring
and mattresses—
Hot Water Radiant
Heat—24 Hour Service
7755 Watson Road
(Highway 66)
St. Louis 19, Mo.

WOODLAND 2-5786

16
All Approved
AAA
Modern
Cabins
24 Hr. Cafe

BENSONS
EAT CAFE

BENSON'S TOURIST CITY

MODERN CABINS

7 Miles
West
of
St. Clair, Mo.
U. S. Hiway 6

A-2019

Hi Agnes
Well it's 4:00
Thursday Morning
and we just stopped
for a cup of coffee.
Had a wonderful
trip so far
"Annie"

Our Motto
Clean - Respectable
Your Home away from Home.
Mr. and Mrs. Lewis J. Benson, Owners

P. S. We stopped here -
Don't pass it up

MWM Color-Litho "Bursheen" Finished, Made Only By MWM — Aurora, Mo.

MORRELLT
NOV
12
'A.M.
1941.

UNITED STATES OF AMERICA
INDUSTRY AGRICULTURE
FOR DEFENSE
POSTAGE 1 CENT

POST CARD

MWM

Devil's Elbow, Scenic Spot on U. S. Highway 66

DEVIL'S ELBOW
CAFE

DEVIL'S ELBOW
U. S. POST OFFICE

Near Fort Leonard Wood, Missouri

SA669-N

Visit
U. S. FISH
HATCHERY
NEOSHO. MO.
CITY of SPRINGS

The FLOWER BOX CITY

CAMP HI—LITE MOTEL - Cafe - Drinks - Gas & Oil - U.S. Hwy. 66 E. - St. James, Mo.

Missouri: Across the Ozarks 73

3 Kansas

Cutting Across the Corner

Jim Hinckley

Greetings from **KANSAS** The Sunflower State

44003

KANSAS Waving Fields of Grain

Route 66 barely clips the southeast corner of Kansas—it's only a thirteen-mile drive from the Missouri line to the Oklahoma border. With the paving of these miles in 1929, Kansas became the second state to make Route 66 an all-weather road. This distinction, the fact that Kansas is the only state completely bypassed with the decommissioning of Route 66, and its concentration of historical sites, make Kansas unique among the eight states this legendary highway passes through.

As in Illinois and Missouri, tangible vestiges of Route 66 history abound in Kansas. Perhaps the most recognizable to fans of this world-famous highway are the Eisler Brothers Grocery in Riverton (opened on the highway that became Route 66 in 1925) and the beautiful Brush Creek bridge—dating to 1923, it's the last arch-style suspension bridge on Route 66.

Driving west on Route 66, the first community you'll reach in the state is Galena, a town named for the type of lead ore found in the area in 1877. At is peak during World Wars I and II, lead mining made this a prosperous community with a population of nearly fifteen thousand, a far cry from the few thousand that reside there today.

An excellent museum housed in the town's old train depot chronicles the rich history of the community, and the restored Kan-O-Tex service station that is 4 Women on The Route captures the very essence of Route 66 as it was and might be in the future. As a side note, a vintage tow truck at this station served as

the inspiration for Mater in the movie *Cars*. This animated modern classic, with its compilation of real Route 66 sites masquerading as "Radiator Springs," has infused a new generation with curiosity about the iconic highway.

The streets of Galena are relatively quiet today, and the whistle at the nearby Eagle-Picher smelter complex is now silent. Although it's difficult to imagine, these peaceful spots were once the frontlines in a war zone. In 1935 John Lewis, union leader of the United Mine Workers, called a labor strike, and angry miners took to the streets attacking carloads of "scabs" returning to their homes in Missouri. The sheriff and his deputies detoured Route 66 traffic and provided armed escort to travelers before Governor Alf Landon, who ran for president against Franklin D. Roosevelt the following year, declared martial law and dispatched armed National Guard troops to quell the violence.

The volatile situation simmered for several years before culminating in another bloody outburst on April 11, 1937. On that day, nine men were gunned down in front of the headquarters of the International Mine, Mill, and Smelter Workers Union; they became the last casualties in this dispute.

In *A Guide Book to Highway 66*, the classic 1947 work by Jack Rittenhouse, an entry indicates that Riverton (population 104) offered travelers limited services, including the Jayhawk Court and a gas station. Today, only the Eisler Brothers store remains.

BOODLE'S MINERAL SPECIMENS. ONE MILE WEST OF GALENA, KANSAS.

Kansas landmarks. *Shutterstock*

The Rainbow Curve Bridge constructed in 1923 over Brush Creek in Kansas, the only remaining Marsh Arch Bridge on Route 66. *Kerrick James*

Baxter Springs, founded in 1858 and billed as the first cow town in Kansas, is built on the site of the trading encampment of Chief Black Dog on the Black Dog Trail. The town has a long and tragic history. In 1863, the legendary Confederate guerrilla, William Quantrill, massacred a small Union expeditionary force under the command of General James G. Blunt on the prairie outside of town. A monument commemorating this event reads, "The blood that flowed in Kansas before and during the Civil War nourished the twin trees of liberty and union."

Incorporated as a city in 1868, the town marked the terminus of the famed Shawnee Trail used by Texas cattlemen to move vast herds of cattle to markets in Kansas City. Its location, coupled with the completion of the Missouri River, Fort Scott, & Gulf Railroad, transformed Baxter Springs into a rough-and-tumble boomtown.

The first in a series of busts followed a few years later, when the focus of the great cattle drives shifted west to Dodge City. Good times returned with the discovery that the mineral springs from which the town derived its name had curative powers; the resulting development of a new tourism-based economy promoted Baxter Springs throughout the nation.

With the discovery of rich deposits of lead ore in the area, mining replaced tourism, with the exception of the annual Soldier Reunion Week, a national convention for Union veterans of the Civil War. After 1926, Route 66 restored the profitability of tourism-based businesses, and led to the town once again becoming an important center of commerce as five major trucking firms established headquarters here.

The pride of Baxter Springs during the 1940s was their local ball club, the Baxter Springs Whiz Kids. For a brief moment in time, this obscure ball team garnered national attention when one of their star players, Mickey Mantle, signed a contract with the New York Yankees.

Baxter Springs today is a delightful tapestry, its rich history offers into a fascinating and colorful display that presents the illusion of quintessential small-town America. Exemplifying this is the Café on the Route and the Route 66 Visitor Center. The latter is housed in a beautifully restored early-1930s Phillips 66 station. The former has an even more interesting history, as it initially served as a bank. In May of 1876, Jesse James and Cole Younger made an illegal withdrawal from this financial institution and rode south into Oklahoma on a trail that would become Route 66 fifty years later.

To drive Route 66 in Kansas is to experience it as it was with but one exception: today it can be savored, just like a good meal or time spent with old friends, because here the old highway is recognized as a national treasure and treated accordingly. ◉

"ROUTE 66!---"

BY BOB TROUP

AS RECORDED FOR CAPITOL RECORDS BY KING COLE TRIO

BURKE & VAN HEUSEN INC.
Music Company

Original sheet music for Bobby Troup's anthem, as recorded by the Nat King Cole Trio.

ROUTE 66 MYTHS AND LEGENDS

Ode to the Mother Road: The Highway's All-American Anthem

Gallup, New Mexico; Flagstaff, Arizona; Kingman, Arizona; Barstow, California; San Bernardino, California; "and don't forget Winona!"—Winona, Arizona, that is.

Troup's song was a celebration of the allure, romance, and freedom of the open road. And it hit all the right chords with America. The song was published in 1946 and recorded that same year by Nat King Cole and his trio for Capitol Records. Cole's jaunty piano and smooth vocals were backed by the slick licks of guitarist Oscar Moore and the string bass of Johnny Miller. Their rendition became an instant hit on both the U.S. R&B and pop charts. "Route 66" was quickly covered by Bing Crosby with the Andrews Sisters.

These versions were followed by a 1959 recording by Perry Como. Como's version was a rarity, one of the few that included Troup's original introductory verse and seldom-heard second verse.

While early recordings were all jazz-flavored, it was the rock 'n' roll renditions of Chuck Berry in 1961 and The Rolling Stones in 1964 that reinvigorated the song. Supercharged by Berry and Keith Richards' double-stop licks on electric guitar, the song now had a new nervous energy to it—almost as if that freedom was fleeting and you'd better grab it fast.

Since the 1960s, "Route 66" has become a standard, covered by everyone from Jerry Lee Lewis and Them with Van Morrison to The Replacements and The Cramps. In 2006, the song was featured in the animated movie *Cars* and the film *RV* with Robin Williams.

As a fitting anthem to the Mother Road, "(Get Your Kicks On) Route 66" has had a long trip of its own. ◉

Bobby Troup truly got

his kicks on Route 66. Driving west from Pennsylvania to Los Angeles in the mid-1940s, he headed out on the main street of America—Route 66. He was coming to the City of Angels in search of his future, like so many before him, many driving those same long miles on that sun-baked pavement. And in L.A., he eventually found it, building a career as a songwriter and actor.

Troup's road trip inspired the song "(Get Your Kicks on) Route 66." In a later interview, he remembered that both the tune and the refrain came to him easily. One story has it that the title and refrain were suggested by Troup's then-wife Cynthia.

Lyrics for the verses, however, eluded him. In frustration, he packed the verses with a running roll call of the towns the Mother Road visits on the way west: St. Louis, Missouri; Joplin, Missouri; Oklahoma City, Oklahoma; Amarillo, Texas;

Songwriter and musician Bobby Troup.

The Nat King Cole Trio's recording of "(Get Your Kicks On) Route 66" from 1946.

Hittin' the High Road to Popularity!

GEORGIE AULD
AND HIS ORCHESTRA
Play and Sing
GET YOUR KICKS ON
ROUTE 66
ON
Musicraft
RECORD

#15072 Backed Up By
A HUNDRED YEARS FROM TODAY
vocal—Sarah Vaughan

Advertisement from 1946 for George Auld's recording of "(Get Your Kicks On) Route 66."

THE REPLACEMENTS E.P.

ALEX CHILTON
NIGHTCLUB JITTERS
ELECTION DAY
ROUTE 66

Post-punk stars The Replacements cut a typically rambling, rowdy version of "Route 66," as released on this English-only EP.

Bing Crosby and the Andrews Sister's recording of "(Get Your Kicks On) Route 66."

Chuck Berry and his guitar popularized "Route 66" for a new era, fueling subsequent versions by The Rolling Stones and many others up to today.

An early curbside Bowser gasoline pump. *Michael Karl Witzel collection*

VOICES FROM THE MOTHER ROAD

Sylvanus F. Bowser: Man Behind the Gasoline Pump

By Michael Karl Witzel

Sylvanus F. Bowser

wasn't thinking about gasoline when he crafted the first practical fuel pump in 1885. At the time, it was a liquid discarded during the process of refining kerosene; without a market, it was a byproduct that only served for special applications. Coal oil reigned as the preeminent fuel for use in wick-burning lamps and stove-heaters, and was the principle profit product for America's petroleum companies

Initially, this high demand for kerosene inspired Mr. Bowser to improve current pumping state of the art and to create a simple dispenser. The resulting prototype used a discarded oil cask for a tank and functioned much like a pump for a water well: At the top center of the keg, a wooden plunger using marbles as valves replaced the bung hole. Attached to a hand-actuated lever, this crude piston created the vacuum required to draw kerosene up from the barrel.

As gasoline moved from the status of waste product to hot commodity, Bowser's focus shifted away from lamp oil. He continued experimenting, and in 1905 unveiled an improved pump model suited for both kerosene and gasoline. The new Bowser Self-measuring Gasoline Storage Pump consisted of a fifty-gallon metal tank, a wooden cabinet, fume vents, and a pump mechanism with preset quantity-stops. By moving a forced-suction plunger with a hand-stroke lever, it dispensed gas via a flexible hose. Jake Gumpper, a stove-gas supplier who became Bowser's first salesman, dubbed it a "filling station."

The S.F. Bowser Company's handy filling stations appeared in front of general stores and auto repair shops and were soon joined by a raft of imitators. As emerging manufacturers debuted their own dispensers during the 1910s, the hand-cranked plunger design that measured out gallons with a mechanical dial indicator rose to the vanguard.

However, this development was not in the best interest of the consumer, since the mechanically-linked dial pump had serious shortcomings. Unscrupulous station operators often rigged the counter mechanisms to falsely boost quantity readings. What's worse, the liquid pumped through them was hidden from sight. As a result, motorcar operators could not be certain whether the gasoline delivered into their tanks was of the right quantity, or if it was diluted with water.

Principals in the industry knew exactly what had to be done about these "blind pumps." As early as the turn of the century, Iowa inventor John J. Tokheim had proven that a multipurpose pump with a visible holding tank could pump kerosene, oil, and even gas. In 1901 he patented the technology, and within five years refined his one-gallon dispenser into an efficient visible and cylinder-measuring pump. He called this configuration his "Dome Long Distance" outfit.

Ultimately, Tokheim's device proved to be little more than an inspiration for the high-volume, hand-cranked, gravity-fed designs to come. The first successful iteration of this concept didn't see extensive commercial use until 1912, when a modification kit was offered by the Gilbert & Barker Manufacturing outfit. The company's T-8 model curbside pump was a typical example of the retrofit that allowed pump owners to upgrade current dispensers. Originally equipped with a dial gauge from the factory, it was easily modified by adding on a small, five-gallon glass cylinder.

When motorists responded favorably, petroleum refiners realized that the ability to observe one's gas as it was pumped could be instrumental in eliminating

An Gilbarco pump. *Michael Karl Witzel collection*

The Tokheim Moneymaker gas pump. *Michael Karl Witzel collection*

Robert Jauch, chief engineer for the Wayne Pump Company, was perfecting a radically new type of price totalizer to supersede current designs. With input from Edward Slye of Veeder-Root Incorporated, Wayne patented this new "variator" and incorporated the device into their products.

Wayne's first gasoline dispensers to feature "the eight-inch computer" debuted in 1934. Upon close inspection by competitors, it became obvious that the Model 34 and Model 37 gasoline pumps rendered all existing equipment obsolete. Slye's ingenious hive of gears read out the gallons in fractional increments and displayed the price simultaneously. With the automatic mechanical calculator, car owners could finally purchase their fuel in any monetary amount.

In a desperate attempt to catch up, pump companies like Bennett and Neptune attempted to replicate the design, but were unsuccessful. Wayne filed numerous lawsuits alleging patent infringement, and eventually all of the major American gas pump manufacturers licensed the technology. By the end of the 1930s, a trio of revolving number wheels tabulated sales at most every corner service station.

For the next forty years, pump companies tried everything to improve the design. The Tokheim Corporation finally suceeded in mid-1975, when its company visionaries adapted solid-state electronics to measure fuel flow. As America was marveling over hand-held, four-function calculators, they debuted the Model 151 Series, a swivel-topped pedestal that was unofficially christened "the Horsehead."

With unprecedented precision, Tokheim's solid-state marvel read pulses from subterranean pumps and routed them via wire bundle to a microprocessor computer. Once decoded, these signals were sent out to the customer display panel, where an array of numitron tubes indicated the price. The gasoline pump had reached its technological zenith.

Today, the modern fuel dispensers found along Route 66 function as sophisticated—albeit sterile—examples of American ingenuity. While innovation has remade it into an efficient utility, progress has eliminated its personality: Pump-mounted debit-card pay terminals, video screens, and point-of-purchase advertising have transformed the fuel pump into nothing more than a cash register. Like the once-familiar call to "Fill 'er up," those whirring, clanging, and sometimes inaccurate Bowsers that pumped combustible motor fuel into the family flivver are just a fading memory. ◉

suspicions about quality. To take full advantage of this trustworthy design concept, a specialized fuel dispenser that combined the raw pumping ability of the blind pump and the honesty of the cylinder tank was needed.

As the automobile replaced the horse and highways like Route 66 linked America, pump companies molded glass cylinders of ten-gallon capacity and mounted them on top of tapered steel pedestals, six-feet high. Inside the transparent beakers, demarcations denoting gallons were etched into glass or indicated by a tabbed metal ladder. Now, after gas from an underground tank filled these containers, its physical volume could be registered—visually.

Unfortunately, a rash of new developments weakened the superiority of the "visible register" fuel pump. The advent of electrically operated motors became the most important factor, forever eliminating the burden of a manually operated crank. After zippy dispensers appeared roadside in 1923, the logic of forcing fuel up into an elevated bowl was questioned too. Car customers were becoming increasingly loyal to brands, rendering the issue of visual inspection moot.

Anticipating this trend, Messrs. L.O. and N.A. Carlson of Erie Meter Systems abandoned the visible concept in 1925. In its place, they introduced a revamped version of the gas pump with an electric meter at its core. By implementing a high-speed electric motor for the drive unit, they attained a dispensing rate of fifteen gallons per minute. The movement of fuel was metered with timepiece precision: a large clock gauge used an "hour" hand to show gallons and a "minute" hand for fractions thereof.

Just about the time service stations were tightening down bolts on these improved models, the clock motif was pushed aside by more accurate methods.

4 Oklahoma
Through Old Indian Territory

Jim Hinckley

A solid argument could be made that Route 66 was conceived in Oklahoma. After all, Cyrus Avery was from Oklahoma, and Cyrus Avery is often heralded as the father of Route 66. It might also be said with a degree of certainty that Oklahoma was integral in transforming Route 66 from mere U.S. highway to the modern perception that this is the Mother Road, a larger-than-life icon that epitomizes the American experience.

To drive Route 66 through the Sooner state is a fascinating adventure filled with sites and attractions that blur the line between past and present. Here Route 66 truly is the Main Street of America.

Four miles south of the Kansas state line, U.S. 66 rolls through dusty Quapaw, a mining town that boomed during World War I near the bluffs on the Spring River, where the Quapaw celebrated the return of their soldiers from both world wars. The next stop is Commerce, another former boomtown turned semi-ghost that is the boyhood home of Mickey Mantle, as noted with signage that proclaims the main drag as Mickey Mantle Boulevard.

Three miles south of Commerce is the jewel box of vintage architecture that is Miami, the first chartered town in the Indian Territory. Dominating the plethora of architectural styles that run the gamut from territorial to 1950s roadside is the stunning Coleman Theater.

Built in a Spanish Colonial style that intricately weaves stucco and terra cotta trim, the Coleman opened its doors in 1929. Oklahoma's favorite native son, Will Rogers, was among the first celebrities to play here.

Between Miami and Afton, awaiting discovery by the perseverant traveler, is a truly unique Route 66 time capsule: a two-mile section of the original pavement that was only nine feet wide! Incredibly, this roadway was in use until 1937.

In Afton, the vacant lots overgrown with weeds fenced by empty buildings, broken concrete amongst the brush, and quiet streets are haunting as they combine to provide an apocalyptic atmosphere. The town may be too big to be a ghost town in the traditional sense but compared to what once was here it is but a shadow of its former self.

In 1926, when signage first designated Route 66 as a U.S. highway, this farming, ranching, and railroad center was a substantial and prosperous community, as reflected in the solidity of the red brick construction of most business. It was a town with a promising future.

The railroad roundhouse and turntable are now gone. The Palmer Hotel, dating to 1911, and its cafe that opened to meet the needs of travelers on Route 66, are empty, as is the building that housed the Pierce & Harvey Buggy Company. Bassett's Grocery closed in 2009 after serving the community for most of the past half century.

Afton Station, a renovated 1930s D-X station that appears like a mirage glistening among the tarnished remnants of better times, is a delightful oasis. In addition to the usual array of Route 66 memorabilia and souvenirs is a wonderful display of lovingly restored Packard automobiles.

Vinita, purportedly named for Vinnie Ream, the sculptor who created the life-sized statue of Abraham Lincoln in Washington D.C., was also a railroad town,

but it is also a town of firsts. This is the oldest incorporated community on Route 66 in the state. It was also the first town in the state to have electricity.

Chelsea's primary claim to fame is that it was the site of the first oil well drilled in the state. Lesser-known historical tidbits include the Hogue House, a well preserved Sears & Roebuck mail-ordered home built in 1913, and the town's association with singer Gene Autry, who lived here while working for the Frisco Railroad.

All of this history, all of these sites, and this is just in the first few miles of a nearly four-hundred-mile expedition across the state of Oklahoma!

Between Chelsea and the ghost town of Texola on the Texas and Oklahoma state line, there is the world's largest totem pole; the J. M. Davis Arms and Historical Museum, a private arms collection of more than twenty thousand guns and a tank; the Rock Café in Stroud, built in 1939; and the 1898 Round Barn in Arcadia.

The fifteen-story Boston Avenue Methodist Church, with its unique art deco towers, has dominated the Tulsa skyline since 1959. Near Chandler is the last barn in Oklahoma painted as an advertisement for Meramec Caverns in Missouri. In Oklahoma City, the highway rolls past Townley's Milk, a towering milk bottle that remains as one of the last thematic architectural structures on Route 66.

In Weatherford, the false front of the Owl Cotter Blacksmith Shop has cast its shadow over travelers for more than a century. Built in 1900 and now listed on the National Register of Historic Places, its vintage, utilitarian simplicity stands in stark contrast to the glitz and neon of the roadside survivors from the 1940s and 1950s.

With the passing of each mile on Route 66 in Oklahoma, tangible links to the era of the Model T, to the frontier, and to the age of the tail fin and station wagon intertwine. Still, the history of each community along the way is what adds depth to the story.

Few stops along the Route reflect this more than tiny Texola, with its abandoned territorial-era jail, a colorful near ghost, and photographer's paradise less than a mile from the Texas state line. The history of this forlorn little town is, to say the very least, truly unique.

An historical marker at the west edge of the dusty settlement notes the town site was the subject of land claims by fourteen different governments. From the town's founding in the 1880s to the present day, eight surveys have provided eight different geographical placements and as a result some area residents have resided in Texas as well as Oklahoma and never moved! ◎

Entering Indian Territory on Route 66

By Kathy Weiser

Princess Pale Moon of the Oklahoma Choctaws.

As you leave Kansas entering Oklahoma's stretch of the Mother Road, you will pass through the tiny community of Quapaw just three miles later. This small town of just less than a thousand souls was named after the Quapaw tribe, who were originally from Arkansas.

Surrounded by tall prairie grasses, the town was once an important hay-shipping area at the turn of the century. Later, cattle grazing and large ranches became essential to the economic industry of the community. However, the real boom of the town was the zinc- and lead-mining industry, which began in the region as early as 1897. The town boomed during the years of 1917 and 1918, and many of the Quapaw received immense royalties during these times.

The Dark Horse Mine, which opened in 1904, became the mainstay of the town, but after World War I the demand for zinc and lead decreased, and Quapaw's boom days were over.

Today, Quapaw is yet another fading mining town in the tri-state area. However, the town displays several nice murals on its buildings that deserve a stop for a photo opportunity. Quapaw is also home to the Spook Light, a dancing ball of light seen on a bluff called Devil's Promenade. Though the Spook Light is located in the Quapaw area, it can only be viewed east of the town and is often referred to as the Joplin Spook Light or the Hornet Spook Light, both cities in Missouri.

If you're passing through Quapaw on July Fourth, the city holds the oldest Indian pow-wow in the United States at Beaver Springs State Park.

For more than 130 years, the celebration has been taking place and is well worth the stop.

As you continue down the Mother Road just another six miles toward Commerce, you'll pass through several manmade mountains of chat, left over from the profitable lead and zinc mining era. In addition to the mining stories that Commerce provides, it was also the scene of one of Bonnie and Clyde's notorious endeavors on April 6, 1934. While fleeing murders in Grapevine, Texas, their Ford got stuck in the mud. When they attempted to flag down a motorist at gunpoint, the driver fled and reported the incident to Police Chief Percy Boyd and Constable Cal Campbell in Commerce. When the officers arrived at the scene, Cal Campbell was shot and Chief Percy Boyd was kidnapped but was later let go. Bonnie and Clyde died less than a month after the incident.

On a more positive note, Commerce was also home to legendary baseball player Mickey Mantle. In the late 1940s, Mantle played for three years with the Baxter Springs Whiz Kids. In 1949, while playing a baseball game in the park in Baxter Springs, Mantle hit a ball into the Spring River. Later, when the game was delayed by a rainstorm, Mantle was approached by Tom Greenwade, a scout for the New York Yankees who signed Mantle up to play. His home, located at 319 South Quincy, will soon be a museum.

Just another five miles or so, as you zigzag along this fine old stretch of Route 66, you'll arrive at the town of Miami. ◉

A family of migrant workers and their trusty Ford along the road in California.
Dorothea Lange/Farm Security Administration/ Office of War Information Photograph Collection/Library of Congress

VOICES FROM THE MOTHER ROAD

John Steinbeck and Route 66

John Steinbeck christened

Route 66 as America's "Mother Road" in his most famous novel, *The Grapes of Wrath*. But not only did he give the highway its enduring nickname, he also penned an indelible chronicle of the Depression-era exodus that took place along Route 66, forever changing lives and the very face of the United States.

Steinbeck was born on February 27, 1902, in Salinas, California. He attended Stanford University intermittently between 1920 and 1926 but never earned a degree. He worked as a manual laborer while writing, and his experiences lent authenticity to his depictions of the lives of the workers in his stories. His first three novels—*Cup of Gold* in 1929, *The Pastures of Heaven* in 1932, and *To a God Unknown* in 1933—were unsuccessful. He achieved popularity, however, with *Tortilla Flat* in 1935, with a film adaptation in 1942. This was followed by *In Dubious Battle* in 1936 and the novellas *Of Mice and Men* and *The Red Pony* in 1937.

The Grapes of Wrath was published in 1939, with the famous film debuting in 1940. The novel told the story of the migration of a dispossessed family from the Oklahoma Dust Bowl to California down Route 66, and their subsequent exploitation by a ruthless system of agricultural economics. The story illustrated the dignity and spirit of man in desperate circumstances.

The book won the august Pulitzer Prize and was the cornerstone of Steinbeck's winning the 1962 Nobel Prize for Literature. Translated into nearly every language in the world, *The Grapes of Wrath* earned Steinbeck international fame.

In Chapter 12 of the novel, he eulogized Route 66, describing its route and the plight of the hapless people traveling west. Here's a short excerpt from the start of his description:

Highway 66 is the main migrant road. 66—the long concrete path across the country, waving gently, up and down on the map, from the Mississippi to Bakersfield—over the red lands and the gray lands, twisting up into the mountains, crossing the Divide and down into the bright and terrible desert, and across the desert to the mountains again, and into the rich California valleys.

66 is the path of a people in flight, refugees from dust and shrinking land, from the thunder of tractors and shrinking ownership, from the desert's slow northward invasion, from the twisting winds that howl up out of Texas, from the floods that bring no richness to the land and steal what little richness is there. From all of these the people are in flight, and they come into 66 from the tributary side roads, from the wagon tracks and the rutted country roads. 66 is the mother road, the road of flight.

Clarksville and Ozark and Van Buren and Fort Smith on 64, and there's an end of Arkansas. And all the roads into

The true story behind John Steinbeck's novel *The Grapes of Wrath*: a farmstead in Coldwater District, north of Dalhart, Texas, almost completely engulfed by the Dust Bowl. This house was still occupied, but most of the houses in the area had been abandoned by the time this photograph was taken by Dorothea Lange in June 1938. Many of the families—like Steinbeck's fictional Joads—headed west on Route 66. *Dorothea Lange/Farm Security Administration/ Office of War Information Photograph Collection/Library of Congress*

Oklahoma City, 66 down from Tulsa, 270 up from McAlester. 81 from Wichita Falls south, from Enid north. Edmond, McLoud, Purcell. 66 out of Oklahoma City; El Reno and Clinton, going west on 66. Hydro, Elk City, and Texola; and there's an end to Oklahoma. 66 across the Panhandle of Texas. Shamrock and McLean, Conway and Amarillo, the yellow. Wildorado and Vega and Boise, and there's an end of Texas. Tucumcari and Santa Rosa and into the New Mexican mountains to Albuquerque, where the road comes down from Santa Fe. Then down the gorged Rio Grande to Los Lunas and west again on 66 to Gallup, and there's the border of New Mexico.

And now the high mountains. Holbrook and Winslow and Flagstaff in the high mountains of Arizona. Then the great plateau rolling like a ground swell. Ashfork and Kingman and stone mountains again, where water must be hauled and sold. Then out of the broken sun-rotted mountains of Arizona to the Colorado, with green reeds on its banks, and that's the end of Arizona. There's California just over the river, and a pretty town to start it. Needles, on the river. But the river is a stranger in this place. Up from Needles and over a burned range, and there's the desert. And 66 goes on over the terrible desert, where the distance shimmers and the black center mountains hang unbearably in the distance. At last there's Barstow, and more desert until at last the mountains rise up again, the good mountains, and 66 winds through them. Then suddenly a pass, and below the beautiful valley, below orchards and vineyards and little houses, and in the distance a city. And, oh, my God, it's over.

The people in flight streamed out on 66, sometimes a single car, sometimes a little caravan. All day they rolled slowly along the road, and at night they stopped near water. In the day ancient leaky radiators sent up columns of steam, loose connecting rods hammered and pounded. And the men driving the trucks and the overloaded cars listened apprehensively. How far between towns? It is a terror between towns. If something breaks—well, if something breaks we camp right here while Jim walks to town and gets a part and walks back and—how much food we got?

Listen to the motor. Listen to the wheels. Listen with your ears and with your hands on the steering wheel; listen with the palm of your hand on the gear-shift lever; listen with your feet on the floor boards. Listen to the pounding old jalopy with all your senses; for a change of tone, a variation of rhythm may mean—a week here? That rattle—that's tappets. Don't hurt a bit. Tappets can rattle till Jesus comes again without no harm. But that thudding as the car moves along . . . ⊙

Dust Bowl refugees make a new home in a tent pitched over the car that had brought them west. *Dorothea Lange/Farm Security*

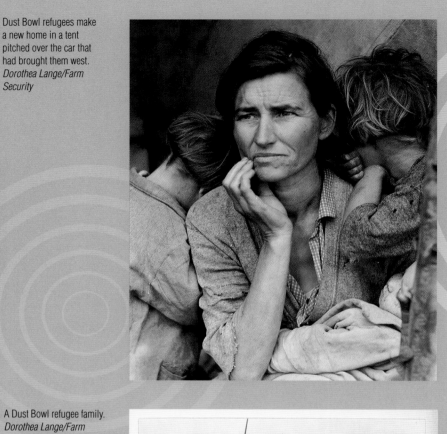

Dorothea Lange's famous photograph of a 32-year-old mother of seven children. The family was doing migratory work as peapickers in California, much like Steinbeck's Joad family. *Dorothea Lange/Farm Security Administration/ Office of War Information Photograph Collection/ Library of Congress*

A Dust Bowl refugee family. *Dorothea Lange/Farm Security Administration/ Office of War Information Photograph Collection/ Library of Congress*

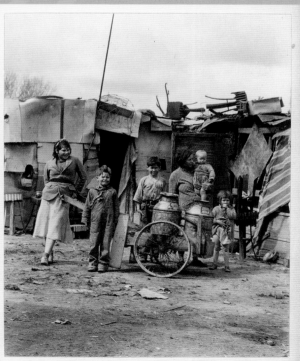

A squatter's camp on the edge of the road in California. Forty families—all refugees from the Dust Bowl—had been camped here for months on the edge of pea fields, hoping for work. *Dorothea Lange/Farm Security Administration/ Office of War Information Photograph Collection/Library of Congress*

Buffalo Ranch Trading Post

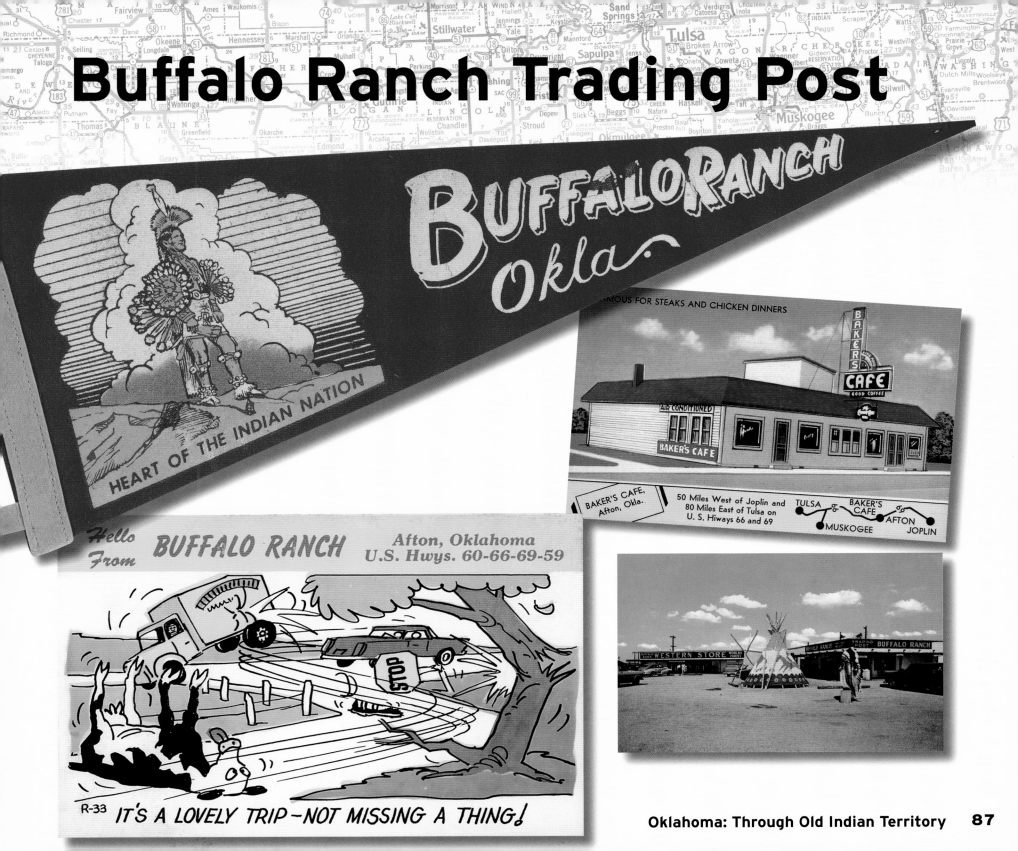

BUFFALORANCH Okla.

HEART OF THE INDIAN NATION

FAMOUS FOR STEAKS AND CHICKEN DINNERS

BAKER'S CAFE
GOOD COFFEE
AIR CONDITIONED
BAKER'S CAFE

BAKER'S CAFE, Afton, Okla.

50 Miles West of Joplin and 80 Miles East of Tulsa on U. S. Hiways 66 and 69

TULSA — BAKER'S CAFE — MUSKOGEE — AFTON — JOPLIN

Hello From BUFFALO RANCH

Afton, Oklahoma
U.S. Hwys. 60-66-69-59

R-33 IT'S A LOVELY TRIP — NOT MISSING A THING!

WESTERN STORE BUFFALO RANCH

Vinita
The Crossroads of America

By Kathy Weiser

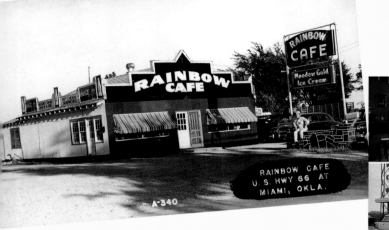

RAINBOW CAFE
U.S. HWY 66 AT
MIAMI, OKLA.

MOTEL CONWAY
EL RENO, OKLAHOMA

Where the golden prairies meet the foothills of the Ozarks is nestled Vinita, Oklahoma, the second oldest town in the state. Established in 1871, when two railroads, the Atlantic & Pacific and the Missouri-Kansas-Texas, were extended to the area, it was first called Downingville. Later the town's name was changed to Vinita, in honor of Vinnie Ream, the who created the life-size statue of Abraham Lincoln at the United States Capitol.

During the days when railroad travel was glamorous, Vinita became home to one of the many popular Harvey House restaurants. Unfortunately there is no sign of the Harvey House today.

Called "America's Crossroads," the term is fitting as Route 66, Interstate 44, U.S. Highways 69 and 60, and State Highway 2 bring travelers and freight carriers to the town. In addition, Vinita continues to be an intersection point for the Burlington Northern and Union Pacific Railroads.

There are several historic buildings in Vinita from the time before Route 66, including the Craig County Courthouse and the Hotel Vinita. Mother Road icons are also plentiful in this fine city. Be sure to check out the Spraker Service Station at 240 South Wilson as well as the many examples of art deco in downtown Vinita. If you're looking for a bite to eat, Clanton's Cafe is the oldest continuously run family-owned restaurant on Route 66 in Oklahoma. Serving a variety of home-cooked meals, the chicken fried steak is said to be one of the best in the nation.

Other points of interest include the Little Cabin Pecan Company, the Eastern Trails Museum, and the nation's largest McDonald's, which straddles the Will Rogers Turnpike. This monstrous structure, spanning the four-lane highway, is almost thirty thousand square feet. An interesting note of which not many are aware is that this tribute to the fast food world was not always there. Before McDonald's took over the interstate, this was home to a restaurant called the Glass House. ◉

Motel Conway
U.S. 66-270 WEST
EL RENO, OKLA.

AN 2-0261

CLEAN
MODERN
COMFORTABLE

Close Cover Before Striking

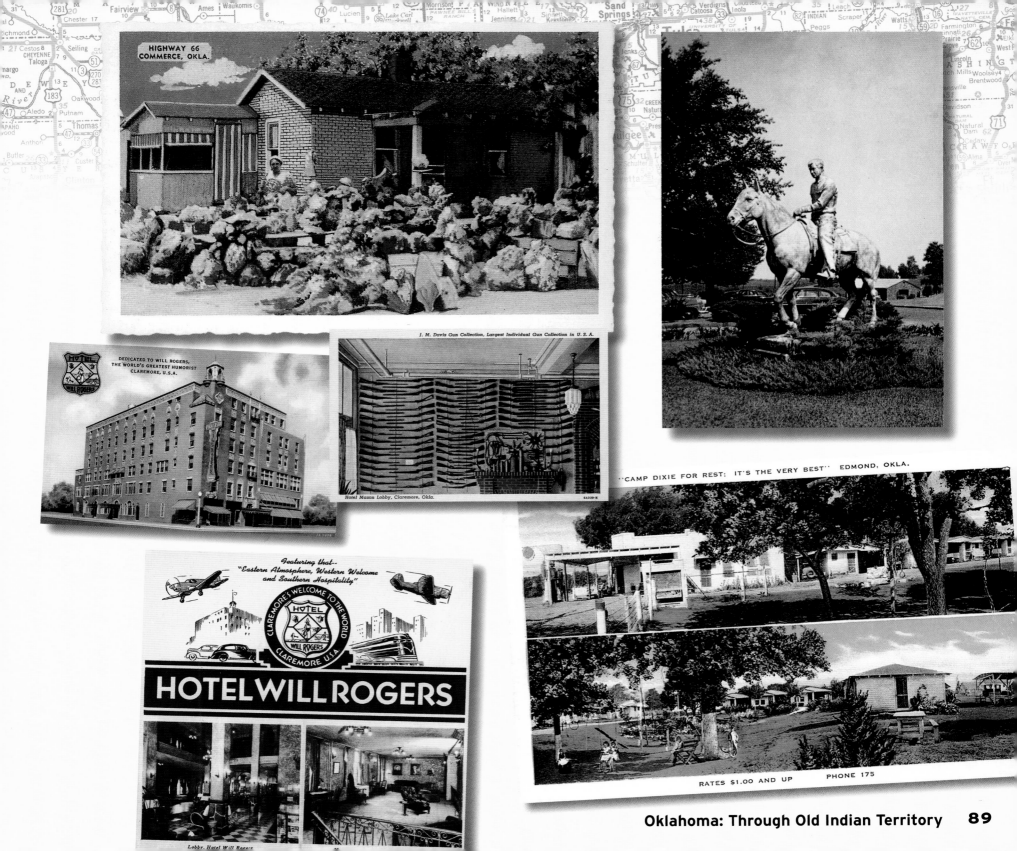

HIGHWAY 66
COMMERCE, OKLA.

J. M. Davis Gun Collection, Largest Individual Gun Collection in U.S.A.

DEDICATED TO WILL ROGERS,
THE WORLD'S GREATEST HUMORIST
CLAREMORE, U.S.A.

Hotel Mason Lobby, Claremore, Okla.

6A330-N

"CAMP DIXIE FOR REST: IT'S THE VERY BEST" EDMOND, OKLA.

Featuring that..
"Eastern Atmosphere, Western Welcome
and Southern Hospitality"

CLAREMORE'S WELCOME TO THE WORLD
HOTEL
WILL ROGERS
CLAREMORE U.S.A.

HOTEL WILL ROGERS

RATES $1.00 AND UP PHONE 175

Lobby, Hotel Will Rogers

Oklahoma: Through Old Indian Territory 89

Details of one of Galloway's totem poles.
Michael Karl Witzel collection

VOICES FROM THE MOTHER ROAD

Nathan Edward Galloway: Foyil's Totem Pole Man

By Michael Karl Witzel

Nathan Edward Galloway is one of those rare people who comes along and sprinkles a little bit of magic into everyone's lives. He was born in Missouri in 1880 and fought in the Spanish-American War. While traveling to his family to California, he took a temporary job in Foyil, Oklahoma and stayed for twenty years. From 1917 to 1937, he worked as the industrial arts instructor at the Charles Page Home for Widows and Orphans in Sand Springs, Oklahoma, and made the everyday lives of people a little bit more enjoyable. Funny thing is, he didn't do it with money or other worldly favors. He simply did what he did best: creating art and stepping back to witness the joy and wonder of those who viewed it.

In his spare time, Galloway loved to craft three-dimensional works for his own edification. His favorite medium was sculpture, in which he created all sorts of animals, intricate pictures of wood inlay, and even some violins. He believed that "the way to open doors for people is to make them something," and proved his adherence to the creed by gifting friends and relations with the one-of-a-kind works his hands made.

Galloway owned a plot of land right off old Route 66 in Foyil, Oklahoma, along the unpaved stretch of Highway 28A, where he built a country home assembled from native rock. Whenever he had some time off, he spent his days refining his plans, fitting stones, and cutting trees. When the structure was completed in 1937, he retired from his teaching job and moved with his spouse to the little stone house he'd built with his own two hands.

As is often the case with retired artists who are blessed with creative talent, Galloway wasn't satisfied with just sitting around watching the grass grow. He had

an idea that was ruminating in his brain for some time, and now he had the time he needed to put his plans into action. In his mind he imagined a totem pole, a *giant* totem pole, a monument positioned alongside the roadway where everyone passing by in their cars could see it.

To bring the immense sculpture to life, Galloway built a simple internal structure that formed the skeleton. To save money, he rescued surplus wire from the railway in Sand Springs and combined it with other scrap to form a superstructure. When completed, the armature weighed six tons. Sandstone rock was added for stability and over that he hand-plastered a mortar mix that used twenty-eight tons of cement. Forget delivery by truck: using a five-gallon bucket, Galloway personally hauled a hundred tons of sand and rock from a nearby creek!

At the time, there were no specialized tools available for him to do the intricate carvings in stone that swirled in his imagination. So, he used good old-fashioned ingenuity to make the custom instruments himself. At the base of the totem, the sculpting of the thirty-foot diameter turtle was easy. But it got more difficult as he moved up the totem to carve the complex reliefs that gave the structure life, and scaffolding was soon required. When the sixty-foot mark was reached, Galloway discovered that the most efficient way to get to the top was to hoist himself up—along with the building materials—using a pulley system.

This was to be his masterpiece. On the exterior of the monolith, he carved reliefs depicting a variety of famous headdressed Native American chiefs, mythical birds, flowers, fish, lizards, owls, and other eye-catching symbols. The carvings were then

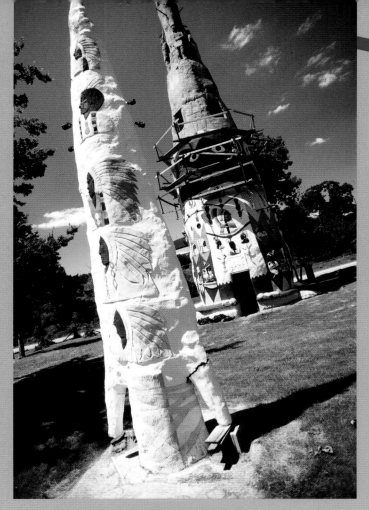

Two of the numerous creations in Ed Galloway's Totem Pole Park. *Michael Karl Witzel collection*

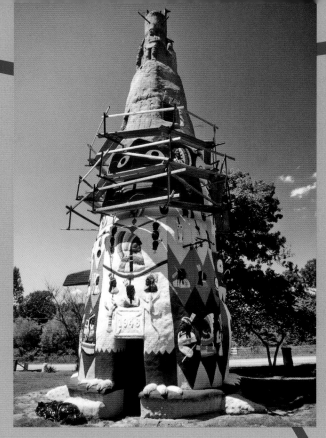

Restoration work underway on a totem pole. *Michael Karl Witzel collection*

covered with a bright rainbow of colored paint, bringing the drab concrete to life. On the inside of the tapered spire, the artwork continued in the same vein, where he painted murals that depicted a variety of memorable events from throughout history.

Eleven years of hard work passed until Galloway's totem pole was finished. In the meantime, he came up with the idea to build a twelve-sided edifice that resembled an Indian hogan. This was to be his personal museum space, supported inside and out by twenty-five concrete totem poles. Inside, he planned to display the three hundred fiddles that he'd carved by hand, each made from a different kind of wood. It also contained his handmade furniture and amazing bas-relief portraits of all the U.S. Presidents up to John F. Kennedy.

To compliment the Fiddle House and the giant totem pole, Galloway also crafted a twelve-foot tree trunk from concrete, with holes where birds could live. He also envisioned (and built) a larger-than-life arrowhead that was topped with a spinning weather vane.

Unfortunately, Galloway had more ideas than he had time, and many of the wonders conceived in his imagination were never built. In 1962, the artist who told others that they should "work on their imaginations" passed away at the age of eighty-two. On his deathbed, he summed up his attitude toward his fellow man when he wrote the words that could have well served as his personal epitaph: "All my life I did the best I knew. I built these things by the side of the road to be a friend to you."

After Galloway's death, Totem Pole Park gradually fell into disrepair. With no steward to watch out for it, it became a target for vandals and decay. Sadly, the fiddle house was burglarized during the 1970s, and all of the fiddles were stolen. The paint began to fade and the weeds began to grow. People began to forget about the curious structures along Highway 28A until a slow resurgence of Route 66 interest brought the curious.

In the 1990s the Rogers County Historical Society, in concert with the Kansas Grass Roots Art Association and the Foyil Heritage Association, embarked on a project to restore the Fiddle House. The outdoor sculptures were restored and repainted, and the world's largest totem pole was rescued from the brink of collapse. Today, Totem Pole Park is a survivor, a gift to roadside America, put there single-handedly by Nathan Edward Galloway, a folk art genius who gave himself away both in his life and in his work. ◉

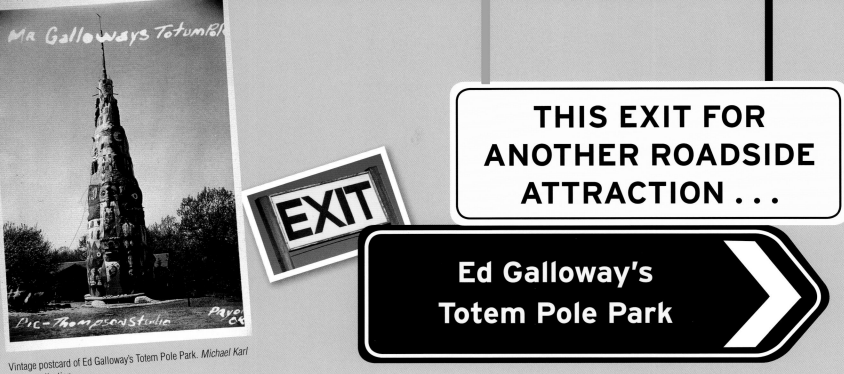

Vintage postcard of Ed Galloway's Totem Pole Park. *Michael Karl Witzel collection*

THIS EXIT FOR ANOTHER ROADSIDE ATTRACTION . . .

EXIT

Ed Galloway's Totem Pole Park

By Kathy Weiser

Listed on the National Register

Listed on the National Register of Historic Places and claiming the title of the World's Largest Concrete Totem Pole, the park features a ninety-foot totem pole that towers over the park in a vivid array of folk art colors.

Ed Galloway built the totem pole over an eleven-year period from 1937 to 1948, utilizing some twenty-eight tons of cement, six tons of steel, and a hundred tons of sand and rock. His tribute to the Native American features two hundred carved pictures, with four nine-foot Indian figures near the top each representing a different tribe.

The centerpiece totem pole, rising from the back of an enormous turtle, sits in the midst of a beautiful nine-acre park. The park also features Galloway's eleven-sided "Fiddle House," which previously housed his hand-carved fiddles. Artifacts made by Ed Galloway and visuals of the park development are also on display in the museum. Throughout the park are numerous of colorful totems that display a variety of Native American folk art.

Nathan Edward Galloway was born in 1880 in Missouri and developed his carving skills as a child, creating mother-of-pearl buttons and small wooden items. After serving in the U.S. Army in the early 1900s, he was introduced to Japanese and Far Eastern art while stationed in the Philippine Islands. After he returned to Missouri from his tour of duty, he began to create massive sculptures from tree trunks where he incorporated human figures with fish and reptiles.

Galloway's unique style soon caught the eye of Sand Springs founder and phi-lanthropist Charles Page in 1914. The discovery led to a long relationship between the two, beginning with Galloway's employment as a manual arts instructor at the Sand Springs Home. He spent the next twenty years teaching boys woodworking in the orphanage in Sand Springs, Oklahoma. In 1937, he retired to the property where the park sits today in Foyil, Oklahoma.

Working mostly by himself, the totem pole and other sculptures in the park kept him busy during his retirement years all the way up until the time of his death in 1962. Every day he rose at five a.m. and continued to work on his elaborate pieces until past sunset. Ed also built the Fiddle House, supported inside and out by twenty-five concrete totem poles.

After his death in 1962, the sculptures began to fall into disrepair from weather and neglect. Unfortunately, many of the fiddles were stolen from the Fiddle House in 1970 and were never recovered.

However, in the 1990s, a restoration effort was undertaken by the Kansas Grassroots Art Association, whose members live near Lawrence, Kansas. Members of the group painted the totems during Labor Day and Memorial Day week-ends over a seven-year period.

The park is located ten miles north of Claremore, Oklahoma, off historic Route 66 highway and four miles east of Foyil on Highway 28A. ⊙

Wrangling alligators. *Michael Karl Witzel collection*

THIS EXIT FOR ANOTHER ROADSIDE ATTRACTION...

EXIT

The Blue Whale in the Midst of Oklahoma

By Kathy Weiser

As you leave Claremore

heading to Catoosa and Tulsa along Route 66, you will soon pass over two huge steel-truss bridges that cross the Verdigris River. Both bridges served original Route 66 travelers but were built more than twenty years apart. The first bridge (now the westbound bridge) was built in 1936, but as travel increased, an additional overpass was constructed in 1957, which now serves eastbound traffic. This pair of mismatched bridges, familiarly called "Felix and Oscar" by the locals, begs a stop for a photograph.

Just beyond the bridges you will come to the site of Catoosa's famous Blue Whale; an absolute must stop for Route 66 travelers. One of the most recognizable icons on Route 66, the attraction was built by Hugh Davis in the early 1970s as an anniversary gift to his wife Zelta, who collected whale figurines. Hugh and Zelta had over forty years of zoological experience when Hugh built the eighty-foot long grinning Blue Whale. Hugh, who had retired by that time, owned the land on which the attraction was built; he completely surprised Zelta with the massive project. Originally, the pond surrounding the massive Blue Whale was spring fed and intended only for family use. However, as many locals began to sneak in to enjoy its cool waters, Davis brought in tons of sand, built picnic tables, hired lifeguards, and opened his masterpiece to the public.

Originally called Nature's Acres, Hugh continued to build the attraction until it eventually included the Fun and Swim Blue Whale and the ARK (Animal Reptile Kingdom). The attraction also featured Hugh's brother-in-law, Chief Wolf Robe Hunt, a full-blooded member of the Acoma tribe, who was famous in his own right

for his paintings and as a highly skilled silversmith. Chief Wolf Robe Hunt once ran the Arrowood Trading post across the highway from the Blue Whale.

In no time at all, its pond, giant Blue Whale, and zoo (housed in a wooden ark), attracted both locals and travelers alike. Children flocked to slide down the tail of the large Blue Whale into the cool waters of the pond, as families enjoyed the picnic tables, concessions, and boats provided at Nature's Acres.

In 1988, the aging couple found they could no longer handle the management of the attraction, and it was closed. Just two years later, Mr. Davis died. The park soon fell into disrepair, crumbling from neglect and weather damage. However, a decade later, the Route 66 landmark benefited from fundraising and volunteer efforts. The Blue Whale was given a fresh coat of paint and the picnic area restored. However, the old ark that once served as a zoo has not been restored and is slowly being overgrown by Mother Nature.

Another interesting thing about Catoosa is that it is a seaport town! An inland seaport? Yes! In fact it is the farthest inland seaport in the United States, linked to the Arkansas River system all the way to Gulf of Mexico.

Located at the head of navigation for the McClellan-Kerr Arkansas River Navigation System, the Port of offers year-round, ice-free barge service with river-flow levels controlled by the U.S. Army Corps of Engineers. Located in a two-thousand-acre industrial park and employing more than twenty-five hundred people, the port ships manufactured goods and agricultural products from America's heartland to the rest of the globe. ⊙

Hugh Davis exhibits snakes from his snake pit. *Michael Karl Witzel collection*

VOICES FROM THE MOTHER ROAD

Hugh Davis: The Blue Whale of Catoosa, Oklahoma

By Michael Karl Witzel

Hugh Davis was involved

with animals for most of his life. He was the former director of Tulsa's Mohawk Park Zoo, and when he retired in 1967, he opened the Catoosa Alligator Ranch. It was stocked with wild alligators gathered from Hope, Arkansas, and other reptile ranches and grew into a local curiosity. In 1970, he expanded the operation into "Nature's Acres," a park featuring nature trails, a petting zoo, snake pits, and a herpetarium that housed a congregation of alligators. He called it the Animal Reptile Kingdom, or ARK.

Decades before Americans had access to animal TV channels, websites, and specialty magazines, it seemed tourists couldn't get enough of places that featured live critters. The occasional news story didn't hurt either: In 1972, Nature's Acres made the local papers after one of their creatures got out. The 200-pound, 8 1/2 foot alligator slipped into the Verdigris River, a mile away. Six months later, it was found by a pair of teenagers who were hunting rabbits. Hugh wanted to rescue the reptile and bring him back to the ranch, but it was too late. The creature was shot dead by a panicked teen when it snapped at his dog.

Around that same time, Davis began dig out a pond on the piece of land he owned in Catoosa. Of course, it was not going to be any ordinary pond. Everyone who knew Hugh was well aware of that. He wanted to surprise his wife Zelta by

building a giant blue whale, and planned to position the beast right at the water's edge. With the help of family friend and welder Harold Thomas, he formed the superstructure for the fantastic creature. Then, he plastered the framework with 126 sacks of concrete. It took him almost two years.

During that whole time, Zelta was kept completely underwater about Hugh's scheme. "It looked like it was going to be an airplane," she later confided. She knew that her husband was building something unique, but never imagined that it was whale. In a 1994 interview, she tells a tale of a fun-loving spouse who wanted to surprise a fun-loving wife: "I'd come home; I'd see pipe going up in my yard. He wouldn't tell me what it was." The guessing game went on for two years and finally, "to shut up my mouth," he revealed the gift.

Unfortunately, the whale remained in a somewhat unfinished state while Hugh got together the money he needed to buy the paint. The exterior surface area came in at about 2,520 square feet, so it wasn't your average weekend painting job. In spite of its bland color, it garnered a lot of interest. Driving down Oklahoma Route 66, it was clearly visible from the roadway. Meanwhile, curious kids in Catoosa caught wind of the big creature and word quickly spread. People wondered, "What the heck is Hugh Davis building out there?"

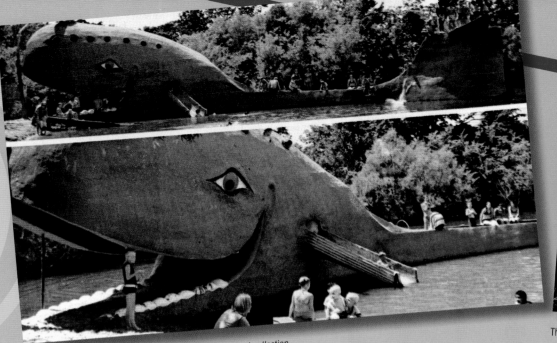

Postcard of the Blue Whale in its heyday. *Michael Karl Witzel collection*

The Blue Whale in decay today. *Michael Karl Witzel collection*

In 1973, Hugh finally began to prep the exterior for its long-awaited paint job. He even had the Anchor Paint Manufacturing Company in Tulsa mix up a custom blend of blue to colorize the concrete gray sea creature. That color—later known as "Blue Whale Blue"—proved to be a more worthwhile investment than any billboard. Indeed, Hugh Davis built it . . . and people came. That summer, the Davises found themselves so busy that they had to close Nature's Acres, keeping the ARK building open for its restrooms and snack bar.

With all the people who traveled Route 66 stopping by to take a dip in his little whale pond, Davis figured it was a good idea to hire some lifeguards for safety. Next, he set out to build a new concession stand and a restroom facility that was closer to the pond. To make the area more beach-like, he trucked in tons of sand for an artificial beach. For picnics, he placed concrete tables and seats along the "shoreline." The total cost for this early water park roadside attraction came to $1,910, a modest sum by today's standards.

During the 1970s, the smiling whale became an iconic attraction along U.S. Route 66. Children of all ages were captivated by its toothy grin and begged their parents to stop there. Hugh knew it would be a kid-magnet, so he designed the whale's belly so swimmers could walk inside by way of the gaping mouth, slide out the side, climb into the loft, peek out the portholes, and dive off the tail. Snagged by the bait of imagination, people were plucked from their cars, only to find themselves in the park-like setting of Davis' water park prototype—diving, sliding, and climbing on the eighty-foot wonder.

The long summer of the great blue whale lasted for almost fifteen years, but like every childhood dream, the sun eventually set on this whimsical attraction. In 1988, Hugh was forced to close the friendly water park due to his failing health.

With no one to maintain it, the whale and the surrounding grounds eventually fell into a state of disrepair. Vandals came next, making off with the whale's big derby hat and tearing off two of the diving boards.

But in spite of the decay, it was an attraction that was still sought out by the growing ranks of roadies seeking out their forgotten yesterdays along the old road. The Blue Whale had transitioned from roadside attraction to Route 66 icon. Even in its dilapidated state, people came from far and wide to catch a glimpse of its heartwarming grin. It struck a chord in people, and reminded them of the happier, simpler times of childhood.

Fortunately, that wasn't the end of the Blue Whale's story and the precious gift that Hugh Davis crafted by hand so many years ago. In 1995, a group of concerned citizens joined forces with the Catoosa Chamber of Commerce in an effort to raise money for the restoration of the eighty-foot whale. By 1997 their efforts had paid off, and the blue whale was restored to its former glory: Now, a new derby hat donned its head and a new coat of paint covered its body. Even its priceless grin was restored to a pearly bright white.

As fate would have it, good fortune continued to smile upon the Blue Whale. The U.S. 66 landmark became the beneficiary of yet another set of boosters when the Hampton Inn's "Explore the Highway with Hampton, Save-A-Landmark" program picked it as its twelfth project. On August 15, 2002, a restoration team descended upon Catoosa to install brand-new "Roadside Attraction" signs. A new fence was built, the snack bar repainted, and a new septic system installed. The Catoosa Blue Whale was back, better than ever, a real-life fish tale that continues to turn heads on the Oklahoma stretch of Route 66. ◉

Tulsa
Oil Capital of the World

By Kathy Weiser

Tulsa, in the midst of Indian Territory, was first settled by Native Americans in 1836 when they were forcibly made to relocate along the infamous Trail of Tears. Each of the larger tribes was given extensive land holdings, and the Native Americans began new lives as farmers, trappers, and ranchers. For many, the journey ended beneath the branches of the Council Oak Tree, located on the east side of the Arkansas River.

Some called their settlement Tallahassee, while others used the Creek word "tulsy" which meant "old town." For the next twenty-five years they would lead a peaceful life in a primarily untamed wilderness, with only a few white settlers in the area.

In 1846 Lewis Perryman, who was part Creek, built a log cabin trading post near what is now Thirty-third Street and South Rockford Avenue. Perryman's business was quite successful in the rugged frontier until the Civil War, when many residents fled the area.

When the war broke out the United States abandoned the Indian Territory, sending its troops to war against the Confederate forces. The Creek were torn as to which side to support. Many of them believed that they should move north into Kansas where they could seek protection. However, when they gathered up their families and possessions, they were attacked by a force of Texas cavalry and Confederate Native Americans. The Battle of Round Mountain was fought northwest of Tulsa, where the Cimarron River flows into the Arkansas River. Two other battles were fought north of Tulsa, including the Chustenahlah and Chursto-Talasah. The surviving Union Native Americans moved into Kansas near the Fort Scott area.

Eventually the Creek enlisted 1,575 men in the Confederate armies and 1,675 men in the Union forces. After the end of the Civil War, the Creek returned to their homes in the Tulsa area. A United States census taken in 1867 showed that the Tulsa area had a population of 264 Creek tribe members.

After the Civil War, numerous outlaws began to take refuge in Indian Territory as it was not yet subject to any government jurisdiction. Wrecking the relative peace of the civilized tribes in the area, Indian Territory soon became known as a very bad place, where desperadoes thought the laws did not apply to them and terror reigned.

Attempting to tame the wild frontier, President Grant appointed Judge Isaac Parker to rule over the federal district court for the Western District of Arkansas, in Fort Smith, Arkansas. This district had jurisdiction over the Indian Territory, and when Parker's tenure began in 1875, he quickly began to enforce the law against the many outlaws who had taken over Oklahoma. Before long, his efforts would earn him the nickname of "the Hanging Judge," as order was restored to the area.

As more and more white settlers began to move into Indian Territory, the government would break its "permanent" arrangement with the Native Americans. The tribes were forced to accept a number of new treaties, which further limited the amount of land each of them held.

In 1889, the unassigned lands in Indian Territory were opened to white settlers, and the people flooding into the area were soon nicknamed "boomers." With the discovery of oil in 1901, Tulsa changed from a cow town to a boomtown. At the nearby community of Red Fork, a giant oil deposit was found, and wildcatters and investors began to flood the city of Tulsa, bringing along their families and settling in. New neighborhoods were soon established on the north side of the Arkansas River and the town began to spread out in all directions from downtown.

Four years later, in 1905, a new, even larger oil discovery was made in nearby Glenn Pool that would lead to Tulsa's golden age of the 1920s, and its title as "the Oil Capital of the World." Many early oil companies chose Tulsa for their home base.

By 1920, Tulsa was called home to almost a hundred thousand people and four hundred different oil companies. The booming town boasted two daily newspapers, four telegraph companies, more than ten thousand telephones, seven banks, two hundred attorneys and more than one hundred and fifty doctors, as well as numerous other businesses. ◉

THE MOTHER ROAD LOST & FOUND

Conoco Station, Arcadia, circa 1940

By Russell A. Olsen

Then: The Conoco Station, Arcadia, Oklahoma.

Now: The Conoco Station, Arcadia, Oklahoma.

It is believed that this
primitive stone gas station was built between 1915 and the very early 1920s. Its location was so remote that electricity was never run to the building. Instead, kerosene lamps were used for lighting at night, compounding the dangers already involved in dispensing gasoline. The station also sold oil and kerosene, which were dispensed from large metal drums with only simple spigots to control the flow.

Local legend has it that the owners were involved in counterfeiting U.S. currency. Times were tough during the 1930s, so when a "salesman" paid a visit and offered a way to make a lot of quick cash, the temptation was too great. The story goes that the owners purchased a set of printing plates to make bogus ten-dollar bills, even adding a tiny room to the back of the station to serve as a print shop. The room was well disguised; its only entrance was a window on the back wall. Eventually the counterfeit bills were traced back to the station, where the plates were found, and the owners were arrested and sent to prison. The station was closed, never to open again. The stone ruins remain, seemingly daring time and the elements to take their best shot. My ten bucks are on the stone. ◉

Stroud
Hell Raising

By Kathy Weiser

Founded in 1892 and named for trader James Stroud, this small town began by selling whiskey to the many cowboys and travelers escaping nearby "dry" Indian Territory. Thirsty for a drink, the town soon boasted nine saloons and became a wild "hell-raising" town, as cattlemen relaxed after days on the range with their herds. Stroud's wild party days soon came to an end when Oklahoma Statehood forced the town dry in 1907.

Though its wild party days might have been over, Stroud had not yet seen the end of its Wild West days. On March 27, 1915, Stroud became the victim of one of the last outlaw robberies in Oklahoma, when Henry "the Cherokee Bad Boy" Starr chose two of the town's banks for a historic double daylight heist.

Henry Starr, along with six other men, decided to rob two banks at the same time, much as the Dalton Gang had unsuccessfully tried to do in Coffeyville, Kansas, in 1892. The Stroud, Oklahoma, robbery would prove almost as disastrous for Henry Starr. While he was proceeding to rob the Stroud National Bank and the First National Bank, word of the holdup spread quickly, and the citizens took up arms against the bandits. Henry and another outlaw named Lewis Estes were wounded and captured in the ensuing gun battle. The rest of the gang escaped with $5,815, thus pulling off a double daylight bank robbery.

Starr was tried and sentenced for the robbery and transferred to the Oklahoma State Penitentiary at McAlester. However, just four years later, he was paroled. In February 1921, Henry died as violently as he had lived, after having been shot during a robbery in Harrison, Arkansas.

Finally, Stroud settled down to become a sleepy little town that made its living primarily from agriculture and oil. However, when Route 66 came through town, Stroud responded like hundreds of other small towns, with services popping up that provided all manner of amenities to the many travelers of the Mother Road.

One such business that still thrives today is the Rock Café, a Route 66 icon. The cafe, the inspiration of a man named Roy Rieves, began in 1936. After Roy had saved his money for most of his life, he spent his retirement starting the popular restaurant when he bought several business lots skirting the city limits of Stroud.

At the time, the Route 66 project was finishing paving in a nationwide effort to connect the East Coast to the West Coast; business was booming along the highway. Roy built the cafe almost single-handedly over the next three years, using the very rocks removed from the old road while paving Route 66.

Finally finished, the Rock Café opened on August 4, 1939. It was run by Miss Thelma Holloway and was an instant success. Before long, the cafe became a Greyhound bus stop, bringing even more travelers into the successful restaurant.

Though Roy retained ownership of the building, he never ran the cafe, which had a series of managers over the years until 1959 when Mamie Mayfield began to run the restaurant. Keeping the cafe open twenty-four hours a day, Mamie ran the business for almost twenty-five years. However, by the early 1980s business had dramatically declined with the coming of the Turner Turnpike, and Mamie was nearing the age of seventy. In 1983 she finally closed the Rock Café.

Now listed on the National Register of Historic Places, the Rock Café has been revived and is operating again today, offering hometown cooking to travelers along Route 66.

Unfortunately, the Rock Cafe caught fire in May 2008, and though plans are being made to repair the building, they are not complete as of this writing. ◉

Oklahoma City

An Overnight Success

By Kathy Weiser

WHERE THE INDIAN TRAIL MEETS THE AIR TRAIL
OKLAHOMA CITY AIR TERMINAL
OKLAHOMA

> 🔊 **Did you know credit for the first use of carhops goes to Vince Stevens, owner of the Dolores Restaurant? Did you know this restaurant was in Oklahoma City?**

When the rolling, grassy hills of what would one day become Oklahoma City were first explored by Francisco Vasquez de Coronado in 1541, this vast land was uninhabited and continued to be sparsely settled for the next two hundred years. After the Louisiana Purchase was made from France, Oklahoma eventually became part of the Arkansas Territory in 1819.

In 1889, the U.S. Government opened parts of Oklahoma to white settlement, which began the historic Oklahoma land rushes. When the territory where Oklahoma City would be built was officially opened on April 22, 1889, more than fifty thousand homesteaders gathered at the boundaries. Some people snuck over the night to stake out prime land early, hiding from the army patrols. These were known as "Sooners."

At noon, the cannon roared, and hordes of people streamed over the line on wagons and buckboards, horseback, on foot, and even on bicycles. Where only the day before stood a railroad station and three buildings, now some ten thousand people had staked claims during a single day.

Claim jumping was common, as were boundary quarrels that led to fights and considerable bloodshed during these first few days. Tents were thrown up in haphazard fashion, and mass confusion reigned in the roughshod camp.

Because Congress had made no provision for a city government, leaders were soon chosen to restore order. A provisional government was selected and elections were held on May 1, 1889.

Just a month after the Land Run, the Commercial Club was formed, which would later be renamed the Oklahoma City Chamber of Commerce. One of the chamber's first orders of business was to attract the railroads to Oklahoma City, which was the key to the quick success of the settlement. Soon Oklahoma City became a crossroads for the nation. Later, the chamber led the way in providing utilities, such as the water system, telephone exchange, electric light, and a gas system.

By 1900, Oklahoma City's population had doubled, and on November 16, 1907, statehood came to Oklahoma. By this time, the streets were lined with brick buildings with fashionable shops, stores, and restaurants. Due to its numerous railroad extensions, the city attracted new industries and packing plants in an area called Packing Town, now known as Stockyards City.

On December 4, 1928, oil was discovered on the corner of Southeast Fifty-ninth and Bryant. In the twenty-seven days before the great gusher could be capped, it spewed 110,496 barrels of oil. The Oklahoma City Field had been discovered, creating the city's most important financial source and making Oklahoma City the world's newest boomtown.

When Route 66 came through town, Oklahoma City responded as enthusiastically as it did to everything else, and literally hundreds of motels, hotels, cafés, and service stations were built throughout the city.

If you're traveling Route 66 through Oklahoma City, there is very little to see until you get near downtown. When you arrive on Thirty-ninth Street, before you enter Warr

Braum's Milk, a landmark in Oklahoma City. *Carol M. Highsmith's America, Library of Congress*

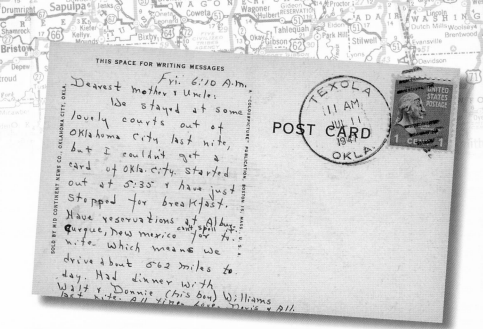

Acres, Oklahoma City provides several glimpses of the past, with hotels and eateries that dot the highway. An absolute must-see is Ann's Chicken Fry House. Located in what was once a 1948 Cities Service gas station, the building was changed into a restaurant in 1966 called the Three Bulls Steak House. In 1971 Al Burchett and his brother purchased the restaurant and renamed it after Al's sister-in-law, Ann.

Today, this superb restaurant not only features great food, but does it in a pure Mother Road style that just can't be beat. Ann's displays all manner of vintage memorabilia, including a classic 1950s police car, a pink Cadillac, gas pumps, and more.

A couple of miles along the Mother Road finds you in Yukon, Oklahoma, which proudly displays the fact that it is home to Garth Brooks. Established in 1891 by the Spencer Brothers, Yukon sits at the site where the Chisholm Trail once ran more than a century ago. In no time at all, the town became an agricultural and milling center.

While in Yukon, check out Sid's Diner, a relic from the past that still serves up hamburgers and fries as well, as the old Mulvey Mercantile at 425 West Main Street. ◉

🔊 **Did you know Carl Magee was the inventor of the parking meter? Did you know Oklahoma City was the first city to utilize them?**

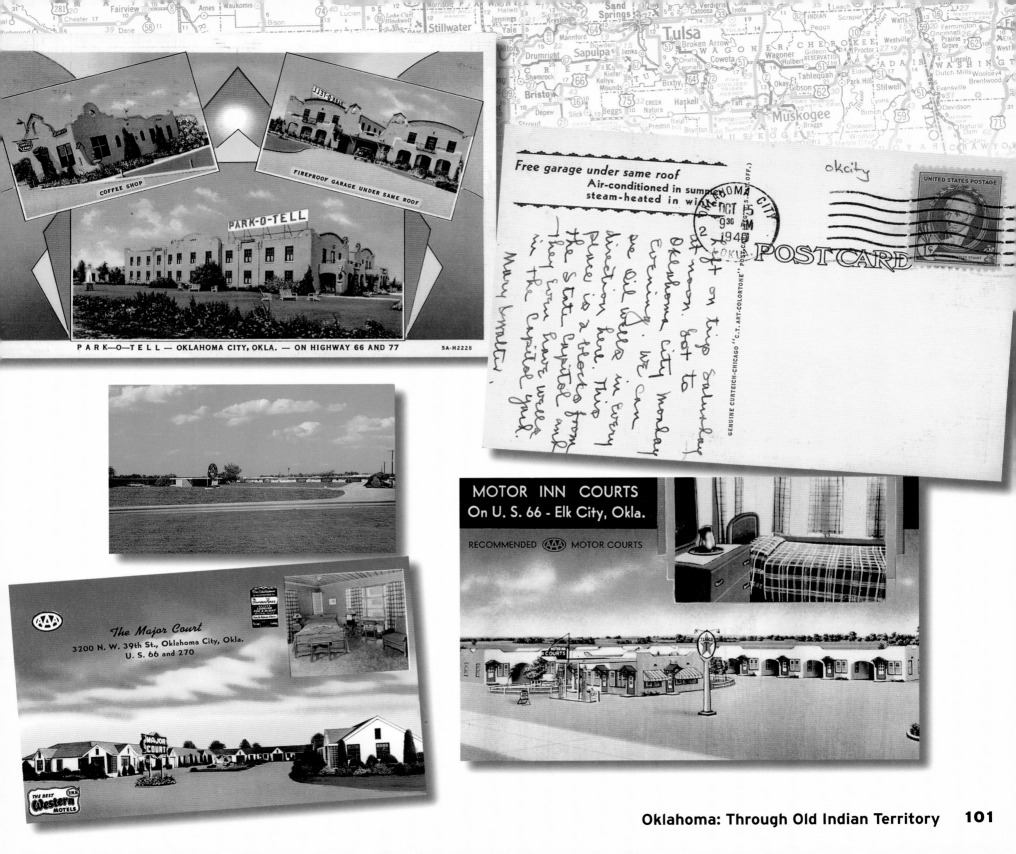

COFFEE SHOP

FIREPROOF GARAGE UNDER SAME ROOF

PARK-O-TELL

P A R K — O — T E L L — OKLAHOMA CITY, OKLA. — ON HIGHWAY 66 AND 77

5A-H2228

Free garage under same roof
Air-conditioned in summer
steam-heated in winter

POST CARD

UNITED STATES POSTAGE

okcity

MOTOR INN COURTS
On U. S. 66 - Elk City, Okla.

RECOMMENDED AAA MOTOR COURTS

The Major Court
3200 N. W. 39th St., Oklahoma City, Okla.
U. S. 66 and 270

THE BEST
Western MOTELS

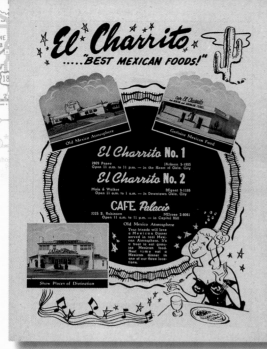

El Charrito
....."BEST MEXICAN FOODS!"

El Charrito No. 1
2909 Paseo — JAckson 5-1855
Open 11 a.m. to 11 p.m. — in the Heart of Okla. City

El Charrito No. 2
Main & Walker — REgent 5-1185
Open 11 a.m. to 1 a.m. — in Downtown Okla. City

CAFE Palacio
3225 S. Robinson — MElrose 2-9061
Open 11 a.m. to 11 p.m. — in Capitol Hill

Old Mexico Atmosphere

Your friends will love a Mexican Dinner served in real Mexican Atmosphere. It's a treat to eat genuine Mexican food. Next time eat a Mexican dinner in one of our three locations.

Show Places of Distinction

CHATEAU INN
RIO MOTEL

the Chateau
Rio Motor Hotel
2460 N.W. 39th

The Finest In American & International Food
Banquet Rooms Available For Private Parties &
Social Events

SALADS

Chef Salad	1.50
Crisp mixed Greens, Julienne of Chicken, Ham & Cheese	
Fruit Salad	1.25
Shrimp Salad	1.65

APPETIZERS

Shrimp Cocktail	1.25
Chilled Juices	.30

SOUP

Soup de Jour	35.	.45
French Onion		.50

Char-Coal Broiled Steaks

Kansas City SIRLOIN STRIP Mushroom Cap	4.95
12 oz. Boneless Sirloin Steak from Select Steer	
16 oz. Choice T-BONE STEAK, Au Champignon	4.75
Choice CLUB STEAK, 9 oz., Au Jus	3.95
FILET MIGNON, Onion Rings	4.50
9 oz. of Tender Selected Beef	
Ladies' FILET	3.95
Just Right For The Ladies	
Chopped SIRLOIN STEAK, Onion Rings	2.25

'ESPECIALLY FOR TWO'

CHATEAUBRIAND	11.00

Garnished With Green Bouquetiere, Mushrooms, Duchess Potatoes
Truly A Banquet For Two

ENTREES

GRILLED CALF LIVER & BACON	1.95
TENDERLOIN TIPS SAUTED IN WINE	2.50
GRILLED CHICKEN LIVER & BACON	2.25
GULF SHRIMP SAUTED AU CURRY RICE	2.50
BEEF TENDERLOIN ALA STROGANOFF EN CASSEROLE	3.75
BROILED AFRICAN LOBSTER TAILS, DRAWN BUTTER	5.15
½ GOLDEN FRIED CHICKEN	1.95
DEEP FRIED FISH & CHIPS, TARTER SAUCE	1.50
COLORADO BROOK TROUT, LEMON GARNI	2.50

*Tossed Green Salad — Baked or French Fried Potatoes — Hot Rolls, Butter

EL RANCHO RIO WESTERN STEW SERVED IN 'YE OL' CAST IRON POT	1.05

International Cuisines

APPETIZERS

Egg Rolls 1.65 Rumaki 1.65 Far-Goo-Gai 1.50

Sweet & Pungent Pork .. 2.95
 Crisp Fried Pork Chunks with Pineapple & Green Pepper in a Tangy Sauce
Chicken Breast ala Kiev on Fluffy White Rice 3.35
Chicken or Shrimp Chow Mein ala Cantonese 2.75
 Served on a Bed of Crisp Pan Fried Noodles
Beef Shish-kabab en Brochette. Garni 3.50
Garlic Frittered Chicken (Bite Size Pieces of
 Chicken dipped in a Special Batter & Crisp Fried) 2.70
Polynesian Hor D'oeuvers' Tid Bits (A Delightful
 Combination of Exotic Far Eastern Appetizers) 2.75
Butterfly Shrimp (Fresh Gulf Shrimp—bacon
 wrapped—dipped in Our Special Batter & Crisp Fried) 2.85

*Crisp Green Salad Hot Rolls

QUICK SNACKS

Chicken Fried Steak, pan gravy .. 1.65
Broiled Red Snapper Maitre d'Hotel .. 1.95
Breaded Veal Cutlet, pan gravy ... 1.75
Golden Fried Shrimp, Cocktail Sauce 2.40

Salad Potatoes Hot Rolls

Children's Special .95

DRUMSTICKS (2) HAMBURGER PATTY SHRIMP (3)

French Fries — Fresh Vegetable — Hot Rolls — Beverage

SANDWICHES

¼ Lb. Beef Burger65
 With Cheese—.10c Extra
Bacon, Lettuce Tomato75
Club Sandwich, Triple Decker 1.35
Baked Ham .. .75
Baked Ham & Cheese85
Sliced Breast of Turkey95
Tender Corned Beef on Rye95
Roast Beef .. .75
Grilled Cheese55

BEVERAGES

Coffee15 Ice Tea15
Milk20 Hot Tea15
Soft Drink15 Sanka15
 Beer45

DESSERTS

Pie35 Ala Mode45
Choc. Sundae .. .40 Ice Cream25
 Sherbets25

> *The Chateau Welcomes the Opportunity to Serve You and We Sincerely Hope That You Will Return and Bring Your Friends. If at Any Time the Food or Service Is Below the Perfection You Expect, Please Let Us Know — And Should We Please You, We Would Like to Know That Also.*
> *Your Host: The Chateau Management*

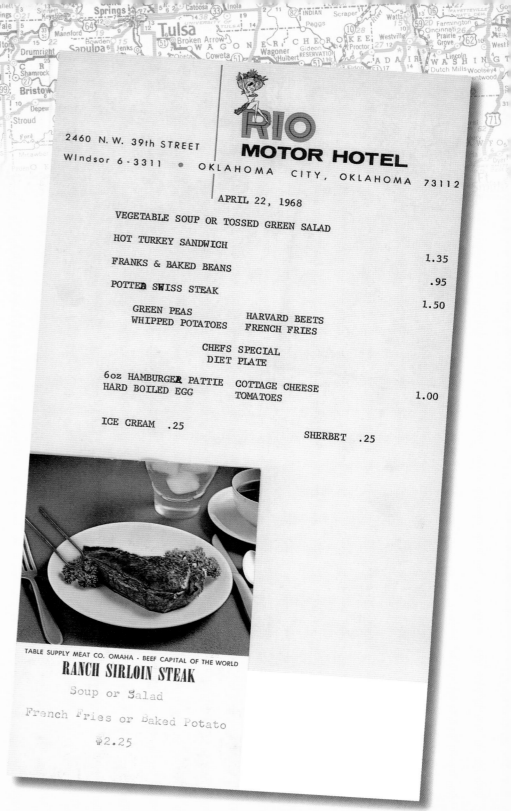

2460 N.W. 39th STREET
WIndsor 6-3311 •

RIO MOTOR HOTEL

OKLAHOMA CITY, OKLAHOMA 73112

APRIL 22, 1968

VEGETABLE SOUP OR TOSSED GREEN SALAD

HOT TURKEY SANDWICH

FRANKS & BAKED BEANS 1.35

POTTED SWISS STEAK .95

GREEN PEAS 1.50
WHIPPED POTATOES HARVARD BEETS
 FRENCH FRIES

CHEFS SPECIAL
DIET PLATE

6oz HAMBURGER PATTIE COTTAGE CHEESE
HARD BOILED EGG TOMATOES 1.00

ICE CREAM .25 SHERBET .25

TABLE SUPPLY MEAT CO. OMAHA - BEEF CAPITAL OF THE WORLD

RANCH SIRLOIN STEAK

Soup or Salad

French Fries or Baked Potato

$2.25

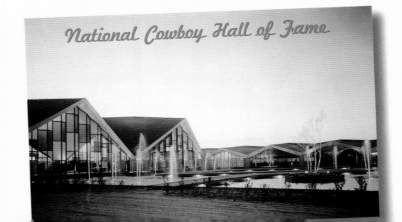

National Cowboy Hall of Fame

VOICES FROM THE MOTHER ROAD

Beverly and Rubye Osborne: Chicken In the Rough

By Michael Karl Witzel

In 1921—decades before

anyone ever heard of Kentucky Fried Chicken, or even the Colonel himself—fledgling restaurateurs Beverly and Rubye Osborne showed would-be fast food kings just how roadside food and fried chicken should be done.

As restaurant history records the tale, they had more time-tested family recipes than they had money. But that wasn't an obstacle: to scrape up the downpayment they needed to buy their first six-stool diner in Oklahoma City, Oklahoma, they borrowed fifteen dollars from their milkman, pawned Rubye's engagement ring, and sold the family car.

The creative financing proved to be a wise plan of action for the enthusiastic foodies, as they quickly packed the tiny eatery located at 209 West Grand. Rubye proved to be a kitchen whiz, and gained a loyal following by perfecting the couple's secret recipe for pancakes. After she put a nineteen-cent meal on the menu, people began coming in droves.

With all of the business, their milkman was paid off quickly, and the Osbornes decided to expand the operation. The couple kept the first location going and purchased a modest drive-in located at 2429 North Lincoln, a local joint that happened to be situated right along the Will Rogers Highway, old Route 66.

By 1936, they had mastered the roadside diner game and were ready for a vacation. Florida was the destination, with a route partially driven over the old road. Somewhere along the way, Beverly hit a pothole, causing Rubye to dump a lunchbox full of chicken onto the floorboards. As she picked up the battered breasts and drumsticks, she quipped, "This is really chicken in the rough!" The comment clicked with Beverly and set his imagination to turning. By the time they returned home, plans were in the works to create a radically new dish—one based on Rubye's offhand observation.

At first, the Osbornes fried up the unjointed chicken pan style, believing it was the only cooking method that would really bring out the true flavor. Unfortunately the method was slow. As demand for the new poultry platter swelled to fifteen hundred orders per day, it was obvious that a faster and more efficient way of preparation was required. So, Beverly collaborated with a local machine shop to build a shallow-pit griddle designed to cook with less grease.

The one-off contraption featured built-in burners for even heat distribution. It also had a shallow slope, which allowed the chickens to be submerged only halfway, regardless of their thickness. What's more, the cleverly designed cooker pan-fried and steamed the pullets simultaneously. With a capacity for preparing thirty orders (150 pieces) at one time, it allowed for the type of production-line cooking that was necessary to turn a profit—without sacrificing the home-style flavor the Osbornes had crafted in the frying pan.

In 1937, the Osbornes patented their unique grill. They also registered their soon-to-be famous, golf-playing, cigar-smoking rooster trademark—marking the official arrival of America's first franchised fast food: fried chicken. But the Osbornes had a knack for making things sound a bit more romantic: they called their bill of fare "Chicken in the Rough," inspired by the incident on their cross-country trip.

Beverly Osborne. *Michael Karl Witzel collection*

OKLAHOMA CITY WELCOMES YOU!

We are proud of the fact that this is the home of

"CHICKEN IN THE ROUGH"

☆　　☆

You are cordially invited to try the world's most famous chicken dish

Chicken in the Rough souvenir welcome card. *Michael Karl Witzel collection*

With their production method perfected, the Osbornes began incubating a plan to market their creation nationwide. Since the Route 66 highway was well on its way to becoming America's Main Street, they started there, signing up numerous restaurants along the road to sell Chicken in the Rough in a franchise arrangement. Sit-down restaurants, carhop drive-ins, motel coffee shops, and even nightclubs signed on. Among the earliest eateries to pluck the opportunity were Mother Road restaurants like Abbot's Cafe in Berwyn, Illinois; Daniel's Duck Inn of Joplin, Missouri; Elliott's Court Cafe in Albuquerque, New Mexico; and Kingman, Arizona's Lockwood Cafè.

The stretch of Route 66 in Oklahoma boasted seven outlets alone, and the Osbornes' original diner expanded from four booths and nine stools to a 1,100-seat feeding frenzy! After Shamrock's U Drop Inn and Galena's Tivoli signed up, "I'll Gladly Be Fried for Chicken in the Rough!" became one of the most remembered food slogans for hungry people traveling the historic highway.

By 1958, the Osborne's meal—consisting of one-half of a golden brown chicken served with a side of shoe-string potatoes, hot buttered biscuits, and a jug 'o honey—gained notoriety from one end of Route 66 to the other. It even fueled the growing craze for drive-ins out on the West Coast, spurring Los Angeles, California, curb-service shrines like Henry's, Carpenter's, and McDonnell's to add the unjointed chicken to their burger-based menus. Soon, the Osbornes managed 156 Chicken in the Rough franchisees—some as far away as Hawaii and South Africa!

Eventually, the rapid proliferation of systematized hamburger joints and the juggernaut known as Kentucky Fried Chicken overtook the Osborne's family recipe. In 1974, rights to the cooking process were purchased by Randy Shaw, an early partner. Later, he bought out the remaining restaurants in Oklahoma City and kept one of the original locations open. Today, Beverly's Pancake Corner (at 2115 Northwest Expressway) still serves Chicken in the Rough the way they used to back in the good old days, along with their original pancake sandwich, Dr. Pepper floats, and homemade pie.

These days, travelers who venture out to explore Oklahoma 66 can still enjoy the same Chicken in the Rough their grandparents chowed down on so many years ago. It's still eaten the same way, without silverware and a stack of napkins. All you need is a healthy appetite and an appreciation for the kind of fast *slow* food pioneered by the Osbornes, "where every bite is a tender delight." ◉

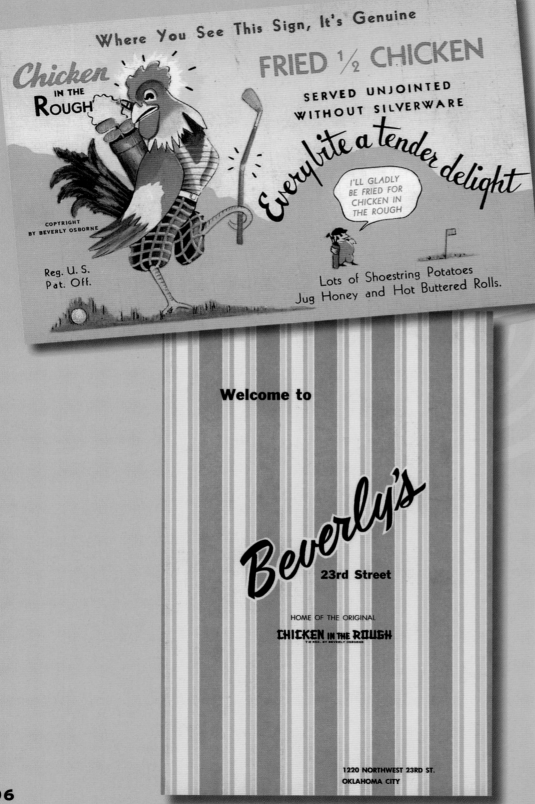

Where You See This Sign, It's Genuine

Chicken IN THE ROUGH

FRIED ½ CHICKEN

SERVED UNJOINTED
WITHOUT SILVERWARE

Every bite a tender delight

I'LL GLADLY
BE FRIED FOR
CHICKEN IN
THE ROUGH

COPYRIGHT
BY BEVERLY OSBORNE

Reg. U. S.
Pat. Off.

Lots of Shoestring Potatoes
Jug Honey and Hot Buttered Rolls.

Welcome to

Beverly's

23rd Street

HOME OF THE ORIGINAL

CHICKEN IN THE ROUGH
T M REG. BY BEVERLY OSBORNE

1220 NORTHWEST 23RD ST.
OKLAHOMA CITY

ALL DAY BREAKFAST

CHILLED ORANGE OR TOMATO JUICE	.20-.30
CEREALS WITH MILK OR CREAM	.35
TWO EGGS, Fried, Scrambled or Poached	.55
BACON OR SAUSAGE AND TWO EGGS	.85
HAM OR CANADIAN BACON AND TWO EGGS	1.00

Served With Thick Toast and Jelly
Side Order Hash Browns20

MAN SIZE BREAKFAST

THREE EGGS, HAM, BACON OR SAUSAGE $1.45
With Hash Browns, Toast and Jelly

PANCAKES

With Choice of Boysenberry or Maple Syrup

THREE LARGE PANCAKES	.40	SIX LITTLE THIN PANCAKES	.40
BUCKWHEAT PANCAKES	.50	APPLE PANCAKES	.50
BLUEBERRY PANCAKES	.55	JELLY ROLLED PANCAKE	.55

SIDE ORDERS

1 Egg	.25	3 Strips Bacon	.30
Country Sausage (1)	.30	Thick Toast, Jelly	.20
3 Link Sausages	.30	French Fries	.25
Ham or Canadian Bacon			.55

PIGS IN A BLANKET70
Three Link Sausages Individually
Wrapped in Pancakes

"ORIGINAL"
PANCAKE SANDWICH60
with Sausage or Bacon and
Scrambled Egg between two Pancakes

SANDWICHES

On Toasted Bread
With French Fried Potatoes

Hamburger	.45	Melted American Cheese	.40
Mustard, Pickles, Onions			
Ranchburger	.45	Baked or Fried Ham	.60
Sweet Pickle Relish			
DeLuxe Hamburger	.50	Bacon and Tomato	.50
Lettuce, Tomato, Mayonnaise			
Cheeseburger	.55	Chicken Salad	.45
Lettuce, Tomato, Mustard, Pickles		Bacon and Egg	.60

SHOPPERS SPECIAL

"BIG-BEV BURGER"66
Truly a King-Size Hamburger of Choice
Ground Sirloin of Beef

Lettuce, Sliced Tomato, Pickles,
Bermuda Onion and Mustard.

HALIBUT "FISH FINGERS"75

Tartar Sauce, Honey, Shoestring

Potatoes, Hot Rolls

We serve Creamery Butter and Oleomargarine, Whipped and Otherwise.
We regret we cannot be responsible for lost or stolen articles.
We reserve the right to seat our guests and refuse service to anyone.

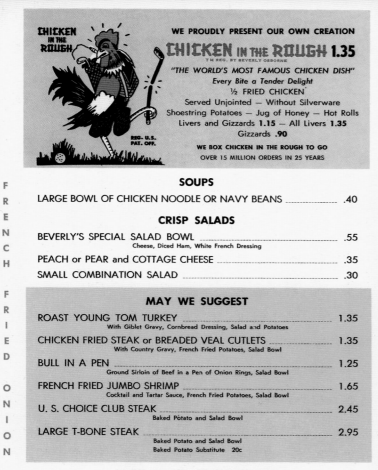

WE PROUDLY PRESENT OUR OWN CREATION

CHICKEN IN THE ROUGH 1.35
TM REG. BY BEVERLY OSBORNE

"THE WORLD'S MOST FAMOUS CHICKEN DISH"
Every Bite a Tender Delight
½ FRIED CHICKEN
Served Unjointed — Without Silverware
Shoestring Potatoes — Jug of Honey — Hot Rolls
Livers and Gizzards **1.15** — All Livers **1.35**
Gizzards **.90**

WE BOX CHICKEN IN THE ROUGH TO GO
OVER 15 MILLION ORDERS IN 25 YEARS

SOUPS
LARGE BOWL OF CHICKEN NOODLE OR NAVY BEANS40

CRISP SALADS
BEVERLY'S SPECIAL SALAD BOWL55
Cheese, Diced Ham, White French Dressing
PEACH or PEAR and COTTAGE CHEESE35
SMALL COMBINATION SALAD30

MAY WE SUGGEST
ROAST YOUNG TOM TURKEY 1.35
With Giblet Gravy, Cornbread Dressing, Salad and Potatoes
CHICKEN FRIED STEAK or BREADED VEAL CUTLETS 1.35
With Country Gravy, French Fried Potatoes, Salad Bowl
BULL IN A PEN 1.25
Ground Sirloin of Beef in a Pen of Onion Rings, Salad Bowl
FRENCH FRIED JUMBO SHRIMP 1.65
Cocktail and Tartar Sauce, French Fried Potatoes, Salad Bowl
U. S. CHOICE CLUB STEAK 2.45
Baked Potato and Salad Bowl
LARGE T-BONE STEAK 2.95
Baked Potato and Salad Bowl
Baked Potato Substitute 20c

FROM SOUTH OF THE BORDER
"THE THING" $1.25
One Tamale, Frijoles, Spanish Rice, Two Enchiladas and One Beef Taco
MONTEREY SPECIAL85
Fried Frijoles, Spanish Rice, Two Enchiladas, Cheese and Onions
TAMALES and CHILI SPREAD85
BOWL OF CHILI65

DESSERTS
FRESH PIES FROM OUR OWN OVENS25
APPLE HONEY ICE CREAM25
Jumbo Malts35 Jumbo Cream Soda45
Chocolate or Butterscotch Ice Box Pie With Whipped Cream30
Complete Fountain Service

WHERE HOSPITALITY IS A FINE ART

BEVERLY'S

We Proudly Present Our World Renowned Specialty

CHICKEN IN THE ROUGH 1.35
(Served without Silverware)
One Half Fried Chicken (Disjointed)
Shoestring Potatoes, Hot Clover Leaf Rolls and Honey

CHEF'S SPECIAL
Lunch Salad
U. S. CHOICE BEEF TIPS WITH HOT SAUCE 90
Lunch Vegetable Hot Clover Leaf Rolls

MERCHANT'S LUNCH
Lunch Salad
OLD FASHION MEAT PIE WITH SHORT CRUST, FAMILY STYLE 85
Lunch Vegetable
Lunch Potatoes Hot Clover Leaf Rolls

FRESH HOME STYLE STRAWBERRY COBBLER-WHIPT CREAM 35

Today's Feature

BOILED BEEF TONGUE WITH RAISIN SAUCE 80

Escalloped Potatoes Lunch Salad
Lunch Vegetable Hot Clover Leaf Rolls

WARM WEATHER SUGGESTION
ASSORTED COLD MEAT PLATE WITH POTATO SALAD 1.15
Rye Bread and Butter

ONE BEEF TACO WITH GUACAMOLE SALAD 65c

BEVERLY'S LOW CALORIE LUNCHEON
Filet of Sole, Tartar Sauce
Sliced Tomatoes, Cottage Cheese,
Pepper Ring, Hard Boiled Egg, Rye Bread
75c

BEVERLY'S ORIGINAL FRENCH DIP SANDWICH 60c
Roast Beef on French Roll with Salad

DESSERTS
Apple Honey Ice Cream 25 Pineapple or Orange Sherbet 25
Strawberry Short Cake-Whipt Cream 25
Chocolate, Cocoanut or Butterscotch Ice Box Pie 25

Knock the T out of can't

Tuesday

Frontier City USA

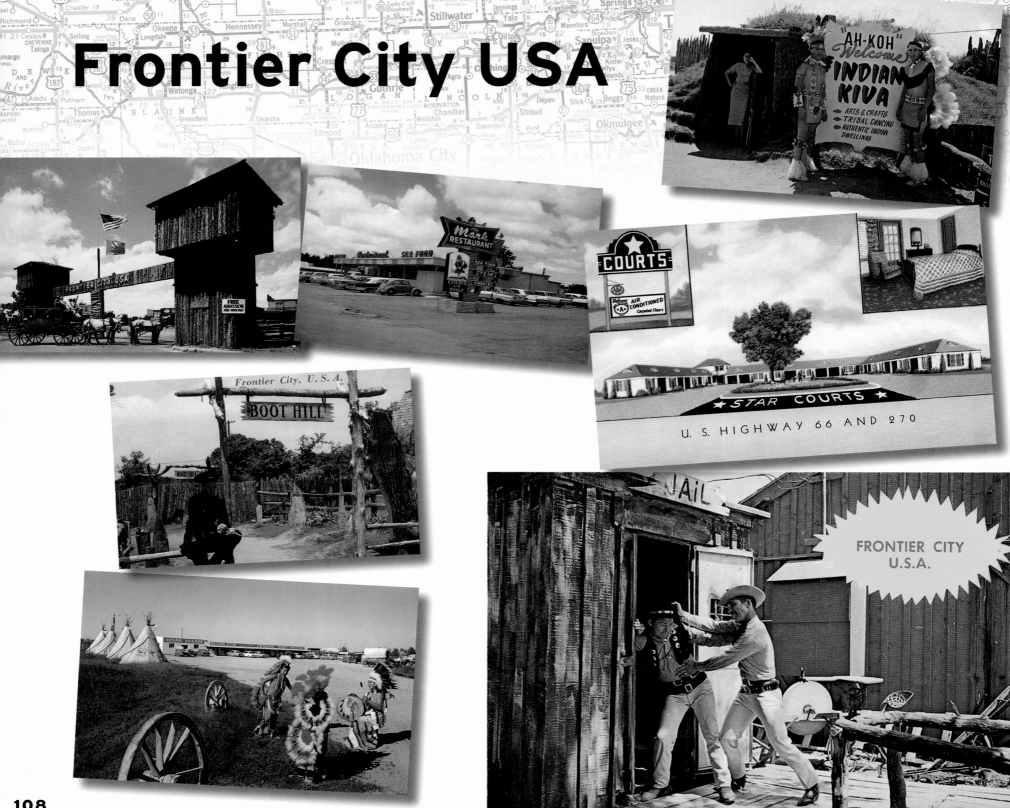

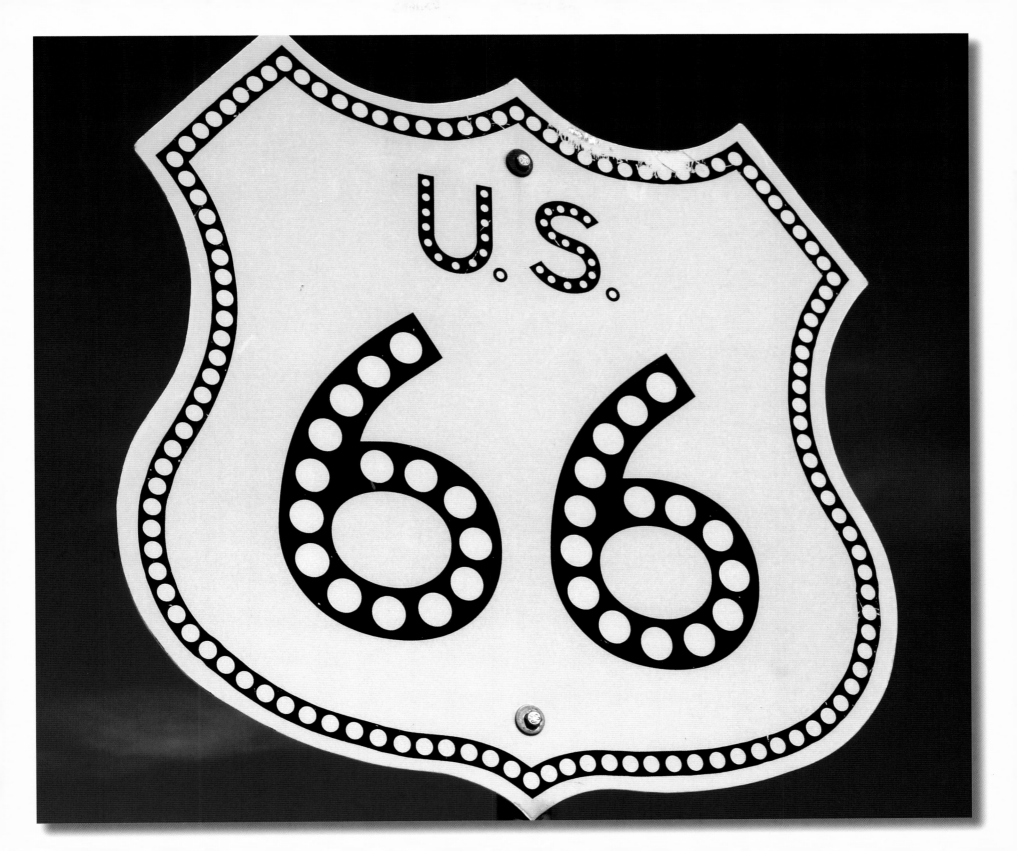

5 Texas
The Panhandle Drive
Jim Hinckley

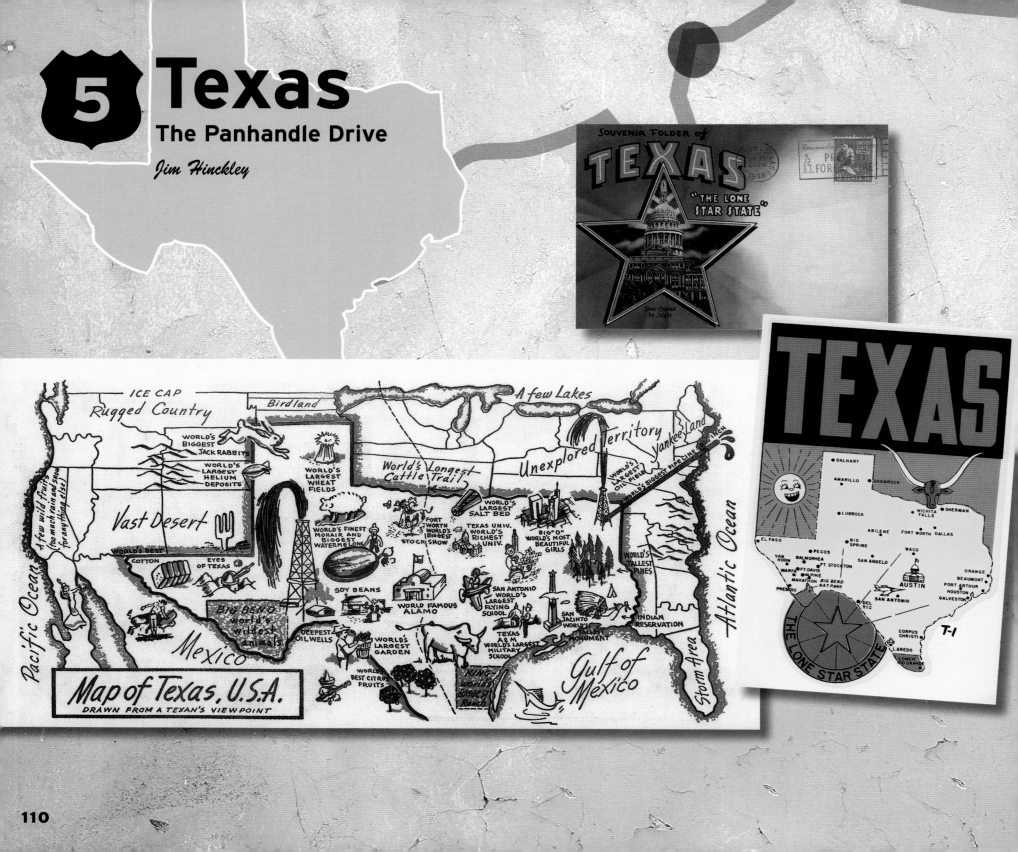

SOUVENIR FOLDER of

TEXAS

"THE LONE STAR STATE"

State Capitol by Night

TEXAS

THE LONE STAR STATE

T-1

ICE CAP
Rugged Country
Birdland
A few Lakes
WORLD'S BIGGEST JACK RABBITS
WORLD'S LARGEST HELIUM DEPOSITS
WORLD'S BIGGEST WHEAT FIELDS
World's Longest Cattle Trail
Unexplored Territory
Yankee Land
WORLD'S LARGEST OIL FIELD
WORLD'S BIGGEST PIPELINE
Vast Desert
WORLD'S FINEST MOHAIR AND BIGGEST WATERMELONS
WORLD'S LARGEST SALT BED
FORT WORTH WORLD'S BIGGEST STOCK SHOW
TEXAS UNIV. WORLD'S RICHEST UNIV.
BIG "D"
WORLD'S MOST BEAUTIFUL GIRLS
WORLD'S BEST COTTON
EYES OF TEXAS
SOY BEANS
WORLD FAMOUS ALAMO
SAN ANTONIO WORLD'S LARGEST FLYING SCHOOL
WORLD'S TALLEST PINES
Pacific Ocean
A few wild fruits (too much rain and snow for anything else)
BIG BEND World's Wildest Animals
DEEPEST OIL WELLS
WORLD'S LARGEST GARDEN
TEXAS A&M WORLD'S LARGEST MILITARY SCHOOL
SAN JACINTO WORLD'S TALLEST MONUMENT
INDIAN RESERVATION
Atlantic Ocean
Storm Area
Mexico
WORLD'S BEST CITRUS FRUITS
KING — WORLD'S BIGGEST RANCH
Gulf of Mexico
Map of Texas, U.S.A.
DRAWN FROM A TEXAN'S VIEWPOINT

DALHART
AMARILLO
SHAMROCK
LUBBOCK
WICHITA FALLS
SHERMAN
ABILENE
FORT WORTH DALLAS
EL PASO
PECOS
BIG SPRING
WACO
VAN HORN
BALMORHEA
SAN ANGELO
MARFA
FT. DAVIS
FT. STOCKTON
ORANGE
ALPINE
MARATHON
BIG BEND NAT PARK
AUSTIN
BEAUMONT
PORT ARTHUR
HOUSTON
GALVESTON
PRESIDIO
SAN ANTONIO
DEL RIO
CORPUS CHRISTI
LAREDO
LOWER RIO GRANDE
THE LONE STAR STATE

Greetings from TEXAS

TEXAS — THE LONE STAR STATE

Initially the distance on Route 66 across Texas, between the Oklahoma and New Mexico state lines, was 178 miles. Amazingly, about 148 miles remain—a bit more if you include the old alignments, now devoid of drivable pavement.

Today Route 66 in Texas largely serves a subservient role as a frontage road for I-40. As a result, along much of the route, the trappings of the modern age stand in stark contrast to the forlorn, dusty, well-worn relics from a time when shiny new Studebakers rolled from the factory in South Bend.

In the 1950s, the state of Texas began modernizing its highway system by converting primary, two-lane roads into four-lane highways. For Route 66, this was manifested by maintaining the old alignment and then adding a new two-lane highway that ran parallel.

Therefore, cruising Route 66 in Texas is a unique opportunity to experience an early manifestation of Route 66 as well as the last incarnation. Enhancing the Route 66 experience here on the high plains are the rest areas built during the 1950s that remain in use today on I-40, where the interstate wholly replaced the old highway.

The general consensus among travelers is that the Texas panhandle is one of the most boring drives on earth. Granted, the landscapes are not overly awe-inspiring, but now that the interstate highway has replaced Route 66, with its string of neon oases and distractions such as roadside reptile farms, these impressions are magnified.

In 1946, Jack Rittenhouse noted one lonely gas station along this fourteen-mile stretch between the Oklahoma border and Shamrock, Texas. Today, Shamrock is a veritable treasure trove of ghostly remnants from a time when Route 66 rolled through the heart of town and numerous refinery-related facilities made it clear to all that oil was king in this portion of the Texas plains.

Surprisingly, one of the most photographed sites on Route 66, the U Drop Inn, is located in Shamrock. This dazzling, neon-lit, art deco masterpiece dates to 1936, and is currently home to the offices of the local chamber of commerce.

McLean has the dubious distinction of being the last town on Route 66 in Texas bypassed by the interstate highway. That was in 1984.

Scattered among the empty stores, the ghostly shells of service stations, and motels that only offer shelter from the howling north winds of December to wildlife, there are gems that hint at better times. One of these is the delightful early-1930s Phillips 66 station, restored as a near-perfect time capsule complete with vintage tanker truck and period gasoline pumps.

Another is the Devil's Rope–Old Route 66 Museum, housed in a factory that once produced women's undergarments. An extensive collection chronicling the evolution of barbed wire and extensive displays of memorabilia from McClean's better days lend a quality to the museum that belies the size of the town.

In 1946, Jack Rittenhouse noted the town of Alanreed had a population nearly fifteen hundred and offered travelers, "Ranch House court, several gas stations, cafes, and a few stores." Today, very little remains to hint of these better times, with the exception of the recently refurbished, Spanish Mission-styled Super Service Station, which dates to 1932.

Greetings from **TEXAS**
THE LONE STAR STATE

Greetings from **WEST TEXAS**
"WHERE THE DEER AND THE ANTELOPE PLAYED — WITH THE COMANCHES RIGHT BEHIND!"

T-15
KING COTTON
TEXAS

The Lone Star State
TEXAS

INTERESTING FACTS ABOUT TEXAS

CAPITAL: Austin
POPULATION: Over 7,712,000
NICKNAME: Lone Star State
FLOWER: Bluebonnet
MOTTO: Friendship
AREA: 267,339 square miles of which 3,695 square miles are water.

The largest state in the Union—is approximately 1/12th the area of the entire United States.

59 of its 254 counties are each as big as—or bigger than Rhode Island.

Fishing—more than 200 varieties of fresh and salt water fish.

Hunting—deer, mountain lion, coyote, fox, wolf, duck, geese, snipe and quail.

Produces over 4,000,000 bales of cotton, more than twice as much as the second ranking state.

Ranks first in total number of livestock raised. Produces more sheep, wool, goats and mohair than any other state.

Over one-half of the known petroleum reserves are located in Texas.

Also leads in production of natural gas, carbon black and helium.

Contains tremendous deposits of sulphur, coal, lignite and brimstone.

The eastern section of the state contains large stands of pine and hardwoods.

Commercial fishing along the Gulf Coast is an important industry.

STATE "MAP-NAP" © 1954
Beach Products Inc., Kalamazoo, Mich.

TEXAS
THE LONE STAR STATE

Another Texas Brag Is the Food at: **BOB ADAMCIK'S CAFE**
SCHULENBURG, TEXAS
HIWAY 90, 1 MILE WEST
Fully Air-Conditioned — 26-Hour Service

Texas
LONG HORN
WIDTH OF HORNS:
9 FT., 6 IN.
TEXAS

OLD TEX
TEXAS LONG HORN STEER
HORNS MEASURING OVER 8 FEET TIP TO TIP
(Originally the Buckhorn Saloon), San Antonio, Texas

GREETINGS FROM
TEXAS

Off for the Roundup

Buffaloes on the Range TX 9

Souvenir of TEXAS
"The Lone Star State"

Just west of Alanreed, and south of I-40, sit the forlorn ruins of a motor court and a couple of houses that mark the site of Jericho. There was a time when this remote oasis of civilization was one of the most recognized names on Route 66. The notoriety was not garnered from positive motoring experiences, as this was the eastern end of the infamous Jericho Gap, the last eighteen-mile section of Route 66 to be paved in the state of Texas. Rains turned the rich black soil into a thick and seemingly bottomless gumbo; dry weather transformed it into an axle-snapping track of deep dust-filled ruts before the paved bypass of 1931.

There was a time ninety years ago or so when Groom was a rather prosperous little high plains burg, the result of extensive cattle ranches as well as wheat farms. Today Route 66 aficionados, as well as travelers on the interstate, know the town for its leaning tower of Groom, built at a slant to call attention to a truck stop in the 1950s, and the 190-foot, illuminated Cross of Our Lord Jesus Christ.

Vestiges of the glory days of Route 66, as well as the frontier era and the role the community played during World War II, are scattered throughout Amarillo. However, there are two landmarks here that are must-see sites, one recognized throughout the world, the other an obscure edifice that dominates the skyline.

The first is the legendary Big Texan Steak Ranch, an icon that opened its doors on Route 66 in 1959 and relocated to its current location after the completion of the I-40 bypass. The second is the former offices of the Santa Fe Railroad, an art deco masterpiece built between 1928 and 1930 at a cost of $1.5 million.

The first site to grab your attention on the road west from Amarillo is the now legendary Cadillac Ranch, a somewhat bizarre, modern rendition of Stonehenge transformed into a monument celebrating . . . ? Strangely enough, the collection of ten vintage Cadillacs buried nose down and covered with graffiti by all who pass by has become a Route 66 icon recognized throughout the world.

West of Amarillo is an empty land once known as Llano Estacado, or "Staked Plains," because of pioneers marking trails with stakes, as there are no natural landmarks here. The name itself speaks volumes about the fortitude of those who first settled here.

In this vast wilderness, the towns that line the old road seem even more forlorn and forgotten. Still, there are time capsules, such as the Midpoint Café in Adrian, little hidden gems unchanged from a time when Packard was synonymous with class.

Glenrio, depending on the map used and the date it was published, is in either New Mexico or Texas. Today, the arguments have little point, as the last or first town is a near-complete ghost, with few lights left to hold the darkness at bay. ◉

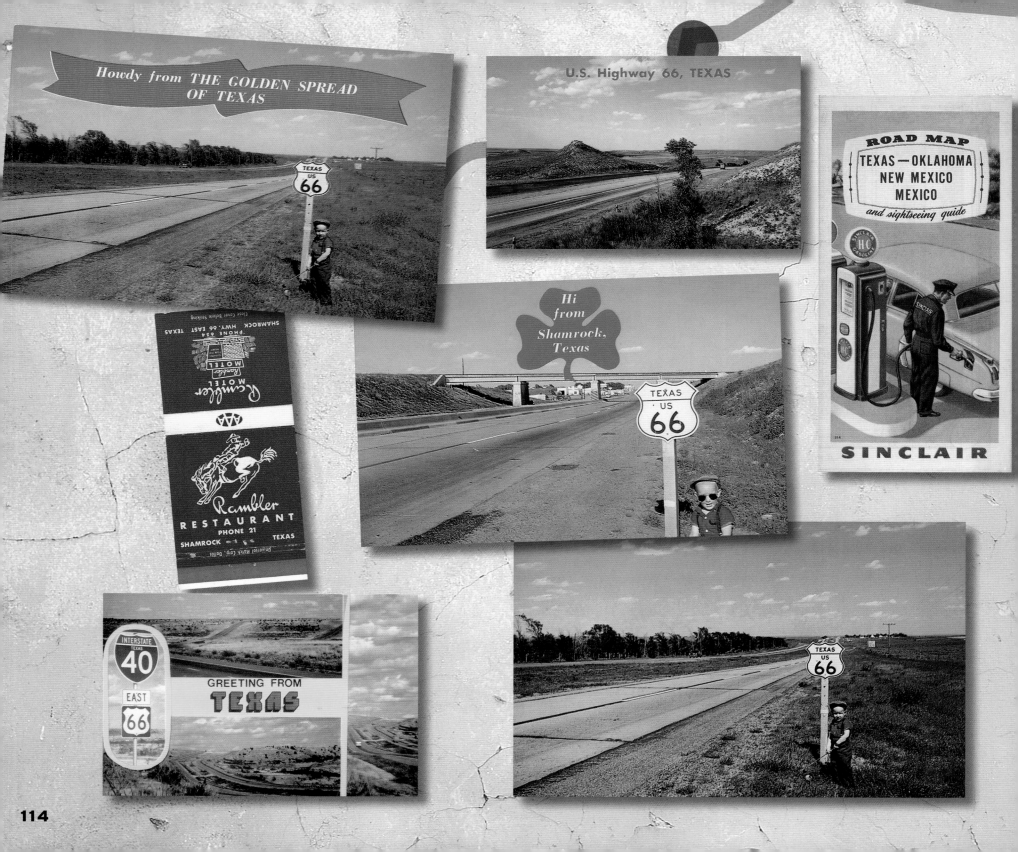

Howdy from THE GOLDEN SPREAD OF TEXAS

U.S. Highway 66, TEXAS

ROAD MAP
TEXAS—OKLAHOMA
NEW MEXICO
MEXICO
and sightseeing guide

SINCLAIR

Rambler
MOTEL
PHONE 654
SHAMROCK, HWY. 66 EAST
TEXAS

Close Cover Before Striking

Rambler
MOTEL

Rambler
RESTAURANT
PHONE 21
SHAMROCK TEXAS

Universal Match Corp. Dallas

Hi from Shamrock, Texas

TEXAS US 66

INTERSTATE TEXAS 40 EAST US 66

GREETING FROM TEXAS

TEXAS US 66

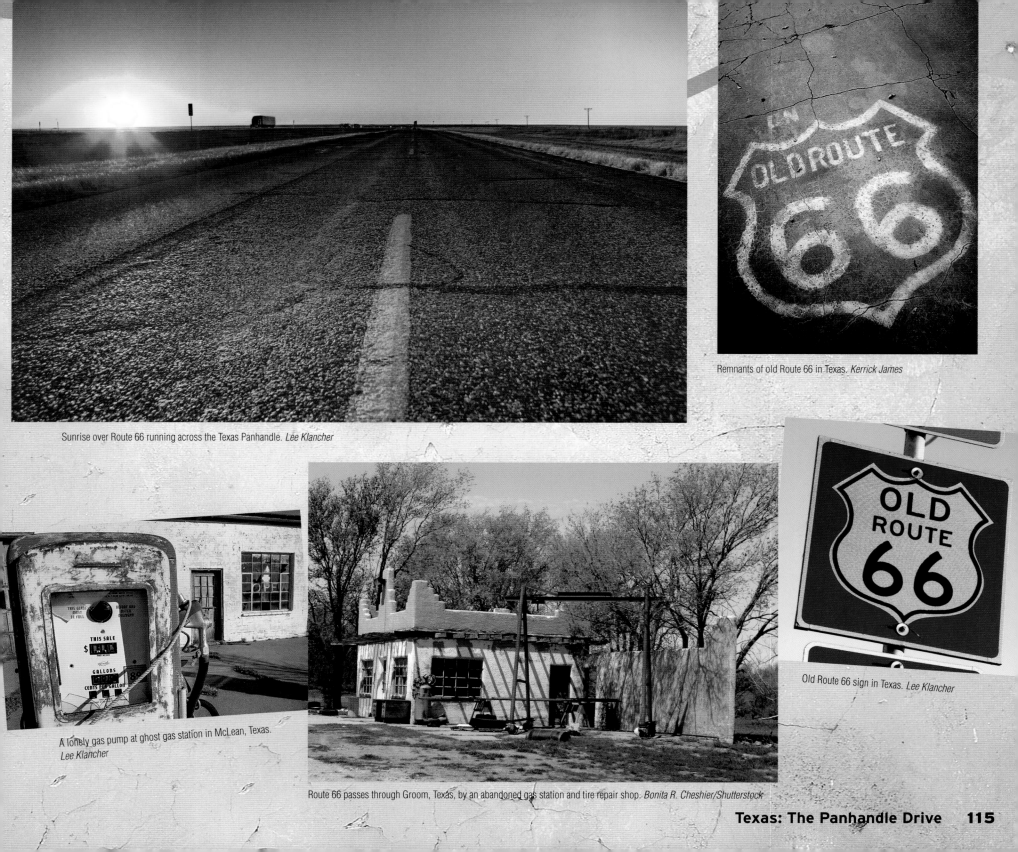

Sunrise over Route 66 running across the Texas Panhandle. *Lee Klancher*

Remnants of old Route 66 in Texas. *Kerrick James*

Old Route 66 sign in Texas. *Lee Klancher*

A lonely gas pump at ghost gas station in McLean, Texas.
Lee Klancher

Route 66 passes through Groom, Texas, by an abandoned gas station and tire repair shop. *Bonita R. Cheshier/Shutterstock*

THE MOTHER ROAD LOST & FOUND

U Drop Inn, Shamrock, circa 1952

By Russell A. Olsen

Then: The U Drop Inn, Shamrock, Texas.

Now: The U Drop Inn, Shamrock, Texas.

The art deco U Drop Inn

at the intersection of Route 66 and U.S. Highway 83 was built in 1936 from plans scratched out by John Nunn in the dirt with an old nail, so the story goes. The main building was built of brick, with green and gold glazed tile accents, while the towers are wood-framed and covered with stucco. A contest to name the cafe was won by a local 10-year-old, who pocketed five dollars in the process. As the only cafe for about a hundred-mile radius, the U Drop Inn enjoyed a brisk business.

Around 1937 the space next to the cafe, which served as a store, was transformed into a dining room and ballroom. Original proprietors John and Bebe Nunn sold the cafe after a few years, only to repurchase it in 1950 and change its name to Nunn's Café. John died in 1957, and in 1960 Bebe sold the business to Grace Brunner, who changed the name once again. The rechristened Tower Café also served as Shamrock's Greyhound bus station, feeding hundreds of travelers daily. After a few more ownership changes, the entire building was purchased in the early 1980s by the son of the original financier, James Tindal, Jr., who had the building repainted in its original color scheme and restored the U Drop Inn moniker. Today the U Drop Inn is an information center created through a $1.7 million federal grant. ◉

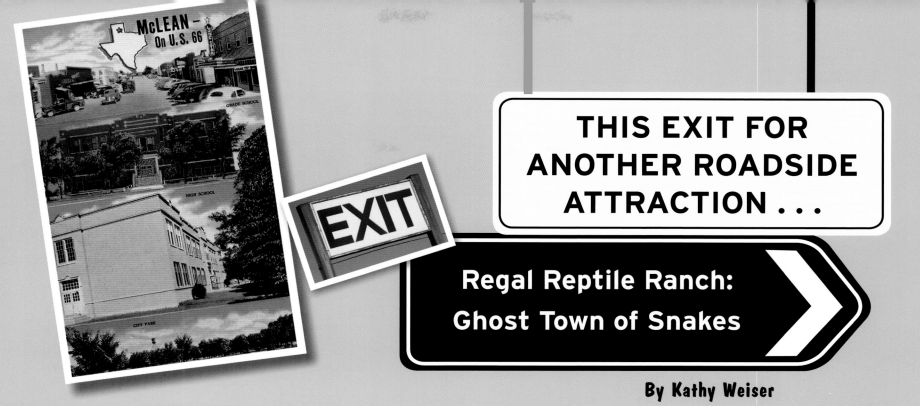

THIS EXIT FOR ANOTHER ROADSIDE ATTRACTION . . .

Regal Reptile Ranch: Ghost Town of Snakes

By Kathy Weiser

On the way to McLean,

the Rattle Snakes Exit Sign stood for decades near the Lela exit in a pasture on the north side of I-40. However, in the Spring of 2007, high winds blew the Route 66 landmark down.

The sign once advertised the exit for the Regal Reptile Ranch that was operated by Mike Allred, a carnival-like operator who once displayed snake attractions all along Route 66—in Elk City and Erick, Oklahoma, and Alanreed,

Texas. The last and final Reptile Ranch was located in a service station at the Lela exit. The station building was moved to McLean and now serves as part of the Red River Steakhouse. The old pumps, however, can still be seen peeking from the high grasses near the fallen sign.

Longtime Route 66 supporters are currently seeing what can be done about salvaging the sign. ◉

The Devil's Rope Museum

By Lee Klancher

The home of the world's

only Devil's Rope Museum is McLean, Texas. Founded by the world's only Delbert Trew, the museum chronicles the history of barbed wire and fencing tools.

The town boomed with Route 66, and housed sixteen gas stations in its prime years. The town's fortune took a turn for the worse in the 1980s, and the population dropped to 850.

The town is a mix of abandoned buildings and tourist attractions today. Trew's Devil's Rope Museum, which also includes a library and Route 66 museum, is housed in a former bra factory.

A stop in McLean is a must for any traveler, particularly because Trew is the curator and knows more about Route 66 history than most. Just be prepared—any chat with Delbert isn't likely to be short! ◉

Amarillo
Panhandle Cow Town

By Kathy Weiser

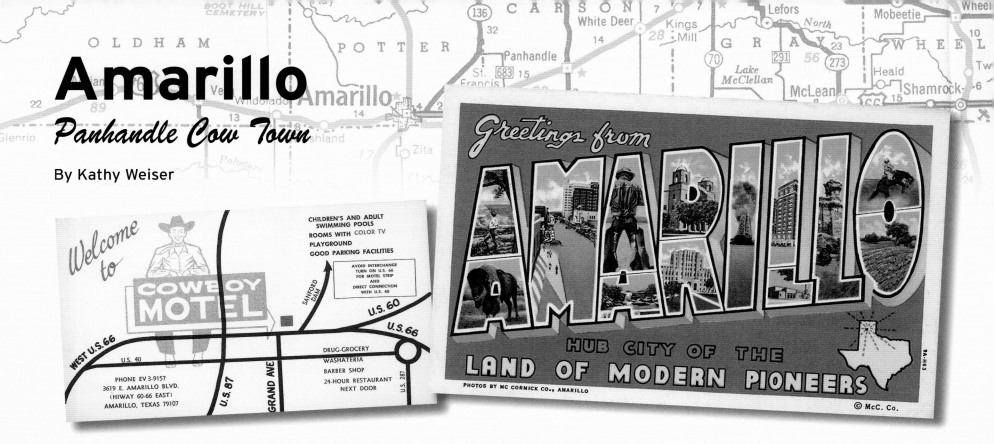

Amarillo is one of the few places where the Old West is literally only steps away as you move from the modern twenty-first century to the many surrounding working ranches that are essentially unchanged from the late 1800s in their day-to-day operations.

Francisco Coronado was the first European to see the vast open spaces of what would one day be the Texas Panhandle—nearly eighty years before the Pilgrims landed at Plymouth Rock. Roving tribes of Native Americans had dominated the area for centuries and were one of the last strongholds against the invasion of "the white man." After the last holdouts lost in the Red River War in 1875, the "staked plains" were opened to settlement.

The vast, empty territory was immediately sought out by buffalo hunters, while the soldiers at Fort Elliott were tasked with keeping the native tribes on Oklahoma reservations. In late 1876, Charles Goodnight drove a herd of longhorn cattle into Palo Duro Canyon to begin the first Panhandle ranch. Quickly following, more cattlemen and sheepherders headed to the area for fresh grazing grounds and a place to start a new life.

The town was first named Oneida, but soon changed to Amarillo. Meaning "yellow" in Spanish, the town was named for the color of the soil on the nearby banks of Amarillo Creek and the abundant yellow wildflowers that bloomed during the spring and summer. Most of the town's first houses were painted yellow in commemoration of the name change. The Spanish pronunciation ("ah-mah-ree-yoh"), was first used to describe the settlement, but that was short lived. As the conductors along the railroad passing through called out their English pronunciation of "am-ah-rillow," the beautiful, original articulation was lost forever.

Gas was discovered in 1918, and three years later oil was found and the black gold frenzy exploded across the Texas Panhandle as vast fortunes were made overnight.

In 1921, a long stretch of Sixth Street became the first paved roadway in Amarillo, a portion of which Route 66 would later follow through the San Jacinto Heights neighborhood. In the earliest days, the route entered Amarillo on Eighth Avenue (which later became Amarillo Boulevard), turned south on Fillmore Street, west on Sixth Avenue, and finally followed Bushland Avenue, leaving the city. Later, as the city expanded, the route was moved entirely to Amarillo Boulevard, bypassing downtown and traveling northwest of much of the city. Numerous service facilities popped up, causing Amarillo Boulevard to often be referred to as "Motel Row."

The 1930s brought drought and black dust bowls to Amarillo, but the decade also saw the rise of tourist stops, numerous motels, and restaurants, as Americans began to feverishly travel Route 66.

For Mother Road travelers, there are two alignments through the city, both of which begin at east Amarillo Boulevard (U.S.-60/B.L.-44), which continues to sport several relics of more prosperous times in this now seedy neighborhood.

On the east end of Amarillo Boulevard, look for the old Triangle Motel at 7954 East Amarillo Boulevard on the south side of the road. Currently, there are plans to restore this old place, but they have a ways to go. Across the street, barely recognizable, is an old Whiting Brothers service station. Down the boulevard look for the vintage sign of the Eastridge Bowling Alley on the north side, the Cattleman's Club and Cafe (which has been doing business for decades), and the Cowboy Motel next door at 3619 East Amarillo Boulevard. Continuing on Amarillo Boulevard, more signs of the vintage Mother Road can be seen, though you gradually see fewer as you move westward.

The original alignment can be accessed by turning south from Amarillo Boulevard onto Pierce Street (U.S.-87), continuing south to Sixth Street and turning west. Along this vintage route are a number of old services that continue to stand, though most not in their original form. That being said, the area has made a comeback, with numerous old buildings refurbished into antiques shops, cafes, and boutiques. Today, this stretch of the old pavement has been listed on the National Register of Historic Places. A must-see along this route is the Nat Dine and Dance Palace, which once catered to customers in the Big Band era and

later to the rock 'n' rollers of the 1950s. Now a bookstore, it is said to be haunted!

While not technically on Route 66 today, the original Big Texan Steak Ranch first stood on Route 66 along East Amarillo Boulevard when the steakhouse was built in 1960. It all began in 1959, when Bob Lee went seeking a large steak in the midst of cow country. To his surprise, Amarillo sported not a single cowboy steakhouse, which Lee soon began to rectify.

A year later, the Big Texan Steak Ranch opened, claiming to serve the largest steak in Texas. But simply serving the largest steak wasn't enough—Lee soon began promoting a free 72-ounce steak dinner if customers could eat the whole thing in less than an hour. It wasn't long before the promotion gained national attention, and travelers thinking of Amarillo immediately associated it with the Texan Steak Ranch, making the restaurant a must-stop for travelers of the Mother Road.

When I-40 barreled through Amarillo, bypassing Route 66, Lee moved the restaurant nearer the traffic, but the famous steakhouse retained its reputation as a Mother Road landmark. In addition to its more than forty-year-old steak promotion and seating for 450 in its restaurant, the Big Texan also sports a motel,

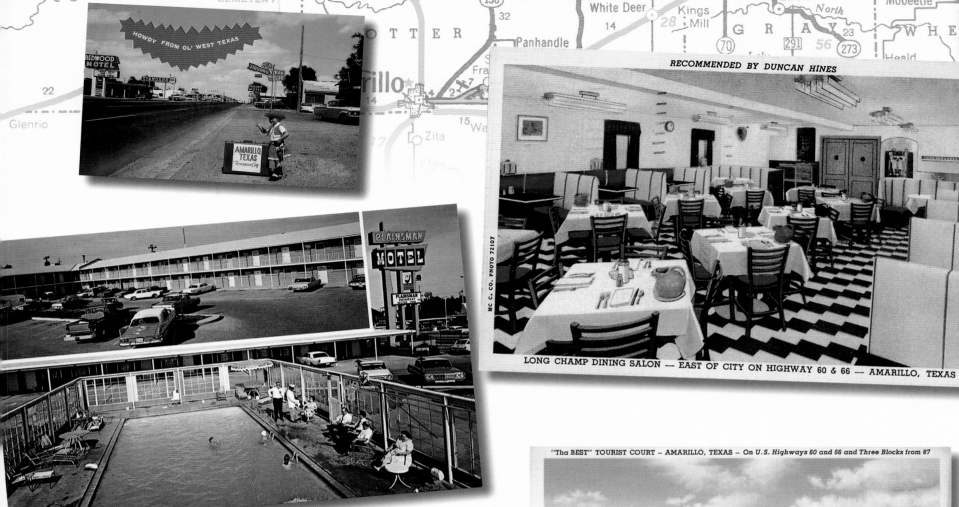

RECOMMENDED BY DUNCAN HINES

LONG CHAMP DINING SALON — EAST OF CITY ON HIGHWAY 60 & 66 — AMARILLO, TEXAS

"Tha BEST" TOURIST COURT – AMARILLO, TEXAS – On U.S. Highways 60 and 66 and Three Blocks from 87

600 N. E. EIGHTH AVE. — (Panhandle Highway) — Opposite Will Rogers Memorial Park

Old West entertainment, a gift shop, and even a Horse Hotel, all decorated to resemble an Old West town. The Lee family continues to operate the complex that is not only lots of fun, but also provides a delicious steak.

In the meantime, keep your eyes open for a series of mock road signs scattered throughout the city that are collectively referred to as the Dynamite Museum. These signs portray odd bits of philosophy, pictures, and sometimes just nonsense. Developed by eccentric millionaire Stanley Marsh, you can see lots of these signs by visiting Cadillac Ranch and Other Panhandle Oddities.

Keep right on travelin' down the Mother Road to the Cadillac Ranch, Vega, and Adrian, Texas.

To stay on the original Mother Road, Amarillo Boulevard will begin to curve back to I-40 when you run into an intersection that is Indian Hills Road (also old Route 66). Follow this road west toward the old town of Bushland, where the road will end. Rejoining I-40, you can continue on the north frontage road to Vega. ◎

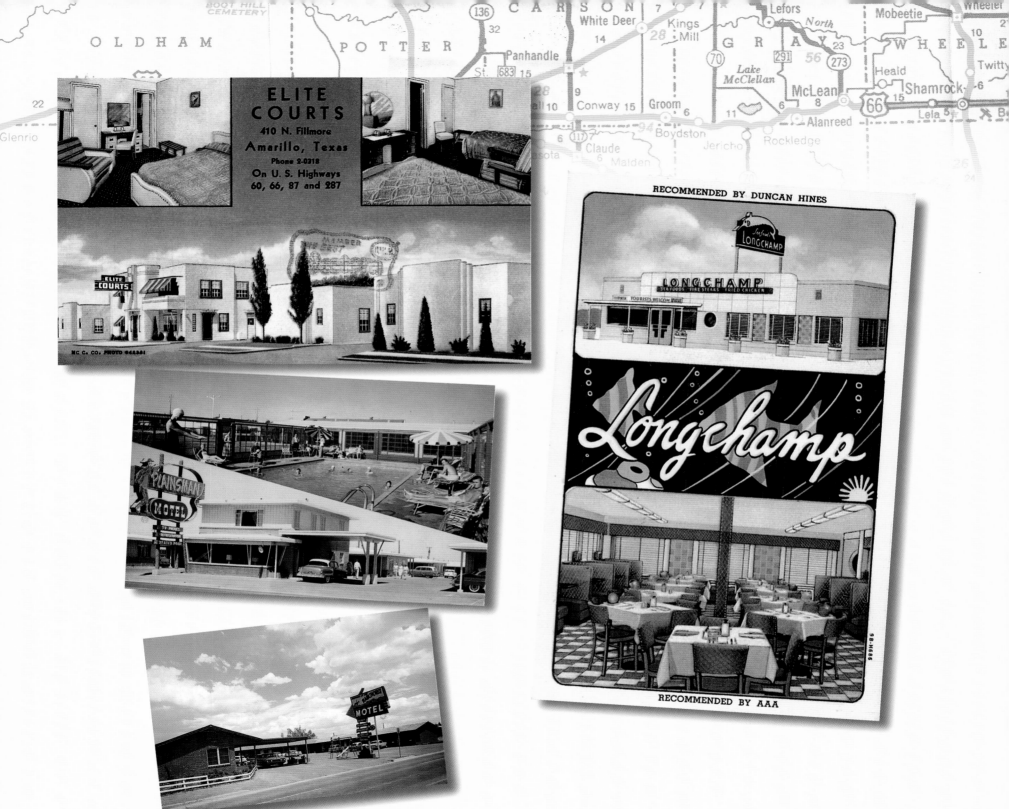

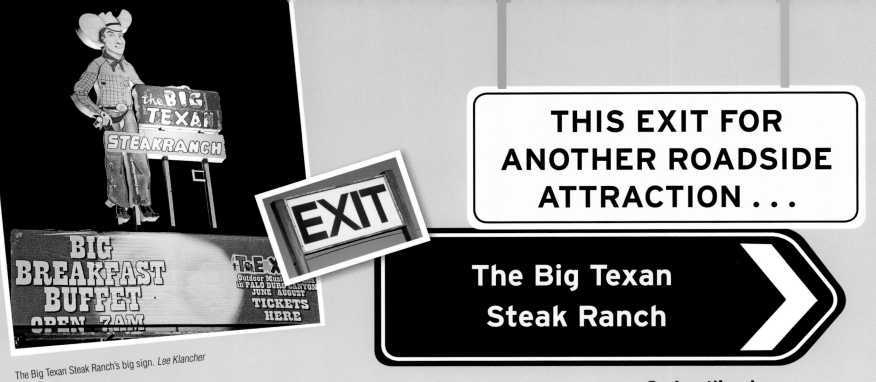

The Big Texan Steak Ranch's big sign. *Lee Klancher*

THIS EXIT FOR ANOTHER ROADSIDE ATTRACTION . . .

The Big Texan Steak Ranch

By Lee Klancher

Route 66 in Amarillo

is an elusive creature. The route of the original Mother Road can be traced through town, but doing so requires a guidebook, time, and dedication. If you don't have the time and patience for crawling along highway access roads and stoplight-choked boulevards, one of the relics of the road that you can't miss is the Big Texan Steak Ranch. Signs advertising the iconic destination litter Interstate 40 for miles. Once you hit Amarillo, the brightly lit, 25-plus-foot-tall cartoon cowboy beckons you to exit and eat some beef.

According to the USDA, 13.6 million beef cattle resided in Texas in 2009. Those cattle would yield about 6.7 billion pounds of meat. That's 27 pounds of beef for each Texas resident.

Given this seemingly endless supply of product, isn't it inevitable that someone would offer you a free meal if you consumed a 72-ounce steak? Since 1965, the folks that own the Big Texan Steak Ranch have done just that. Legend has it that a big rancher sauntered into the Big Texan and declared he could eat a whole cow. He sat down and consumed 4.5 pounds of steak. Owner R.J. "Bob" Lee decided on the spot that anyone who could consume four pounds of steak should eat for free. In short order, he emblazoned his promise on billboards hundreds of miles away from Amarillo.

Legends are legends, and Lee was a savvy entrepeneur who surely understood that offering a free piece of beef would lure hoards of travelers off Route 66. Perhaps he underestimated the appeal of his gimmick, as not only did he draw in thousands of customers during the heydey of Route 66, he continues to serve a staggering amount of beef to people despite the fact that today's road traffic consists mainly of semis hauling cattle.

The Big Texan Steak Challenge is simple. The restaurant serves up a 72-ounce piece of meat, cooked to your taste, as well as a shrimp cocktail, a baked potato, and a dinner roll. The rules are simple: eat all the food on the plate in sixty minutes—no sharing, leaving the table, or puking—and the meal is free. If you don't finish or you get sick, you are out seventy-two bucks. You must eat at a table on a raised platform in the middle of the restaurant, and your experience is broadcast live via webcam.

Billy Bob Thornton's road crew for his band, the Boxmasters, loves the Big Texan and stop in whenever they are on the road in Texas. On *The Jimmy Kimmel Show*, Thornton said that about seventy thousand people had tried to eat the steak, and only eight thousand had succeeded. The list of those who have succeeded includes a man from Nevada who ate two of the steaks on *The Donny and Marie Osmond Show*, a sixty-nine-year-old grandmother, and former Cincinnati Reds pitcher Frank Pastore, who consumed the dinner in 9.5 minutes on May 3, 1987. A 500-pound Bengal tiger ate the meal in 90 seconds, and a 120-pound Wall Street reporter ate it in 60 minutes.

I went to Amarillo intending to join the list of those who'd tried. When the assignment came up and I read about the place, the idea of eating that much steak appealed in equal measures to my gluttonous and competitive sides. Plus, eating is one of my talents. When I was eleven years old, my grandfather used to order two meals just to watch me devour them and top it off with dessert. Joan, my wife, still marvels at my ability to clean my plate in less than thirty seconds, and is constantly reminding me, "Eating is not a race."

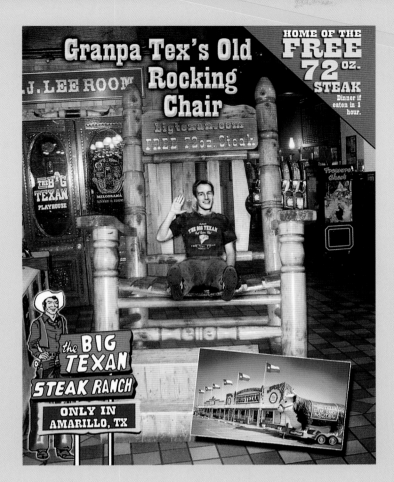

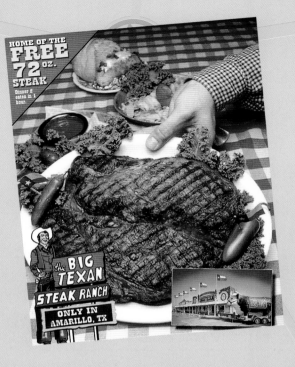

Besides, if a sixty-nine-year-old grandmother can eat this steak, I thought, why not me?

I prepared for the event by eating lightly during my two days in the area. Apples, cheese sandwiches, and coffee were my only staples. When I arrived at the Big Texan, I was starving.

The parking lot was packed, even at eight o'clock on a Thursday night in early December. A horse-friendly hotel is off to the side, and a giant fiberglass cow stands outside the bright yellow faux Western storefront of the restaurant. The interior decor has a Wall Drug emporium meets Yosemite Sam feel. Miles of wood paneling are capped with steer heads, cartoonish cowboy signs, rusty license plates, and wagon wheel chandeliers.

The host asked me where I wanted to sit. I eyed the raised platform and spotted two contestants. I told him I'd like to look around a bit.

I walked up to the cowhide-covered table and found two college-age guys remorsefully picking away at two huge pieces of meat. They appeared to have each eaten no more than a quarter of their steaks, and had twenty minutes left on the clock. Despite the fact that fifteen of their friends were cheering them on, both of them looked like they wanted to throw up. Clearly beaten by the beef on

their plates, these boys would leave with three pounds of leftovers and wallets that were seventy-two dollars lighter.

As I watched the lads pushing around the pile of meat on their plates, I began to get a sense of the magnitude of the Steak Challenge. The pile of meat was enormous. I realized I couldn't make it through that mound in two days, much less sixty minutes.

The part I failed to grasp is the sheer size of 72 ounces of steak. The recommended serving size for a male aged 40–59 (me) is 5.3 ounces. In order to finish the steak at the Big Texan, I would have to consume more than thirteen healthy servings of meat in one sitting.

I went back to the host and asked for a table in the back. I ordered 12 ounces of filet off the cartoon-emblazoned menu. The two steaks that showed up were tender, perfectly cooked, and nicely seasoned. I was also convinced to try the deep-fried mountain oysters. They tasted like most deep-friend things (delicious). I skipped the fried rattlesnake (and visiting with the Big Texan's resident live rattlesnake) but partook of dessert. I chose a giant brownie smothered in ice cream, fudge, and caramel. The finishing touch on the evening was a serenade by the Big Texan Western singers, who belted out a reasonable rendition of Willie's "On the Road Again."

I left late, full of beef, beer, and country music. The raised cowhide-covered Steak Challenge table was empty and the digital clocks read zero. The Big Texan was nearly cleared out of customers. This is a rare state for the place, as they serve more than a hundred thousand meals each year.

Texas Route 66 is nearly gone, but a whiff of the era lives on in the Big Texan's uniquely American blend of good food, Western kitsch, and gluttony gone wild. ◎

Vintage postcard of Cadillac Ranch. *Michael Karl Witzel collection*

VOICES FROM THE MOTHER ROAD

Stanley Marsh 3:
The Cadillac Ranch of Texas

By Michael Karl Witzel

Stanley Marsh 3

—who prefers to use the Arabic numeral in his name because he thinks that the "III" is too pretentious—likes to get the attention of the Amarillo community. Local fat cat, helium tycoon, and television station owner, Marsh was born into a wealthy oil family and maintains the offices of Marsh Enterprises in Amarillo's tallest building, the Chase Tower. But don't let his high-powered business entanglements fool you. Marsh is also an artist, philanthropist, and a trickster—known for mysterious acts of various flavors, and as someone with a penchant for pranks.

Marsh was the benefactor behind the so-called "Dynamite Museum," billed as "the only museum in the world without four walls." The main activity of this museum's "staff" was to sneak diamond-shaped road signs into neighborhoods around Amarillo and set them in cement. The next day, unsuspecting residents and motorists would find them. Each one-of-a-kind sign was painted by individual artists and carried everything from depictions of dueling pigs to dramatic passages from Shakespeare. The critics weren't much impressed, but the mock signs caught the public fancy, emblazoned with messages such as "Lubbock is a grease spot," "Road does not end," and "I have traveled a great deal in Amarillo."

During the 1970s—when the Arab oil embargo was in full swing and Americans waited in long lines at the local gas station—Marsh collaborated with a group of artists to design and execute a car sculpture on his Amarillo ranch.

He liked the work that a San Francisco artists' group called Ant Farm was doing, so he commissioned them to build a homage to American car culture along the Route 66 roadside.

But this was not going to be another run-of-the-mill public art project, by any means. For this project, Marsh wanted eye-catching installation art (an artistic genre of site-specific, three-dimensional works designed to transform the perception of a space). His sculpture was going to be something that would turn heads, a monument, statement, and grand concept that would endure like the Pyramids, Great Wall of China, Coliseum, or any other of the man-made wonders of the world.

To build the sculpture, Ant Farm artists Doug Michels, Chip Lord, and Hudson Marquez scoured the Texas Panhandle area for any and all running and derelict Caddies that they could get their hands on. Combing through every junkyard and used car lot that they could find, they were primarily interested in models that represented the so-called "Golden Age" of American automobiles. These were the General Motors models that ranged in years from a 1949 club coupe to a 1963 sedan. There was strong symbolism at play here: this was the span that highlighted the rise and fall of the tail fin, perhaps the Cadillac's most defining feature

During the 1950s, the Cadillac was touted in print advertising as the "Standard of the World" in engineering, "ride," safety, and dependability. For Americans

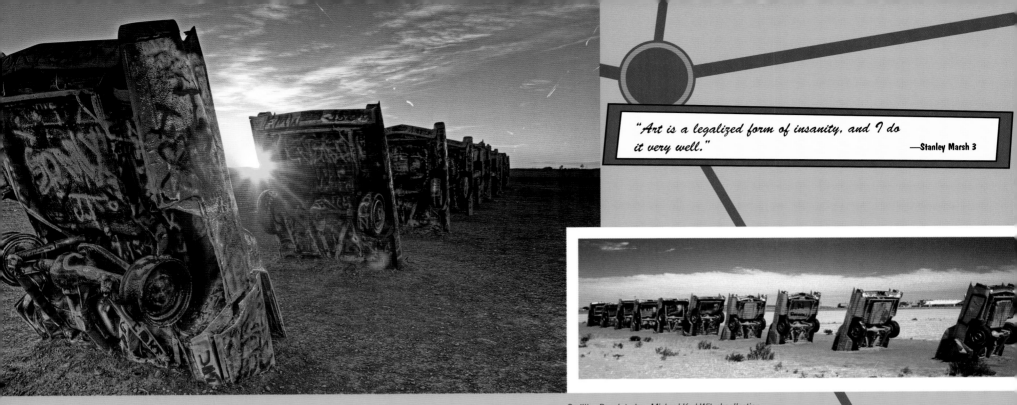

Sunset at Cadillac Ranch. *Lee Klancher*

Cadillac Ranch today. *Michael Karl Witzel collection*

enjoying a postwar economic boom, it was also a potent status symbol and an automobile that you just *had* to have. Forget the clunky Ford station wagon: a Cadillac broadcast the message that you had arrived. Driving down the highway seated in one of these gleaming chariots of chrome and glass, it was more than obvious to everyone else in the world that you were a success.

At the Cadillac Ranch, it was these dreams that were partially buried in the earth, nose first, to a depth of eight feet to be exact. The group was positioned to face West too, copying the angle of alignment seen at the Cheop's pyramids in Egypt. Marsh had created a monument to what *we* revered, our kings. The automobile has always been the royal lineage of this nation, the great marques the kings of our times, remembered well by their chrome jewelry, two-tone thrones of upholstered leather, gleaming exterior paint, stereophonic radio sets, four barrel carburetors, eight-cylinder internal combustion engines, steel-belted radial tires . . . and their gluttony for gasoline.

For maximum exposure, Marsh's homage to America's drive-in dreams was positioned right along the pathway of America's fabled "Main Street," U.S. Route 66, as much a well-known icon in itself. And so, with a built-in audience of onlookers rolling by at highway speeds, the Amarillo Stonehenge of derelict cars gained an immediate following. People from all walks of life and every social class were drawn to the public sculpture. They all came with their own reasons, their own agenda: to take pictures of it, deface it with graffiti, write articles about it, sing songs that featured it, and to use it as a backdrop for every road pilgrimage and B-movie buddy vehicle to come out of Hollywood.

By 1997, the city of Amarillo had grown in size, and urban sprawl made its mark on the dusty prairie. Suddenly, Marsh got worried that the explosive growth would put the status of his Cadillac farm in jeopardy, so he made plans to quietly move the art installation two miles to the west. It was ironic that Interstate 40—the freeway that replaced Route 66 in Texas—would become the ranch's new home. It was also another chance for Marsh to show his playful side: the only evidence left behind at the old location were ten huge holes and a sign that read "Unmarked Graves for Sale or Rent."

Today, the Cadillac Ranch is forever linked with roadside America and bound inextricably with the myth, magic, and mystique that people know as Route 66. Now, the pop art grouping of cars reminds us of the gradual demise of American car culture and our dependence on foreign oil. When it comes to building cars, our nation is no longer the leader. The economy of Detroit, along with the big three, is in ruins. Although not its intention when first built, the Cadillac Ranch provides a fitting memorial: Ten classic cars, steel tombstones marking the grave of America's once mighty auto industry. ◉

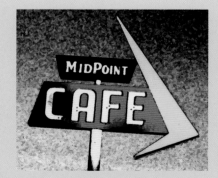

A waitress clears a table at the Midpoint Cafè in Adrian, Texas. Adrian is at the halfway point in Route 66 between Chicago and Los Angeles, both of which are exactly 1,139 miles away. *Robyn Beck/AFP/Getty Images*

THIS EXIT FOR ANOTHER ROADSIDE ATTRACTION . . .

The Midpoint Café

By Lee Klancher

One of the obvious stops

on a Route 66 road trip is the Midpoint Café. The promotional hook is that the little restaurant is halfway between Los Angeles and Chicago. The truth is a bit more muddy, and a number of other towns claim to hold that honor. Founded in the 1930s, the place is covered with memorabilia, the burgers are rumored to be good, and the "ugly crust" pie is also highly recommended.

The key to the place's draw, however, is that you don't really have many other choices. The stretch of Route 66 is mostly gone, replaced by Interstate 40, and there flat isn't much else around. If you want to stop for lunch, Adrian is the spot.

I did just that on a warm December afternoon. I had been up taking photos all morning and had passed on breakfast. When I pulled up, I was starving.

As it turned out, the place was closed up tight as a drum. No one there.

My GPS told me the nearest food was thirteen miles back or forty miles ahead, so I sat in the parking lot for a while. A black Ford Explorer pulled up. I hoped it might be the owner. When I asked the young woman in the passenger seat, she responded cheerily in one of those bright British accents that slap you in the forehead.

Byrony and husband Rob Steel were also hoping to eat a burger and the muddy crust pie.

Interested in what would bring a British couple to one of the most lonesome places in America, I chatted with the two for a bit. Our mutual hunger led us to share a table and a cup of coffee at the BBQ restaurant down the street. Rob told me that he was enlisted in the British Army. On a break after a seven-month assignment in Afghanistan, he and Byrony decided to drive Route 66 from Chicago to Los Angeles.

The biggest draw for the pair was meeting people in small towns and venues. Their favorite moment was meeting all the regulars in a diner in Chicago.

"You get to properly meet the locals," Rob said. "and see all the small-town America. That's what I love about it."

For the couple, the wide expanses of unpopulated areas were completely unique. "If you stand still," Byrony said, "You can't hear anything. It's the land that time forgot."

We agreed to continue on together and explore Glenrio for the afternoon, and had a great time poking around. The Midpoint Café's burger and ugly crust pie eluded me, but meeting two like-minded souls reminded me that unexpected encounters are one of the greatest joys of the road. ◉

The Midpoint Café's sign along old Route 66.
Lee Klancher

126

THE MOTHER ROAD LOST & FOUND

Tommy's Café, Adrian, circa 1962

By Russell A. Olsen

Then: Tommy's Café, Adrian, Texas.

Manuel Loveless built

the Kozy Kottage Kamp in Adrian in the early 1940s. The Kamp's service station and cafe were destroyed by fire in December 1947, but the Loveless family continued renting cabins under the name Adrian Court. The property where the service station and cafe once stood was sold to the Harris family. Bob Harris, who had worked at the Kozy Kottage Kamp before World War II, returned after the war with the idea of building a cafe on the newly acquired property. Harris wanted to design the cafe in a way that would compel motorists to stop. The nearby U.S. Army and Air Force bases were selling surplus military items, including a control tower. Harris bought the tower, moved it to his property, and proceeded to build his cafe around it. The completed eatery was christened the Bent Door Café for the canted door that accommodated its slanting walls.

Harris left Adrian and his mother to operate the cafe, and in 1950 Loveless leased the restaurant. In the late 1960s the Interstate bypassed Adrian and the steady flow of traffic slowed to a trickle. In 1970, the onetime twenty-four-hour cafe and service station closed its doors. They sat empty for three decades until Harris returned for a visit and heard the cafe was to be condemned. He repurchased the property and set a reopening for September 9, 1995, but it wasn't to be. On September 9, the fryers and ovens sat empty and cold. The cafe has remained closed ever since. ⊙

Now: Tommy's Café, Adrian, Texas.

Along Route 66. *Lee Klancher*

THIS EXIT FOR ANOTHER ROADSIDE ATTRACTION...

Glenrio, Texas

By Lee Klancher

Glenrio is the end

of the road in both Texas and New Mexico, as it straddles the border between the two states. The tiny town became a standard stop mainly because it was so remote. You stopped at Glenrio, or you didn't stop at all. The place blossomed when Route 66 travelers were numerous, and died along with the highway as traffic subsided.

You can take a nap on the windblown stretch of original road that runs through the town. Only one resident remains, the widow of a restaurant owner who was murdered in 1976. The rest of the town is a broken-windowed string of boarded-up buildings and the old post office, all littered with the debris of a hasty departure. ◎

> **"The land rolled like great stationary ground swells.**
> **Wildorado and Vega and Boise and Glenrio.**
> **That's the end of Texas."**
>
> —John Steinbeck, *The Grapes of Wrath*

Opposite page: Ghost town remains at Glenrio. *Lee Klancher*

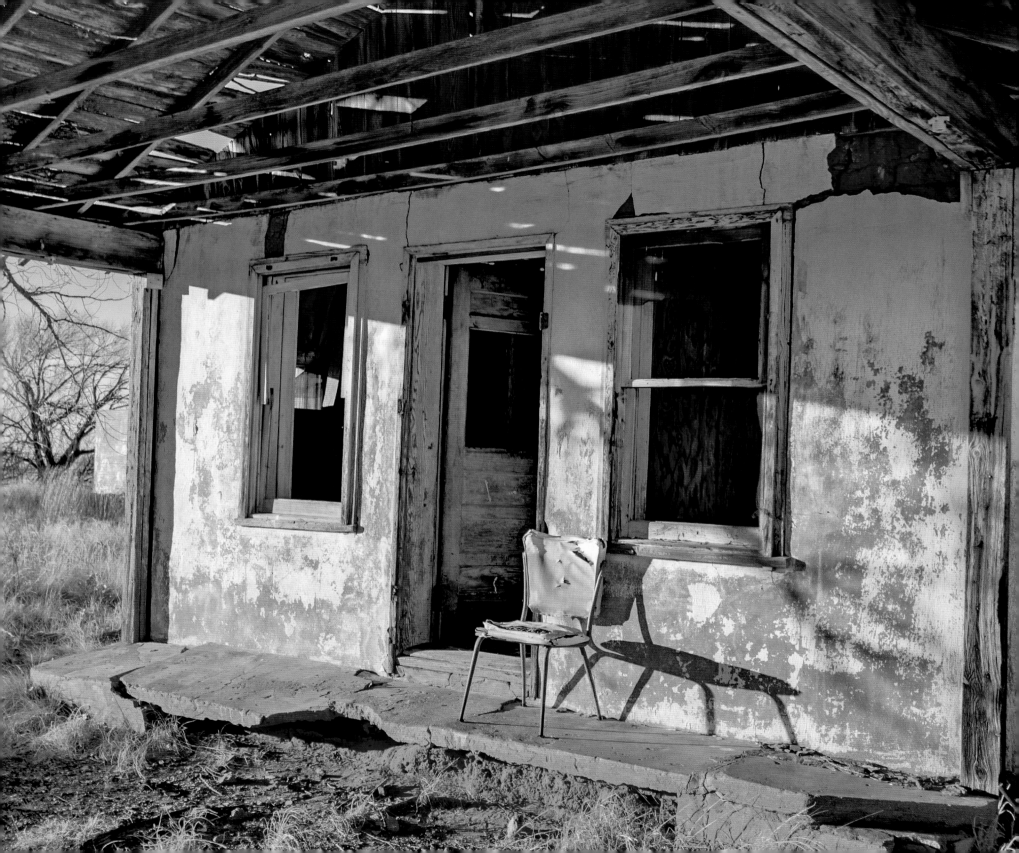

6 New Mexico

The Modern World's Camino Real

Jim Hinckley

From Chicago to Santa Monica, Route 66 provided continuity to an existing network of trails by knitting them together. In New Mexico, the highway signed with a shield and two sixes linked portions of Native American trade routes with the Spanish colonial Camino Real, the Santa Fe Trail, the National Old Trails Highway, and the Ozark Trail.

In eastern New Mexico, the adventure begins for the daring traveler with an early alignment of Route 66, now an occasionally graded gravel track that leads west from Glenrio through a timeless landscape that would be recognizable to the Spanish conquistadors who sought the legendary golden cities of Cibola. The first encounter with the modern era is the haunting ruins of an early auto court. This is the remains of Endee, a small ranching community that Jack Rittenhouse noted had a population of just over one hundred, as well as a gas station, grocery store, and garage, in 1946.

San Jon, dating to 1904, was the boomtown along this section of the old road, with gas stations, garages, a hotel, numerous cafes, stores, an implement company, and several auto courts. Today the empty stores, tumbledown ruins, and overgrown stations, are a photographer's paradise and a monument to the high cost of progress.

The landscapes, the towns, and the history of western New Mexico are the flip side of the eastern side of the state, and could easily lead the uninformed to believe that they have unknowingly entered another state, or perhaps even another country. Here are vast plains dotted with villages whose origins predate the arrival of the Spanish in the early 1500s, and towering monoliths of stone that cast long shadows.

Just east of the Arizona state line, Route 66 hugs the towering wall of Devil's Cliff, flows past the ruins of roadside trading posts, and enters Gallup. For more than a century this dusty old town where the modern generic world of the interstate highway blends with tarnished relics from the glory days of Route 66, as well as with those from a time when this was an outpost on the western frontier, has been a center for Native American arts and crafts.

Exemplifying the hidden gems nestled amongst the generic and the neon is the grand dame of historic lodging in the area, El Rancho Hotel. Built with money from film mogul D.W. Griffith, the hotel opened in 1937 and featured an eclectic mix of native art, faux frontier trading post, and subtle luxury. The guest register reads like a who's who of celebrities and politicians.

Encapsulated in the central portion of the state is a rich and diverse history with Route 66 serving as the link between the past and the present. In addition, it is here you will find the most drastic realignment in the highway's history.

From Santa Rosa to Albuquerque, I-40 almost entirely supplanted Route 66. However, this portion of Route 66 was a relatively recent incarnation dating back to the realignment of 1937 that shaved more than 125 miles from the original route.

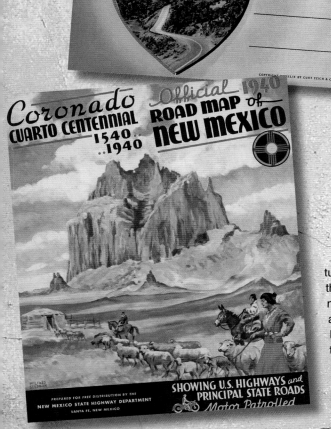

THROUGH THE *HEART OF* New Mexico ON U.S. 66

PLACE STAMP HERE

COPYRIGHT NOVELIX BY CURT TEICH & CO., INC., CHICAGO, U.S.A.

Coronado CUARTO CENTENNIAL 1540..1940

Official 1940 ROAD MAP OF NEW MEXICO

SHOWING U.S. HIGHWAYS *and* PRINCIPAL STATE ROADS *Motor Patrolled*

PREPARED FOR FREE DISTRIBUTION BY THE
NEW MEXICO STATE HIGHWAY DEPARTMENT
SANTA FE, NEW MEXICO

SCENIC THRU New Mexico

U.S. 66 • INTERSTATE 40 • SANTA FE

NAVAJO INDIAN RES.
TO FARMINGTON, SHIPROCK
GALLUP
GRANTS
ZUNI INDIAN RES.
CANONCITO INDIAN RES.
LAGUNA
ACOMA INDIAN RES.
ISLETA INDIAN RES.
TO LAS CRUCES AND WHITE SANDS NAT'L MON.
ALBUQUERQUE
MORIARTY
CLINES CORNERS
TO ROSWELL-ALAMOGORDO-CARLSBAD CAVERNS NAT'L PARK
SANTA ROSA
TO SANTA FE-LAS VEGAS
TUCUMCARI
TO CLOVIS
ARIZONA NEW MEXICO
NEW MEXICO TEXAS

CHURCH ROCK, GALLUP • ACOMA WATER HOLE • Sandia Peak Tramway, ALBUQUERQUE • PARK LAKE, SANTA ROSA • TUCUMCARI MOUNTAIN

Before this date, the highway turned north toward Las Vegas and the Santa Fe Trail. The first settlement on this alignment was Dillia, a community originally known as El Vado de Juan Paiz, with origins that predate Route 66 by almost a century.

At Romeroville, listed as Romero on 1929 maps, the road again turned west, but many motorists detoured to Las Vegas, a surprisingly modern community with ties to the raucous days of the Santa Fe Trail and even Teddy Roosevelt and the Rough Riders.

Romeroville is today little more than a dusty, wide spot on a dusty, bypassed highway. There is little to indicate the prominence the town and its namesake, Don Trinidad Romero, once had, as indicated by his hosting of numerous personalities, including General Sherman and President Hayes, in his mansion on a hill above the town.

Tecolate was a supply point for travelers on the Santa Fe Trail long before automobiles replaced oxcarts. In San Juan a steel truss bridge built around 1921, now truncated from the main road at both ends, is a relatively recent addition to a community where the plaza church dates to 1825.

For a brief moment in its long history, the old Pigeon Ranch enticed tourists on Route 66 to stop and see "the Most Wonderful Old Indian Spanish American Well." The promotion was not all hype, as maps dating to the mid-1700s note the existence of the well, and the ranch itself dates to at least the time of the Civil War.

To the west are Glorieta and the pass by the same name, the highest point on Route 66 before 1937 at 7,500 feet. A pivotal battle here on March 27 and 28, 1862, ended the Confederate army's ability to effectively operate in the territory of New Mexico.

Surely many Route 66 travelers that rolled onto the narrow streets of ancient Santa Fe must have wondered if they had taken a wrong turn into another country, or even another century. This is the oldest colonial settlement in the United States, and at its heart very little has changed here since the first wave of Americans arrived in 1849 on their way to the gold fields of California.

In many places, Route 66 from Santa Fe to Albuquerque, now a city of the twenty-first century with roots that reach further into the recesses of time than

Taos Pueblo

Santa Fe, follows the path of the Spanish colonial era Camino Real. Perhaps the most notable effort to adapt this ancient road to the modern needs of the motorist was on La Bajada Hill.

Before 1926, motorists followed the original trail down the hill in a dizzying series of switchbacks. The initial alignment of Route 66 was only marginally better as the grade was only eight percent in places and the series of Z's featured pullouts. Amazingly, this alignment remained signed as Route 66 until 1932!

Traveling Route 66 in New Mexico is more than a road trip on a grand scale; it is an expedition into a lost world and another time. ⊙

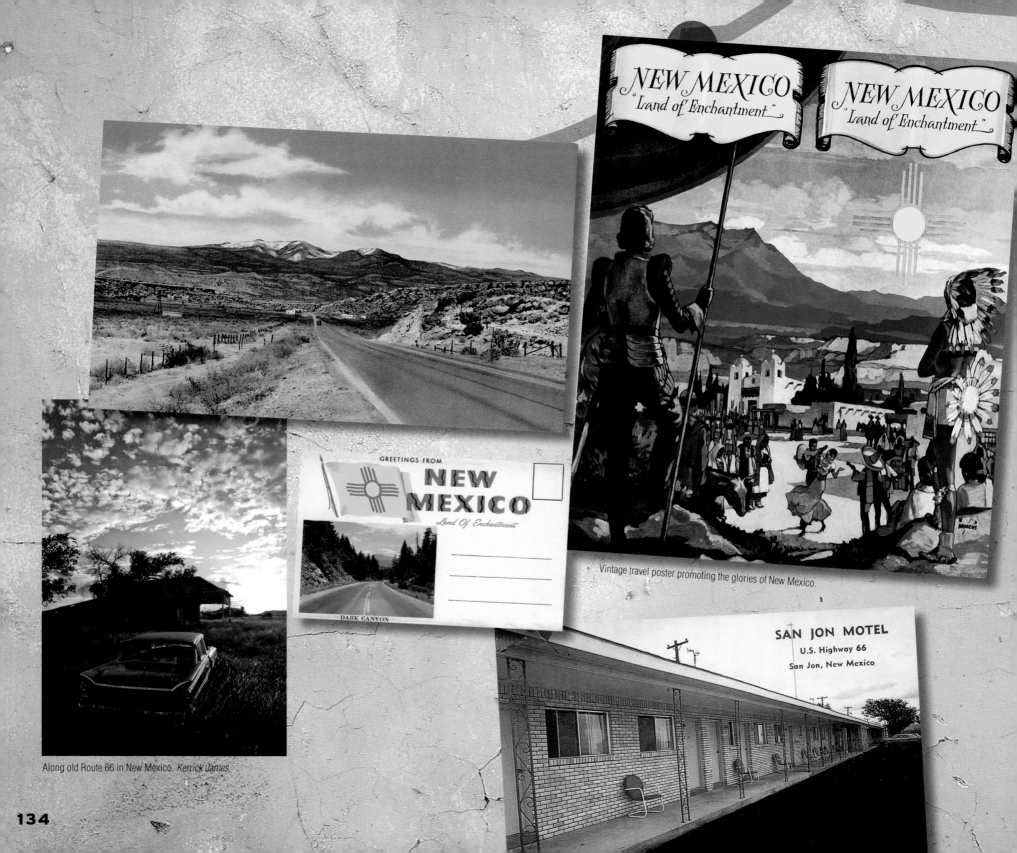

NEW MEXICO
"Land of Enchantment"

NEW MEXICO
"Land of Enchantment"

Vintage travel poster promoting the glories of New Mexico.

GREETINGS FROM
NEW MEXICO
Land Of Enchantment

DARK CANYON

SAN JON MOTEL
U.S. Highway 66
San Jon, New Mexico

Along old Route 66 in New Mexico. *Kerrick James*

ROUTE 66 MYTHS AND LEGENDS

A Brightly Lit Route 66 in New Mexico

By Kathy Weiser

Route 66 is brightly

lit through New Mexico, thanks to the efforts of the Route 66 Neon Restoration Project. Managed by the New Mexico Route 66 Association, partnering with the New Mexico Historic Preservation Division and the National Park Service Route 66 Corridor Preservation Office, more than ten signs have been restored to date.

From the wonderful TeePee Curio Shop in Tucumcari to the wild and crazy neon Rotosphere in Moriarty, the beauty and artistry of classic neon is once again dazzling and delighting Route 66 enthusiasts throughout New Mexico.

After World War II, companies believed advertising with neon signs helped their businesses. Before long streets were lined with a palette of sapphire blue, ruby red, sizzling orange, and emerald greens, promising all manner of adventure, home cookin', and other travel services.

Cowboys whirling lassos, sombreros sitting atop Mexican restaurants, teepees providing shelter for the evening, cactus, longhorn steers, and all types of neon critters adorned the night, calling out to Route 66 travelers to stop and experience something unique.

Those were the good ol' days. But over the years, one by one, these once-glorious signs began to blink into darkness, leaving little more than a peeling façade where once-brilliant colors harkened.

When the project began, applications were accepted for the restoration projects. Though businesses owners were at first skeptical that there could be a government program that was intended to help mom-and-pop businesses directly, many of them were pleasantly surprised when their applications were approved.

Over the next couple of years, the Route 66 Association got to work, restoring ten vintage neon signs that have resulted in business owners, as well as entire communities, renewing their pride in their Mother Road heritage. Today, Route 66 travelers are thrilled by the evening ride through these New Mexico cities with their flashing, spinning, rotating, and whirling neon.

Good job New Mexico with your brightly colored sky and the buzz of high-voltage transformers! ◉

Tucumcari
a.k.a. Six-Shooter Siding

By Kathy Weiser

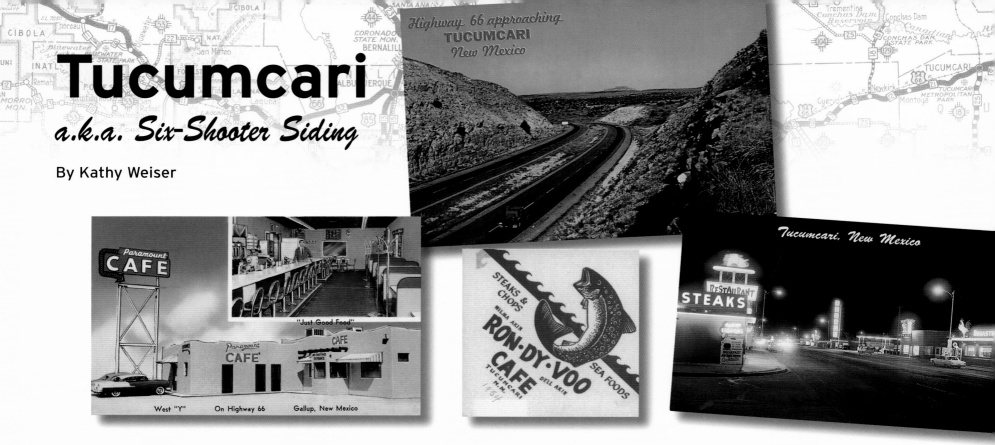

Once nicknamed "Six-Shooter Siding," Tucumcari, New Mexico, got its start as a rowdy railroad camp filled with saloons and outlaws. The camp began in 1901 when the Rock Island Railroad pushed west through the area. The small settlement of Liberty, some three miles north, wasted no time dismantling and moving closer to the railroad. Soon the camp was filled with merchants, gamblers, saloon keepers, and dancehall girls.

The fathers of Tucumcari were five businessmen from Liberty who filed on the land, then donated 120 acres of land for a town site. They were: M. B. Goldenberg, A. D. Goldenberg, Jacob Wertheim, J. A. Street, and Lee K. Smith. J.A. Street is credited with erecting the first tent in the new railroad camp.

The camp was officially called Douglas in the beginning, but just one year later the town took the name Tucumcari to reflect the scenic Tucumcari Mountains that acted as a backdrop for the city. The word "tucumcari" is loosely derived from a Comanche word for lookout.

The first passenger train arrived in Tucumcari on March 12, 1902, and before long there were four passenger trains arriving daily, two from the east and two from the west.

Some of the first businesses to open in 1902 were the Waldorf-Astoria Hotel (with rooms for two dollars a day), the Monarch Saloon, as well as many other baudy taverns, a furniture store, a livery barn, a boarding house located at First and Turner Streets, several mercantile stores, and the Exchange Bank.

Max Goldenberg's home was the first permanent home built in Tucumcari, and contained the town's post office.

The Elk Drug Store was established in 1906. It was owned by drugstore cowboy Herman Moncus, who collected a mammoth assortment of items more or less relating to the history of the area. He hung his collection from the ceiling of his drugstore.

Within six years, the mesa lands around Tucumcari had been inundated by homesteaders who had arrived in Oklahoma Indian Territory too late to get land. By 1907, there were twenty small towns scattered about Tucumcari. Just three years later, in 1910, there were over seventy businesses in Tucumcari, plus a school system and several churches.

Primarily thriving from the railroad and area ranching opportunities, the town continued to prosper until the Depression. At that time, most of the small towns that surrounded the city were abandoned and quickly reverted to cow pastures.

However, Tucumcari hung on with new businesses created with the advent of Route 66. And in 1940, when the South Canadian River was dammed, this created some sixty thousand acres of irrigated farmland. What were once cow pastures soon became rich farmland, pulling Tucumcari out of its slump.

Today, with a population of over six thousand, Tucumcari provides a number of area attractions, including the Mesalands Dinosaur Museum, the Tucumcari Historical Museum, which includes a historic Route 66 exhibit, and Ute Lake State Park.

For Good Food . . . and Good Coffee

Paramount Cafe

Complete Dining Service
Luncheon — Dinners
Breakfast anytime . . . open 24 hours
Always plenty of parking space
Highway 66 — at the West "Y"
GALLUP, NEW MEXICO
Home of the Inter-Tribal Indian Ceremonial
and American Indian Memorial.
Steve Pappas, Mgr.

POST CARD

Darling Mom. All is O.K. Enjoying the trip. Hope you're well. Don't clean or bother. Don't know when I'll be home but you'll know. Keep well. Love Vi.

CACTUS MOTOR LODGE
TUCUMCARI • NEW MEXICO

A Western Welcome Awaits You

CACTUS MOTOR LODGE

We stayed here last nite

East on U. S. Highway 66 at City Limit

Two Gun Harry's Curios and Coffee Shop in Tucumcari stood at the junction of U.S. Highways 66 and 54.

Tucumcari's five-mile claim to Route 66 fame is along Tucumcari Boulevard, where travelers can get a real glimpse of what Route 66 was all about. The 1940s and 1950s flavor of the Mother Road can clearly be seen here in Tucumcari's treasure trove of motels, restaurants, and curio shops.

Numerous neon signs beckon travelers to stop at the legendary Blue Swallow Motel, established in 1939; the Tee-Pee Curios trading post, a Route 66 icon; the Paradise Motel; and dozens of others.

Tucumcari is truly a Route 66-er's delight. Be sure to allow yourself plenty of time as you stop to snap dozens of pictures before heading on down the road to Montoya and Santa Rosa. ⊙

On the corner of Route 66 and First Street in Tucumcari, New Mexico, is a Texaco Station that is the only service station to have operated continuously from the Route 66 era to the present.

Santa Rosa

City of Natural Lakes

By Kathy Weiser

Santa Rosa, New Mexico is known as the City of Natural Lakes due to the many natural lakes and streams in the area. Situated where the Great Plains rise up to meet the Rocky Mountains lies this startling oasis amid the red mesas of the flatlands.

Founded in 1865, the town began as nothing more than a large Spanish rancho, and was called Aqua Negro Chiquita. Sometime around 1890, it took a new name honoring a chapel built by Don Celso Baco, who named it for his wife and Saint Rose of Lima, the first canonized saint of the New World. Santa Rosa remained a minor community until the Chicago, Rock Island & Pacific Railroad steamed into town in 1901, then became an important transportation hub of the area. Just two years later, Santa Rosa became the Guadalupe County seat.

When Route 66 was completed through Santa Rosa in 1930, transportation services again increased in the city. During the days of early Route 66, after travelers had tired of the long, hot, dusty miles, Santa Rosa became known as a welcome and well-known oasis in the desert. Travelers arrived in Santa Rosa to eat, rest, and perform car repairs, if necessary, at the many motels, cafes, and service stations that lined the highway.

The old road ran into town past the 81-foot-deep Blue Hole and Park Lake, a motorist campground and source of water during the Depression. Scenes in Rudolfo Anaya's award-winning novel *Bless Me*, and John Steinbeck's *Grapes of Wrath*, took place on Route 66 at the Pecos River Bridge.

In 1935, Phillip Craig and Floyd Shaw built the Club Café, adorned with with the smiling, satisfied face of the Fat Man. For more than fifty years, thousands of hungry Route 66 travelers would stop to enjoy a tasty home-cooked meal. The Fat Man logo soon became synonymous with Route 66 in Santa Rosa.

In 1940, when Steinbeck's epic novel *Grapes of Wrath* was made into a movie, director John Ford used Santa Rosa for the memorable train scene, where Tom Joad (Henry Fonda) watches a freight train steam over the Pecos River railroad bridge, into the sunset.

In 1972, I-40 opened through Santa Rosa, and though the city remained a busy off-ramp, many of the vintage Route 66 businesses began to die. However, others continued to serve the exiting travelers of I-40, including the Club Café, which survived for almost another twenty years. Finally, it too served its last meal, in 1991. The Club Café stood vacant and soon fell into disrepair with the passing of the years.

Joseph and Christina Campos, who own Joseph's Bar and Grill down the road on Route 66, purchased the building with plans to reopen the Club Café. Unfortunately, the building was too far gone to resurrect. However, they did resurrect the Fat Man, bringing him home to Joseph's Bar and Grill, saving the famous icon.

Today, there are plenty of signs of the good ole' days of Route 66 throughout Santa Rosa. Look for "billboards" painted on huge roadside boulders and the still-

POST CARD

Wed. May 28 · 1958

Drove this route

Spend the night at

La Loma Motel at

Santa Rosa, N.M.

Ruth Baker

Ruth

Marguerite

Charline

SaraJane

drove 373.1 miles today.

COAST TO COAST

FREE RESERVATIONS

THE BEST Western MOTELS

BEST WESTERN / BEST EVERYWHERE

SURF MOTEL

West Highway 66

Santa Rosa,

New Mexico

BEST WESTERN / BEST EVERYWHERE

grinning faces of Fat Man signs before you enter the town. A particularly scenic stretch of Route 66 parallels Interstate 40 and can be accessed from the three exits east of the city. Once you enter Santa Rosa you can see the Comet Drive In, as well as the Silver Moon, Sun and Sand, and La Loma motels. If you're traveling at night, the neon lights will thrill your Route 66 sensibilities. While in Santa Rosa, another must-stop is the Route 66 Auto Museum.

In the early days of Route 66, from 1926 through 1937, the old alignment of Route 66 left Santa Rosa to continue on toward Santa Fe, the capitol of New Mexico, before dropping back down to Albuquerque and Los Lunas. In late 1937, Route 66 was straightened out to go directly to Albuquerque and bypassed Santa Fe completely.

Here, you will need to make a choice as to which alignment you will take westward to Albuquerque. Both alignments are a delight, as you'll pass by numerous vintage peeks of the Mother Road, historic places, ghost towns, and beautiful views. ◉

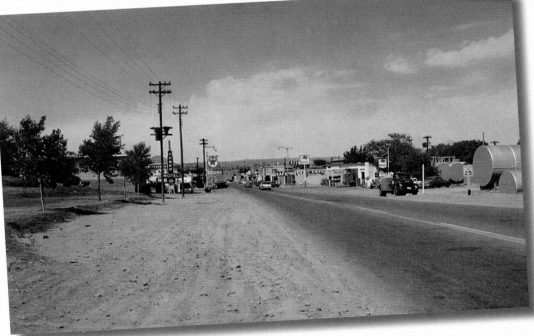

Santa Rosa, New Mexico.

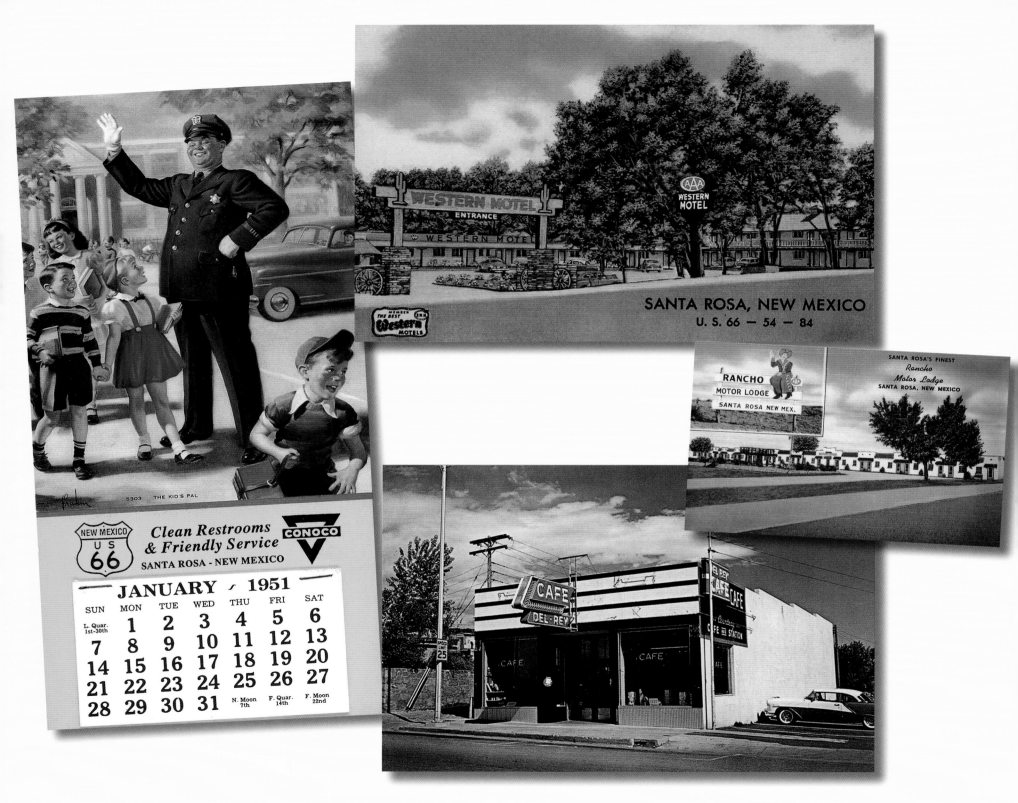

WESTERN MOTEL
ENTRANCE
WESTERN MOTEL
AAA
WESTERN MOTEL

MEMBER THE BEST Western MOTELS

SANTA ROSA, NEW MEXICO
U. S. 66 — 54 — 84

RANCHO
MOTOR LODGE
SANTA ROSA NEW MEX.

SANTA ROSA'S FINEST
Rancho
Motor Lodge
SANTA ROSA, NEW MEXICO

5303 THE KID'S PAL

NEW MEXICO
US
66

Clean Restrooms
& Friendly Service

CONOCO

SANTA ROSA - NEW MEXICO

JANUARY 1951

SUN	MON	TUE	WED	THU	FRI	SAT
L. Quar. 1st-30th	1	2	3	4	5	6
7	8	9	10	11	12	13
14	15	16	17	18	19	20
21	22	23	24	25	26	27
28	29	30	31	N. Moon 7th	F. Quar. 14th	F. Moon 22nd

CAFE
DEL-REY

THE MOTHER ROAD LOST & FOUND

Rio Puerco Trading Post, Rio Puerco, circa 1940

By Russell A. Olsen

Then: The Rio Puerco Trading Post, Rio Puerco, New Mexico.

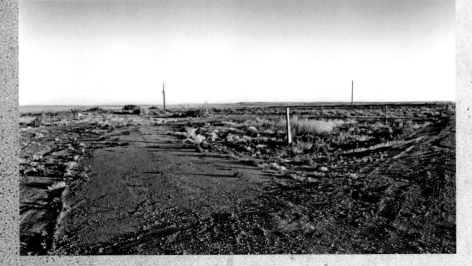

Now: The Rio Puerco Trading Post, Rio Puerco, New Mexico.

The Rio Puerco Trading Post

was first built in the early 1940s by George Thomas Hill, Jr., and his wife Morene, nineteen miles west of Albuquerque on the south side of the post-1937 realignment of Highway 66. A fire destroyed the original trading post, and the process of rebuilding began in 1946. The updated trading post burned in the 1960s to be replaced by a new enterprise owned by the Bowlin Corporation, the same company that owns the Flying C Ranch and many other roadside facilities in the Southwest.

Every trading post needed a gimmick, and the Rio Puerco was no exception. A full-sized stuffed polar bear standing in a glass case greeted visitors as they entered the building. One night someone broke into the trading post, broke the glass case, and made off with the bear. It was later found ripped to shreds in the Sandi Mountains outside of Albuquerque.

The Rio Puerco is home to a historically significant bridge that was preserved by the New Mexico State Highway Department. The Parker Bridge, a through truss that spanned 250 feet over the often-treacherous Rio Puerco River, was fabricated by the Kansas City Structural Steel Company and completed in 1933. The bridge helped to further the cause for the much sought-after 1937 realignment of Highway 66 that bypassed Isleta and Los Lunas. The bridge no longer handles vehicle traffic, but can be crossed and explored on foot. ◉

THIS EXIT FOR ANOTHER ROADSIDE ATTRACTION . . .

Cline's Corners: In the Middle of Nowhere—and on the Road to Everywhere

By Kathy Weiser

A Route 66 landmark

since 1934, Cline's Corners has been pumping gas and selling souvenirs for over seventy years. However, it hasn't always been at the same place. In the beginning, Cline's Corners was located in Lucy, New Mexico, but the location wasn't good for owner Roy Cline. Soon he moved the station to Route 66, at the junction of Highway 6 and Highway 2. But then, in 1937, Route 66 was realigned north of his station, so Roy picked up and moved his building again. At its final resting place along the ever-popular Route 66, Cline's Corners began to do a brisk business. Old-timers in the area laugh when they remember that Cline sold gasoline for ten cents a gallon and water for a dollar a gallon—water was obviously scarce in the area in those days.

In 1939, Cline sold Cline's Corners to a man named S. L. "Smitty" Smith, but continued to own and operate other service stations on Route 66. Continuing to grow, Cline's Corners added more and more employees, and homes were built for them, which continue to be used today. When Smitty died in 1961, the business changed hands again. Continuing to grow, a post office was added in 1964.

Today, there are about sixty people working at Cline's Corners who continue the traditions that former owners Roy and Smitty began so many years ago. Flat tires are still repaired, someone will still fill your gas tank, biscuits and gravy are served for breakfast, and hundreds of postcards are mailed from this place in the middle of nowhere and on the road to everywhere. While you're there, you will no doubt be sure to find a rattlesnake ashtray, a beaded belt, or a rubber tomahawk to remember your journey.

Beyond Cline's Corners at exit 208 is a supposed ghost town called Wagonwheel. Originally a stop for covered wagons, it no doubt could tell a story or two, but today all that stands here are the faded remains of an old motel sign and the modern Wagonwheel Texaco.

Another few more miles down the road just past exit 203 are the ruins of the old Longhorn Ranch. Once a favorite Old West stop along the Mother Road, the owner has long since razed most of the buildings. All that's left today is the old rambling bank structure and nearby, the Longhorn Ranch Motel.

Continue your journey on to Moriarty through Tijeras Canyon and on into Albuquerque. ◉

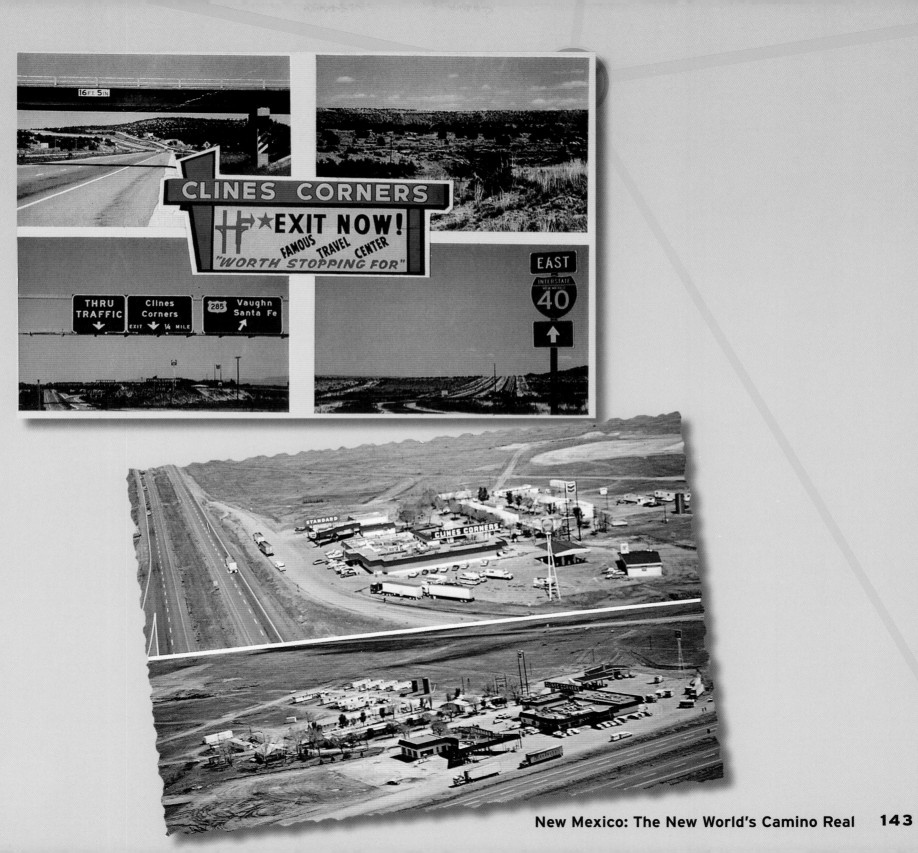

Santa Fe
The City Different

By Kathy Weiser

Olden-days Santa Fe.

Established in 1607, Santa Fe is the second oldest city founded by European colonists in the United States. Only St. Augustine, Florida, founded in 1565, is older. Built upon the ruins of an abandoned Tanoan Indian village, Santa Fe was the capital of "the Kingdom of New Mexico," which was claimed for Spain by Coronado in 1540. Its first governor, Don Pedro de Peralta, gave the city its full name: La Villa Real de la Santa Fe de San Francisco de Asís, or "the Royal City of the Holy Faith of Saint Francis of Assisi."

San Miguel Chapel in Santa Fe is the oldest church in the United States, constructed around 1610. The Palace of the Governors was built between 1610 and 1612 and is the oldest government building in the country.

During the next seventy years, the Spanish colonists and missionaries sought to subjugate and convert the hundred thousand and some Pueblo living in the region. However, in 1680, the Pueblo revolted, killing almost four hundred Spanish colonists and driving the rest back into Mexico. The conquering Pueblo then burned most of the buildings in Santa Fe except for the Palace of the Governors and the San Miguel Chapel. They occupied Santa Fe until 1693, when Don Diego de Vargas reestablished Spanish control. Santa Fe remained

Spain's provincial seat until 1821, when Mexico won its independence from Spain and the city became the capital of the Mexican territory of Santa Fe de Nuevo México.

When Mexico gained its independence from Spain, Santa Fe became the capital of the province of New Mexico. Trade was no longer restricted as it was under Spanish rule, and trappers and traders moved into the region. In 1821 William Becknell opened the thousand-mile-long Santa Fe Trail, bringing hundreds of new settlers to the area.

On August 18, 1846, during the early period of the Mexican-American War, an American army general, Stephen Watts Kearny, took Santa Fe and raised the American flag over the Plaza. Two years later, Mexico signed the Treaty of Guadalupe Hidalgo, ceding New Mexico and California to the United States.

For twenty-seven days in March and April of 1862, the Confederate flag of Brigadier General Henry H. Sibley flew over Santa Fe until he was defeated by Union troops. With the arrival of the telegraph in 1868, and the coming of the Atchison, Topeka and Santa Fe Railway in 1880, Santa Fe and New Mexico underwent an economic revolution. Corruption in government, however, accompanied the growth, and President Rutherford B. Hayes appointed Lew Wallace as a territorial governor to "clean up New Mexico." Wallace did such a good job that Billy the Kid threatened to come up to Santa Fe and kill him. New Mexico gained statehood in 1912, with Santa Fe remaining as the capitol city.

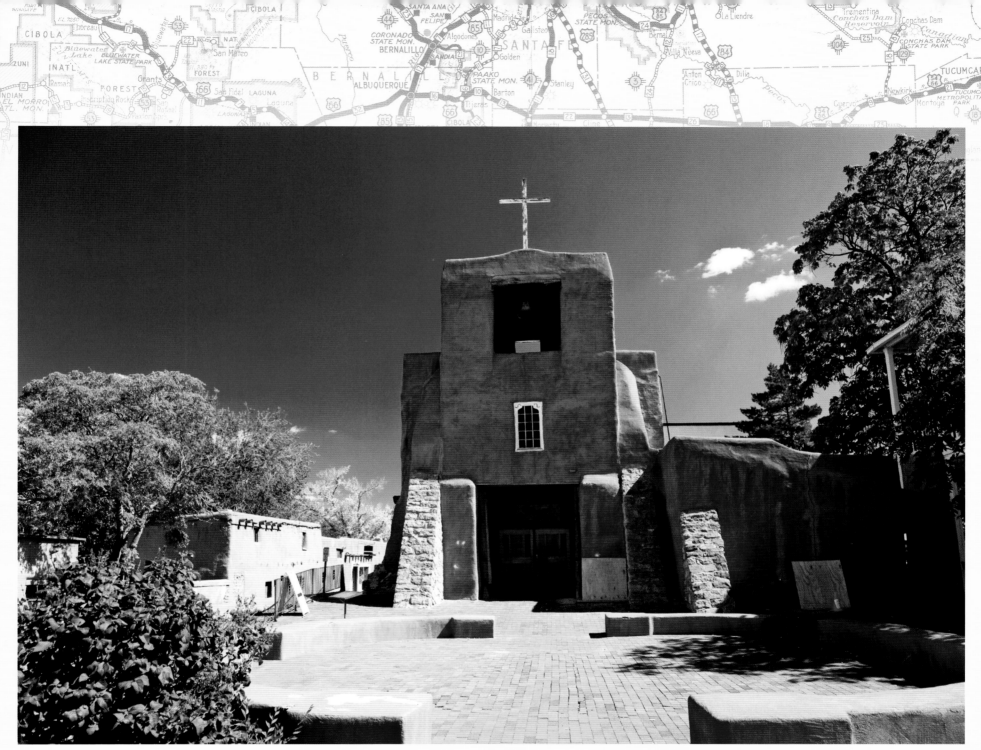

Santa Fe's San Miguel is the oldest church in the United States. *Shutterstock*

Though not everyone knows it, Route 66 went though Santa Fe during its early years. Following the Old Pecos Trail from Santa Rosa, the path wound through Delia, Romeroville, and Pecos on its way to Santa Fe.

Beyond the capitol, the Mother Road continued on a particularly nasty stretch down La Bajada Hill toward Albuquerque. One of the most challenging sections of Route 66, the five-hundred-foot drop along narrow switchbacks struck terror in the hearts of many early travelers, so much so that locals were often hired to drive vehicles down the steep slope.

Although plans were that Santa Fe would continue to stay on the route of the Mother Road, it was not to be, due to political maneuverings of the New Mexico governor in 1937.

Having lost his re-election, Governor Hannett blamed the Santa Fe politicians and, vowing to get even, he rerouted the highway in his last few months as governor. So hastily was the road built that it barreled through both public and private lands without benefit of official right of ways.

By the time the new governor was in place, a new highway connected Route 66 from Santa Rosa to Albuquerque, bypassing the capitol city and its many businesses. The new route was more direct and reduced some of the more treacherous road conditions. It was along this path that I-40 would be built many years later.

For many years this picturesque city has consciously attempted to preserve and display a regional architectural style. By a law passed in 1958, new and

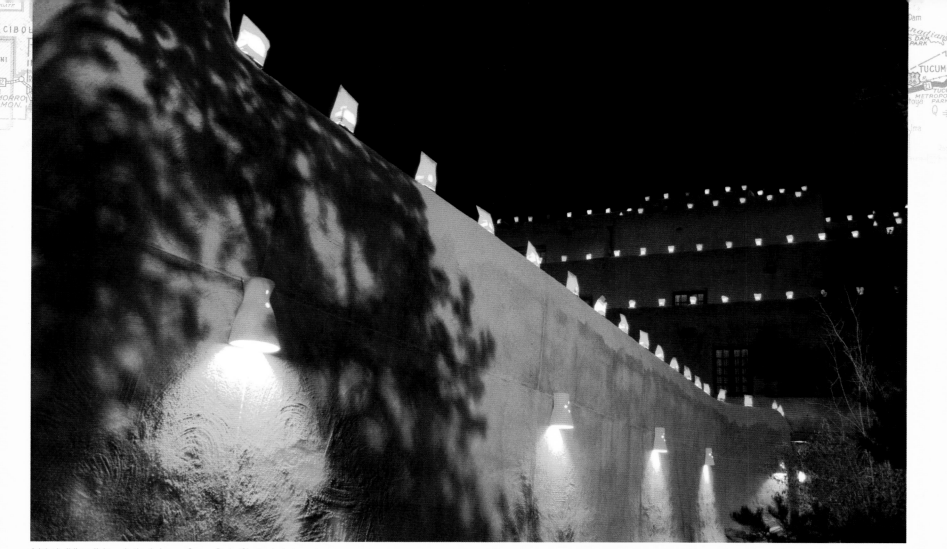

Adobe buildings light up in the darkness. *George Burba/Shutterstock*

rebuilt buildings, especially those in designated historical districts, must exhibit a Spanish Territorial or Pueblo style of architecture, with flat roofs and other features suggestive of the area's traditional adobe construction.

Nestled at seven thousand feet in the foothills of the Rocky Mountains, Santa Fe boasts a population of almost sixty-five thousand. While in Santa Fe, be sure to visit La Fonda Hotel, which has been providing a restful place for weary travelers since 1920. In 1926 the Atchison, Topeka & Santa Fe Railway acquired the hotel, which they leased to Fred Harvey. From 1926 through 1969, La Fonda was one of the famous Harvey Houses. Reportedly La Fonda also hosts a resident ghost.

From Santa Fe, Route 66 travelers will continue southwest through several small towns. La Bajada Hill is in La Cienga, but is difficult to find, so you will need some good Route 66 maps and, if you want to drive it, a high-clearance 4x4 is required. Continuing, you'll soon arrive in Domingo, where one good stop is Fred Thompson's Indian Trading Post. A side trip opportunity also presents itself here to visit the Santa Domingo Pueblo just a few miles west. Called home to more than three thousand, Santa Domingo Native Americans have lived here for centuries. Here, you will see many roadside stands with jewelry, pottery, and silverwork. The pueblo also offers a cultural center and small museum for visitors.

Returning to Route 66, the road winds through the small towns of Algodones, Bernalillo, and Alameda before rejoining with the later alignment in Albuquerque. ◉

Postcard showing one of the many roads—including Route 66—that followed Aubry's explorations. *Michael Karl Witzel collection*

VOICES FROM THE MOTHER ROAD

Francois Xavier Aubry: Legendary Route 66 Trailblazer

By Michael Karl Witzel

Before there was a highway

called Route 66, people traveled across country by horseback and carriage on trails—paths blazed by intrepid explorers who were convinced that there was a better, safer way to get there.

One of the earliest of these fearless trailblazers was Francis Xavier Aubry, a man who earned a reputation for getting there fast. One of his most notable trips began on September 12, 1848, when he departed Santa Fe, New Mexico. In a full gallop, he rode to Independence, Missouri, just to prove how fast it could be done. To everyone's amazement, he completed the trip in only five days and sixteen hours, traveling at the unheard of rate of 140 miles a day. For the pre-automobile era, that was moving pretty darn fast.

The *Santa Fe Republican* reported that "Aubry traveled over eight hundred miles through mud and rain, he broke down six horses, walked twenty miles, slept only a few hours, and ate but six meals." A far cry from the cushy modes of travel we see today, indeed. "On Sunday night, September 17, his foaming horse half ran, half staggered into Independence," the article continued. It was quite a feat, as state-of-the-art travel during Aubry's time was defined by horses, steam engines, and wooden-wheeled carriages. "The extraordinary feat of this gentleman transcends the history of traveling," wrote the *Weekly Reveille* on September 23, 1848.

The American public agreed: As fast as telegraph keys could tap out the news in Morse code, Aubry's exploits spread nationwide, propelling him to hero status. Fortunately, he lived up to the stereotype of an intrepid explorer: without fear of attack from local tribes or border hooligans, horse thieves, and other bushwhackers of ill

repute, he was portrayed in the media as a cross between Indiana Jones and Evel Knievel. People called him "the most intrepid traveler the world has ever produced" and gave him nicknames like "Skimmer of the Plains" and "Prairie Telegraph." The Indians were impressed too, and honored him with the name "White Cloud."

Along with being a skilled horseman who could cover more country in a day than any of his contemporaries, Aubry also secured his name by proving his finesse in the art of trading. Back then that was an important quality for trailblazers, since travels were usually self-funded ventures that relied on the profits made from transactions along the way. A little free publicity also helped the effort: Aubry's life in the fast lane was further promoted by the fact that he carried and delivered public mail and news with him on his journeys.

That's where the early history of Route 66 comes in: Aubry wanted to find a reliable route from Santa Fe to California, one that was free of the dangerous mountain ranges that slowed movement. On November 16, 1852, he began an ambitious trip laden down with more baggage than any of today's travelers might bring along. This included ten large wagons, a hundred mules, a handful of horses, and a mob of thirty-five hundred sheep. His plan was to drive the herd west and sell them in the California market to recoup expenses. His main goal, however, was to explore the land between the two cities and forge a route that was practical for covered wagons and a railroad line.

Almost four months later, Aubry arrived in Los Angeles, California, the present-day terminus of Highway 66. A couple of weeks later, his wallet was bulging from

Map of the trails explored by Francis Xavier Aubry. *Michael Karl Witzel collection*

Francois Xavier Aubry. *Michael Karl Witzel collection*

the sale of his sheep. His investment recouped, he announced his next project: full-time exploration of the thirty-fifth parallel running through California, Arizona, and New Mexico. He spent the next few months gathering intelligence for the trip, a task that included meeting with Native American guides and mountain men who were familiar with the many dangers of the Sierra Nevada passes.

Aubry put together a team that consisted of twenty men, pack animals, and supplies. Wasting no time, the group crossed the Sierra Nevada near present-day Kern County, California. From there they continued through the Mojave Desert and paused at the Colorado river. At river's edge, they constructed rafts to make the crossing in a spot two hundred yards wide and twenty-five feet deep. In Arizona, they explored territory near the future Route 66 towns of Oatman, Kingman, Seligman, Ash Fork, Flagstaff, Padre Canyon, Winslow, Joseph City, and Holbrook.

When the adventurers arrived in Albuquerque, New Mexico, Aubry realized that he had found his elusive overland route. "I am satisfied that a railroad may be run almost mathematically direct from Zuni to the Colorado, and from thence to the Tejon Pass in California," he said, as reported in the *Santa Fe Weekly Gazette* on September 24, 1853. It was yet another historic feat in the history of long-distance travel, recorded in Aubry's journal: "I set out in the first place, upon this journey simply to gratify my own curiosity as to the practicability of one of the much talked of routes for the contemplated Atlantic and Pacific railroad." While others had explored the thirty-fifth parallel before him (among them Captain Lorenzo Sitgreaves), Aubry was the first to document the topography of the land in its totality from New Mexico to California.

As the decades passed, Aubry's exploits were quietly immortalized. Segments that he mapped out during his escapades were followed by the Atchison, Topeka and Santa Fe Railway from Albuquerque, New Mexico, en route to Bakersfield, California. A Missouri River steamboat was named after him, too—as were Aubry Cliffs in Seligman, Arizona; Aubry Valley, Arizona; Fort Aubry, Kansas; and towns in Missouri, Oklahoma, and Texas.

Although the automobile and the roads it would one day travel upon on were still years in the offing during his lifetime, Aubry may indeed be counted as one of America's first travel pioneers. He forged the most practical path through the uncharted plains and deserts of America on horseback as he blazed a trail through history. His discovered route of passage would become an important part of the National Old Trails Highway, which evolved into the cross-country vacation route where motorists got their kicks: the legendary highway called 66. ◉

Albuquerque
The 300-Year-Old Duke City

By Kathy Weiser

A full moon rises over the Sandia Mountains on the route to Albuquerque. *Centrill Media/Shutterstock*

Albuquerque's history dates back twelve thousand years when the ancient Pueblo tribe settled in the area. Living here for two centuries between the years 1000 to 1300, this inspiring group planted corn, beans, and squash and constructed adobe and brick pit homes along the banks of the Rio Grande. Furthermore, they established several communities throughout northeastern New Mexico, connecting them with sophisticated roads.

Then, in 1540, conquistador Francisco Vasquez de Coronado came north in search of the mythical Seven Cities of Cibola. Though Coronado left empty-handed, it didn't stop even more Spanish settlers arriving in the area, looking for the elusive gold. The Pueblo Rebellion of 1680 discouraged further settlement until Spanish general Don Diego de Vargas arrived in 1692. By the end of the sixteenth century, several trading posts were established just north of the present-day city.

By the beginning of the seventeenth century, the area that would one day become Albuquerque was called Bosque Grande de San Francisco Xavier. In 1706, the ambitious provisional governor of the territory, Don Francisco Cuervo y Valdez, petitioned the Spanish government for permission to establish the bosque as a formal villa and call it Alburquerque, after Viceroy Francisco Fernandez de la Cueva, the Duke of Alburquerque. Later the spelling was changed because some influential person couldn't pronounce the *r* in Alburquerque. The city is still nicknamed "Duke City."

During much of the eighteenth and nineteenth century, Albuquerque was little more than a dusty trading center along El Camino Real, the trail linking Mexico and Santa Fe. Close-knit families of Spanish descent accounted for most of the population living around the central plaza, in what is now Old Town.

This began to change when Josiah Gregg, a frontiersman and trailblazer, established the Old Fort Smith Wagon Road between Arkansas and Santa Fe in 1839. For ten years few people cared about the trail, until the California Gold Rush of 1849, when it became heavily traveled by those pioneers seeking their fortunes in the far west.

In 1846, the United States claimed the territory when General Stephen Kearny established an army post. During the Civil War, Confederate troops briefly occupied Albuquerque, but once the war was over, white merchants and tradesmen began to arrive in numbers.

When the railroad steamed through in 1880, the city changed drastically, bringing in hundreds of white settlers and changing the demographics and architecture of the city. Numerous new businesses were established around the new railroad, and the city began to grow. By 1885, Albuquerque was incorporated.

Growth continued steadily into the twentieth century and saw another spurt when Route 66 brought a steady stream of traffic right through the city. Before the 1930s, Albuquerque's Main Street, now called Central Avenue, consisted of a few motor courts, gas stations, campgrounds, and a cafe. In no time at all new

The Sandia Mountain Loop on Route 66.

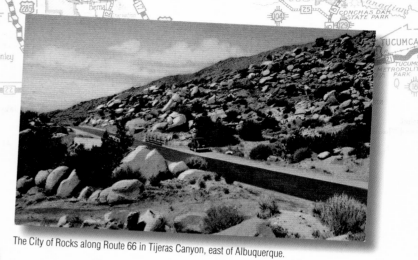
The City of Rocks along Route 66 in Tijeras Canyon, east of Albuquerque.

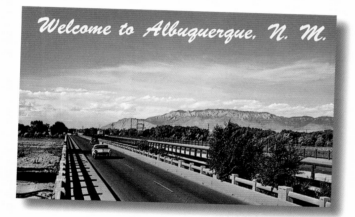
Welcome to Albuquerque, N. M.

Route 66 traverses Tijeras Canyon.

motels, restaurants, and services, complete with neon signs began to compete for the attention of Mother Road travelers. A cafe shaped like an iceberg opened for business on the present site of the Lobo Theatre; a sombrero-shaped restaurant offered Mexican food, and the Aztec Lodge and De Anza Motor Lodge presented pueblo-inspired accommodations.

When the realignment of Route 66 was completed in 1937, there were more motels on Central Avenue than had been built in the previous ten to twelve years on the other alignment. By 1955, there were more than a hundred motels on Albuquerque's Central Avenue, and in the summer, it was hard to find an open room.

The Aztec Motel is the oldest surviving Route 66 motel in New Mexico. Beginning as the Aztec Autocourt in 1931, it changed hands a number of times over the years. It had become a haven for prostitutes and drug dealers by the time the Natha family bought it in 1991. They worked to restore the Aztec's family atmosphere, along with the physical plant. The Aztec's unique decor is courtesy of Phyllis Evans, a retired professor who lives there part-time.

El Vado Motel, near Old Town, was built in 1937 by a former Waldorf-Astoria bellboy. This enclosed motor court, built of adobe in the Pueblo Revival style, is considered the purest surviving Route 66 motel in the city. Owner Sam Kassam has turned down some handsome offers for the motel's neon Indian.

In 1959, Albuquerque's vintage Route 66 suffered a blow when I-40 plowed through the city, circumventing the narrow road of Route 66. Though many of the Route 66-era roadside architecture was lost with the advent of the interstate,

Greetings from **ALBUQUERQUE**
NEW MEXICO
© J. R. WILLIS

Souvenir of **ALBUQUERQUE**
NEW MEXICO

PLACE STAMP HERE

Sandia Loop Road

Greetings from **OLD TOWN PLAZA**, ALBUQUERQUE, N. M.

Albuquerque still provides a number of Mother Road icons as well as a wealth of historical sites for the nostalgic traveler.

A trip down Central Avenue at night is a trip back through time, as you view the numerous neon lights sparkling along Route 66. You can also still see many Route 66 icons such as the De Anza Motel, the Royal Motor Inn, the Town Lodge Motel, and the Aztec Motel, all built in the 1930s. Check out Nob Hill, built 1936–1947, and the Lobo Theater and Lobo Pharmacy & Bookstore (originally Barber's El Rancho Market), both built in the 1930s.

Downtown there are several buildings that were highlights in the 1940s and 1950s, including the Sunshine Building (built 1923–24), the First National Bank Building (1922), the Rosenwald Building (1910), and the KiMo Theater (1927). Other sites west of Old Town include Lindy's Restaurant (1929), Maisel's (around 1940), and El Vado Motel (1937). Continuing your journey, head north on I-25, take the Algodones exit, and return south via N.M. Highway 313. Original Route 66 is now Fourth Street, Isleta Boulevard, and New Mexico Highway 314. ⊙

📢 **The famous KiMo Theater on the Mother Road in Albuquerque, New Mexico, is said to be haunted by the ghost of a six-year-old boy by the name of Bobby Darnall, who was killed at the theater in 1951 by a boiler explosion. According to legend, the impish spirit causes the performers problems by tripping them and creating a ruckus during performances. To appease the spirit, the cast leaves doughnuts backstage, which are always gone the next morning.**

La Hacienda Welcomes You

— And sincerely hopes that you will enjoy the food and service, presented in the quaint surroundings and atmosphere of Old-Time New Mexico. It is a pleasure to serve you.

Apache Indian,"Devil Dance"--New Mexico

Willard Andrews ©1944

ENCHILADAS NEW MEXICAN

$1.60

(In the native Spanish style....
....not for beginners!)

Two thick Indian blue-corn tortillas, topped with a fried egg and fiery chile con carne (chopped pork).

Frijoles Refritos Chile con Papas
Tortillas de Harina

Cafe, Te, or Leche Piña

RECOMMENDED by DUNCAN HINES
MEXICAN AND AMERICAN DISHES

Menu

DINING ROOM OPEN DAILY
SERVING LUNCH AND DINNER

La HACIENDA DINING ROOMS (The Original "LA PLACITA" Restaurant) on the Plaza, in OLD ALBUQUERQUE, NEW MEXICO

Comidas Mexicanas

No. 1 $1.95
Jugo de Fruta con Tostadas
Guacamole o Aguacate
Enchilada Taco Tamal Frijoles Arroz
Sorbete
Salsa de Chile Verde Tortillas o Sopaipillas
Postre
Cafe, Te, Leche, o Chocolate

No. 2 $1.80
Jugo de Fruta con Tostadas
Chile Rellenos con Queso
o
Torta de Huevos con Pollo
Tortillas o Sopaipillas
Ensalada de Fruta
Postre
Cafe, Te, Leche, o Chocolate

No. 3 $1.55
Jugo de Fruta con Tostadas
Enchilada Taco Tamal Frijoles Arroz
Tortillas o Sopaipillas Ensalada de Fruto
Postre
Cafe, Te, Leche, o Chocolate

No. 4 $1.45
Enchilada Taco Tamal
(dos platos)
Frijoles Arroz
Tortillas o Sopaipillas
Postre
Cafe, Te, o Leche

No. 5 $1.55
Jugo de Fruta con Tostadas
Guacamole Mezclado

Taco Crespo con Chorizo
Frijoles y Chili con Queso
o
Chalupa Compuesta
Tortillas o Sopaipillas
Postre
Cafe, Te, Leche, o Chocolate

Like our Sopaipillas--?
Our Famous **Sopaipilla Mix** is available Here or at Your Grocery Store --Make them Yourself--Easily and Quickly

Shrimp
or
Avocado Cocktail
A La Carte
45¢

$1.95
Fruit Juice
HACIENDA FRIED CHICKEN
Chef's Salad, French Fried Potatoes
Hot Rolls
Coffee, Tea or Milk
Dessert

$1.65
HACIENDA
Fried Shrimp
Chef's Salad - French Fried Potatoes
Hot Rolls
Coffee - Tea or Milk

Chef's Salad
served with either
Roquefort Dressing
or
Hacienda Dressing

Dinners Prepared
with
Hot Sauce
on Request
NO EXTRA CHARGE

✓

If you would like a Souvenir Menu, the cashier will give you one, with our compliments.

●

American Dinners

$2.00
Canapes with
Fruit Juice, Tomato Juice, or Fruit Cocktail
Pot Roast of Beef or Chicken Pie
Fresh Vegetable Potatoes
Hot Rolls
Fruit, Avocado, or Chef's, Salad
Dessert
Coffee, Tea, or Milk

$3.25 $2.75
T-bone Steak New York Steak
French Fried Potatoes, Chef's Salad, Hot Rolls
Coffee, Tea, or Milk

$1.75
Fruit Juice or Tomato Juice
Pot Roast of Beef
or
Plain Omelette or Chicken Liver Omelette
Fresh Vegetable Potatoes Hot Rolls
Fruit or Chef's Salad
Dessert Coffee, Tea, or Milk

$1.60
Chicken, Fruit, or Shrimp Salad
Hot Rolls Dessert
Coffee, Tea, or Milk

$1.60
Pot Roast of Beef
or
Plain Omelette or Chicken Liver Omelette
Fresh Vegetable or Salad
Potatoes Hot Rolls
Dessert
Coffee, Tea, or Milk

$1.10
Combination Salad Hot Rolls
Dessert Coffee, Tea, or Milk

La HACIENDA
DINING ROOMS
on
the Plaza
in
OLD
ALBUQUERQUE
NEW MEXICO

La Hacienda on the Plaza in old Albuquerque offered traditional Mexican fare—"In the native Spanish style . . . not for beginners!"

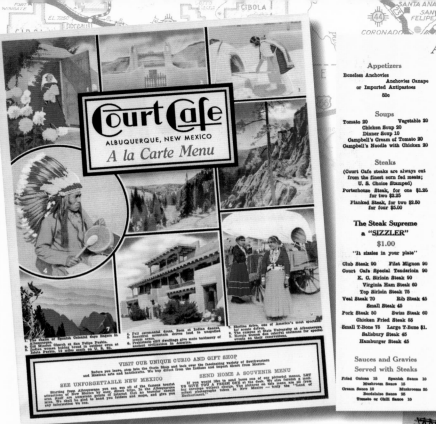

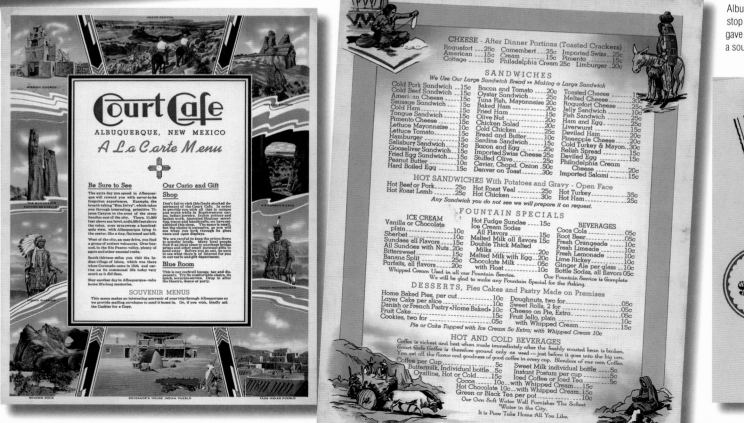

Albuquerque's Court Café was a famous stop for travelers along Route 66—and gave away copies of its colorful menu as a souvenir.

Albuquerque's San Felipe De Neri church at the heart of the old city. *Richard Susanto/Shutterstock*

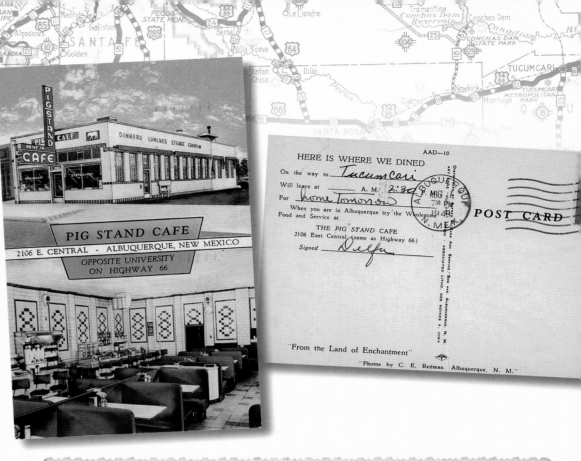

HERE IS WHERE WE DINED

On the way to *Tucumcari*

Will leave at A. M. *2:30*

For *home Tomorrow*

When you are in Albuquerque try the Wholesome Food and Service at

THE PIG STAND CAFE
2106 East Central (same as Highway 66)

Signed *Delfa*

POST CARD

"From the Land of Enchantment"

"Photos by C. E. Redman. Albuquerque, N. M."

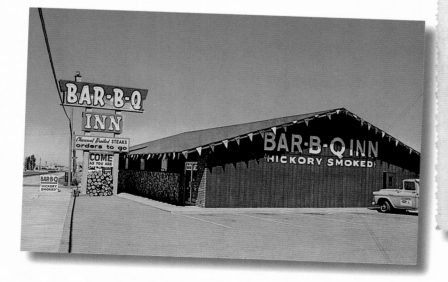

KATSON'S DRIVE-IN ALBUQUERQUE, N. M.

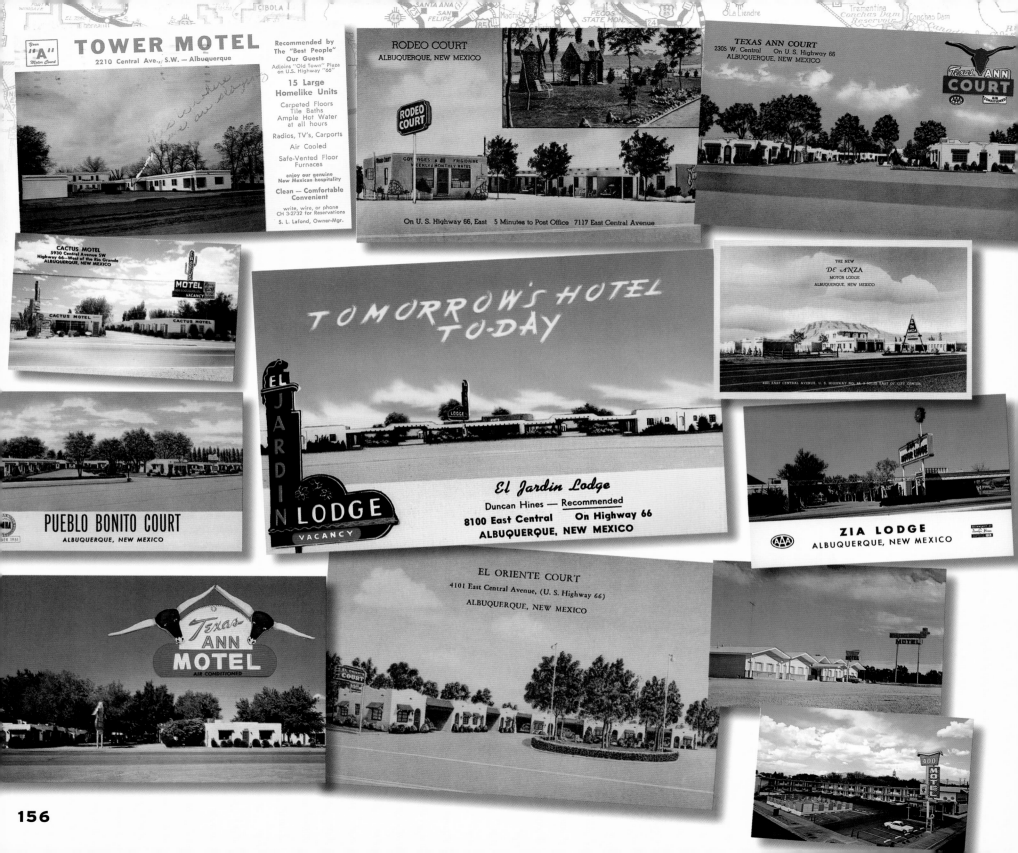

TOWER MOTEL

2210 Central Ave., S.W. — Albuquerque

Recommended by
The "Best People"
Our Guests

Adjoins "Old Town" Plaza
on U.S. Highway "66"

**15 Large
Homelike Units**

Carpeted Floors
Tile Baths
Ample Hot Water
at all hours

Radios, TV's, Carports

Air Cooled

Safe-Vented Floor
Furnaces

enjoy our genuine
New Mexican hospitality

Clean — Comfortable
Convenient

write, wire, or phone
CH 3-2732 for Reservations

S. L. Lafond, Owner-Mgr.

RODEO COURT
ALBUQUERQUE, NEW MEXICO

On U. S. Highway 66, East 5 Minutes to Post Office 7117 East Central Avenue

TEXAS ANN COURT
2305 W. Central On U.S. Highway 66
ALBUQUERQUE, NEW MEXICO

CACTUS MOTEL
5930 Central Avenue SW
Highway 66—West of the Rio Grande
ALBUQUERQUE, NEW MEXICO

TOMORROW'S HOTEL TO-DAY

THE NEW
DE ANZA
MOTOR LODGE
ALBUQUERQUE, NEW MEXICO

PUEBLO BONITO COURT
ALBUQUERQUE, NEW MEXICO

El Jardin Lodge

Duncan Hines — Recommended

8100 East Central On Highway 66
ALBUQUERQUE, NEW MEXICO

ZIA LODGE
ALBUQUERQUE, NEW MEXICO

EL ORIENTE COURT
4101 East Central Avenue, (U. S. Highway 66)
ALBUQUERQUE, NEW MEXICO

Texas ANN MOTEL
AIR CONDITIONED

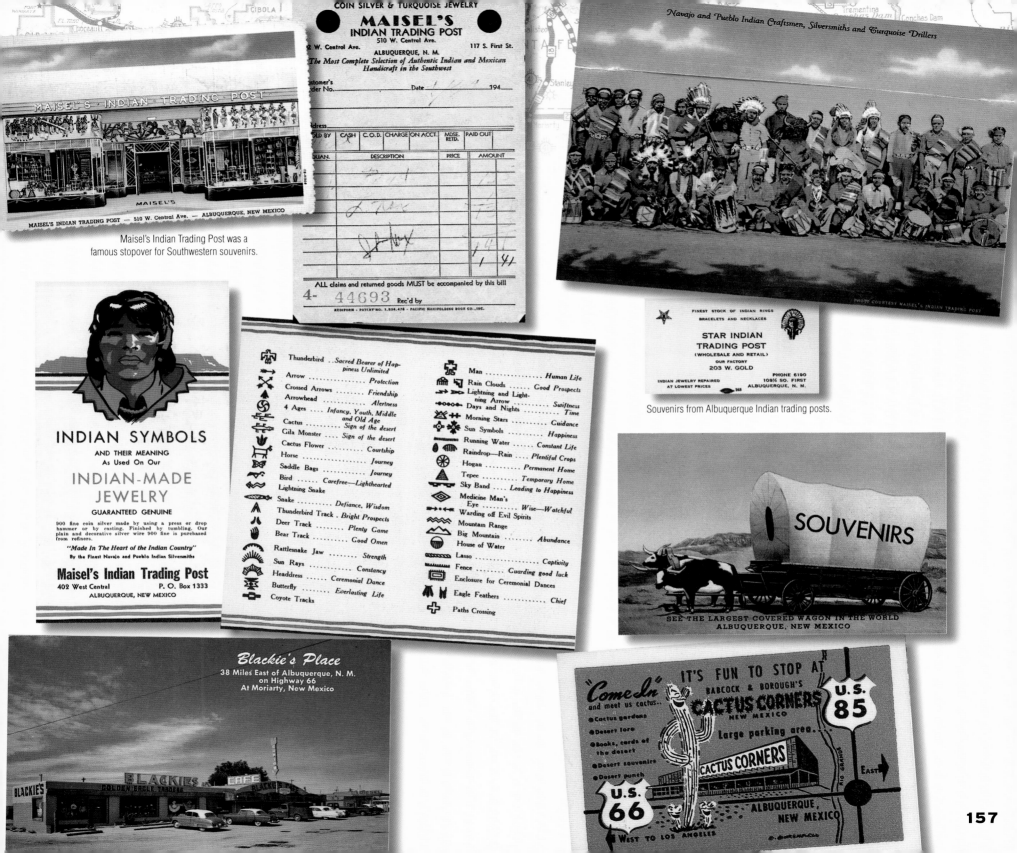

Maisel's Indian Trading Post was a famous stopover for Southwestern souvenirs.

Souvenirs from Albuquerque Indian trading posts.

Longhorn Ranch Indian Trading Post and Museum of the Old West

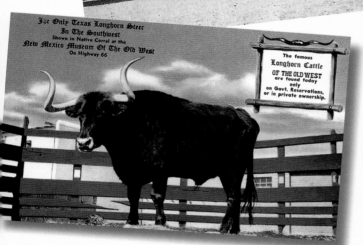

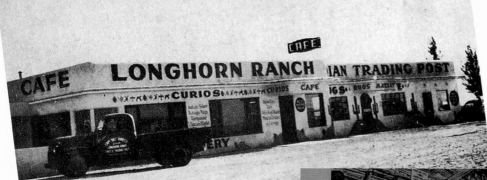

The Only Texas Longhorn Steer In The Southwest
Shown in Native Corral at the
New Mexico Museum Of The Old West
On Highway 66

The famous Longhorn Cattle OF THE OLD WEST are found today only on Govt. Reservations, or in private ownership.

NEW MEXICO Museum OF THE OLD WEST

Longhorn Ranch Saloon
of 1866
With Fixtures Used During the Gold Rush Days

THE SPIRIT OF THE OLD WEST STILL LIVES AT
The Longhorn Ranch

Real Concord Stagecoach used to Haul Mail and Passengers in the days of Buffalo Bill

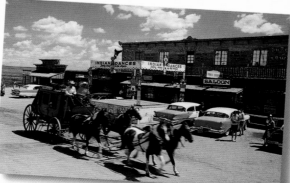

Route 66 Pinups

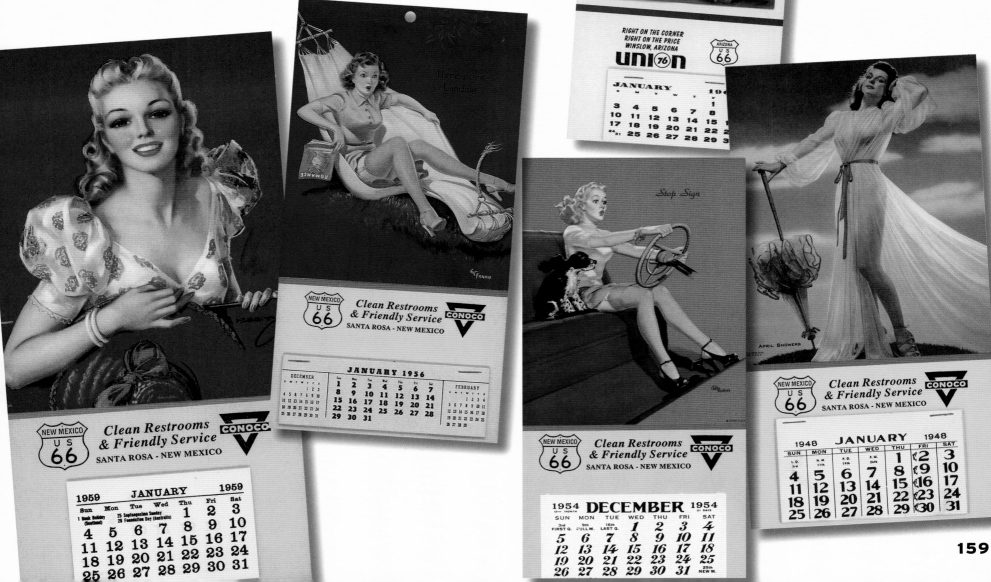

Many businesses and gas stations along Route 66 gave away souvenir and promotional items, often with cheesecake pinups, such as these calendars promising "Clean Restrooms & Friendly Service."

SWITCH HITCH

RIGHT ON THE CORNER
RIGHT ON THE PRICE
WINSLOW, ARIZONA

UNION 76

ARIZONA
US 66

Three-point Landing

ROMANCE

Stop Sign

April Showers

NEW MEXICO
US 66

Clean Restrooms
& Friendly Service

CONOCO

SANTA ROSA - NEW MEXICO

NEW MEXICO
US 66

Clean Restrooms
& Friendly Service

CONOCO

SANTA ROSA - NEW MEXICO

NEW MEXICO
US 66

Clean Restrooms
& Friendly Service

CONOCO

SANTA ROSA - NEW MEXICO

JOHNNIES CAFE, THOREAU, N. MEX.
GOOD EATS
Reasonable Prices Tourist Headquarters
U. S. HIGHWAY 66

Mileage from Johnnies Cafe

WEST TO		EAST TO	
Continental Divide	5	Grants	31
Gallup, N. Mexico	32	Laguna	65
Painted Desert	106	Los Lunas	116
Petrified Forest	118	Albuquerque	139
Holbrook, Ariz.	134	Domingo	176
Winslow	167	Santa Fe	203
Flagstaff	230	Las Vegas	277
Maine	250	Trinidad, Colo.	418
Grand Canyon	315	**NORTH TO**	
Williams	266	Crown Point	28
Needles, Cal.	470	Chaco Canyon	60
Los Angeles	770	**SOUTH TO**	
		Albuquerque	139
		El Paso	444

Then: Johnnies Café, Thoreau, New Mexico.

THE MOTHER ROAD LOST & FOUND

Johnnies Café, Thoreau, circa late 1920s

By Russell A. Olsen

At the time of its construction,

both Johnnies and Highway 66, then a primitive dirt path, were located on the north side of the tracks in Thoreau (pronounced "thuh-roo"). In February 1936, founders Johnnie and Helen Maich sold the business to John and Anna Radosevich. John was the cook and his wife Anna did a little bit of everything, including waiting tables. The small cafe was only 20x40 feet and consisted of a counter with a couple of stools and four tables. In its early years, the food was prepared on a Coleman wood stove and dishes were washed with water heated by a wood fire. A one-cylinder diesel generator was pressed into service to supply electricity for lights during the evening hours. Shortly after John and Anna purchased the cafe, Route 66 was rerouted to the south side of the tracks. Johnnies itself was moved, building and all, to its current location alongside the new alignment in 1947. In 1949 an addition was made to the building's east side, and in the early 1950s another section was built on to the west side. Today, the western addition is an off-sale liquor store. Johnnies was well-known in the area for serving outstanding chili and thick steaks. "People would drive from Gallup just for the chili," says John Radosevich, whose family still owns the building. ⊙

Now: Johnnies Café, Thoreau, New Mexico.

Funny Bunnies and Trophy Jackalopes

Punching Cattle on a Jack Rabbit

Jackalope

Ain't We Got Fun? No. 71

TX-5 Texas Cowboy Riding a Jack Rabbit

Travelers and tourists seemed to think there was nothing funnier than rabbits—at least judging by the humorous postcards they sent to loved ones back home. From jackalopes to gigantic rabbits in "exaggeration postcards," a funny bunny was always a hit. Maybe it was all due to white-line fever.

When we go after anything in Okla. we get it.

You Don't Stick These Bunnies In Your Hunting Coat Pocket

Across the Continental Divide on Route 66

By Kathy Weiser

Greetings from the **CONTINENTAL DIVIDE, NEW MEXICO**

Indian Village Gift Shop
Continental Divide, New Mexico

CONTINENTAL DIVIDE
NEW MEXICO
ELEV. 7275 FT.

As you continue your journey from Grants, you'll head through several small villages including Milan, Bluewater, Prewitt, and Thoreau before reaching the Continental Divide. Between Milan and nearby Prewitt is an interesting section of the old road, as it is quite wide but seldom used. At intervals, abandoned motels and empty gas stations can be seen along this stretch of the road. When Route 66 was young this was a major carrot-producing area covering thousands of acres.

Another five miles west of Thoreau brings you to the Continental Divide. In typical Route 66 fashion there are a number of trading posts here to take advantage of the many people who stop along the route. In the early days of the Mother Road, the site included the Great Divide Trading Company, the Continental Trading Post, and the Top O' The World Hotel and Café.

If you are traveling the original road, you will need to rejoin I-40 at exit 47 as the old road dead-ends just beyond the Continental Divide. However, it might be worth a mosy down this short piece of road as you will find some old businesses, including the Black App Trading Post. ◉

Owl Rock along Route 66, about 40 miles west of Albuquerque.

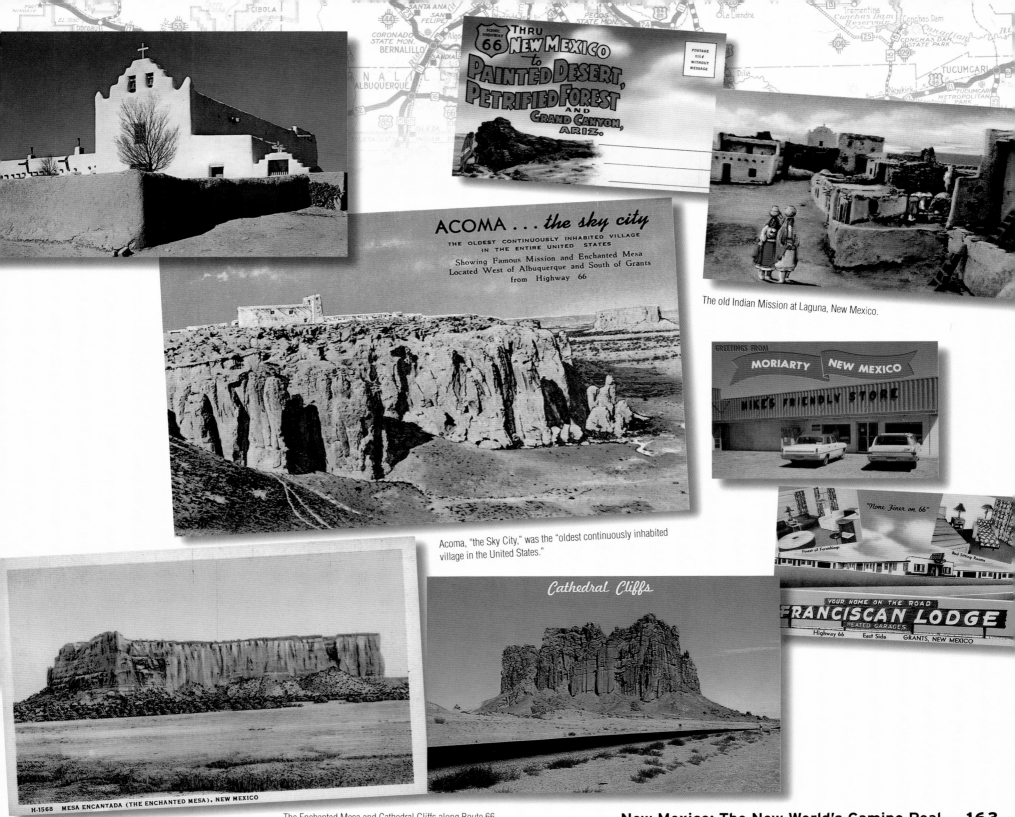

THRU
SCENIC HIGHWAY
66 NEW MEXICO
to
PAINTED DESERT,
PETRIFIED FOREST
AND
GRAND CANYON,
ARIZ.

POSTAGE 1½¢ WITHOUT MESSAGE

ACOMA . . . the sky city
THE OLDEST CONTINUOUSLY INHABITED VILLAGE
IN THE ENTIRE UNITED STATES

Showing Famous Mission and Enchanted Mesa
Located West of Albuquerque and South of Grants
from Highway 66

The old Indian Mission at Laguna, New Mexico.

GREETINGS FROM
MORIARTY **NEW MEXICO**
MIKE'S FRIENDLY STORE

"None Finer on 66"

Finest of Furnishings Bed Sitting Rooms

Acoma, "the Sky City," was the "oldest continuously inhabited
village in the United States."

Cathedral Cliffs

YOUR HOME ON THE ROAD
FRANCISCAN LODGE
HEATED GARAGES
Highway 66 East Side GRANTS, NEW MEXICO

H-1568 MESA ENCANTADA (THE ENCHANTED MESA), NEW MEXICO
The Enchanted Mesa and Cathedral Cliffs along Route 66.

Gallup
Indian Center of the Southwest

By Kathy Weiser

One of the oldest towns in the United States, Gallup's population can be traced back to 2500 B.C. with the settlement of the ancient Puebloans in Canyon de Chelly. As the Pueblo population rose, so did trading in the area. By the time the Spanish conquistadors arrived in 1540, a highly sophisticated Native American culture was thriving. Although not quite the "Seven Cities of Gold" that Coronado and the Spanish crown were hoping to find, these settlements displayed building, craft, and farming methods that were uncommonly sophisticated, as well as a network of roads connecting other important settlements throughout the region.

In the early days, Gallup was a typical, western frontier town, but comparatively quiet by most Old West standards. Gallup had its share of saloons, false storefronts, wooden sidewalks, and a single road paralleling the railroad tracks. Today, this road is known as Main Street and Route 66. There were occasional, minor tribal uprisings, but the soldiers of nearby Fort Wingate were able to discourage any major attacks. Most of the citizens carried arms until a law in 1896 limited the practice.

For the first half of the twentieth century, the economy of the emerging town was largely supported by plentiful coal mining in the region. In fact, Gallup was called "Carbon City" for a time.

When Route 66 came through town in 1926, numerous motels and service business sprang up on Main Street. But the most prevalent businesses were the dozens of trading posts that sprouted up displaying Native American arts and crafts to the many travelers along the Mother Road. Many of these vintage trading posts can be seen today, along with galleries, gift shops, old motels, and restaurants along historic Route 66 in Gallup. ◉

ARROWHEAD LODGE

Arrowhead Lodge Motel · GALLUP, NEW MEXICO
In the Heart of the Indian Country — East Side on U.S. Highway 66

The LARIAT LODGE

LARIAT LODGE · Gallup, New Mexico
East Entrance on U.S. Highway 66

Thunderbird Lodge
GALLUP, NEW MEXICO
CLOSE COVER BEFORE STRIKING

Fred Harvey
El NAVAJO HOTEL
GALLUP, NEW MEXICO

No. 10—1954

CASA LINDA COURT
GALLUP, NEW MEXICO
MEMBER UNITED MOTOR COURTS, Inc. · OFFICIAL AAA COURT · U. S. HIGHWAY No. 66 · 1½ MILES EAST of GALLUP

hotel El Rancho HIGHWAY 66 and COURTS
GALLUP, NEW MEXICO
World's Largest Ranch House
400 GUESTS
.....with the Charm of Yesterday and the Convenience of Tomorrow!
MAIN LOBBY · ENTRANCE · DINING ROOM

Shalimar
GALLUP, NEW MEXICO

Desert Skies MOTOR HOTEL
Desert Skies

HOTEL El Rancho WELCOME VISITORS
Individual Architectural Character ... Typical Ranch House Furnishings
Located in the Center of the Unspoiled Cowboy & Indian Country
East of GALLUP, NEW MEXICO ON U.S. HIGHWAY 66

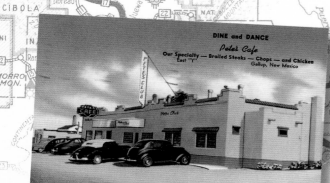

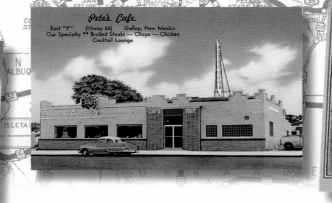

MANHATTAN CAFE, GALLUP, N. M.
Serving the Visitors of The Indian Capital
The FINEST OF FOODS
for over twenty-five years

AVALON CAFE
EAST HIGHWAY 66, GALLUP, N. M.

Recipe for: **Navajo Fry Bread**

3 cups flour

shortening

½ teaspoon salt

1½ teaspoons baking powder

1 ⅓ cups warm water

Use either all white or half whole wheat flour. Mix the flour, baking powder, and salt. Add warm water and mix. Dough should be soft but not sticky. Knead until smooth.

Tear off a chunk about the size of a peach. Pat and stretch until it is thin. Poke a hold through the middle, and drop in sizzling hot deep fat. (Lard is the traditional shortening, but you might prefer to use vegetable oil.) Brown on both sides. Drain and serve hot. Eat with honey or jam

New Mexico: The New World's Camino Real **167**

One of the first sites to greet westbound travelers on I-40 as they cross the Arizona line are stunning landscapes of towering, weathered cliffs, colorful billboards that are true throwbacks to the 1950s, and the Chief Yellowhorse Indian Trading Post. Though relocated with the realignment and eventual replacement of Route 66, the trading post is a veritable time capsule from the era of the Mercury Turnpike Cruiser station wagon.

The trading post and the landscapes that frame it set the stage for Route 66 in Arizona. Here, the old highway may be broken and segmented, but the landscapes are timeless, the time capsules plentiful, and in many places the past and present flow just as the Beale Wagon Road became the National Old Trails Highway that became Route 66 that became I-40.

The picturesque ruins of the Painted Desert Trading Post on a deadend section of the old road that's now little more than broken asphalt, ruts, and sand is today a Mecca of sorts for fans of Route 66. The fact that hundreds of people from throughout the world seek these isolated ruins on a forgotten ghost highway speaks volumes about the power to entrance that Route 66 still has.

In the well-worn town of Holbrook, a town that has weathered more than a century of storms and that was once more infamous than Tombstone, a true time capsule that provides the briefest glimpse into what Route 66 once was has, like the highway, transcended its original purpose to become an icon. This is the Wigwam Motel, a semicircle of motel rooms masked as teepees built in 1950.

Winslow has fared better than most communities bypassed by I-40 and has even managed to thrive, at least out along the new highway. Along old Route 66 dusty, empty, and abandoned businesses outnumber those that still offer services to travelers or locals.

The exception is the recently refurbished La Posada. Built in 1928 this ornate old hotel is more than a Route 66 time capsule, it is also a monument commemorating the beginning of the end for the railroad's dominance in passenger transport, as this is one of the last operational Harvey Houses found in the southwest.

The wonders and sites opened to travelers by Route 66 were not all man-made, nor were they all garish roadside sideshows. In the late 1940s, the Arizona unit of the U.S. Highway 66 Association posted a massive billboard on the eastern border that proclaimed a myriad of wonders awaiting discovery along Route 66 and with short detours to the north or south. There was Meteor Crater, the world's largest meteor impact crater on land, and El Dorado Canyon, the cliff dwellings of Walnut Canyon, and the Petrified Forest. As the billboard noted, with short detours of less than one hundred miles, the Route 66 traveler could experience the wonders of the Grand Canyon, the red rock spires of Sedona, and the only road that allowed automobile access to the Colorado River at the bottom of the Grand Canyon.

Few communities on Route 66 have capitalized on the international hunger for the Route 66 experience as has Williams. The entire business district is a dizzying tapestry of pre-statehood-era stores and hotels, 1950s motels with bright neon, mom-and-pop diners, art galleries in century-old banks, congested streets, and even a

functioning century-old railroad that provides access to the Grand Canyon. Here the entire town has become a living time capsule of the pre-interstate era of Route 66.

From Seligman to the California state line on the Colorado River, Route 66 is intact, making these 180 miles the longest remaining uninterrupted stretch of the highway. Enhancing this rare opportunity is that west of Kingman it is possible to drive the last incarnation of Route 66, a four-lane highway that is now masked by I-40, or the pre-1953 alignment that initially served as the route for the National Old Trails Highway.

Every year, on the first weekend in May, the mists of time part and more than eighty years of highway history surge into the present as hundreds of participants in the Fun Run Weekend again transform the empty road into a busy thoroughfare. For three brief days, the parking lot at Grand Canyon Caverns again becomes a sea of chrome-laden land yachts, finding a seat at the cafe in Truxton is a challenge, and Model T Fords labor to make the daunting grade over Sitgreaves Pass.

The pre-1953 alignment west of Kingman represents an increasingly rare opportunity to experience automotive travel as it was. The road follows the lay of the land across the wide Sacramento Valley, up the increasingly steep flanks of the forbidding Black Mountains, past the 1930s Cool Springs and the ruins of Ed's Camp, and over Sitgreaves Pass with its stunning views of three states.

On the west side of the summit are the steepest grades and the sharpest curves found anywhere on Route 66, as the road descends through the ruins of Goldroad. In Oatman, a gold-mining town that withered on the vine in the 1930s and died with the bypass of 1953, Route 66 is the narrow main street. Congested with tourists, traffic, and free-roaming burros, it is a fair representation of travel when this highway served as the Main Street of America.

At the Colorado River, best accessed from the California side, is a strikingly symbolic picture of Route 66 in Arizona. The I-40 bridge represents the last automobile bridge built across the river at this point. To the south is the graceful Old Trails Arch Bridge, the first automobile bridge built across the river in 1916.

The old bridge is also important for the role it played in creating the myth of Route 66. It plays prominently in the classic 1940 film by John Ford, *Grapes of Wrath*, as the background for the fictional Joad family as they enter California. ◎

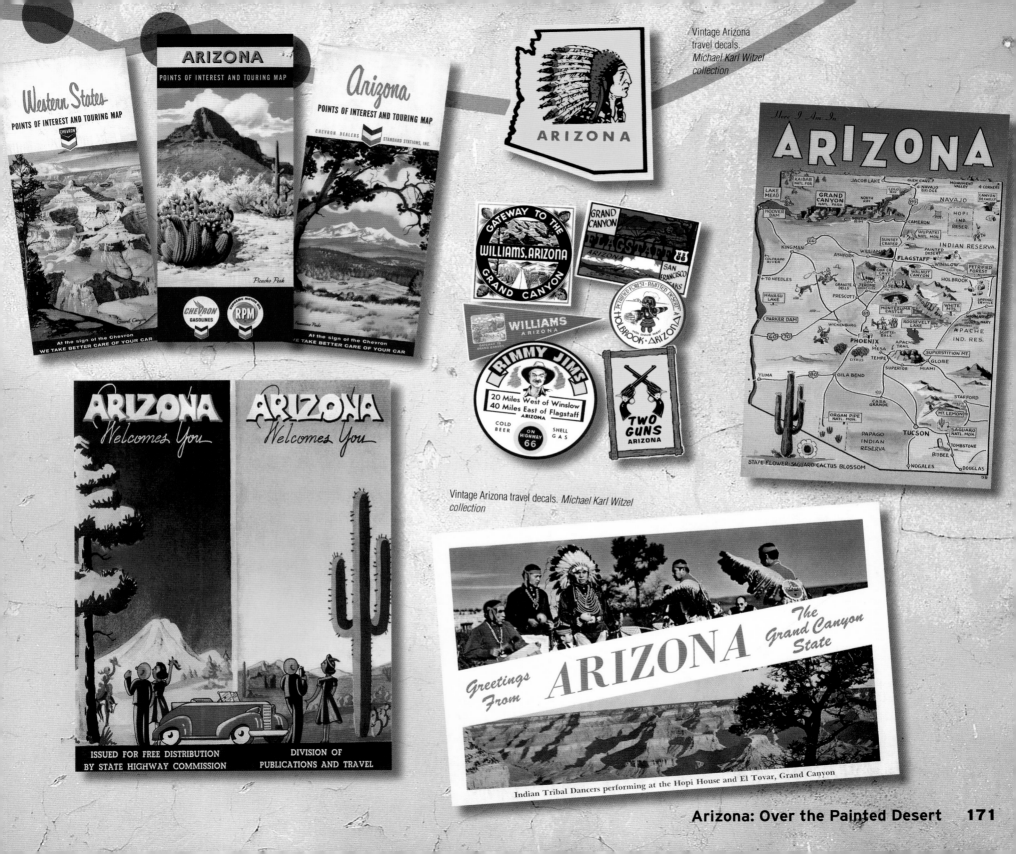

Vintage Arizona travel decals. *Michael Karl Witzel collection*

Vintage Arizona travel decals. *Michael Karl Witzel collection*

Across the Painted Desert on Route 66

By Kathy Weiser

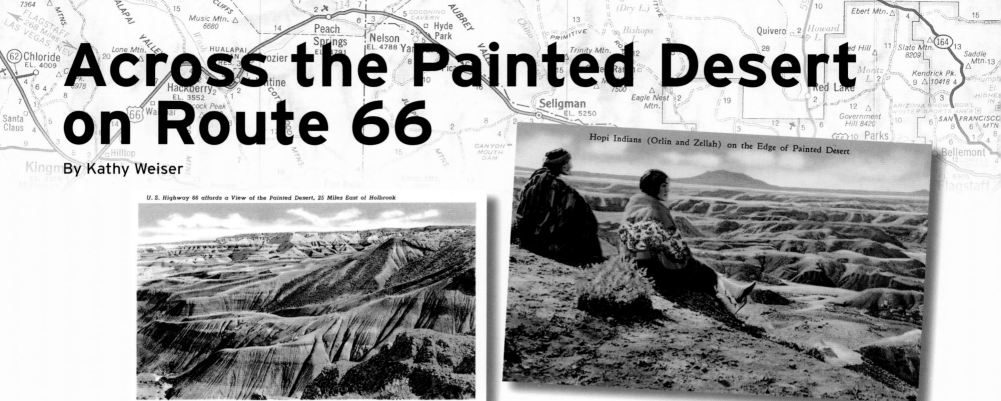

U.S. Highway 66 affords a View of the Painted Desert, 25 Miles East of Holbrook

The Painted Desert Reaches diagonally from Vermillion Cliffs to the Petrified Forest

Hopi Indians (Orlin and Zellah) on the Edge of Painted Desert

As your Mother Road journey begins to cross Arizona you will travel through Navajo country, the Painted Desert, past the Petrified Forest, and more than a dozen small towns, of which many are little more than a trading post, and others nothing but a ghost town. It is through this section that you can truly get a feel of what Route 66 might have been like long ago—the small towns are still small towns, many local Native Americans continue to make their living from the trading posts, and though not always in very good shape, original sections of the old pavement lie intact upon this section of Arizona's high desert.

Beautiful vermilion cliffs surround you on both sides of the highway as you enter Arizona, setting the tone for the colorful drive you are about to take.

The original road from Lupton to Chambers closely follows I-40, mostly to the north of the interstate. There are pieces through here where the road is in bad shape and turns to gravel or dirt. From Chambers to Holbrook, the old road simply disappears or is on private property. There are exits from the interstate to the sites you may want to see through the Painted Desert, so your best bet might be to stay on I-40 from Lupton west to Holbrook.

Beginning your drive in Lupton, Arizona, a hardy welcome invites you from the high sandstone bluffs, where statuesque figures of deer, bear, and eagles peer down from above. Immediately, you are surrounded by a number of trading posts at the base of the cliff, selling all manner of Native American treasures. Several of these have been in business since the birth of Route 66, including the Tee-Pee Trading Post.

Soon you'll pass through Allentown on your way to Houck, where you can stop for a moment at Fort Courage, a mock fort inspired by the old television show *F-Troop*. Just past Houck at the Pine Springs exit (exit 346), you can follow an old alignment on the north frontage road, which crosses the box canyon, passes by the ruins of the Old Querino Canyon Trading Post, and over the Querino Canyon Bridge. However, be aware that the north frontage road is a rough ride— it soon turns to dirt and becomes impassible during heavy rains.

As you head on through Sanders and Chambers to Navajo, you begin to see signs of the Painted Desert, with its multicolored sand formations and tremendous views. The Painted Desert covers almost a hundred thousand acres, stretching from the Petrified Forest to the Grand Canyon. There are times when even the sky above this colorful park glows with the pink and purple hues of the desert.

It is just beyond Navajo that you can view the ruins of the Painted Desert Trading Post by taking exit 320 from I-40. Soon you will reach the Petrified Forest, where hundreds of ancient trees lay scattered upon the mile-high desert. Take a pass and move on! ◉

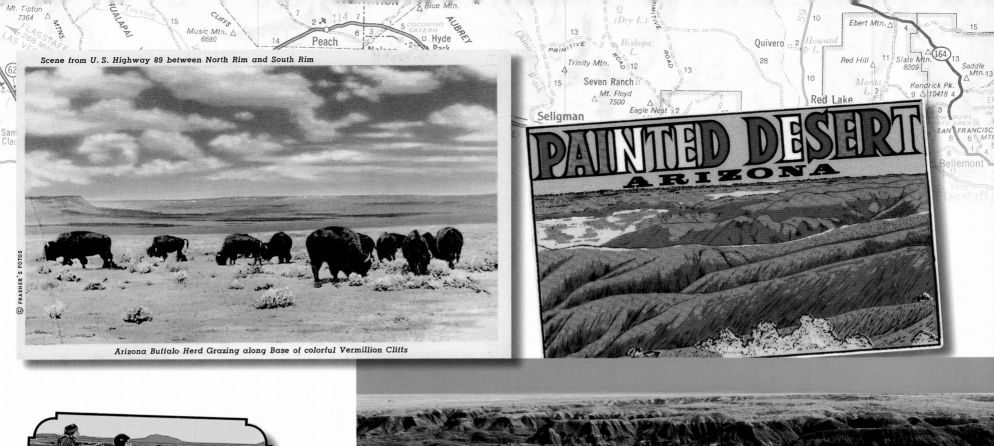

Scene from U.S. Highway 89 between North Rim and South Rim

© FRASHER'S FOTOS

Arizona Buffalo Herd Grazing along Base of colorful Vermillion Cliffs

PAINTED DESERT ARIZONA

PAINTED DESERT *Ariz.*

SCENIC HIGHWAY 66 THRU NEW MEXICO to PAINTED DESERT, PETRIFIED FOREST AND GRAND CANYON, ARIZ.

PLACE STAMP HERE

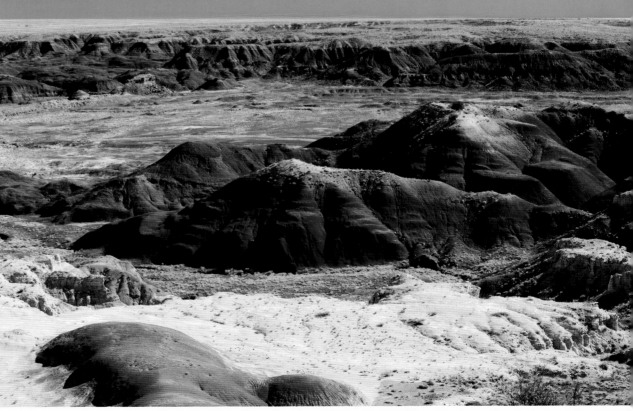

The Painted Desert. *Laurin Rinder/Shutterstock*

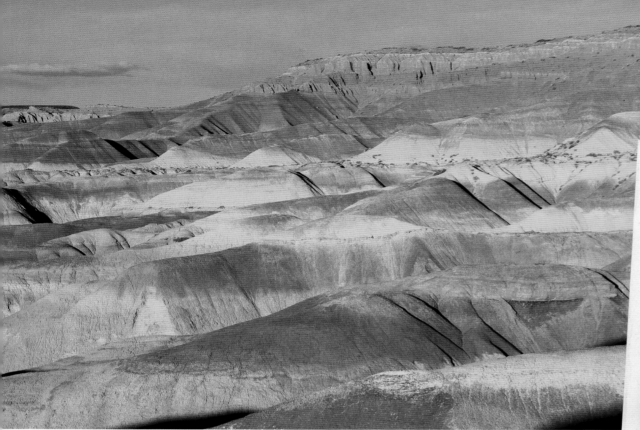

The Painted Desert glows in the late afternoon sun. *Patrick Poendl/Shutterstock*

ONLY BY HIGHWAY
you'll meet these 'Amazing Americans' at home!

Put yourself in this picture, *this Fall!*
The setting is in the vast and colorful Southwest ... an Indian rug weaver plies her skilled fingers as her ancestors have done for uncounted centuries ... the girl from the waiting bus tries on one of the rainbow-tinted blankets, and gives her own big-city version of an Apache war whoop!

Such friendly scenes are typical of travel by highway, in the sun-drenched land of the first Americans. It's an interesting fact that many Indian tribes, with their fascinating customs and costumes, can still be seen along the highways, not only in the Southwest, but in the evergreen

Northwest, among the Great Lakes, in the Midwest, in Florida, and even in New England! Greyhound trips and "Amazing America" Tours introduce you pleasantly to just such interesting people and places in all the 48 states, and in Canada. Whatever your reason for traveling—pleasure, business, or personal—we invite you to go the way that will help you to meet the real America ... *and real Americans!*

TIMELY TIP: Early Fall, after the mid-summer rush, is the best time for travel of any kind. Transportation is less crowded, weather is milder, there is more room in hotels and resorts.

and remember... By Highway means By Greyhound!

GREYHOUND

Vintage Greyhound bus services advertisement promoting the glories of Route 66.

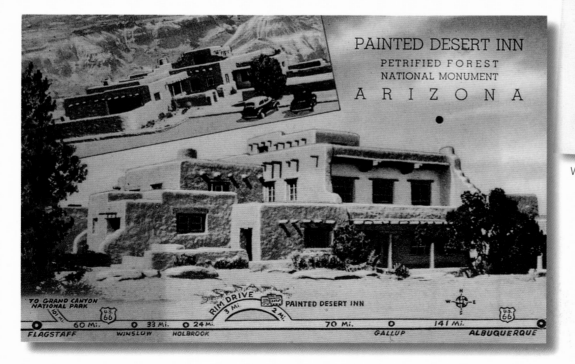

PAINTED DESERT INN
PETRIFIED FOREST
NATIONAL MONUMENT
ARIZONA

THE MOTHER ROAD LOST & FOUND

Painted Desert Trading Post, Navajo, circa 1942

By Russell A. Olsen

Then: The Painted Desert Trading Post, Navajo, Arizona.

Now: The Painted Desert Trading Post, Navajo, Arizona.

Imagine the loneliest,

most sun-baked desert expanse conceivable, where a single lizard might be the only living thing—other than yourself—for miles. There, right smack dab in the middle of lonely, you will find the Painted Desert Trading Post. Dotch and Alberta Windsor opened the Painted Desert Trading Post in the early 1940s, selling Native American curios, cold drinks, and sandwiches, as well as gasoline from gravity pumps. The trading post had no telephone, so calls were placed at the Painted Desert Park several miles to the west. Appliances ran on electricity generated by a windmill.

The Windsors operated the post together until their marriage ended around 1950. Joy Nevin, who ran a veterinary supply business in Holbrook, Arizona, met Dotch at the trading post during a business trip and the couple married, with Joy giving birth to a daughter in 1952. Dotch and Joy operated the trading post together until they divorced in 1956.

The section of Route 66 that ran past the business was relocated, widened, and designated Interstate 40 in the late 1950s, and the trading post has sat empty and abandoned ever since. Joy went on to become a leading figure in nearby Holbrook, where she still resides and where a street is named in her honor. Dotch died in October 1964, but the skeletal remains of the Painted Desert Trading Post still sit alongside the abandoned roadway, slowly being reclaimed by the desert that once gave it life. ◉

VOICES FROM THE MOTHER ROAD

Frank A. Redford: Chief of the Wigwam Villages

By Michael Karl Witzel

Frank Redford caught a glimpse of a cone-shaped ice cream stand in Long Beach, California, during the early 1930s and was inspired to action. Impressed by the whimsical, attention-getting nature of the programmatic structure, he built a mimetic gas station and restaurant of his own along Highway 31E in Horse Cave, Kentucky. He modeled the architecture to resemble the shape of a teepee.

Nearby Mammoth Cave brought in a lot of automotive traffic, but visitors to the area were equally charmed by his man-made structures. And why wouldn't they be? The station office was a sixty-foot-tall, cone-like construction made of wood and stucco, accompanied by a smaller, matching pair of wigwam restrooms (for squaws and braves of course). At the time, the "cowboys and Indians" theme was big in the movies and American pop culture, so the public ate it up.

Soon, customers who stopped in for a tank of gas, slice of pie, and a Coca-Cola began asking about where they could stay for the night. "Why are there no teepee-shaped cabins?" they wondered. Redford wondered the same thing. Seeing an opportunity to increase revenues, he added on six "sleeping rooms" in 1935, and you guessed it—built them to look like little teepees. Arranged in the typical fashion of the motor court, each of the teepee cabins was an autonomous unit. Although it was a communal arrangement with a grassy courtyard, people could drive right up to their room and park their car outside. Customers liked the privacy, since there were no common walls between the rooms.

Unlike real teepees, Redford's wigwams were watertight and insulated for what promotional postcards described as the "peace and quiet" of his guests. The internal framework consisted of wooden timbers arranged to form a cone, covered in tar paper. The exterior was plastered with stucco and sculpted at the entry to create the illusion of a rolled-back flap of cowhide. It was the same for the four lodge poles that poked through the tip—they were there for visual effect only and served no structural purpose.

On the outside, the teepee's stucco finish was covered in bright whitewash and featured accents of decorative color. At the top of each, a contrasting splash of red was edged with a zigzag border. Another course of colorful rickrack encircled the middle of each cabin, leading the eye to an ornamental line that surrounded the unit's diamond-shaped window. The visual effect was ordered and geometric, evoking a style that people accepted as being Native American in origin.

Inside the cabins, lodgers were privy to all of the day's modern conveniences. Guests appreciated the full bathroom facilities in each unit, complete with a sink, toilet, and shower (with hot and cold running water). There were no fire pits and open roof to vent the smoke as there might be in a real teepee, but instead a modern heating system that relied on a thermostatically-controlled steam radiator. Electrical outlets allowed for customers to plug in whatever devices they brought with them, such as radio sets, fans, and other appliances. During the 1950s, television sets became a standard fixture in each room.

The room decor followed the exterior theme, albeit it with less Native American styling. The furniture was dude ranch modern, with the bed, nightstand, and chair hand-crafted from lodge-pole hickory—complete with the real bark.

Mon. Nite May 7

X on Front
our Wigwam

"SLEEP IN A WIGWAM"

A Novel and Unique Place to Stay

In the Heart of the Indian Country, and Gateway to Petrified Forest and Painted Desert National Monuments. Solid Hickory Furniture. Modern throughout, Insulated for your Peace and Quiet.

Approved playground equipment

Air cooled Vented heat

Hi — Left Los Vegas 10:30 AM. Took a few more pictures - going up to 98° today already in 90's. Got to Boulder Dam at noon - took pictures and ate. Wrapped Phidy in a wet washcloth to keep him cool - worked just fine. Air coming in car was like heat from a furnace. Was cooler when we got to Arizona. 77° - some change. We are staying here tonite - it sure is cute - we saw these last year and wished we could have stayed - so this time we did. love K+D.

Published by Petley Studios, Phoenix, Arizona

7861

The Wigwam Motel at Holbrook, Arizona—"Sleep in a Wigwam."

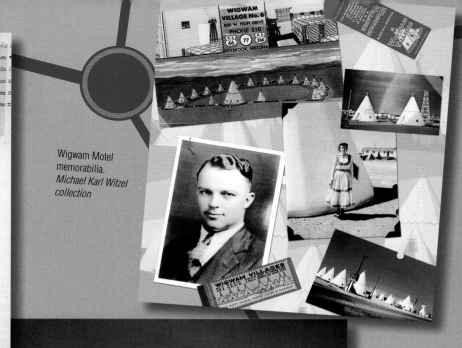

Wigwam Motel memorabilia.
Michael Karl Witzel collection

U. S. HIGHWAY 66, HOLBROOK, ARIZONA

Guests kept warm with authentic Apache blankets and walked on colorful Navajo rugs. There were even teepee-shaped table lamps and wigwam ash trays! The angled teepee walls were covered with knotty-pine paneling, too. It was all part of a carefully orchestrated fantasy, culminating in a teepee-shaped neon sign out front, imploring all those who passed to "Eat and Sleep in a Wigwam!" At the time, there were few motel chains that could say that.

As the wigwams gained a following, people started asking how they could open up their own teepee-themed roadside camp. Redford was more than willing to show them how. But first, he patented the ornamental design of the teepees and was officially granted number 98,617 in 1936. Interestingly enough, the original patent drawing shows four prominent swastikas encircling the building above each cabin door. To the Navajo, it was a symbol for a whirling log, a sacred image representing a legend used in healing rituals (after it was associated with the Nazis, the Navajo stopped using the symbol).

Redford welcomed eager franchisees into his motor court tribe and helped them get started. During a time in America when there were few amusement parks and other mega-attractions to distract the motorist's attention, it seemed there was no end to the fascination with his whimsical setup. In fifteen years, there were seven teepee-themed motor court sites doing business in six states. Two of the best-known Wigwam Village locations were built along Route 66, the perfect tourist venue.

In 1950, when Arizona motel owner Chester Lewis opened Wigwam Village number six in Holbrook, Arizona, he worked out a novel arrangement in terms of royalties: Redford was paid every dime that was dropped in the coin-operated radios. The location did a good business but was closed in 1982, and Chester Lewis died in 1986. However, his widow and children caught the vision and reopened the fifteen-room court in 1988. Today, they operate the overnight camp as a popular Route 66 attraction.

The last of the Wigwam Villages, number seven, was built in San Bernardino, California, by Redford himself in 1947. It is perhaps the ultimate location, with everything the postwar (and modern) traveler might desire, including nineteen thirty-foot-tall teepees, a grass recreation area, an outdoor barbecue grill, and a kidney-shaped swimming pool. Going on its sixtieth anniversary, the remodeled classic motor court continues to welcome those looking for something a little bit different. Through the ongoing support of car lovers, vacationing families, curious foreigners, roadies, historians, and preservationists alike, Redford's dream of a motel village where people could eat, sleep, and dream in a wigwam lives on. ◉

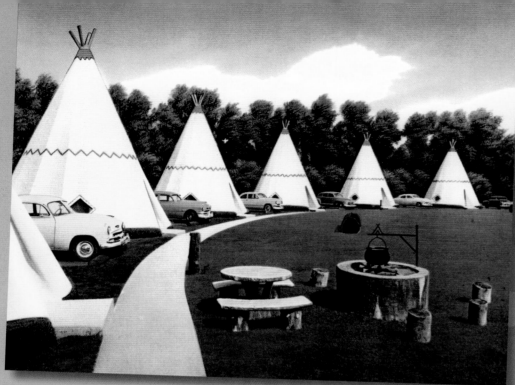

Postcard of the Wigwam Village. *Michael Karl Witzel collection*

The interior of a teepee motel room at the Wigwam Village in Holbrook. The entrance door is on the right and the bathroom door on the left. *Robyn Beck/AFP/Getty Images*

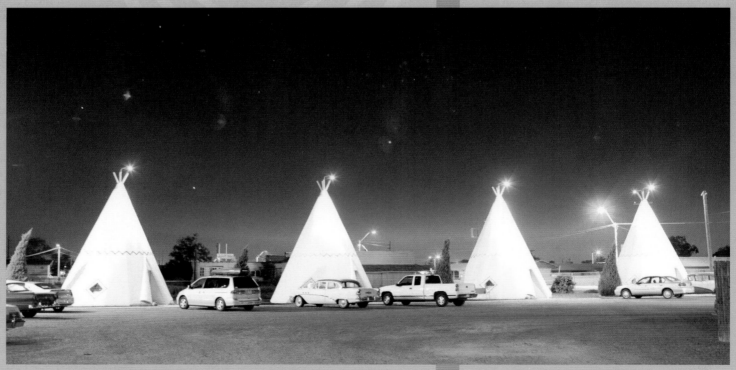

The night sky is illuminated by the concrete teepee-shaped motel rooms at Wigwam Village on Route 66 in Holbrook, Arizona. After Route 66 was bypassed by Interstate 40, owner Chester Lewis closed the teepee motel due to a lack of business. Now, Lewis' son and daughter have reopened and renovated the teepee motel, which still has the original furniture and fixtures. Visitors from as far away as Japan and Europe make reservations in advance to be sure to have a chance to stay in this well-preserved taste of classic Americana. *Robyn Beck/AFP/Getty Images*

Holbrook, Arizona

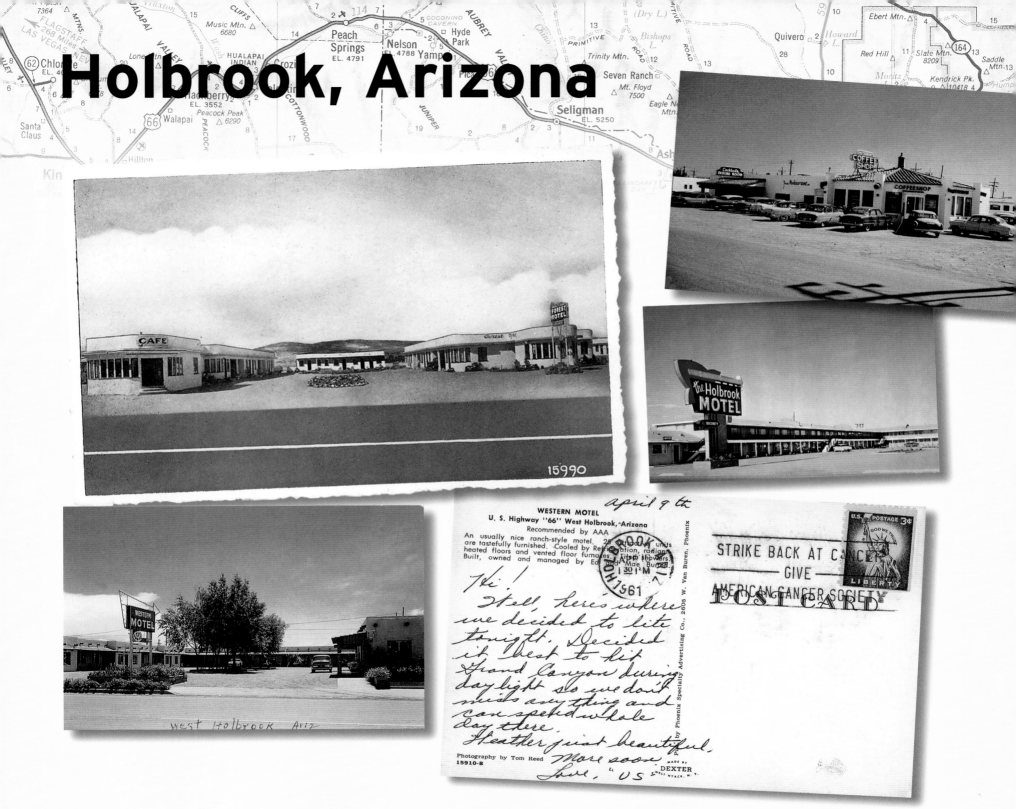

WESTERN MOTEL
U.S. Highway "66" West Holbrook, Arizona
Recommended by AAA

An usually nice ranch-style motel. 28 outdoor units are tastefully furnished. Cooled by Refrigeration, radiant heated floors and vented floor furnaces. Tiled showers. Built, owned and managed by Ed and Mae Buren.

Photography by Tom Reed
15910-B

April 9th

Hi!

Well, here's where we decided to lite tonight. Decided it best to hit Grand Canyon during daylight so we don't miss anything and can spend whole day there. Heather just beautiful. More soon.

Love, "US"

STRIKE BACK AT CANCER
GIVE
AMERICAN CANCER SOCIETY

west Holbrook Ariz

15990

The Beasley family. *Michael Karl Witzel collection*

VOICES FROM THE MOTHER ROAD

The Yellowhorse Boys: Indian Traders along Old Route 66

By Michael Karl Witzel

The Yellowhorse Trading Post

is one Route 66 business that can literally claim it began with a pile of rocks. But make no mistake: these weren't the stones used to construct the building, oh no. These were fossils—petrified wood to be exact—that caused tourists traveling by in their automobiles to stop and buy a souvenir of their trip.

It all began in the very early days of the old road, when Frank Yellowhorse's father, Arthur Beasley, took the people who stopped at the Dead River train depot on side excursions through Arizona's Petrified Forest. After witnessing the majesty of the fossilized wood strewn about, everyone wanted to take a piece home with them, a practice that was prohibited by law since the stone forest is a protected preserve.

Frank's father had an epiphany when he realized how he could satisfy the craving of his tour groups and make a good living at the same time. He knew where there was an almost endless supply of the petrified trees on private land and soon began hauling it out for safekeeping. Local ranchers didn't have much love for the petrified wood because it inhibited the growth of grass, something they needed to feed their herds.

"My dad collected tons of it," recalls Yellowhorse. "He had big piles of all kinds of petrified wood . . . some really nice specimens!" Beasley set up a small shop where he graded, cut, and polished the rock into something that he could sell. When it was ready, he loaded up his saddlebags and rode out to the Alamanda train station. There, he hawked his fossilized treasures directly to people in the trains, right through the windows!

Beasley discovered that he had a talent for selling trinkets to tourists and that his Native American ancestry gave him the street credibility he needed to be successful. By 1935, he recruited his wife Anna Yellowhorse (a full-blooded Navajo) and opened his first trading post in Querino Canyon. It was right on Highway 66, four miles from the Arizona border.

To get attention without paying for billboards, Beasley put up an ornate fence that surrounded a small trio of pyramid-like structures made with a stick framework and covered with mud. The hogans were a great attention getter and doubled as a place for the family to live as the business grew. Out in front, he built a small roadside stand where he sold "Navajo" rugs to tourists. "He would travel into Mexico and bring back loads of Mexican blankets," says Yellowhorse. "He'd string them up on long lines for a hundred feet on each side of the stand." Local residents called the roadside oddity "the Navajo Castle."

Eventually, Beasley's fours boys joined the family business, and at one time or another ran some sort of a trading post along the Mother Road. During the 1960s, brothers Juan, Frank, and "Shush" built a place about eight miles west of the Arizona border, on a Navajo business site lease. Along westbound 66, they set up shop inside a small building and a two-story teepee.

To play up the Native American angle, the brothers decided to name their trading post after "Cut-hair" Yellowhorse, their grandfather-in-law on their mother's side of the family. Juan was already known by the nickname "Chief," so they decided to combine the two. "Stop at Chief Yellowhorse" proclaimed the new signs, "Friendly Navajo Ahead!"

The Yellowhorse Trading Post.
Michael Karl Witzel collection

One of the Yellowhorse boys. *Michael Karl Witzel collection*

Petrified Forest
HOLBROOK · ARIZONA

DESCRIPTIVE · HISTORICAL · ILLUSTRATIVE

Vintage booklet on the history of petrified wood. *Michael Karl Witzel collection*

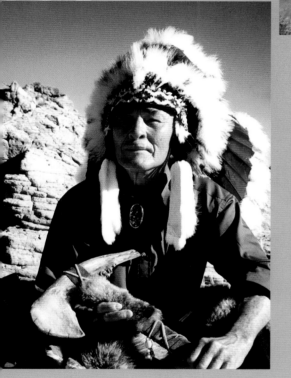

Chief Yellowhorse. *Michael Karl Witzel collection*

Despite the warm greeting, the Yellowhorse brothers overestimated the bravery of the white tourist. For whatever imagined reason, people were afraid to stop. To counter the fears, Juan and Frank came up with a plan to install funny signs along Route 66. Much like the Burma-Shave Company did, they painted two-foot squares of plywood with their black, red, and yellow colors and planted them every fifty miles along the Arizona road.

Now, Route 66 travelers were greeted by signs that read "Indians Ahead, Welcome. We No Scalpum Pale Face, Just Scalpum Wallet!" Despite the political incorrectness of it all, the brothers came up with a bunch of witty slogans, all playing off the Native American stereotypes. As it turned out, the humor bode well for the family's fortune. Soon, the Chief Yellowhorse Trading Post and the Beasley brothers were making a heap big business selling the proverbial rubber tomahawk and other geegaws.

Unfortunately, the setup wasn't permanent: During the late 1960s, Interstate 40, locally known as the Mojave Freeway, cut a merciless ribbon through Arizona. Plans called for the road to rip right through their store!

Reluctantly, the brothers moved to a new location on the Arizona-New Mexico border. This time, a larger-than-life, five-story teepee became the core of a brand-new Route 66 Chief Yellowhorse Indian trading post.

Even that didn't last. The structure burned down during the early 1970s and the Yellowhorse boys split up to seek their fortunes by themselves. But nine years later, they came to the realization that their strength came from family and they reunited. They found a plot of land that was prominent along I-40 and built Fort Yellowhorse. The place never really came together as they had envisioned, but Juan set up a small sales stand there, and eventually a store. Later, he replaced the word "Fort" with "Chief" on the signs and commenced to trade in the shadow of I-40 for many moons, until he died in 1998.

Today, Frank Yellowhorse is still selling souvenirs along old 66. Located directly under the dramatic red cliffs of I-40's exit 359, his Yellowhorse Ltd. trading outlet is a Lupton, Arizona fixture. These days, he still supplies the public with what they want, just like his father did, selling one-of-a-kind jewelry, collectible knives and inlaid Zippo lighters.

"My father always said that this highway is paved with gold," remarks Frank. "Treat the people well and help them as much as you can. The road will provide you a living!" ◎

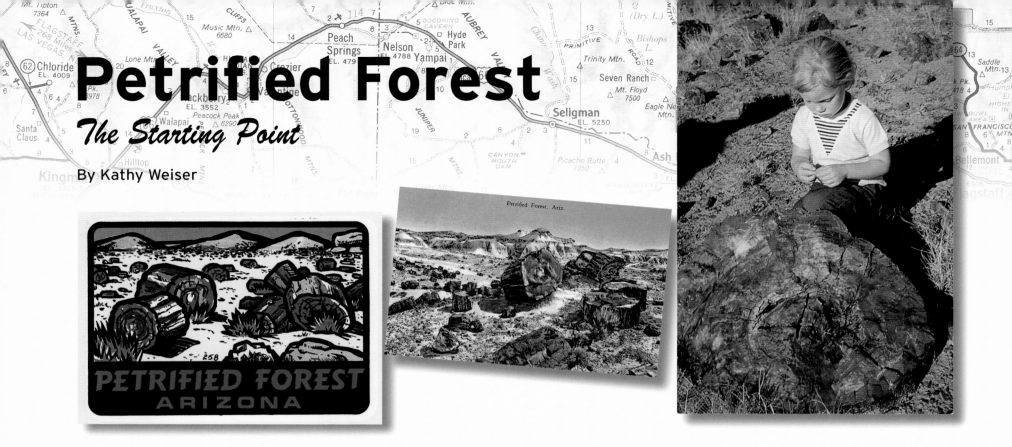

Petrified Forest
The Starting Point

By Kathy Weiser

Located in northeastern Arizona, the Petrified Forest National Park is between Holbrook and Navajo along I-40. The park is a surprising land of scenic wonders and fascinating science featuring one of the world's largest and most colorful concentrations of petrified wood, the multihued badlands of the Chinle Formation known as the Painted Desert, historic structures, archeological sites, and displays of fossils that are 225 million years old.

The park consists of two large areas connected by a north-south corridor. The northern area encompasses part of the multihued badlands known as the Painted Desert. The southern area includes colorful terrain as well as several concentrations of petrified wood. Several Native American petroglyph sites are also found in the southern area.

The Petrified Forest area was designated a national monument on December 8, 1906. The Painted Desert was added later, and on December 9, 1962, the whole monument received national park status. Today, the park covers 93,000 acres.

Landmarks include the Agate House Pueblo, built of petrified wood; the Agate Bridge, a petrified log spanning a wash; and the Painted Desert Inn, listed on the National Register of Historic Places.

The Agate House is a partial reconstruction of a pueblo built around 1100 A.D. Its walls were built of petrified wood and sealed with mud mortar. Sitting atop a knoll overlooking the vast expanse of desert, the eight-room pueblo is thought to have been occupied for a brief time due to the small amount of cultural debris found in the area. Reconstruction of its rooms occurred after archaeological excavation in 1934.

The Agate Bridge is a natural formation created by centuries of scouring floodwaters that washed out the arroyo beneath this 110-foot petrified log. The stone log, harder than the sandstone around it, resisted erosion and remained suspended as the softer rock beneath it washed away. Enthusiastic visitors fascinated by Agate Bridge worked to preserve it through the establishment of the Petrified Forest National Monument in 1906. Conservationists felt this ages-old natural bridge needed architectural support, and in 1911 erected masonry pillars beneath the log. In 1917 the present concrete span replaced the masonry work.

The Painted Desert Inn was built in 1924, on a high perch overlooking the Painted Desert, by a man named Herbert Lore. The two-story inn, named the Stone Tree House due to the petrified wood used in its construction, was operated as an inn and tourist attraction for almost twelve years. Meals were served in the lunchroom, Native American arts and crafts could be purchased in the curio shops, and a cool drink could be enjoyed in the downstairs taproom. Rooms were available for two to four dollars a night. Lore also gave two-hour car tours through the Black Forest in the Painted Desert below.

During the Dust Bowl days, thousands of heartland residents fled west on Route 66 in search of a better life. Hollywood documented the era in *The Grapes of Wrath*, which included scenes at the Painted Desert Inn.

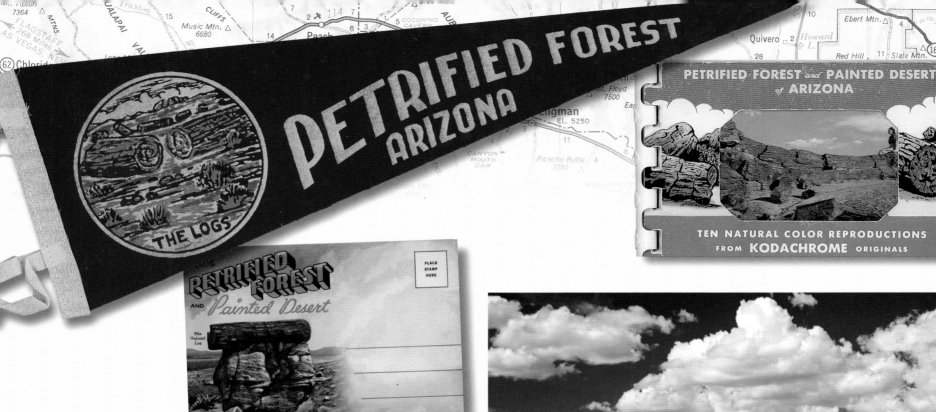

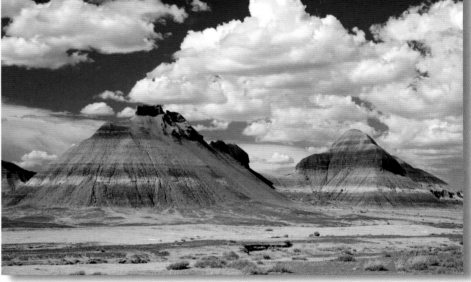

The famous Tepees in the Petrified Forest National Park. *William Silver/Shutterstock*

During World War II the Inn was closed, but it reopened after the war was over. Shortly thereafter, the Fred Harvey Company took over the management in 1947. In no time, the legendary Harvey Girls complimented the Inn with their excellent service in the spotless dining room.

A year later, the company's architect and interior designer, Mary Colter, oversaw the remodeling of the dining rooms, hiring Fred Kabotie to paint murals in two rooms that would reflect his Hopi heritage. In the same year, the Painted Desert Inn became the park's northern headquarters.

Following the war, Route 66 became busier than ever as people began to experience vacations. For many, the Mother Road included a stop at the Petrified Forest and a bite to eat or curio shopping at the Painted Desert Inn.

Unfortunately, after I-40 replaced Route 66, a new Painted Desert headquarters was opened and the Painted Desert Inn was closed. Already suffering from foundation problems, the building sat abandoned for the next 27 years. Only open for periodic events, deterioration continued to occur and the building was nearly demolished in 1965 and again in 1975. However, in 1975 the Painted Desert Inn was placed on the National Register of Historic Places and in 1987, it became a National Historic Landmark. The building was restored and is now open as a museum.

The petrified wood of the Petrified Forest is the "state fossil" of Arizona. The pieces of permineralized wood are from a family of trees that is extinct in the Northern Hemisphere today, surviving only in isolated stands in the Southern Hemisphere. During the Late Triassic period, this desert region was located in the tropics and was seasonally wet and dry. In seasonal flooding, the trees washed from where they grew and accumulated in sandy river channels, where they were buried periodically by layers of gravelly sand, rich in volcanic ash from volcanoes further to the west. The volcanic ash was the source of the silica that helped to permineralize the buried logs, replacing wood with silica, colored with oxides of iron and manganese. ◉

THIS EXIT FOR ANOTHER ROADSIDE ATTRACTION . . .

The Jackrabbit Trading Post

By Kathy Weiser

When Route 66 came through,

the town of Joseph City was just a quiet stop for services. After World War II, when people really began to travel, traffic increased through the small town. It was during this time that a hardy man named James Taylor built the Jackrabbit Trading Post in 1949.

In the beginning, Taylor bought an asphalt-shingled shack that had formerly been used as a snake farm. He turned out all the snakes, much to the alarm of several area residents. Soon he began to revamp the building, with dancing chiefs painted on the front, thirty twelve-inch jackrabbits hopping along the roofline, and a large rabbit painted on one side of the building. He then installed a three-foot-high, composition jackrabbit with yellow eyes, just inside the door to welcome the many tourists stopping by. Many old-time travelers can tell stories of having their picture taken atop this rabbit when they were children. Inside, the counters and shelves were lined with pieces of petrified wood, turquoise jewelry, and Native American souvenirs.

But owning a Trading Post in those days just wasn't enough. Dotting the highway, they were a dime a dozen, and competing with the nearby Geronimo Trading Post, with its visual pulling power of large decorative teepees, Taylor had to do something more.

And something more he did! Joining forces with Wayne Troutner, owner of the For Men Only Store in Winslow, the pair traveled Route 66 to Springfield, Missouri, plastering billboards all along the way. Hopping rabbits paired up with a dancing cowgirl for more than 1,000 miles, enticing travelers to stop at the Jackrabbit and the For Men Only Store in Winslow. After all those miles, travelers couldn't miss the huge yellow sign that simply said "Here It Is" paired with its famous jackrabbit icon.

Obviously Taylor's tactics worked, because the Jackrabbit is still in business and has long since become a Route 66 legend. For two decades Taylor operated the post until he leased it to Glen Blansett in 1961. Blansett purchased the business in 1967 and passed it on to his son and daughter-in-law who eventually sold it to their daughter and son-in-law, Cynthia and Antonio Jaquez, who run the trading post today. ◉

Here it is! The famous sign for the Jackrabbit Trading Post in Joseph City, Arizona. *Carol M. Highsmith's America, Library of Congress*

Standing on a Corner in Winslow, Arizona

By Kathy Weiser

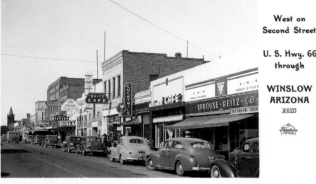

West on
Second Street

U. S. Hwy. 66
through

WINSLOW
ARIZONA
X820

It was in the late 1800s that a man named John Lorenzo Hubbell began building Navajo trading posts all over Arizona and New Mexico. These were just part of a trading empire that included freight and mail lines, as well as curio shops in California, bean farms near Gallup, New Mexico, and apple farms near Farmington, New Mexico. Hubbell was instrumental in bridging the gap between the white settlers and the Navajo people. In Winslow, the building still stands that once housed the Hubbell Wholesale Store, which operated from 1924 to 1948.

On May 15, 1930, the famous Posada Harvey House Hotel opened its doors for business. For the last one built in the famous Harvey Hotel and restaurant chain, Winslow was chosen for the site, as it was the headquarters for the Santa Fe Railway. During those days, Winslow was growing so fast that the railroad anticipated the town would soon become another Santa Fe, New Mexico.

Up until the 1960s, Winslow was the largest town in northern Arizona. But life began to slow down in Winslow, and when the town was bypassed by I-40 in the 1970s, tourism died and businesses began to close their doors.

In 1972, when the Eagles came out with their first hit single "Take it Easy" the verse "standing on a corner in Winslow, Arizona," put the town on the national map of consciousness, but Winslow's downtown was still frozen in time.

However, when the railroad announced plans to move out of Winslow for good in 1994, and La Posada was scheduled for demolition, the town gathered up and went to work. First on the list was to save the old hotel, which they did. Second was the restoration of Winslow's downtown historic district, which continues to this day.

Today, La Posada has been fully restored and stands as an oasis in the desert, catering to a new generation of Route 66 adventurers. Make sure to capture a photograph or two at the Standin' on the Corner Park. Throughout your cruise in Winslow you'll catch glimpses of vintage Route 66. ◉

The Valentine Hi Way Diner in Winslow, Arizona, still serving hungry travelers. *Michael Karl Witzel collection*

ROUTE 66 MYTHS AND LEGENDS

Valentine Diners Along the Mother Road

By Kathy Weiser

Before the days

when busy streets were lined with the fast food chains of McDonald's, Wendy's, Burger King, and Taco Bell, there were literally hundreds of all-American mom-and-pop diner's. One of the most popular varieties of these old-time diners was the Valentine Diner.

Webster's Dictionary defines a diner as "a restaurant in the shape of a railroad car." In the case of Valentine Diners, as well as many others, this was true, as the manufacturing design reflected the style of railroad dining cars.

The lunch wagon, the predecessor to the diner, was invented in 1872 by Walter Scott, who later became a commercial manufacturer of lunch wagons in 1887. The lunch wagon idea caught on so quickly that many towns passed ordinances to restrict their hours of operation. As a result, many operators looked for a more permanent solution, turning old railroad cars and obsolete, horse-drawn streetcars into diners. New manufacturers of these cars also cropped up at an amazing pace. These new and innovate "dining cars" were constructed with indoor bathrooms, tables, and repositioned counters to accommodate a larger food selection.

During the early days, most of the dining car manufacturers were located on the East Coast, producing shiny stainless steel structures. Because of their distant location, diners didn't catch on in the west for many years. However, that all changed when Arthur Valentine came to Kansas in 1914. A natural salesman, he first started selling cars in Great Bend, then sometime around 1930 he and his wife, Ella, opened a restaurant in the small south-central town of Hazelton, Kansas.

Enjoying their successful business, they soon expanded to include two more restaurants in Wichita and Hutchinson, Kansas. These restaurants were the predecessors of what would become known as the Valentine Lunch System. These original small diners operated in buildings that Valentine had either purchased or leased. At the same time a company called Ablah Hotel Supply was making prefabricated lunchroom buildings, and around 1932, they made one for Arthur Valentine. Valentine was so impressed that he began working for Ablah, becoming a salesman for their buildings.

Eventually, Valentine owned and operated as many as fifty of these lunchrooms. However, by the end of the decade, Ablah discontinued the manufacture of prefab buildings and allowed Valentine to take on that part of the business.

In 1938, Valentine arranged with the Hayes Equipment Manufacturing Company to build his sandwich shops, but the arrangement was short-lived when

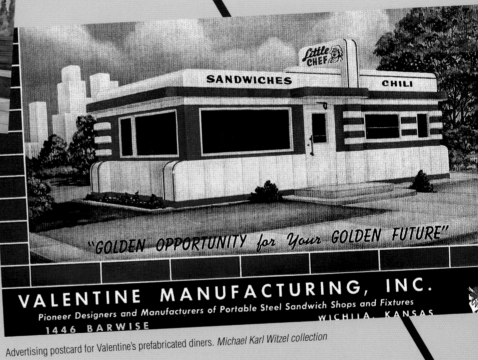

Valentine diner advertisements. *Michael Karl Witzel collection*

Advertising postcard for Valentine's prefabricated diners. *Michael Karl Witzel collection*

material shortages created by World War II shut the operation down. Frustrated, Valentine became a Boeing inspector during the war, but shortly after it was over he recreated the business, calling it Valentine Industries.

Valentine continually tinkered with new ideas to achieve business success. In addition to selling his diners fully equipped, he also sold them with only a few shelves for other purposes such as liquor stores and barbershops. But his true success was the Valentine Lunch System. These eight-to-ten-seat diners could be operated by just one or two people. The little square-sided structures were designed to be easily moved on flatbed railroad cars. Inside, stools were placed around a counter. Some designs had pick-up windows. The catalogs reinforced the idea that an individual purchasing one of these diners could make a substantial living and that they could add additional units if they desired. Ordering the diner through a catalog, the struggling entrepreneur could buy the boxy little diner for just $5,000 with monthly installment payments of $40. Arriving complete with grill, counter, and stools, the operation could be unloaded, set upon a concrete slab, and be operational within hours.

In an industry where nearly all major diner manufacturers were on the East Coast, Valentine soon became very successful as the diners were shipped all across the country, particularly to small towns, where they were sometimes the only restaurant available.

Sadly, Arthur's health began to fail in 1951 just as Valentine Diners were becoming extremely successful. His involvement in the company thereafter diminished until his death in 1954. The business was sold to the Radcliff family in 1957 and continued to operate until August 1968.

Thankfully, the American diner has seen resurgence in popularity in the last several years. For those of us who would prefer a pleasant smile and a great grilled burger, to the manufacturing-like mentality of many of the fast food places, this is a great relief. ◉

THIS EXIT FOR ANOTHER ROADSIDE ATTRACTION . . .

Meteor City Trading Post and Meteor Crater

By Kathy Weiser

First few words

After leaving Winslow and heading west on Route 66 you will soon come to Meteor City, a tourist stop inviting you to sample their many wares before heading on down to see the Meteor Crater. Just so you know, Meteor City, really isn't a city. Rather, it's a trading post that calls itself a city. However, it's a great photo opportunity, with its geodesic dome, vintage trucks, and the world's largest dream catcher.

Just beyond Meteor City is the road to the Meteor Crater, some six miles south of I-40. The crater was formed approximately 50,000 years ago, when an iron mass weighing over 60,000 tons entered the Earth's atmosphere, resulting in the formation, which is about 4,000 feet wide and 570 feet deep.

During the heydays of Route 66, a man named D.M. Barringer built an observatory just off of the Mother Road so that the many travelers passing by the area could see the crater without having to travel the additional six or so miles to the site. For just twenty-five cents, travelers could stand from the observation tower and see the crater through a telescope.

Today the observatory is nothing but stone ruins; however, a visitor's center and guided tours are available at the crater itself. ◉

METEOR CRATER

ARIZONA

THE GREAT METEOR CRATER OF ARIZONA

THE WORLD'S GREATEST WONDER
.....OF ITS KIND

LOCATED JUST OFF U.S. 66
[BET]WEEN FLAGSTAFF AND WINSLOW

Brochures for Meteor Crater—"The World's Greatest Wonder . . . of it's Kind."

VISIT ARIZONA'S DRAMATIC
METEOR CRATER

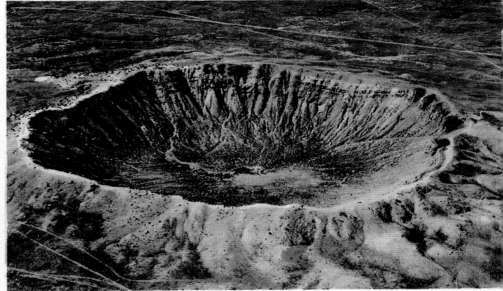

Meteor Crater, 5 Miles South of U. S. Highway 66 between Flagstaff and Winslow

This Huge Pit dug by a Meteor Thousands of Years ago is 800 Feet Deep and a Mile across

"METEOR CRATER"
THE GRAVE OF ARIZONA'S GIANT "METEOR"
WIDTH 4150 FT. - DEPTH 600 FT.
OFFICIAL ENTRANCE - ON U.S. 66 - AT METEOR ARIZ.

"The Grave of Arizona's Giant 'Meteor'."

THE MOTHER ROAD LOST & FOUND

Two Guns, circa 1948

By Russell A. Olsen

Then: Two Guns, Arizona.

Now: Two Guns, Arizona.

Located halfway between

Winslow and Flagstaff, no other town on Route 66 has such a frightening and storied past as Two Guns. In 1881, the story goes, more than fifty Navajo men, women, and children were slaughtered by a band of Apaches at a Navajo camp in the nearby Painted Desert. Navajo warriors tracked the Apaches, trapped them in a nearby cave, and quickly gathered sagebrush, wood, and anything else that would burn. The Navajos then built a fire at the entrance to the cave, which quickly filled with fire and smoke, then opened fire into the cave. They entered it the next day to find the charred and riddled remains of forty-two Apaches. The cave is still known as the Apache Death Cave and carries with it a curse of bad nearby canyon by train robbers.

By the 1950s, Two Guns had become a very popular stop along Route 66. What kid wouldn't want to see Navajo cliff dwellings, mountain lions, and the occasional cowboy or Indian? Stores, cafes, a service station, and a motel were also there for tired tourists. The concrete bridge through town crosses the Canyon Diablo and was listed on the National Register of Historic Places in 1988. The former roadside stop is now a crumbling ghost town. Stop and visit at your own risk. ⊙

The famous twin arrows mark the exit. *Sue Smith/Shutterstock*

THIS EXIT FOR ANOTHER ROADSIDE ATTRACTION . . .

EXIT

Twin Arrows Trading Post >>

By Kathy Weiser

The next stop upon

your journey is the old Twin Arrows Trading Post at exit 219. A long-lasting Route 66 icon, the Twin Arrows Trading Post didn't cease doing business that long ago, as its price of gas is frozen at $1.39 per gallon. Sadly, its prominent red and yellow arrows are quickly deteriorating in the desert winds and the Arizona sun. ◉

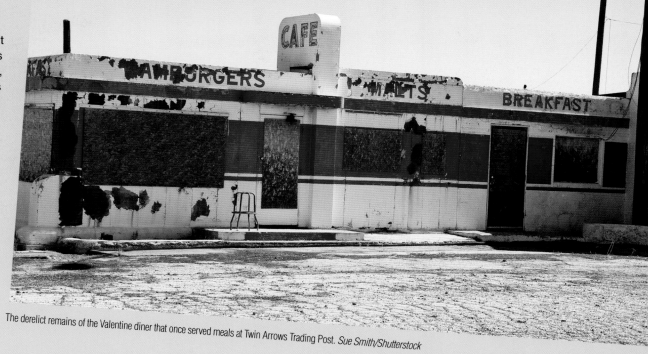

The derelict remains of the Valentine diner that once served meals at Twin Arrows Trading Post. *Sue Smith/Shutterstock*

A GREAT ROAD SHOW

Wherever it goes, "Route 66", 116 hours of realism and romance, runs competitors off the highway. This four year network favorite, starring George Maharis, Martin Milner and Glenn Corbett is now available for local TV. Great **SCREEN GEMS** for late afternoon or early evening stripping. For details contact

ROUTE 66 MYTHS AND LEGENDS

Route 66, TV Style

The Mother Road starred

on television in the 1960–1964 show *Route 66*. Actor Martin Milner played Tod Stiles alongside George Maharis as Buz Murdock, along with a Chevrolet Corvette. Together, they solved mysteries and righted wrongs. ◉

CAPITOL FULL DIMENSIONAL ⇆ STEREO

ST 1771

ROUTE 66 THEME

AND OTHER GREAT TV THEMES

NELSON RIDDLE AND HIS ORCHESTRA

BEN CASEY · THE DEFENDERS
DR. KILDARE · NAKED CITY
THE ANDY GRIFFITH SHOW
THE ALVIN SHOW
THE STEVE ALLEN SHOW
MY THREE SONS
SING ALONG WITH MITCH
SAM BENEDICT
THE UNTOUCHABLES

US 66

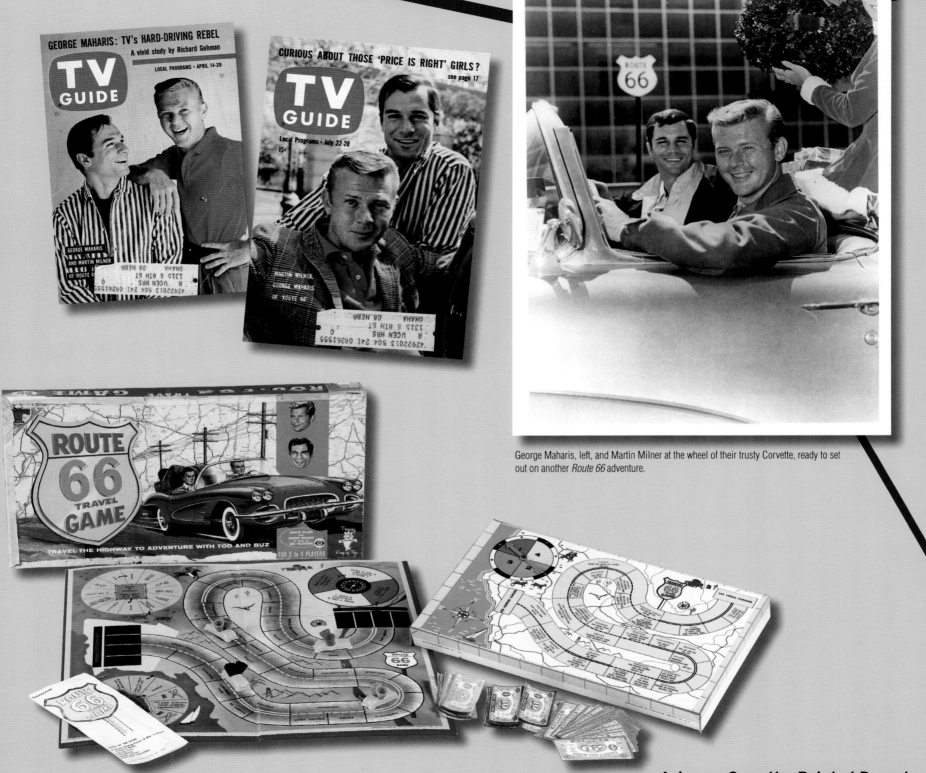

George Maharis, left, and Martin Milner at the wheel of their trusty Corvette, ready to set out on another *Route 66* adventure.

THE MOTHER ROAD LOST & FOUND

Canyon Padre Trading Post, Twin Arrows, circa 1949

By Russell A. Olsen

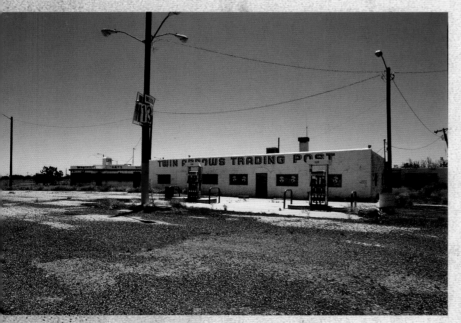

Then: The Canyon Padre Trading Post, Twin Arrows, Arizona.

Now: The Canyon Padre Trading Post, Twin Arrows, Arizona.

If you are looking for

the quintessential Route 66 tourist stop, the Canyon Padre Trading Post would have to be a frontrunner in the voting. The Canyon Padre Trading Post was built in the late 1940s and consisted of a store, gas station, and cafe. The cafe was a small, ten-stool diner designed by the Valentine Manufacturing Company. Such prefabricated diners were very popular during the 1940s and 1950s and can still be found throughout the United States.

Sometime during 1950s, the Canyon Padre Trading Post became the Twin Arrows Trading Post. To catch the eye of passing motorists, two brightly painted arrows, each twenty feet high, were placed alongside the main building. Made from old telephone poles, the arrows are one of the most frequently photographed sights along all of Highway 66 and are icons of roadside architecture. The Twin Arrows was even featured in a car commercial in the mid-1990s.

A wide variety of goods were available in the trading post, including Navajo rugs, moccasins, and jewelry. When the interstate came through in the late 1960s, an exit to the Twin Arrows saved it from certain demise. The trading post closed in the early 1990s, but in 1995 it was reborn with the help of Spence and Virginia Reidel. Advertised as "The BEST 'Little' Stop on I-40," the post once again featured shelves stocked with souvenirs and pumps dispensing gasoline. Unfortunately this rebirth did not last, and the business has remained closed since the late 1990s. The property has been severely neglected and is currently in an advanced state of disrepair. The twin arrows that once attracted camera-ready tourists from around the globe now stand beaten and worn, marking the end of an era. ◉

THE MOTHER ROAD LOST & FOUND

Ella's Frontier Trading Post, Joseph City, circa 1950s

By Russell A. Olsen

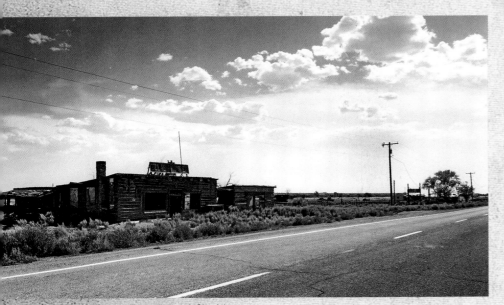

Then: Ella's Frontier Trading Post, Joseph City, Arizona.

Now: Ella's Frontier Trading Post, Joseph City, Arizona.

Ella's Frontier Trading Post

sits on an abandoned section of Route 66 just outside the western edge of Joseph City. The business was owned and operated by Ella Blackwell, who purchased the property (previously called the Last Frontier Trading Post) in 1955 after divorcing her husband. A former student at the Julliard School, Ella kept a piano in the store, which she claimed was established in 1873, making it the oldest such establishment on Route 66. Ella, however, was considered quite eccentric among locals, many of whom doubted her claim. Nevertheless, Ella's Frontier was in every way a classic tourist stop. Most of the things sold there—feather headdresses, moccasins, rubber snakes—would be considered mere souvenirs to adults, but treasures to kids traveling out west with their folks. Theo Hunsaker, the executor of Ella's estate, claims, "She had acquaintances all over the world; people who had stopped there would stay in touch with her." When she died in 1984, Hunsaker found duffle bags full of her correspondence.

In 1969, Interstate 40 bypassed Ella's, marking the beginning of the end for the longstanding roadside tourist stop. Standing on the dead-end road that once carried hundreds of automobiles each day with travelers gazing at Ella's Frontier and dreaming of the cold soda in the machine door or the large tomahawk under the counter glass, you get the feeling of being in a life-size, historical diorama—a living museum piece complete with a barely audible Mozart sonata drifting through the ruins. ◉

Flagstaff
City of Seven Wonders

By Kathy Weiser

WONDERLAND MOTEL—FLAGSTAFF, ARIZONA

Literally surrounded by seven natural wonders, Flagstaff, Arizona, is often called "the City of Seven Wonders" because it sits in the midst of the Coconino National Forest and is surrounded by the Grand Canyon, Oak Creek Canyon, Walnut Canyon, Wupatki National Monument, Sunset Crater National Monument, and the San Francisco Peaks.

The story of how Flagstaff obtained its name has several versions, all having to do with stripping a lone pine tree and making it into a flagpole. The spring and its small settlement had several names beginning with Antelope Spring, then Flagstaff, and then Old Town. By the time the Atlantic and Pacific Railroad (now the Santa Fe) came through in 1882, there were ten buildings in Old Town, but they soon moved closer to the new railroad depot. In no time at all, Old Town was almost deserted, and when a post office was established near the new train depot, the town assumed the name of Flagstaff. With the new railroad the lumber and cattle businesses began to thrive, assuring the growth of the community.

When Route 66 plowed through the burgeoning city of Flagstaff, a number of motor courts, auto services, and diners sprouted up along the new highway. Today the city still sports a number of vintage cafes and motor courts in its historic downtown district. There are several that are still open today, such as the Wonderland Motel, nestled up against the pine covered hills at 2000 East Route 66; the Frontier Motel, with its quiet yellow lantern, at 1700 East Route 66; the Red Roof Inn, with its flower filled window boxes, at 1526 East Route 66; the Saga Budget Inn Motel at 820 West Route 66, complete with bright blue neon sign; and many more. ◉

FLAGSTAFF, ARIZONA
Elevation 6,907 ft.
★
TOURIST MECCA OF
NORTHERN ARIZONA
★

	Miles
Grand Canyon Nat'l Park	89
Oak Creek Canyon	18
Sunset Crater	15
Cliff Dwellings	9
Montezuma Castle	68
Hopi Snake Dances (August)	115
Meteor Crater	45
Rainbow Bridge	165
Mormon Lake	25
Ice Caves	15
Painted Desert	115
Petrified Forest	115
San Francisco Peaks Drive	4

★
Last But Not Least—
THE BLACK CAT CAFE
—On U.S. 66

8A-H1682

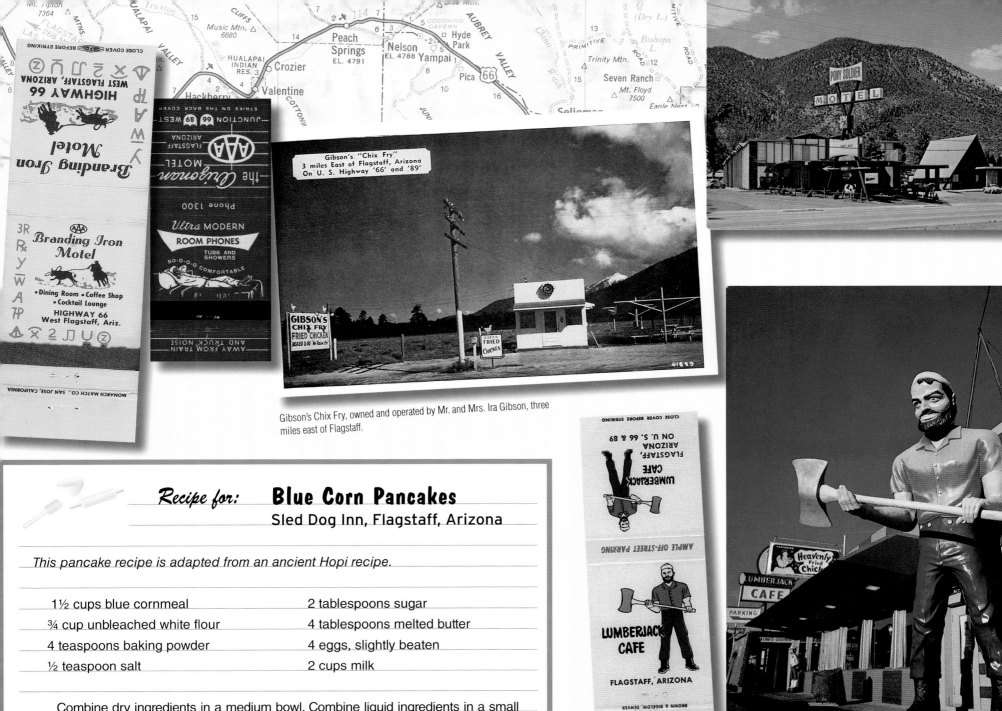

Gibson's Chix Fry, owned and operated by Mr. and Mrs. Ira Gibson, three miles east of Flagstaff.

Recipe for: **Blue Corn Pancakes**

Sled Dog Inn, Flagstaff, Arizona

This pancake recipe is adapted from an ancient Hopi recipe.

1½ cups blue cornmeal	2 tablespoons sugar
¾ cup unbleached white flour	4 tablespoons melted butter
4 teaspoons baking powder	4 eggs, slightly beaten
½ teaspoon salt	2 cups milk

Combine dry ingredients in a medium bowl. Combine liquid ingredients in a small bowl. Add the liquid ingredients to the dry and mix until moistened. Allow batter to sit a few minutes before cooking on medium hot griddle.

Flagstaff's Lumberjack Café—"Look for the Big 20 Foot Lumberjack!" *Michael Karl Witzel collection*

THE MOTHER ROAD LOST & FOUND

Winona Trading Post, Winona, circa 1955

By Russell A. Olsen

Then: The Winona Trading Post, Winona, Arizona.

Now: The Winona Trading Post, Winona, Arizona.

In the early 1920s,

Billy Adams built a one-story rock structure from river stones and nearby ruins and called it the Winona Trading Post. He offered necessities for modern motorists, including fan belts, coils, tools, and tires. Cold drinks and dry goods were also available. In 1924 a post office was established in the trading post, and Myrtle Adams became the first female postmaster in Arizona. Soon after completing the trading post, Billy Adams and his sons built ten small wooden cabins said to comprise one of the first motor courts in the United States. Each cabin measured 10x14 feet and featured a wood-burning stove, mirror, and washstand. In 1925, Adams built the two-story Winona Motel, once again of stone. The motel had fourteen rooms upstairs and a small lobby below. Through the 1940s it was a beehive of activity, especially during World War II when convoys of troops would come through town. Billy's son Ralph recalls, "They would buy every bottle of pop and every candy bar we had and run us out completely in one visit."

The early 1950s saw a realignment of Route 66 to its current location, and a new trading post, including a cafe, tourist cabins, and service station, was built alongside the new alignment. Billy Adams and his family eventually left the post to become ranchers. The current owners bulldozed the motel, trading post, and campground. ◉

Williams
Gateway to the Grand Canyon

By Kathy Weiser

Route 66 between Flagstaff and Williams, Arizona, running in the shadows of San Francisco Peaks.

Grand Canyon Caverns, 22 miles west of Seligman, were opened as a tourist destination in 1962.

Like the rest of the vast West, Williams was first home to many Native American tribes for thousands of years. Later Spanish explorers would first see the Grand Canyon while searching for the Seven Cities of Cibola in the mid-1500s. One can only imagine their amazement when stumbling upon that massive canyon, after having traveled hundreds of miles over nothing but desert sand.

In the early nineteenth century, mountain men began to push west in search of the plentiful game, when the fur trade was at an all-time high. One of these men was William Sherley Williams. "Old Bill," which he was most often called, wandered all over the western states as a trapper and a scout on the Santa Fe Trail. Soon other men in search of gold began to roam the area. After the Civil War, land speculators, anticipating the construction of the westward railroad, began to make claims on numerous areas in northern Arizona, including what would soon become Williams. Attracting sheep and cattle ranchers, the settlement was founded in 1876, taking the name of the famous mountain man, Bill Williams. In 1881 the first post office was established and on September 1, 1882, the railroad finally arrived. In no time at all, Williams became the shipping center for the nearby ranching and lumber industries.

In the beginning Williams, like so many other towns of the Old West, gained a reputation as a rough and rowdy settlement filled with saloons, brothels, gambling houses, and opium dens. Restricted by a town ordinance to Railroad Avenue's "Saloon Row," it didn't stop the numerous cowboys, railroad men, and lumberjacks from frequenting these many businesses.

In 1926, Route 66 was completed through Williams, which spurred several new businesses along the highway. It was this increased automobile traffic that would eventually shut down the rail service in Williams in 1968.

Ironically, the entire town would suffer the consequences of American's need for speed when Williams became the very last Route 66 town to be bypassed by I-40 on October 13, 1984.

Along the way, check out Cruiser's Cafe, which is housed in the old C. Bene Gas Station, the Turquoise Teepee, and Rod's Steak House, a Mother Road icon since 1945.

Williams' entire downtown area has been placed on the National Register of Historic Places, and there are several buildings along here that deserve a stop. One interesting business is the Red Garter Bed & Bakery, located at 137 Railroad Avenue. This century-old inn was once a popular saloon and bordello, and reportedly now houses a ghost. ◉

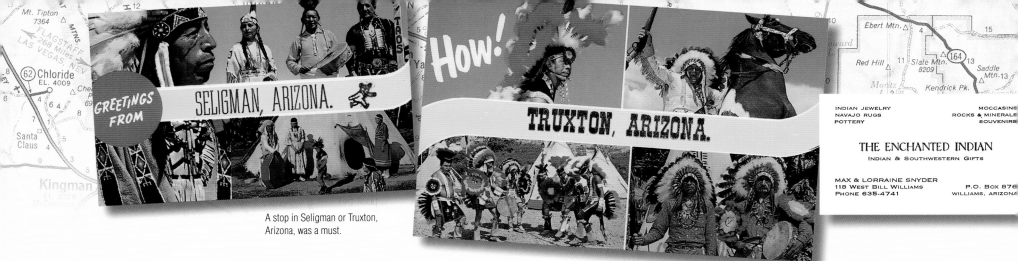

GREETINGS FROM SELIGMAN, ARIZONA.

How! TRUXTON, ARIZONA.

THE ENCHANTED INDIAN
Indian & Southwestern Gifts

INDIAN JEWELRY
NAVAJO RUGS
POTTERY

MOCCASINS
ROCKS & MINERALS
SOUVENIRS

MAX & LORRAINE SNYDER
118 West Bill Williams
Phone 635-4741

P.O. Box 876
WILLIAMS, ARIZONA

A stop in Seligman or Truxton, Arizona, was a must.

Recipe for: **Ranchero Sauce**
Old Smokey's Restaurant & Pancake House, Williams, Arizona

Old Smokey's is owned and operated by Dan and Clara Barnes.

1 can diced tomatoes	2 teaspoons garlic powder
1 can tomato paste	4 teaspoons chili paste
1 large pepper	2 teaspoons seasoning salt
3–4 ounces chopped green chili	1½ tablespoons sugar
1 medium onion, minced	

In a large skillet, saute the green peppers and onions. Add the rest of the ingredients and bring the mixture to a boil. Take off the heat and serve immediately.

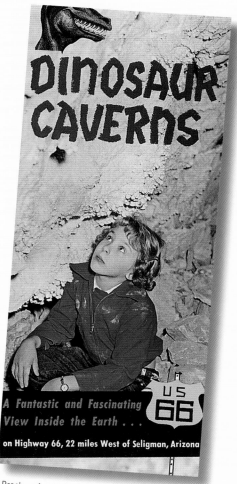

DINOSAUR CAVERNS

A Fantastic and Fascinating View Inside the Earth . . .

US 66

on Highway 66, 22 miles West of Seligman, Arizona

Brochure for the "Fantastic and Fascinating" Dinosaur Caverns.

Grand Canyon, Ariz.

Williams was the gateway for many a sidetrip to the Grand Canyon.

Howdy From WILLIAMS Arizona

Recipe for: Grand Canyon Green Chile Burro

2 cups broth or bouillon cubes

2 cups water

1 teaspoon oregano

1 small onion, chopped

2–3 cloves garlic, pressed

1 can (16 oz.) whole tomatoes

2 cups pork, cooked and diced

2 cups beef, cooked and shredded

2 cans (4 oz.) green chiles, chopped

1 teaspoon salt, or to taste

2 tablespoon cornstarch

flour tortillas, warmed

Place the broth or bouillon and water in a large Dutch oven. Add the oregano, onion, garlic, and tomatoes. Cook until the onion is tender. Add the meat and chiles and stir well. Cook at medium heat for 20 minutes. Make a paste of water and cornstarch and add to the meat mixture. Cook slowly until thick. Spoon onto warmed flour tortillas.

Serves 4 to 6.

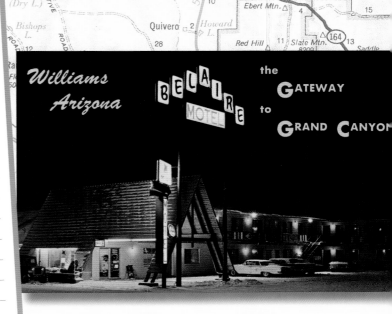

Williams Arizona — the Gateway to Grand Canyon — BEL AIRE MOTEL

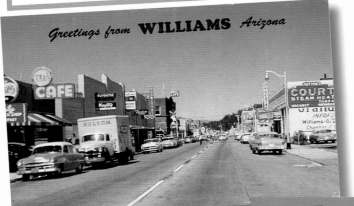

Greetings from WILLIAMS Arizona

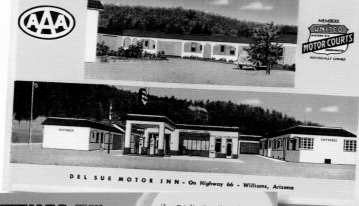

DEL SUE MOTOR INN - On Highway 66 - Williams, Arizona

GREETINGS FROM THE INDIAN COUNTRY OF THE GREAT SOUTHWEST

PUEBLO INDIAN GIRL BEADING RABBIT FOOT DOLLS

Arizona: Over the Painted Desert 201

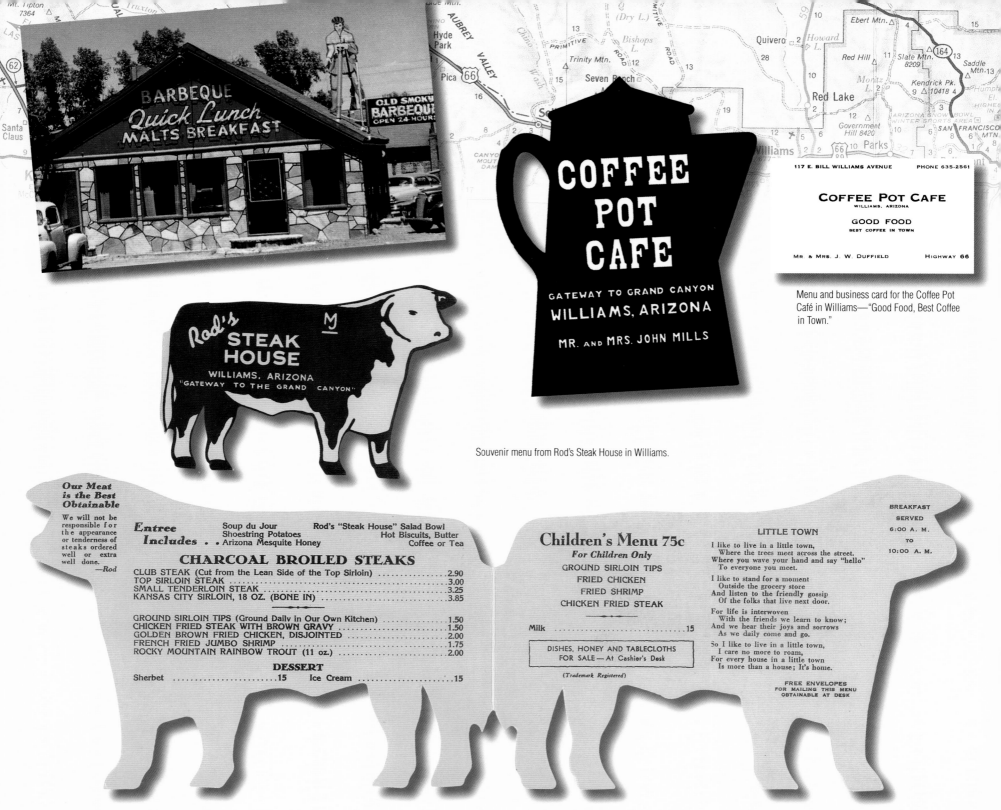

Menu and business card for the Coffee Pot Café in Williams—"Good Food, Best Coffee in Town."

COFFEE POT CAFE

GATEWAY TO GRAND CANYON

WILLIAMS, ARIZONA

MR. AND MRS. JOHN MILLS

117 E. BILL WILLIAMS AVENUE PHONE 635-2561

COFFEE POT CAFE
WILLIAMS, ARIZONA

GOOD FOOD
BEST COFFEE IN TOWN

MR. & MRS. J. W. DUFFIELD HIGHWAY 66

Souvenir menu from Rod's Steak House in Williams.

Rod's **STEAK HOUSE**
WILLIAMS, ARIZONA
"GATEWAY TO THE GRAND CANYON"

Our Meat is the Best Obtainable

We will not be responsible for the appearance or tenderness of steaks ordered well or extra well done. —Rod

***Entree Includes* . .**
Soup du Jour Rod's "Steak House" Salad Bowl
Shoestring Potatoes Hot Biscuits, Butter
Arizona Mesquite Honey Coffee or Tea

CHARCOAL BROILED STEAKS

CLUB STEAK (Cut from the Lean Side of the Top Sirloin) 2.90
TOP SIRLOIN STEAK ... 3.00
SMALL TENDERLOIN STEAK .. 3.25
KANSAS CITY SIRLOIN, 18 OZ. (BONE IN) 3.85

GROUND SIRLOIN TIPS (Ground Daily in Our Own Kitchen) 1.50
CHICKEN FRIED STEAK WITH BROWN GRAVY 1.50
GOLDEN BROWN FRIED CHICKEN, DISJOINTED 2.00
FRENCH FRIED JUMBO SHRIMP 1.75
ROCKY MOUNTAIN RAINBOW TROUT (11 oz.) 2.00

DESSERT

Sherbet15 Ice Cream15

Children's Menu 75c
For Children Only
GROUND SIRLOIN TIPS
FRIED CHICKEN
FRIED SHRIMP
CHICKEN FRIED STEAK

Milk ..15

DISHES, HONEY AND TABLECLOTHS
FOR SALE — At Cashier's Desk

(Trademark Registered)

LITTLE TOWN

I like to live in a little town,
 Where the trees meet across the street.
Where you wave your hand and say "hello"
 To everyone you meet.

I like to stand for a moment
 Outside the grocery store
And listen to the friendly gossip
 Of the folks that live next door.

For life is interwoven
 With the friends we learn to know;
And we hear their joys and sorrows
 As we daily come and go.

So I like to live in a little town,
 I care no more to roam,
For every house in a little town
 Is more than a house; It's home.

BREAKFAST
SERVED
6:00 A. M.
TO
10:00 A. M.

FREE ENVELOPES
FOR MAILING THIS MENU
OBTAINABLE AT DESK

Kingman
Gateway to Hoover Dam

By Kathy Weiser

◄)) Did you know Oprah Winfrey drove Route 66 through Arizona in 2006, or that she stopped in Kingman, Arizona, to feature Mr. D'z Route 66 Diner (the former Kimo Café) on her show? Did you know that when the show aired she gave everyone in her audience samples of the diner's signature root beer?

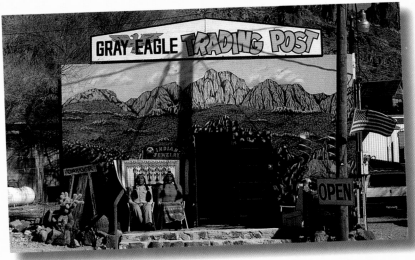

Gray Eagle Trading Post in Oatman.

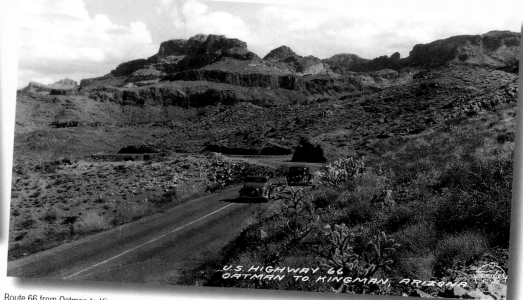

Route 66 from Oatman to Kingman, Arizona, circa 1947.

In October 1857, Lieutenant Edward Fitzgerald Beale first explored the present site of Kingman when he and his team surveyed the thirty-fifth parallel in anticipation of building a wagon road. In the heat of the desert they used camels for transportation, an idea they were sure would catch on. Alas, it never did. When the wagon road, stretching from Fort Defiance, New Mexico, to the Colorado River was complete, it was named for the lieutenant. Soon Beale Road saw all manner of travelers trekking through the desert. In the beginning these were primarily miners and prospectors seeking their fortunes.

When the railroad began to reach this part of the west, a man named Lewis Kingman surveyed the route between Albuquerque, New Mexico, and Needles, California, in 1880. The new railroad, when it arrived, would closely parallel Beale's old wagon road. Later, when Route 66 came barreling through, it too would closely follow this historical path.

In 1882, a settlement cropped up along the railroad tracks that soon had a rooming house and a couple of stores. The fledgling town was named after Lewis Kingman, the railroad surveyor. ◉

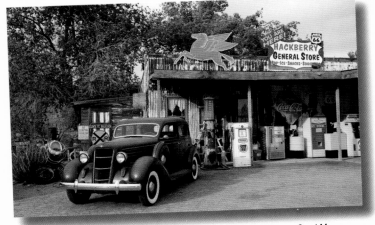

The famed Hackberry General Store on old Route 66 in Hackberry, Arizona. *Carol M. Highsmith's America, Library of Congress*

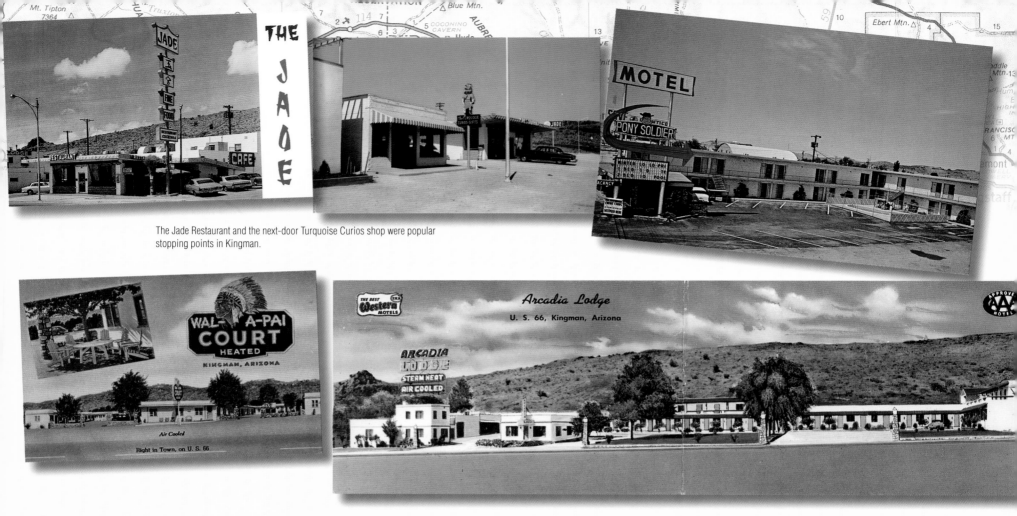

The Jade Restaurant and the next-door Turquoise Curios shop were popular stopping points in Kingman.

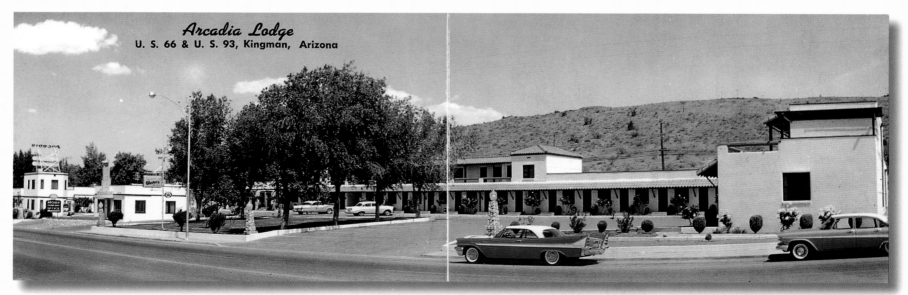

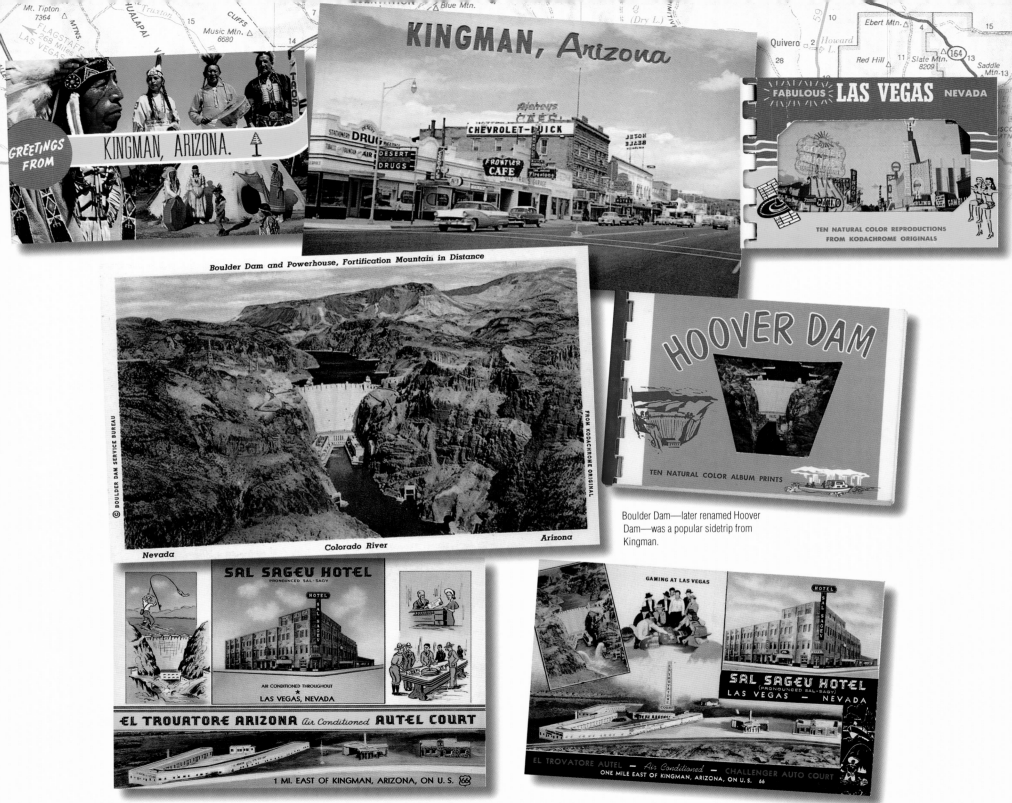

Boulder Dam—later renamed Hoover Dam—was a popular sidetrip from Kingman.

A sidetrip to Las Vegas, Nevada, was a common destination—for those without children, of course.

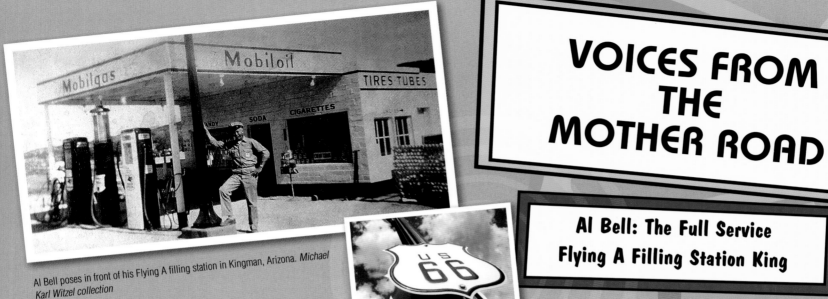

Al Bell poses in front of his Flying A filling station in Kingman, Arizona. *Michael Karl Witzel collection*

VOICES FROM THE MOTHER ROAD

Al Bell: The Full Service Flying A Filling Station King

By Michael Karl Witzel

In its heyday, Route 66 hosted a number of larger-than-life attractions, many actual businesses themselves. For motorists cruising into Kingman, Arizona, this was plainly evident: here was Al Bell's filling station, a flagship Flying A refueler that had more in common with a drive-in automobile casino than a place where cars guzzled gasoline.

At Bell's, it was the sign that was the main attraction. Going east or west, you could see it for miles, resplendent in the evening hues of the desert with its 209 light bulbs, electrified arrows, and sequentially flashing lights. Add some neon tubing for extra effect and you had a billboard that was hard to resist. This was the Arizona desert, folks—stereotyped with images of bleached cow skulls, vultures perching atop cacti, and people dying of thirst. That's why the smaller sign that advertised "Jugs Iced Free" was so important.

For those only familiar with today's bottled waters and canned energy drinks, that meant you could bring in a container and get free ice water. During the halcyon days of travel—before the ice cube became the ubiquitous commodity that it is today—it was much more difficult to get a cold drink on demand. And, if you were traveling through the desert on the way to California, there was no way you could make it without a supply of H_2O, especially if you were driving a car without air conditioning. Plus, if an overheated engine slowed you down, you could use your supply to refill your steaming radiator, too.

Bell's big sign shone brightly from Memorial Day until the last week of September, during the times when Route 66 was the most packed with traffic.

For the sake of his bank account, Bell finagled a deal with Tidewater Petroleum to cover the cost of the outlandish electric bill. It was a win-win arrangement for both, since the three-story monstrosity pulled $150 worth of kilowatt hours in a month's time! During the 1950s, that was a lot of juice.

When the summer temperatures were at their peak, hundreds of cars poured in from 66—many of them coasting on fumes. Beneath the glowing neon, they found the ultimate in car service, featuring four service islands, twelve fuel pumps, and eight drive-through lanes. Four pump jockeys dressed in white overalls and bow ties worked as a team. One wiped the windows while another checked the oil. A third attendant checked the tire pressure as the fourth pulled the oil dipstick. Mr. Goodwrench would have been green with envy.

Serving up the ice water was the job of Bell's son, Bob. Like a carhop at a drive-in, young Bob ran out to the cars as soon as they came to a stop and poked his head in the window. "I'm not sure how many times I asked 'Got any jugs you want iced?'" he recalls. A heavy-duty York ice machine cranked out the shimmering cubes at the rate of 450 pounds per day. Bob began toting the frozen crystals to the cars when he was only nine years old and worked every season until he graduated from high school. His only pay came from tips.

"What was amazing about working at the station was that during the 1950s everybody was bound for California," he remembers. "Many thought it was the promised land out there. You could see it in their eyes. During July, it was around 103 degrees in Kingman, and they would all get out of their cars wilted from the

Al Bell's Flying A station in the late 1950s. *Michael Karl Witzel collection*

heat and ask, 'How far to California?' I'd say, 'About sixty miles.' Almost every time, they would smile and blurt out, 'Oh . . . thank God!' I didn't have the heart to tell them that sixty miles away was California all right—Needles, one of the hottest locations on the planet other than Death Valley!"

One afternoon, Bob was filling up a tank with gasoline when he heard sirens. While holding the filler nozzle, he watched Floyd Cisney (his baseball coach and a part-time driver in the demolition derby) pull up alongside a speeding car, pass it, and turn, forcing both vehicles off the road. "That part of 66 was a bottleneck for hot cars," explains Bell. "Cisney held the record for nabbing stolen vehicles with over five thousand arrests to his credit!"

Unfortunately, the super station setup eventually ran its course, as all good things eventually do. By 1959, Al Bell reached his goal of bringing in $100 a day. When Tidewater took a look at his receipts, they told him that he was "makin' too much money!" Greed got the best of them and now, they wanted more money for the lease. Bell declined. Another guy took over but couldn't make a go. As Bell tells it, "the Flying A Station went successfully downhill." It took more than a glittery sign to make it along Arizona Route 66.

The Flying A Stations were eventually bought out by Phillips Petroleum in the west and the fanciful winged logo retired. The 1960s brought other changes as well, the most notable being the arrival of the interstate highways and the rerouting of traffic around many once-bustling Route 66 venues. After the river of cars thinned out to a mere trickle, there was no way that anyone could keep a

A Flying A attendant offering service with a smile.

filling station profitable, despite the razzmatazz of flashing signs, billboards, and other attention-getting devices they could think of.

The age of self-service began its insidious incursion into the realm of the service station and ever so gradually, the methods of operation that were once taken for granted were shelved in favor of discount prices. Along the Mother Road, even the great stations like Al Bell's fantastic Flying A crumbled. Within a few years, the only remnants were broken-down walls and rusting gas pumps—tombstones memorializing the forgotten era of full service, jugs iced free, and the great American gas station. ◉

ROUTE 66 MYTHS AND LEGENDS

Kingman: Mother Road Landmark

By Jim Hinckley

Kingman in western Arizona

will forever be associated with the Mother Road thanks to Bobby Troup and his classic song, "(Get Your Kicks on) Route 66," which transformed a U.S. highway into an icon. However, this is not the only brush with fame the dusty desert town named for Lewis Kingman, a railroad engineer and surveyor, has had.

In 1857 Secretary of War Jefferson Davis, the president of the Confederacy during the Civil War, under direction from President James Buchanan, authorized Lieutenant Edward Beale to survey a road that would connect Fort Defiance in the territory of New Mexico with Fort Mohave on the Colorado River. This expedition was to have a second purpose: testing the viability of camel transport for military application in the desert southwest.

A dependable all-year source of water to the west of present-day Kingman was designated Beale Springs. Additional homage to Beale came in the name bestowed upon the fort established at the springs during the 1870s and a primary street in Kingman that runs parallel to Route 66.

The railroad in its westward expansion during the 1880s closely followed the road he surveyed, known as the Beale Wagon Road, along the thirty-fifth parallel. In turn, the railroad was followed closely by the National Old Trails Highway and then by the first alignment of Route 66.

The National Old Trails Highway figured prominently in the last of the Desert Classic Cactus Derby races. The course for the 1914 race was from Los Angeles to Ashfork in Arizona, and then south through Prescott to Phoenix. This incredible test of machine and man featured some of the most prominent names associated with the sport of racing during this period, including Louis Chevrolet and Barney Oldfield. The racers stopped long enough in Kingman for fuel and much-needed repairs.

It is unknown if nine-year-old Andy Devine, the gravely voiced character actor, turned out to watch the racers roar into town, but he would have had a front row seat if he did. His father, Tom Devine, was the proprietor of the Hotel Beale on Front Street.

Initially the hotel where Andy Devine received the injury that permanently damaged his vocal chords was one block north of Route 66, but after the realignment of 1937, the highway was at its front door. It was during a segment of *This Is Your Life* that Andy Devine learned that this street was being renamed Andy Devine Avenue. Signage today still carries this designation for Route 66 from east to west through Kingman.

Another Route 66 landmark associated with Andy Devine is the Crozier Canyon Ranch to the east of Kingman near Hackberry, where he worked during the late teens. In addition to ranching, the Crozier also served as a small resort with bathhouses and a huge spring-fed swimming pool. The railroad provided Sunday afternoon excursions from Kingman during the months of summer, making this oasis a very popular getaway.

The Crozier Ranch has another link to Hollywood hidden away in the downstairs bathroom; Fatty Arbuckle's bathtub obtained from a Ground's family (owners of the ranch) associate who'd worked as an architect in Los Angeles and remodeled the actor's home. ◉

THE MOTHER ROAD LOST & FOUND

Ed's Camp, Goldroad, circa 1947

By Russell A. Olsen

Then: Ed's Camp, Goldroad, Arizona.

Now: Ed's Camp, Goldroad, Arizona.

Beginning the rugged

approach to Sitgreaves Pass from the east, one of the most feared and dreaded sections on all of Route 66, travelers will notice the fading letters of Ed's Camp, spelled out in painted white rocks on the side of a hill. Lowell "Ed" Edgerton purchased the property that Ed's Camp sits on in the late 1930s, hoping to cash in on the ever-increasing flow of tourists. Throughout the 1930s and 1940s, Edgerton expanded his desert oasis to include a grocery store, gas station, trailer camp, and souvenir shop. It was a "camp" in every sense of the word—there were never any cabins or rooms at the site. Motorists on a budget would pull in and sleep in tents or in their cars. For a dollar, a tired traveler with a little bit of extra cash could sleep on a cot in a screened porch. Water was an-all-too precious commodity and was sold to guests on a per-bucket basis unless they paid the buck to spend the night—then it was free.

Edgerton went on to become a world-renowned figure in the field of geology. Amateur geologists came from around the world to hunt the area for precious stones, paying Edgerton a small fee for the privilege. In 1952, Route 66 was realigned around the Black Mountains from Kingman to Topock, bypassing the steep and treacherous mountain pass. Ed died in 1978, but his camp remains, for all intents and purposes undisturbed and hearkening back to better days. ⊙

8 California

The Journey's End

Jim Hinckley

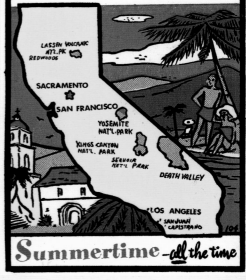

Route 66 from the Colorado River to the coast at Santa Monica is largely intact, with only a few short sections truncated or obliterated under the modern highway system. At the western terminus preservation is largely the result of the explosive metropolitan growth that swallowed the highway with surface streets and boulevards. The remainder survives for the same reason the ruts of the old Mohave Road, the scars from World War II maneuvers, and Native American trade routes survive: this is the harshest climate in the United States and increments of centuries, not decades, mark change.

The hottest temperatures in the nation, often for days at a time, are recorded in Needles, California. This and the fact that the country to the west is a vast desert wilderness with very limited services gave rise to a lucrative service industry that met the needs of motorists, first on the National Old Trails Highway and then on Route 66.

An amazing number of these business locations survive, though in different guises from original intent. There are even vestiges from the years before the automobile and the airplane nudged the railroad from prominence, such as El Garces, a former Harvey House on the square.

From Needles to the summit of South Pass the post-1931 alignment of Route 66 lies buried under the four lanes of I-40. The earlier alignment of Route 66 remains, following the railroad north behind the mountains and through the ghost town of Goffs before rejoining the modern incarnation of Route 66 and I-40 at Fenner, another wide spot in the road.

The harsh beauty of the desert landscapes that seem void of constraints of time mock the feeble attempts of man to make his mark here, as evidenced by the weathered stations, the ruins, and the thin thread of asphalt that rolls west across the rock-strewn plains. This section of Route 66, enveloped in such surreal beauty, is truly haunting.

The little town of Essex exemplifies just how remote and desolate the path Route 66 follows across the Mohave Desert is. During World War II, a small prisoner of war camp was located here, as there was very little fear that anyone would escape. In 1977, the town received international attention on *The Johnny Carson Show* as the last town in America without television reception.

For long stretches, the road runs arrow straight across the desert plains accentuated with barren knobs of rock and long dark flows of ancient lava. Even barren oases, such as Chambless or Danby, that consisted of a tree, a service station, and running water must have seemed heaven sent to travelers on Route 66, especially in the years before air conditioning. Today only forlorn ruins mark the site of many of these oases and only the most obsessed fan of the highway will care enough to seek these faint traces amongst the desert brush.

Surprisingly, the resurgent interest in the highway has breathed new life into a few survivors, some with histories that predate Route 66. Amboy, with Amboy Crater dominating the immediate southern horizon and recently purchased by a successful California businessman, is undergoing renovation. In the old mining

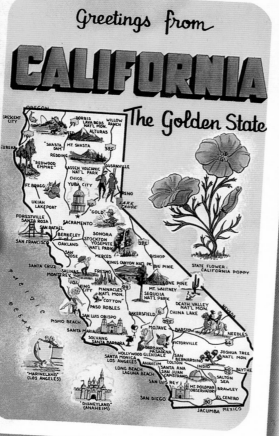

town of Ludlow, the cafe has a new lease on life, and the motel is a favorite secret among Route aficionados.

In some of the desert towns, where everything seems frosted with the patina of age, Route 66 is simply another chapter in a long history of boom and bust. In Daggett, once a railroad stop and an important supply center for area mines, the Stone Hotel is now empty but the Desert Market, opened in 1908 as Ryerson's General Store, still meets the needs of locals and travelers alike.

The road (be it the National Old Trails Highway, Route 66, or I-40) and the railroad have long been a key component of life in Barstow. Modern hotels and truck stops, dark neon on equally dark motels, and the recently refurbished Harvey House that is now home to a railroad museum as well as a Route 66 museum, are manifestations of this long association with transportation and tourism.

From Barstow to Victorville, the old road follows the course of the Mojave River in a gentle curve, as did its predecessors the National Old Trails Road, the Spanish Trail, and the Mojave Road. Modernity encroaches with housing developments and the trappings of suburbia, but to a large degree the road is as it was. Only the ruins and skeletal remnants of roadside businesses hint that this is no longer the Main Street of America.

To a large degree Route 66 has been erased on the Cajon Pass by I-15, just as U.S. 66 erased the National Old Trails Highway, which erased traces of the old Spanish Trail. Still, there are vestiges of those bygone times, such as the Summit Inn and the Old Outpost Café.

From Cajon Pass to the end of the road at Ocean Avenue and Palisades Park in Santa Monica, a few blocks from the historic Santa Monica Pier, Route 66 is a seemingly endless string of stoplights and traffic. As a result, only passengers will have the opportunity to marvel at the vast array of vintage Route 66 landmarks that line both sides of the old highway.

There is the historic Arroyo Seco Parkway in Pasadena and the Wig Wam Motel in Rialto, cousin to the teepee motel in Holbrook; the historic Sycamore Inn, built in 1848, in Rancho Cucamonga; and literally hundreds of similar historic locations. To drive Route 66 through the urban landscapes of the greater Los Angeles area is to understand why, by 1970, the old highway had outlived its purpose just as the Spanish Trail before it.

Route 66 in California offers a multitude of fascinating and unique opportunities to experience the non-generic era. It is also an unusual opportunity to add context to the concept of "good old days." ⊙

Vintage Roto-Map for Route 66 into Los Angeles.

Needles

Gateway To The Colorado River

By Kathy Weiser

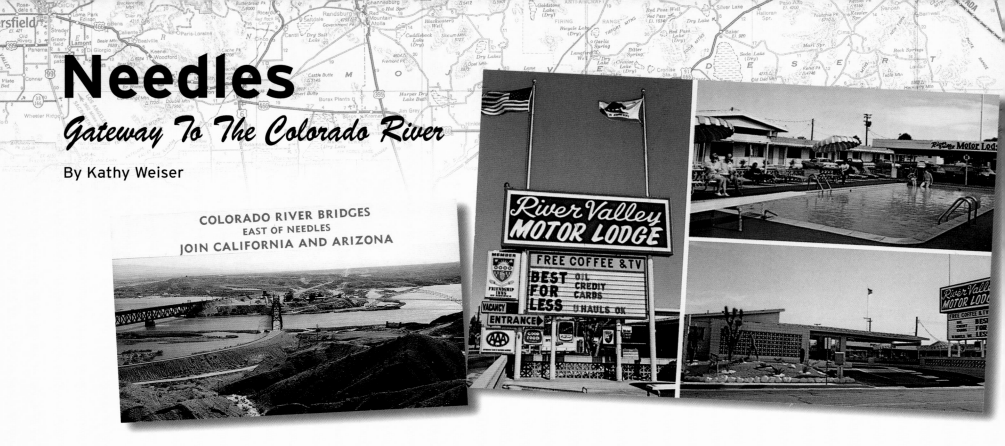

COLORADO RIVER BRIDGES
EAST OF NEEDLES
JOIN CALIFORNIA AND ARIZONA

Long before the town of Needles was founded, this valley was home to the Mojave Indians for thousands of years, many of whom still live in the area today. The area, rife with petroglyphs, pictographs, old trails, and stone work, bears witness to the ancient Native Americans that lived here long before the white man entered the area.

When the railroad pushed westward at the Colorado River in 1883, the town was founded and called "the Needles," after the sharp peaks at the southerly end of the valley. In the beginning most people traveled to Needles by rail, and a wooden depot was built to accommodate the steam engines and the many travelers.

When the original depot was destroyed by fire, it was replaced by El Garces Harvey House and Train Depot, which was completed in 1908. The building was named El Garces in honor of Father Francisco Garces, a missionary who visited the area in 1776.

El Garces was part of the Fred Harvey chain of hotel restaurants that extended along the Santa Fe Railroad to provide meals and lodging. Considered the crown jewel of the entire Harvey chain, El Garces is remembered for the real linen and silver, distinctive china, and fresh flowers provided for its guests daily. The food, served for lunch and dinner, was of the highest quality. The lunchroom had two horseshoe-shaped counters that could accommodate many people. Community members also utilized the facilities for elegant private dinners, banquets, and special occasions.

The waitresses, who soon earned the moniker of "Harvey Girls," were cultured young ladies, some from foreign lands. They received special training in neatness, courtesy, and excellent service. Though they were required to sign a contract not to marry for one year, many eventually married railroad men once their contracts were satisfied.

Harvey Girls and management lived upstairs from the dining room. Legend has it that railroaders in the early twentieth century would clamber atop the railcars during late afternoon stops at El Garces, hoping they could spot some of the Harvey Girls relaxing in their nightgowns outside their dormitory.

As automobiles became more popular, travelers still stopped at El Garces as they made their way down the Old Trails Highway, which was later renamed Route 66 when the highway connected Chicago, Illinois, to Santa Monica, California.

When the Mother Road was completed, thousands dust bowl escapees and tourists journeyed to California, and Needles sprouted all types of services, motels, and cafes, many of which can still be seen today.

In the 1950s dams were built along the Colorado River, which ended a long history of flooding in the region and made the land around Needles suitable for agriculture. This, as well as new recreation opportunities for boating and fishing, gave a boost to the Needles economy.

When I-40 threatened to bypass Needles, local citizens worked hard to keep the freeway from missing the town and condemning it to a slow death.

Recipe for: **Potato Cake**
Old Trails Inn, Needles, California

1 cup shortening	1 teaspoon cinnamon
2 cups sugar	2 teaspoons baking soda
3 eggs	2 cups flour
1 cup cold mashed potatoes	½ cup sour milk
2 tablespoons cocoa	

Whip the shortening and blend in sugar. Add the eggs and potatoes. Combine dry ingredients and add to the egg mixture along with the sour milk. Mix until blended.

Pour batter into two 8-inch greased cake pans. Bake at 350 F for 30 minutes.

Makes 12 servings.

Route 66 running through the mountains near Needles.

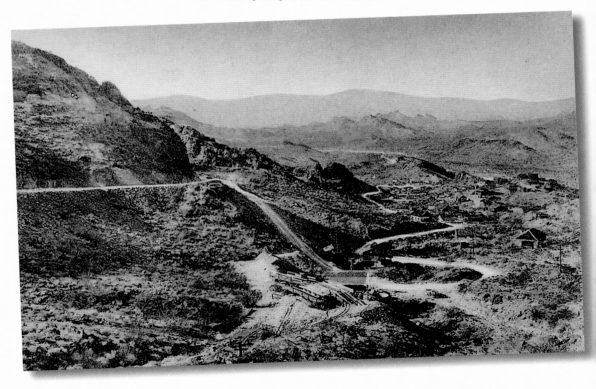

Their efforts prevailed, which contributed greatly to the town's promising future.

For those traveling the Mother Road, approximately ten miles of Route 66 is located in Needles, where a number of vintage icons can still be seen today, including the Route 66 Motel, the Palm Motel, the former El Garces Fred Harvey Hotel and Santa Fe Depot, the Historic Needles Theatre, and several other old motels.

Enjoy the beautiful desert surroundings and the scenic Colorado River before continuing your journey along the Mother Road. A word of caution—you have more than 150 miles of barren desert ahead with not a single service stop if you take original Route 66, and only a few stops if you take I-40, where you will pay outrageous prices at the gas pumps. Fill up your tank in Needles, or better yet, fill it up in Arizona before crossing to California to save a few bucks for a much-needed ice cream sundae after crossing the long, hot Mojave Desert.

An old alignment of Route 66 presents itself just after passing through Needles. At the Moabi Road exit, the old 1947–1966 Route 66 winds around past a campground and under a railroad bridge to dead-end at the Colorado River. After making this short detour, return to the Moabi Road exit and join I-40 westbound to continue your trip along Route 66. ◉

Ghost Towns Across the Mojave

The Amboy Crater along Route 66.

Old Route 66 runs through the ghostly remains of once-thriving traveler's stops in the Mojave Desert. *Alex Garaev/Shutterstock*

Interstate 40 left in its a wake more than a hundred miles of old Route 66 that is today littered with ghost towns. From Goffs, near Needles, California, all the way to Ludlow, where the Mother Road picks back up with I-40, the desert is littered with relics from the past and little more.

While driving this dry, barren stretch of battered highway, one can only imagine how difficult it would have been to travel it as a fleeing dust bowler in the 1930s. With dreams of "beautiful California" and its golden opportunities dancing in their heads, what a letdown it must have been to arrive in this sweltering bit of desert.

If you are a ghost town enthusiast, this old stretch of the road is a dream come true, with a plethora of crumbling buildings and photo opportunities. But if you're looking for quaint stopping points, curio stands, or open gas stations, restaurants, or motels, you won't find it on this abandoned piece of pavement.

Exiting off of I-40 at U.S. 95 North, you will turn left onto Goffs Road, which will lead you down a forty-mile stretch of near nothingness. This pre-1931 alignment of Route 66 was once home to several towns, including Ibis,

Bannock, and Homer, nothing of which can be seen today before reaching what is left of Goffs.

The ghost town of Goffs has a few interesting remnants, including an old general store and a 1914 schoolhouse that has been renovated by the Mojave Desert Heritage and Cultural Association and now houses a museum. The association maintains a collection of historical materials inside the schoolhouse and dozens of artifacts outside, including vehicles and mining equipment. The rest of the town is a lonely sight with nary a soul around and littered with junk and falling relics of the former mining industry.

On to what was once the small town of Fenner, old Route 66 crosses under I-40 and continues on to Essex, where you can see the post office and the remains of an old gas station out in the middle of nowhere. Beyond Essex were once the towns of Danby and Summit, of which nothing remains today.

Continuing your journey down this crusty road you will soon come to a once-popular stop at Chambless, California, then on to Amboy, Ludlow, and Daggett. ◉

660 JOSHUA PALMS ON THE DESERT

3A-H994

The beautiful side of the Mojave Desert.

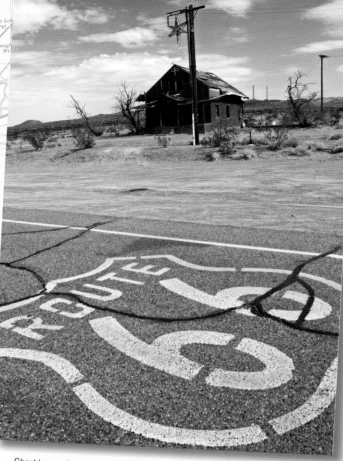

Ghost town ruins in the Mojave Desert near Ludlow, California.
Zinnanti/Shutterstock

Recipe for: **It's Not Your Mother's Meatloaf**
Bagdad Café, Bagdad, California

Seasoning Mix:

1 whole bay leaf

pinch cayenne pepper

¾ teaspoon black pepper

½ teaspoon cumin

¼ teaspoon nutmeg

Meatloaf:

3 tablespoons butter

¾ cup chopped onions

½ cup chopped celery

½ cup chopped green bell pepper

¼ cup chopped scallions

2–5 cloves of garlic, minced

Hot Sauce to Taste:

1 tablespoon Worcestershire sauce

¼ cup milk

¼ cup ketchup

1¼ pounds ground beef

¾ pounds ground pork or

 sausage

2 eggs, lightly beaten

1 cup fine dry bread crumbs, with

 Italian seasoning

Combine the seasoning mix and set aside. Melt the butter in saucepan over medium heat. Add the onions, celery, bell peppers, scallions, garlic, hot sauce, Worcestershire sauce, and seasoning mix. Saute 5 to 6 minutes, stirring occasionally. Mixture will begin sticking to bottom of pan; scrape the bottom as you stir. Add the milk and ketchup. Continue cooking for about 2 minutes, stirring. Remove from heat and allow mixture to cool to room temperature. Remove bay leaves.

In a bowl, place the ground beef, pork, eggs, cooked vegetable mixture, and bread crumbs. Thoroughly mix by hand. Shape into a loaf and place in the middle of a 9x13-inch baking pan.

Bake at 350˚ F for 30 minutes, then raise heat to 400˚ F and continue cooking until done, about 30 minutes longer.

Recipe for: **Guacamole**
Chambless Camp, Cadiz, California

Chambless Camp in Cadiz was in the jagged Marble Mountains and run by Gus Lizalde. The camp was known for its great Mexican food.

3 ripe Haas avocados

1 tablespoon warm water

1 small tomato, finely diced

1 small onion, finely diced

pinch of salt

Spoon out the avocado and mash. Add water to the pulp and blend until soft and smooth. Stir in the tomato and onion. Salt to taste.

Makes 2½ cups of guacamole.

Andre Pruitt. *Michael Karl Witzel collection*

VOICES FROM THE MOTHER ROAD

Andre Pruett: Proprietor of Mojave's Bagdad Cafe

By Michael Karl Witzel

Andre Pruett and her husband first came to the Mojave Desert to buy land. The plan they had in mind was for Harold to start a small ostrich farm and for Andre to concentrate on her freelance writing career. They hoped that the high desert location would provide them plenty of space . . . and the peace and quiet to get things done.

As it happened, their land search didn't take very long, and they soon came across a 2.5-acre plot that already had a water well and fencing, so they bought it. Afterward, they stopped for a bite to eat at a local place called the Sidewinder Café. During the meal Harold got to talking with the owner, and learned from the lady that the restaurant was somewhat famous. The proprietor bragged about how it "was in a movie" and that—by the way—it was presently for sale. She threw out a price . . . and Harold's ears perked up.

That's when the simple plans the Pruetts had when they first arrived changed. Harold shot a quick glance back at Andre, only to hear her say, "Don't even think about it!" But it was too late. There was nothing she could say about it, Harold was already dreaming, his imagination already turning, dreaming, and scheming about all the great things he could do with the diner. He assured her that he would run the place and that she would be able to concentrate on her creative work. To help out, he would bring in another couple as partners.

Ultimately the friends never showed, and the Pruetts had to go it alone; it really didn't matter, as Harold was completely gung-ho about the plan. He jumped right in and soon they were working out the kinks, learning how to run the Sidewinder all by themselves. Of course, Andre's writing plans were put on hold.

It was the winter of 1995 when the Pruetts ended their residence of twenty-one years in Los Angeles and began their new life in the desert. Eventually, they bought 642 acres and Harold started raising his ostriches. To start fresh, they decided to rename the restaurant the Bagdad Café. But while changing the name was easy, the restaurant business turned out to be a big challenge for Andre. "At the time, there were two waitresses and a cook working there, and I overheard them say, 'She won't last six months!' Well, I've been here for ten and a half years and they've been gone for quite a while now," Pruett recalls.

As she gained more experience in her new occupation as manager, cook, waitress, and resident dishwasher, she also learned from the locals that her Bagdad Café wasn't the first one. The original cafe that had the same name was between Amboy and Ludlow, in the Route 66 town known as Bagdad. The town was still managing to hang on, but there was nothing left of the old Bagdad Café except a crumbling concrete slab.

She also discovered a few interesting things about the Sidewinder, namely that it was built during the late 1940s and closed down around 1975. In 1982 it was remodeled by Jack and Shirley Hileman. Two years later, the cafe was sold to Harold and Stephanie Kelly and Jerry and Kim Fessler, who leased the building from Ed Young—a local fellow who purchased the building as an investment.

Andre was already up to speed about the joint's famous movie tie-in. All of *that* hoopla took place in 1987, when the production company for producer Percy Adlon's film *Bagdad Café* (called *Out of Rosenheim* in Europe) descended upon

A forlorn Airstream trailer left over from filming the movie *Bagdad Café. Michael Karl Witzel collection*

The dilapidated motel sign at Bagdad. *Michael Karl Witzel collection*

the Sidewinder and commenced to filming the movie there. Some of the local residents even appeared as extras. Against the desolate backdrop of the Mojave Desert, actors Marianne Sägebrecht, C. C. H. Pounder, and Jack Palance starred in a offbeat slice of desert life that was both sad, funny, and poignant.

When Kelly passed away in 1991, the cafe was closed for a short while until it was reopened by Dick Develin. He was the first person to christen the small eatery with the moniker "Bagdad Café," in honor of the famed movie shoot. Ownership changed again when building owner Ed Young passed away in 1994, when the Hilemans once again bought into it. Interestingly enough, they decided

to take down the new sign on the lonely desert diner and to reopen once again as the Sidewinder.

When the Pruetts took over, they changed the name back again to the Bagdad Café, hoping that they could play off of some of the notoriety generated by the film. Of course it wasn't that easy to build up a customer base, especially when they were in such a remote location. People would stop to look, but many didn't come inside. "When I first came here, the French tourists looked into the window and wouldn't come in, so I went outside and brought them in," laughs Pruett.

Fortunately, all of that has changed. These days, visitors from across the pond don't need to be convinced to come inside. "They love the Bagdad Café," Pruett says. "I had one French lady come in crying with her family and say, 'I dream of the Bagdad Café . . . and my children dream to come to the Bagdad Café!'" French tour guides feature the restaurant, accounting for the sixty percent of her summer visitors who speak French. Another fifteen percent arrive from Japan, with the remainder making the trip from Germany, Brazil, Haiti, and even French Africa.

"To make them feel special and thank them for coming in, that's the least I can do," Pruett says. "Because, if it wasn't for my tourist visitors, the Bagdad Café wouldn't be in business!" It's no exaggeration: inside the dining room, a map of France is crammed with cards, pictures, and other mementos. Many have signed their name. There're also maps of Japan, Germany, and Italy, along with eighteen guest books to sign, each three hundred pages long! The Bagdad Café has definitely made it onto the map, not only that of Route 66—but of the entire world. ◉

THE MOTHER ROAD LOST & FOUND

Bagdad, circa 1950s

By Russell A. Olsen

Then: The Bagdad Café, Bagdad, California.

Now: The Bagdad Café, Bagdad, California.

The desert town

of Bagdad began in 1883 as a small railroad stop. When the Orange Blossom and Lady Lou mines struck pay dirt around the turn of the century, the town of Bagdad became a major gold shipping point. As the mining industry declined, so did Bagdad's fortunes. In 1923 the town lost its post office and by 1937 the mines were closing at a rapid pace, but the Santa Fe depot remained to transport ore, and Bagdad continued to be a coal and water stop for steam engines.

By the 1940s most of the mines were closed, and Bagdad, whose population once peaked at close to six hundred, dropped to about twenty residents. Still, business from Route 66 traffic kept some of the town alive. Paul Limon, a onetime gas station attendant, remembers, "Bagdad was a lively little place. People from all over the desert would come here because of the Bagdad Café, owned and operated by a woman named Alice Lawrence. The Bagdad Café was the only place for miles around with a dance floor and jukebox." The cafe, gas station, cabins, and market continued to serve travelers until 1972, when the interstate opened to the north. The 1988 film *Bagdad Café*, inspired by the town and its cafe, was actually filmed in Newberry Springs, fifty miles west of Bagdad. In 1991 the site was used as storage for a natural gas project and the town was wiped clean. Today, there is no evidence the town ever existed. ◉

Old Trails Highway to Victorville

By Kathy Weiser

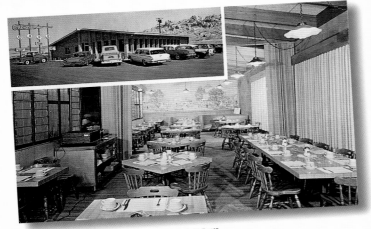

Joe's Café in Victorville—"Look for the Baseball Bat!"

Although collectors of bottles and other items found in the desert have all but gone by the wayside, Elmer Long carries on the tradition with his continual creation of a forest of bottle trees on old Route 66 near Oro Grande, California. *David McNew/Getty Images*

Along the National Old Trails Highway, old Route 66 continues on for some thirty miles from Barstow until you reach Victorville. Along this slate-colored stretch, you will pass through the small towns of Lenwood, Helendale, and Oro Grande. There was once another little town called Hodge between Lenwood and Helendale, but today, nothing is left of this one-time supply center.

About eighteen miles further down the road you'll see a sign that says you've reached Helendale; however, you'll look around wondering where it is. Unfortunately, Helendale is really not a town any more, just a smattering of buildings spread among the sagebrush of the desert. Here you can see the remains of the old Burden's Store and Post Office, which once served as the center of activity in this small community.

As you continue south, look for the old Potapov Service Station and Auto Court, an old stone station built in 1943 that now stands in ruins. Soon, you will come to Oro Grande, a town built on the dreams of early prospectors. Gold never panned out in this old town, but limestone soon became its economic base. Supported today by a large cement company, there are several old Route 66 buildings here, including the Iron Hog Saloon and the abandoned Mohawk Mini-Mart. You'll also find the largest antique mall in the high desert here, the Antique Station, as well as an old cemetery that dates back to the early days of the miners.

Continuing on the old road, you will cross the Mojave River on a 1930s steel truss bridge as you enter Victorville. Beginning in the mid-1880s, this town was first known as Victor. It was named for Jacob Nash Victor, a construction superintendent for the California Southern Railroad. An abundance of good water and rich bottom lands soon attracted agricultural development. In 1901 the post office changed the town's name to Victorville so no one would confuse it with Victor, Colorado. It was about this time that rich deposits of limestone and granite were discovered in the area, which soon led to the cement manufacturing industry, which remains the largest economic focus of the town.

When Route 66 was established through town, numerous business sprang up to serve the hungry and thirsty travelers of the old road. It was during the popular days of the Mother Road that Hollywood filmed several old western movies in the Victorville area.

Today, this quickly growing town of some sixty-five thousand still provides vintage looks at its past at the New Corral Motel at 14643 Seventh Street, the Best Western Green Tree Inn at 14173 Green Tree Boulevard, and the California Route 66 Museum, housed in the home of the old Red Rooster Café. The California Route 66 Museum, established in 1995, maintains a large collection of photographs and artifacts of the history of Route 66. Operating on donations only, the museum is located at 16825 D Street. ◎

Barstow
Crossroads Of Opportunity

By Kathy Weiser

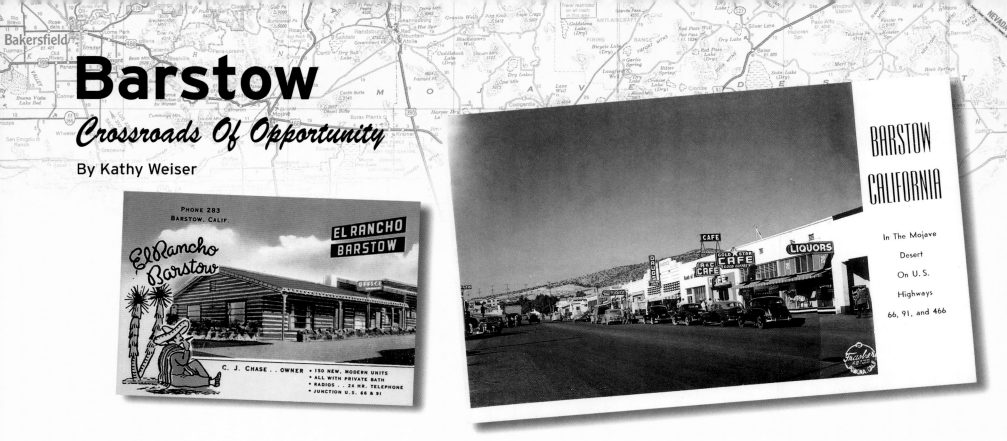

Barstow was founded in 1888 when the Santa Fe Railroad arrived. Located on the Mojave River, the area had already become a thriving mining center when silver was discovered six miles north in the Calico Mountains in 1882.

Named for the president of the Santa Fe Railroad, William Barstow Strong, Barstow thrived along with the nearby successful mining towns of Daggett and Calico. However, as the silver began to play out in the nearby mines, Daggett and Calico began to die, but Barstow grew to become a busy rail center. At the turn of the century, rail travel was considered glamorous, and in 1911 the Fred Harvey Company opened up the Casa Del Desierto, where gourmet cuisine was served on fine china to the many travelers along the rails.

As the automobile began to replace rail travel, Route 66 traveled Barstow's new Main Street, barrelling straight through the middle of town, and the Harvey House remained a popular stopping point.

However, when the Santa Fe Railroad started serving meals on the trains, the Harvey Houses became shadows of their former selves. The building was then used mainly for a machine shop, with a cafeteria and a small Amtrak ticket office. Before long, the Casa Del Desierto was abandoned altogether.

In the late 1980s, the Santa Fe Railway considered tearing down the old Harvey House until an outcry was raised by local citizens and historians. The old

building was saved by the City of Barstow and restoration began. The Casa Del Desierto was rededicated in 1999 and is now home to the Greyhound and Amtrak stations, several arts groups, the Mother Road Route 66 Museum, and the Western America Railroad Museum.

As you roll through Barstow along Route 66, which is today's Main Street in Barstow, keep your eyes open for the Barstow Station on your right at 1611 East Main Street. The Barstow Station includes gift shops and a famous McDonald's built entirely from railroad passenger cars, where you can see a great collection of vintage photographs.

Further on down the road, the historic El Rancho Motel sits on your left at 100 East Main Street. Built in 1943 with wooden railroad ties from the Tonepah & Tidewater railroad line, the old motel is said to have once been frequented by the likes of Marilyn Monroe. Looking to your right at 195 West Main you'll see the Route 66 Motel. And don't forget to take a look at the historic Fred Harvey Casa Del Desierto, which now houses the Route 66 Museum at 681 North First Avenue, one block north of Route 66 (Main Street). To get there you can drive over an old iron bridge that leads to the railroad depot and the site of the historic Harvey House.

Barstow lies at the junction of Interstate Highways 15 and 40, on the routes between Los Angeles, Las Vegas, and Flagstaff. ◉

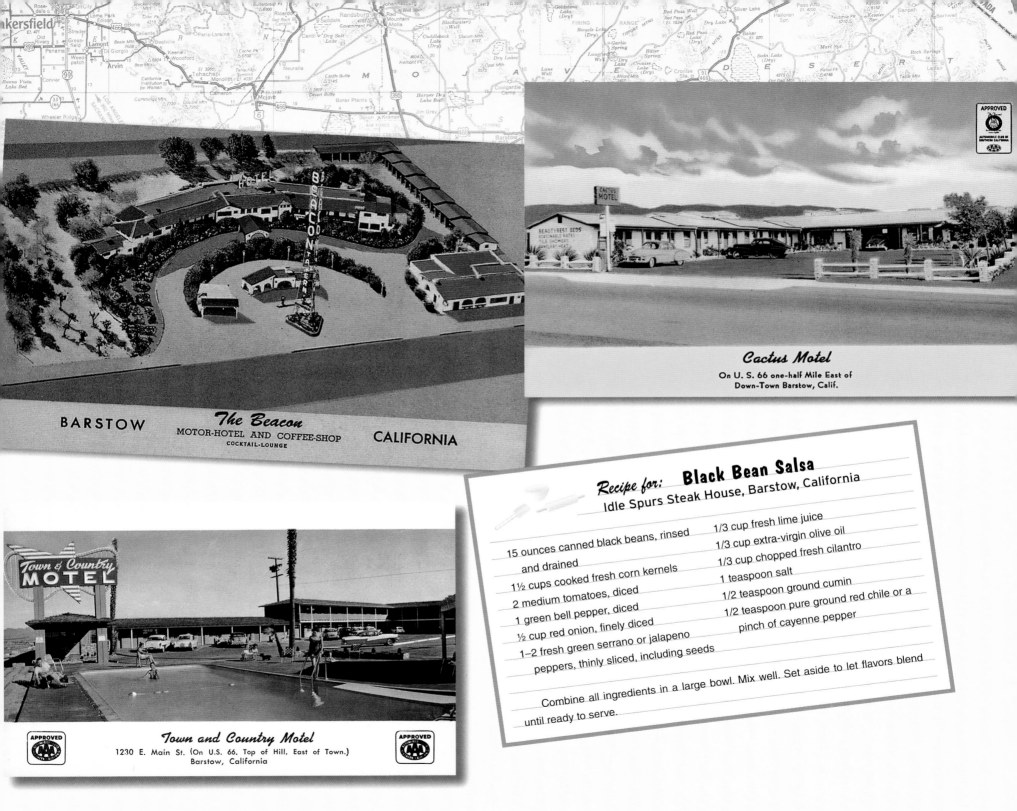

BARSTOW **The Beacon** CALIFORNIA
MOTOR-HOTEL AND COFFEE-SHOP
COCKTAIL-LOUNGE

Cactus Motel
On U. S. 66 one-half Mile East of
Down-Town Barstow, Calif.

Recipe for: **Black Bean Salsa**
Idle Spurs Steak House, Barstow, California

15 ounces canned black beans, rinsed
and drained
1½ cups cooked fresh corn kernels
2 medium tomatoes, diced
1 green bell pepper, diced
½ cup red onion, finely diced
1–2 fresh green serrano or jalapeno
peppers, thinly sliced, including seeds

1/3 cup fresh lime juice
1/3 cup extra-virgin olive oil
1/3 cup chopped fresh cilantro
1 teaspoon salt
1/2 teaspoon ground cumin
1/2 teaspoon pure ground red chile or a
pinch of cayenne pepper

Combine all ingredients in a large bowl. Mix well. Set aside to let flavors blend
until ready to serve.

Town and Country Motel
1230 E. Main St. (On U.S. 66, Top of Hill, East of Town.)
Barstow, California

APPROVED
AAA

APPROVED
AAA

California: The Journey's End 223

Greetings From Amboy, California
"The ghost town that ain't dead yet!"
Juan Pollo Inc., Albert Okura Owner
G. Taylor Louden AIA Arc

EXIT

THIS EXIT FOR ANOTHER ROADSIDE ATTRACTION . . .

No More Burgers at Roy's (For Now) ⟫

By Kathy Weiser

Driving on toward Amboy,

you'll begin to notice that the bank on the north side of the highway is filled with the rock-strewn graffiti of the many people who pass this way. Amboy is an intact town of ten buildings and supposedly twenty residents. However, it appears totally deserted, and the famed Roy's Cafe is closed.

The town was originally owned by Roy and Velma Crowl in the 1930s, and the cafe, motel, and service station were built somewhere around 1938. The Crowls had two children who helped them with the business: Lloyd Irwin and Betty.

Over the years the station, motel, and cafe served thousands of customers who would rave about Roy's burgers and the service they received along that desolate stretch of Route 66. In those days, Amboy was an oasis in the desert where hot and tired travelers could stop for food, a cool drink, mechanical services, and gas, while a big smile and a kind voice awaited them at Roy's Cafe and Motel.

In the early days, Roy Crowl had a small plane that he kept in a hangar behind the cafe and once used to rescue a woman who had fallen down into Amboy Crater. He also used it to fly his grandchildren around, taking in the view of the desert when they came to visit. Roy was also an entrepreneur, and owned additional real estate in Sedona, Arizona, and Cherry Valley, California.

When the children grew up, Lloyd moved to Twenty-Nine Palms, California, about fifty miles southwest of Amboy, but continued to travel back daily as he worked in the salt mines east of Amboy. In the meantime, a man named Buster "Herman" Burris rode into town on horseback and got a job working for Roy. He soon fell in love with Roy's daughter Betty and they married. After Roy passed away, Buster and Betty continued

to run the busines with the same excellent service until the late 1970s when Betty died of cancer.

Later, Buster would remarry a woman named Bessie, and the two continued the tradition of exceptional care of travelers through the years. During this time, Buster was known to open his doors clearly marked "Closed for Thanksgiving" to weary tourists out of gas or stranded. The cafe was renowned for its burgers, chili, and other homemade delights by travelers who stopped for a welcome respite on the long, hot, desert stretch of road. Buster continued to change tires on trucks and busses right up until the day he retired, at more than eight years of age.

Buster finally sold the town in 1995 and moved to Twenty-Nine Palms, where he passed away in the year 2000. The two guys who bought the town primarily used the site to host movie companies and photo shoots. Though the restaurant was still open at times, the hours were sporadic.

Early in 2005, Buster's widow Bessie foreclosed on Amboy and sold it at a foreclosure sale in late February.

Fortunately for Route 66 enthusiasts, the new buyer was a man named Albert Okura, who is dedicated to preserving the old Mother Road. He purchased the 690-acre town, lock, stock, and barrel for $425,000—a bargain in California! Okura owns the Juan Pollo restaurant chain, as well as the very first McDonald's restaurant in San Bernardino, which today operates as a museum.

Okura has plans to restore Amboy's gas station, convenience store, diner, twenty motel rooms, eight motel cottages, and four houses to their 1950s grandeur. He has

Menu

Home Made Soup .15 & .25

Ham & Bean	Vegetable Beef
Chicken Corn Soup	
Oyster Stew .60 & .80	Chili .25 & .35

Assorted Juices

Breaded Beef Drumsticks, 2 veg.	1.25
Breaded Veal Patties, 2 veg.	1.25
Beef Patties, 2 veg.	1.25
Roast Beef, Gravy, 2 vegetables.	1.25
Roast Fresh Ham, 2 vegetables, Gravy.	1.35
Baked Ham, Pineapple Sauce, 2 vegetables	1.35
Country Fried Ham, 2 vegetables	1.45
Ham Steak, 2 vegetables, Pineapple Sauce.	1.35
Grilled Pork Chops, 2 vegetables.	1.45
Tenderloin Steak, 2 vegetables	1.75
Boneless Sirloin Steak, 2 vegetables.	1.80 & 2.35
T-Bone Steak, 2 vegetables	1.75 & 2.50
Rib Steak, 2 vegetables	1.85
Cube Steak, 2 vegetables	1.25
Veal Cutlet, Tomato Sauce, 2 vegetables	1.25
Southern Fried Chicken, 2 vegetables	1.25
Chicken and Waffles, a la carte95
Hamburg Steak, Gravy, 2 vegetables95
Fresh Ground Round Steak, 2 vegetables	1.10
Chopped Sirloin Steak, 2 vegetables	1.35

All Seafood Has Tartar Sauce

Breaded Haddock, 2 vegetables	1.35
Fish Sticks, 2 vegetables .	1.35
Breaded Shrimp, 2 vegetables	1.35
Fried Oysters, 2 vegetables	1.35
Deep Sea Scallops, 2 vegetables	1.35
Crab Cakes, 2 vegetables	1.35
Combination Seafood Platter, 2 vegetables	1.45
Mountain Trout, 2 vegetables	1.45

Vegetables

Limas	Baked Beans	Mashed Potatoes
Creamed Corn	Apple Sauce	French Fries
Kidney Beans	Pepper Slaw	Potato Salad
Cole Slaw	Macaroni Salad	Pickled Egg
Tossed Salad	Pickled Beets	Cottage Cheese
		Home Fries

Hot Chicken Sandwich, one vegetable95
Hot Beef or Hot Pork Sandwich, one vegetable95
Beef, Pork or Ham Barbeque55

Bread Pudding25	Pie30
Rice Pudding25	Fruit25
Ice Cream10 & .20	Jello20

Thank You CALL Again

The famous old sign for Roy's, a beacon for many travelers. Shutterstock

Recipe for: Chili
Roy's Café, Amboy, California

20 pounds chili meat

2 #10 cans tomato sauce
(#10 can is 6 pounds, 12 ounces)

12 tablespoons chili powder

6 tablespoons crushed chili flakes

2 tablespoons black pepper

4 tablespoons salt

3 tablespoons garlic

2 teaspoons oregano

2 teaspoons cumin

15 tablespoons paprika

8 cups diced fresh onion

cooked beans, to add late

Place the cubed meat in a large roaster in a preheated 450° F oven to brown. Stir frequently until done. Add the remaining ingredients and set oven at 375° F. Cover and bake the chili for 3 hours in the oven. (The chili can be frozen in blocks to be thawed and served later.)
Keep a fresh pot of beans on the stove to add to the chili just before serving.

already made progress. As of 2009, the Amboy Cafe has reopened as a gift store that sells Route 66 and Amboy merchandise and souvenirs. Plans are still in the works to reopen it as a restaurant, but a number of improvements are still needed before that dream can become a reality.

Two and a half miles west of Amboy, the Amboy Crater rises above the desert floor. This volcano, which erupted some ten thousand years ago, was once an active Route 66 tourist attraction. Today it sits silently in the desert reminiscing of better days, along with the scattered remnants of the rest of the road.

Six miles west of Amboy once stood the town of Bagdad, which has been totally obliterated today. You will also pass by the old sites of Siberia and Klondike, which, like Bagdad, are nothing more than names on an old map. At last you'll reach Ludlow, where you'll finally see some signs of life. ◎

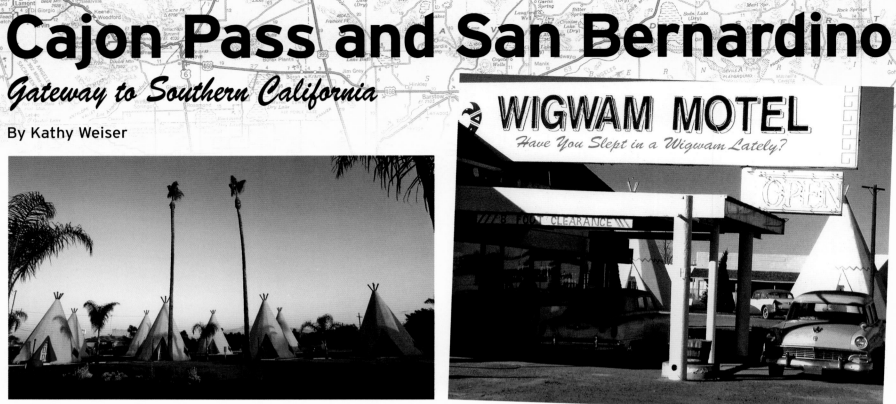

Cajon Pass and San Bernardino
Gateway to Southern California

By Kathy Weiser

The Wigwam Motel in Rialto, California. In 2007, the National Trust for Historic Preservation included the old teepee motels of Route 66 on its list of the most endangered historic places. *David McNew/Getty Images*

The Wigwam Motel in its heyday—"Have You Slept in a Wigwam Lately?"

Cajon Pass, which separates the San Gabriel Mountains from the San Bernardino Mountains, was once the only gateway through the mountains negotiable by wagon trains. It was here that the Mojave Trail, the Santa Fe Trail, the Mormon Trail, and the Spanish Trail converged. Along this old path traveled Native Americans, trappers, explorers, and scouts on their way to what would become the San Bernardino Valley. The first paved highway was built over the pass in 1916 and was upgraded several times until the highway was replaced by I-15 in 1969.

At the top of the pass at the Oak Hill exit is the historic Cajon Summit Inn, a Route 66 landmark serving customers since 1952, and one of the few survivors along this stretch of highway.

As you travel down the pass, keep your eyes open for ghosts of the old road, including a vintage "Eat" sign peeking from the roadside foliage, crumbling cabins, and pieces of the original pavement. Soon, you'll enter the historic San Bernardino Valley.

Spanish missionaries were the first to settle in the area in the early 1800s, building an outpost for other missionaries who traveled the California territory

preaching to local tribes. The two tribes that inhabited the valley for as long as four thousand years before the Spanish arrived were the Serranos and the Cahullia.

The first mission was established on May 20, 1810, and was named "San Bernardino" after the patron saint of the day on the Catholic calendar. The missionaries also taught the Indians how to plant and irrigate crops and the valley began to flourish. Another mission, the Asistencia, was built in 1830 but was looted by attacking tribes in 1834 and passed into private hands. This property has been restored and can still be seen today on Barton Road in the suburbs of Redlands.

The mission era came to an end in 1834 when California's governor José Figueroa ordered them closed. Soon, the abandoned mission became an important post on the trading route known as the Spanish Trail, where people such as Kit Carson and Jebediah Strong made frequent stops. Spanish landowners built haciendas and ranchos in the area as it began to grow. However, the desert tribesmen began to steal the herds of cattle, and many of the ranchers gave up and moved out of the area. The cattle rustling continued until nearly five hundred Mormons arrived in the valley in 1851. Purchasing the forty-thousand-acre San Bernardino Rancho to settle on, they built a stockade and named it Fort San Bernardino to protect themselves

WIGWAM VILLAGE No. 1

3 MILES EAST OF HORSE CAVE, KY., ON 31-E

6A-H184

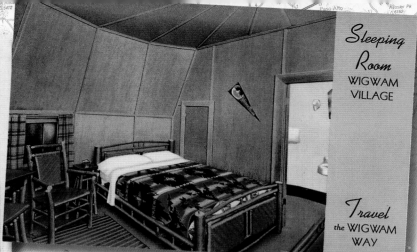

Sleeping Room WIGWAM VILLAGE

Travel the WIGWAM WAY

Postcards of Wigwam Motel No. 1 in Kentucky, which became the model for all teepee motels—"Travel the Wigwam Way."

San Bernardino, California

TRAVELODGE

746 "E" Street • U.S. Highway 66

On the road to Cajon Pass. *Shutterstock*

from the raids. However, because they weren't raising cattle or horses, the tribesmen left them alone and soon families began to move outside of the stockade. By the time the city of San Bernardino was officially incorporated in 1854, the community had a population of approximately twelve hundred.

In 1926, Route 66 was completed through San Bernardino, and the town quickly responded with motels, gas stations, and other services for the many travelers, several of which can still be seen todThere were two alignments of the Mother Road through San Bernardino, the latter one now called Business 66. Here you can see the first McDonald's restaurant, which now houses the McDonald's Route 66 Museum at Fourteenth and E Streets. Also along this route is the California Theatre of Performing Arts, a landmark since 1928 and the place of Will Rogers's last performance. The theatre now displays a mural of the performer.

Along the older alignment, several motels and cafes can be found tucked between the newer buildings, one of which is the Mitla Café at 602 North Mount Vernon Avenue. Established in 1937, this historic restaurant is a family-owned business that's been serving up great Mexican cuisine since the early days of Route 66. ◉

Urban Sprawl at the End of Route 66

By Kathy Weiser

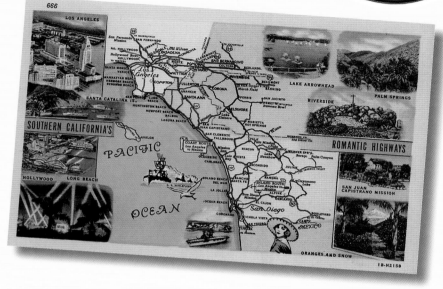

Though you actually meet the beginnings of urban sprawl in San Bernadino, from there forward, it gets worse. From San Bernadino to the Santa Monica Pier, much of old Route 66 has disappeared as roads have changed and Los Angeles and its suburbs continued to build and expand.

When Route 66 began, its purpose was to connect the small towns between Chicago and the Pacific Coast, and at that time, many of the Los Angeles suburbs *were* small towns, filled with mom-and-pop diners, motels, roadside fruit stands, and curio shops. But in the rush to California for which Route 66 was partially responsible, the area boomed as travelers escaped the dust bowls of the Midwest, attracted to the climate and opportunities that the Golden State provided.

However, die-hard Route 66 fans can still travel along various alignments of the "original" road, as the path continues to exist along a number of thoroughfares all the way to Santa Monica, snaking through suburbs that pass seamlessly one into the other. From Pasadena, Route 66 is eighty miles of city streets through a number of Los Angeles suburbs and streets variously known as Foothill Boulevard, Colorado Boulevard, Huntington Drive, Sunset Boulevard, and Santa Monica Boulevard, until you reach the western end of the Mother Road at the Santa Monica Pier. If you plan to drive the original route, estimate a full day of frustrating traffic bogs and traffic lights before reaching your destination.

On the other hand, if your goal is just to make it to the end of America's Main Street, you can take I-10 from San Bernardino all the way to Santa Monica. Or better yet, try a combination of streets along the outskirts, transferring to a highway when your frustration level has reached its peak.

If continuing the original route toward Pasadena through the suburbs of Fontana, Rancho Cucamonga, Azusa, Monrovia, and more, there are several remaining vintage icons if you know where to look between the strip malls and fast food restaurants.

As you begin your trek along the old route, you'll first come to the San Bernardino suburb of Rialto, which was once known for its many lemon groves. At the city's edge is the infamous Wigwam Motel, which used to rent its rooms by the hour with a sign displaying "Do It In a Teepee." Serving Route 66 travelers since 1947, these teepee-style cottages have recently gone through a total makeover, including improvements to both the building's interior and exterior as well as the motel's landscape. The Wigwam Motel is located at 2728 West Foothill Boulevard.

Continuing along, you will soon reach the suburb of Fontana, which offers a couple of vintage roadside peeks. At the southwest corner of Foothill Boulevard and Sultana Avenue sits a classic Italian restaurant called Bono's. Right next to it, however, you can see the last of many orange juice stands that once dotted all of California's Route 66.

515 GOLDEN FRUIT — WINTER IN CALIFORNIA

IA-H397

The enticing postcard vision of "Winter in California."

◄» **Did you know that in 1940 the McDonald brothers, Richard and Maurice, dismantled their Airdrome orange juice stand and rebuilt it at the corner of Fourteenth and E Streets, Business U.S. 66, in San Bernardino, California? Did you know this business became McDonald's in 1945?**

Rancho Cucamonga was once known for its many vineyards and orange groves, which have since been replaced by numerous businesses as the city has become one of the fastest-growing suburbs in the metropolitan area. However, this suburb does provide a couple of Route 66-era opportunities. At Haven Avenue is one of California's oldest wineries, the Virginia Dare, and at the northwest corner of Foothill Boulevard and Archibald sits the 1920s Richfield Oil station. Dating back to time when Route 66 passed through nothing but countryside and vineyards, this place stands out among the more modern views of the road.

Rancho Cucamonga also sports the historic Sycamore Inn that once stood as a San Bernadino Stage stop. Located at 8318 Foothill Boulevard, this old place has been offering great food and friendly service for almost 150 years. While in Rancho Cucamonga also be sure to visit the Route 66 Visitors Center and Museum at 8916 Foothill Boulevard.

Soon you will arrive at Upland, which features the vintage Buffalo Inn, where buffalo burgers have been served since 1929. Here in this frontier saloon atmosphere, you can enjoy a burger and brew in a laidback atmosphere before continuing your journey westward. The Buffalo Inn is located at 1814 West Buffalo Boulevard.

Next you'll come to the city of Claremont, where you can see the Rancho Santa Ana Botanic Garden on the right side of Route 66, just before the intersection with Indian Hill Boulevard. As you continue on pay attention, as Foothill Boulevard curves slightly to the right when entering Pomona, California,

home to vintage Wilson's Restaurant at the northwest corner of the intersection with Garey Avenue.

From here, the route takes you through La Verne and San Dimas, before arriving in Glendora. In it is the Golden Spur Restaurant, which has a history dating back more than eighty years. There is also a 1940s gas station at the intersection of Alosta Avenue and Loraine. Glendora also sports a quaint downtown district where several of its buildings haven't changed for more than a century.

As you continue along Route 66 you will soon come to Azusa, home to the vintage Foothill Drive-in Theatre. The last historic drive-in on Route 66 west of Oklahoma, the vintage theatre was designated as a California historical resource in 2002.

As you continue on, you will pass through Irwindale and Duarte before arriving at Monrovia, which provides numerous views of yesteryear. One block north of Colorado Boulevard on Shamrock is a vintage gas station left over from an earlier alignment of Route 66.

Next you will pass through Arcadia, California, where a 1930s art deco building stands at Santa Anita Racetrack, just beyond First Avenue. Designed by Gordon Kaufmann, architect of the Hoover Dam, the horse track was opened in 1934 and has hosted a number of famous attendees, such as Charlie Chaplin, Clark Gable, Cary Grant, and Bing Crosby.

During World War II, the track was used as a detention camp for twenty thousan Japanese Americans awaiting relocation to internment camps. Today,

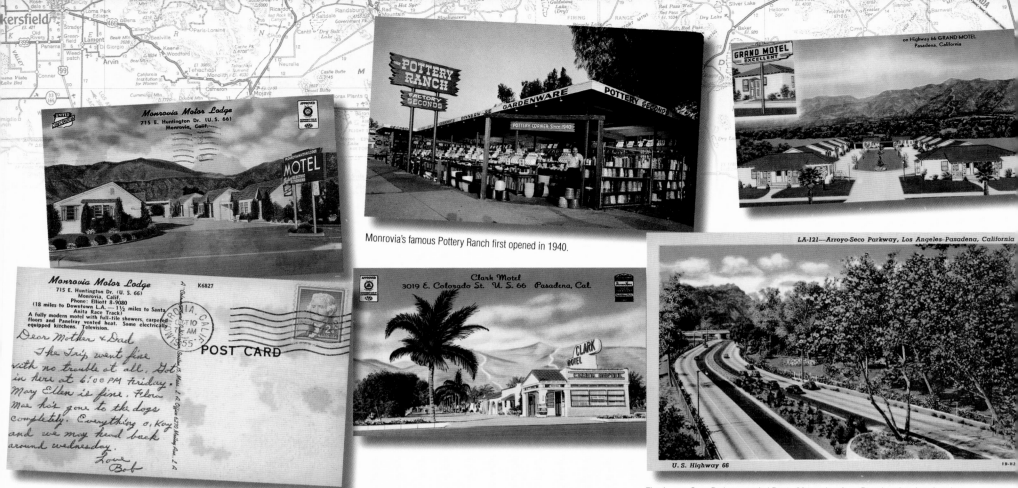

Monrovia Motor Lodge
715 E. Huntington Dr. (U.S. 66)
Monrovia, Calif.

POST CARD

Monrovia Motor Lodge
715 E. Huntington Dr. (U. S. 66)
Monrovia, Calif.
Phone: Elliott 8-9080
(18 miles to Downtown L.A. — 1½ miles to Santa Anita Race Track)
A fully modern motel with full-tile showers, carpeted floors and Panelray vented heat. Some electrically equipped kitchens. Television.

K6827

Dear Mother & Dad
The Trip went fine with no trouble at all. Got in here at 6:00 PM Friday. Mary Ellen is fine. Flora Mae has gone to the dogs completely. Everything o.Kay and we may head back around wednesday.
Love
Bob

Monrovia's famous Pottery Ranch first opened in 1940.

LA-121—Arroyo-Seco Parkway, Los Angeles-Pasadena, California

U. S. Highway 66

The Arroyo-Seco Parkway carried Route 66 travelers from Pasadena into Los Angeles.

the track still serves racing fans and tourists alike, and includes several restaurants. Also in Arcadia is the historic windmill atop the Denny's restaurant that was saved from demolition by preservationists. The windmill dates back to the days when this building was an old Van de Kamp eatery.

The next thing you know, you'll have entered Pasadena, where you can plan on being in congested traffic if you haven't already. Foothill Boulevard becomes Colorado Boulevard as it moves west into Pasadena. Along this route several vintage views can be spied amongst the modern buildings, such as the Astro Motel, which features a 1950s futuristic design that makes it look a little like a launching pad for a rocket. Also along this stretch can be seen the stone Holliston Church and the Pasada Motel.

Pasadena's twenty-two-block historic district showcases more than two hundred historic buildings where art deco and nineteenth-century architecture mingle to form a colorful, eclectic collection. The original center of town has been completely restored and now serves as one of southern California's most popular nightlife, shopping, dining, and entertainment districts. One delightful view is the

Fair Oaks Pharmacy, which opened its doors in 1915 and through the years has served Route 66 tourists with thousands of sodas, ice cream floats, and cherry rickeys. The Fair Oaks Pharmacy is located at 1526 Mission Street.

As the Mother Road continued its westward path from Pasadena, two different alignments passed through here, the first crossing the Colorado Street Bridge, which predates Route 66. Originally built in 1913, travelers crossed this arched span until 1940 when the Arroyo Seco Parkway was opened. On December 30, 1940, the Arroyo Seco Parkway opened and became the new official alignment for Route 66. Connecting Pasadena to Los Angeles, the parkway extends through Arroyo Seco's Arts and Crafts-style landscape of the early twentieth century, and has now been designated as a Federal Scenic Byway. The parkway is significant as the first freeway in the west, representing a transitional time in history when parkways became freeways. This scenic drive takes you through quiet parks and bustling urban activity; however, according to a UCLA study, the parkway is the site of the most traffic accidents in the Los Angeles area. ◉

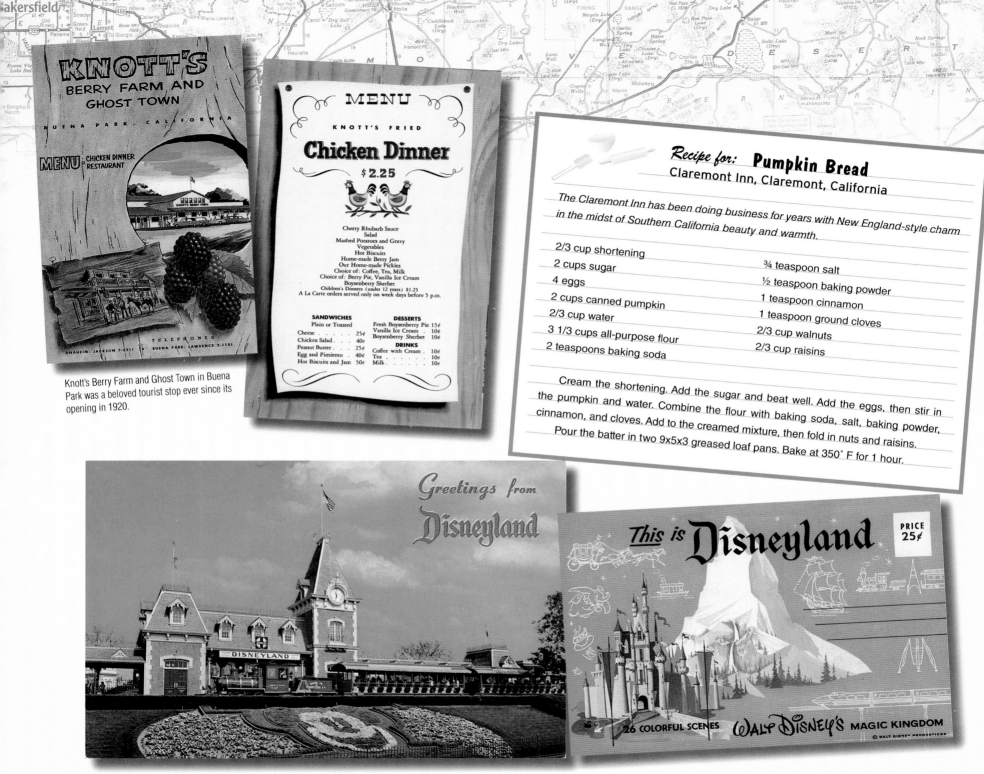

KNOTT'S
BERRY FARM AND GHOST TOWN
BUENA PARK, CALIFORNIA

MENU · CHICKEN DINNER RESTAURANT

TELEPHONES
ANAHEIM: JACKSON 7-7211 • BUENA PARK: LAWRENCE 2-1121

Knott's Berry Farm and Ghost Town in Buena Park was a beloved tourist stop ever since its opening in 1920.

MENU
KNOTT'S FRIED
Chicken Dinner
$2.25

Cherry Rhubarb Sauce
Salad
Mashed Potatoes and Gravy
Vegetables
Hot Biscuits
Home-made Berry Jam
Our Home-made Pickles
Choice of: Coffee, Tea, Milk
Choice of: Berry Pie, Vanilla Ice Cream
Boysenberry Sherbet
Children's Dinners (under 12 years) $1.25
A La Carte orders served only on week days before 5 p.m.

SANDWICHES
Plain or Toasted
Cheese 25¢
Chicken Salad . . 40¢
Peanut Butter . . 25¢
Egg and Pimiento . 40¢
Hot Biscuits and Jam 50¢

DESSERTS
Fresh Boysenberry Pie 15¢
Vanilla Ice Cream . 10¢
Boysenberry Sherbet 10¢

DRINKS
Coffee with Cream . 10¢
Tea 10¢
Milk 10¢

Recipe for: Pumpkin Bread
Claremont Inn, Claremont, California

The Claremont Inn has been doing business for years with New England-style charm in the midst of Southern California beauty and warmth.

2/3 cup shortening
2 cups sugar
4 eggs
2 cups canned pumpkin
2/3 cup water
3 1/3 cups all-purpose flour
2 teaspoons baking soda

¾ teaspoon salt
½ teaspoon baking powder
1 teaspoon cinnamon
1 teaspoon ground cloves
2/3 cup walnuts
2/3 cup raisins

Cream the shortening. Add the sugar and beat well. Add the eggs, then stir in the pumpkin and water. Combine the flour with baking soda, salt, baking powder, cinnamon, and cloves. Add to the creamed mixture, then fold in nuts and raisins. Pour the batter in two 9x5x3 greased loaf pans. Bake at 350° F for 1 hour.

Greetings from Disneyland

This is Disneyland

PRICE 25¢

26 COLORFUL SCENES

WALT DISNEY'S MAGIC KINGDOM

Disneyland in Anaheim opened in 1955, and quickly became an essential stop for Route 66 travelers.

Poster for the 1940 film version of John Steinbeck's *The Grapes of Wrath* starring Henry Fonda as Tom Joad.

ROUTE 66 MYTHS AND LEGENDS

The Movies and Route 66

By Jim Hinckley

In light of the diverse landscapes

that embrace Route 66, as well as a popularity that spans decades, it should be no surprise to find this old highway has a lengthy association with the motion picture and television industry. What is surprising is the obscurity of some of this history.

In 1937, at the junction of U.S. 666 and U.S. 66 in Gallup, New Mexico, R. E. Griffith, brother to legendary movie mogul D. W. Griffith, opened El Rancho Hotel & Motel. The stunning western landscapes that surrounded Gallup and his extensive Hollywood contacts enabled R. E. Griffith to profit greatly as movie companies flocked to the area and his luxurious hotel became a home away from home for the actors.

The guest register from the first thirty years of this Route 66 landmark is a veritable who's who of Hollywood celebrities, including the Marx Brothers, Ronald Reagan, Errol Flynn, Kirk Douglas, John Wayne, Humphrey Bogart, and Spencer Tracy, to name but a few. Today the rooms named for past guests provide visitors with a tangible link to the glory days of both Hollywood and Route 66.

The inspiration behind Wallace and Mary Gunn's decision to relocate their small trading post to the village of Cubero, New Mexico, in 1937 was the endless stream of traffic on Route 66 that flowed through town. The trading post quickly morphed into a tourist court and cafe.

This remote oasis in a sea of awe-inspiring scenery became an unlikely outpost for celebrities during the 1940s and 1950s. Gene Tierney and Bruce Cabot stayed here during the filming of *Sunset*. Lucille Ball and her husband were frequent guests, as Vivian Vance owned a ranch nearby. Ernest Hemingway spent several weeks here while writing *The Old Man and the Sea*.

The open spaces, the colorful and stark landscape, and the proximity to Hollywood via Route 66 led a number of early movie companies to film in the area of Victorville, California. Many scenes in movies starring Tom Mix, Gene Autry, Roy Rogers, and William Hart, as well as in episodes of the *Cisco Kid*, are still identifiable in the hills around this high desert community.

Roy Rogers became so enamored with the landscape he purchased a ranch along the Route and the Mojave River north of Victorville. Until its recent relocation to Branson, Missouri, the Roy Rogers Museum was located here.

The use of landscapes surrounding Victorville to add texture or feel to films was not limited to western epics, nor are all of these associations ancient

232

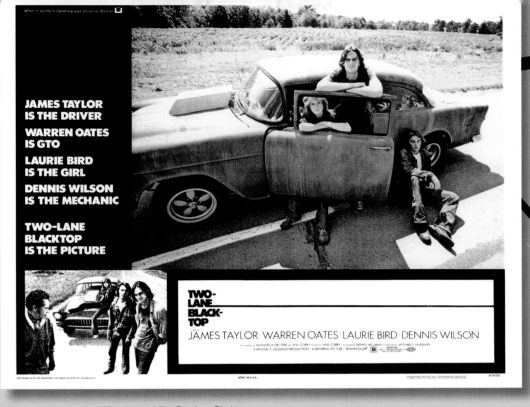

Lobby card promoting the 1971 rebel road film *Two-Lane Blacktop.*

history. Movies filmed here include *Harvey Girls* (1942), *It Came From Outer Space* (1954), *The Hills Have Eyes* (1977), *Breakdown* (1997), *Hitcher* (1986), and *Kill Bill Volume 2* (2004).

The Green Spot Motel in Victorville, dating to 1937, remains as a tarnished gem on an older alignment of Route. For more than twenty years, the motel served as the focal point for the Hollywood crowd while in Victorville.

Perhaps the most notable association the Green Spot Motel has with movie history is the role the establishment played in the creation of *Citizen Kane*. It was here that John Houseman and Herman J. Mankiewicz wrote the first two drafts of the script for this film.

The Oatman Hotel in Oatman, Arizona, no longer rents rooms but it still preserves the "suite" rented by Clark Gable and Carole Lombard, who married in Kingman, Arizona, in 1939. Oatman also figures prominently in several movies filmed in the area, including *Edge of Eternity* (1959), and *Foxfire* (1955).

Only a snowstorm prevented Flagstaff, Arizona, from becoming the center of the motion picture industry in the United States. In 1911, Cecil B. DeMille and Jesse Laskey had decided to relocate their New York based motion picture company in an effort to find an area with access to more suitable landscapes for the filming of outdoor films. When the train arrived in Flagstaff, the deep blue skies, the towering pines, and the frosted San Francisco Peaks in the background immediately appealed to their artistic sensibilities. The euphoria was short lived,

as two days after their arrival a storm that brought ferocious winds and icy rain that soon turned to snow transformed the town into an arctic landscape.

From Chicago to Santa Monica, Route 66 and its landmarks have appeared as backdrops in literally hundreds of motion pictures. The original Colorado River Crossing, the 1916 Old Trail Bridge, figures prominently in a scene in John Ford's classic rendering of John Steinbeck's *The Grapes of Wrath*. The bridge's replacement, which now serves as a river crossing for I-40, is featured in the opening scenes of *Easy Rider*, starring Dennis Hopper and Peter Fonda.

The Big 8 Motel in El Reno, Oklahoma, dating to the 1940s, was but one of hundreds of motels lining Route 66 that enticed travelers with the colorful use of neon. It was as a backdrop in *Rain Man*, starring Dustin Hoffman, that the old motel had a brief moment of glory before its closing.

The Tavern, now a machine shop and an old store turned residence, now demolished, on the original alignment of Route 66 in Kingman, Arizona, figured prominently in *Roadhouse 66*, starring Judge Reinhold. Cool Springs, now a refurbished time capsule, was the location for an explosive action sequence in *Universal Soldier*, starring Dolph Lundgren.

In an odd twist, the television program *Route 66*, which debuted in 1960 and starred George Maharis and Martin Milner, was an instant success at a time when the popularity of its namesake highway was waning. Even more ironic is the fact that in the filming of the program few scenes were filmed on Route 66. ◉

From Los Angeles to the Sea

By Kathy Weiser

If you venture into Los Angeles, Seventh and Broadway was the original end of Route 66 until it was extended to Santa Monica in 1935. Here, in the midst of downtown Los Angeles, are multiple great examples of 1920s architecture, including the largest concentration of pre-World War II movie palaces in America. Many of these theatres began as vaudeville stages, where live acts like the Marx Brothers and Sophie Tucker entertained the wealthy families of early Los Angeles. With the advent of film, they were transformed into movie theaters.

Following the last alignment of Route 66 to the Pacific Ocean, Santa Monica Boulevard travels through Hollywood, where you can see its famous sign that has stood as a landmark for generations.

Importing its name from a town in Ohio, the sign once spelled "Hollywoodland," for a real estate development in Beachwood Canyon. Erected in 1923, the sign measures 450 feet long, with each letter rising above the ground almost 50 feet. After maintenance on the sign stopped, it deteriorated badly. However, in 1949, the Hollywood Chamber of Commerce stepped in and offered to remove the last four letters and repair the rest. The sign, located near the top of Mount Lee, is now a registered trademark.

While in Hollywood, numerous attractions present themselves, including Grauman's Chinese Theater, the Hollywood Walk of Fame, Universal Studios, and much more.

Continuing on, you will soon pass through West Hollywood and a theater district filled with trendy shops and boutiques before entering upscale Beverly Hills. While here, you can spend your hard-earned cash at its many pricey shops or grab a map and look for the stars. However, you're more likely to spot their gardeners than you are the stars themselves

Finally, Route 66 ends in Santa Monica at Pacific Palisades Park and the famous Santa Monica Pier, where taking a stroll and watching the sunset is a must for your final moments along your historic journey. By now, you no doubt have a camera full of photographs and a mind full of memories that will last you a lifetime. ◉

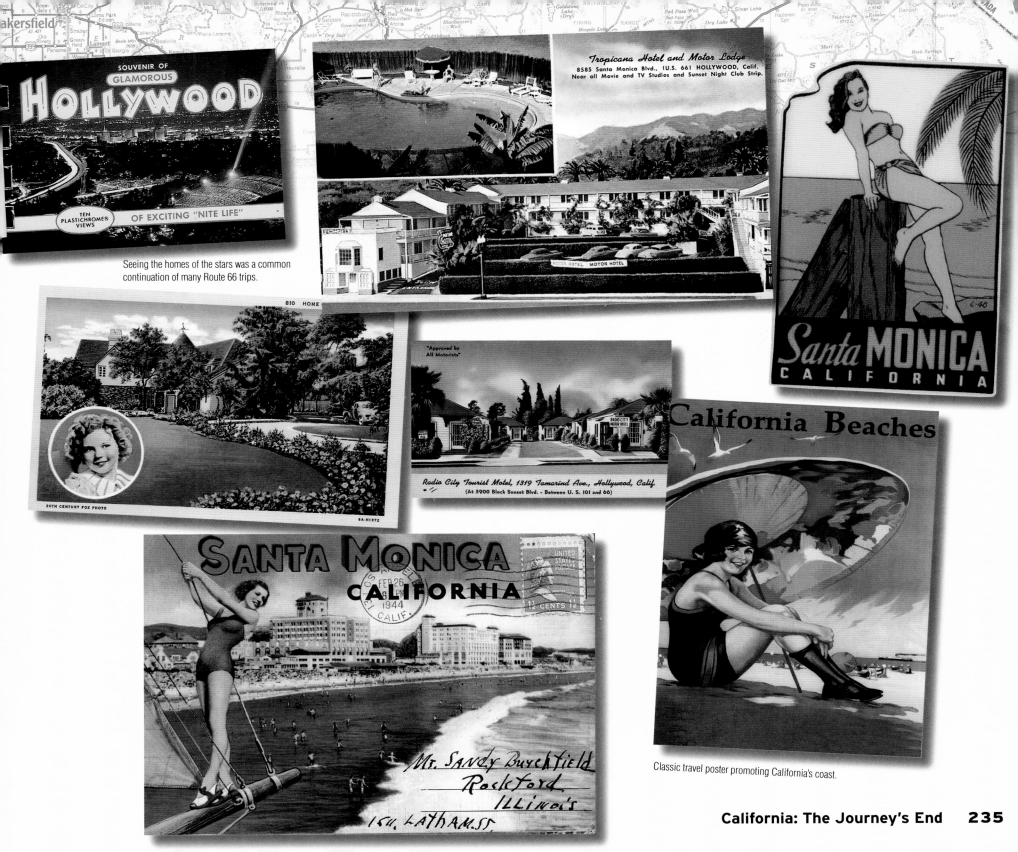

SOUVENIR OF GLAMOROUS HOLLYWOOD

TEN PLASTICHROME® VIEWS

OF EXCITING "NITE LIFE"

Seeing the homes of the stars was a common continuation of many Route 66 trips.

Tropicana Hotel and Motor Lodge
8585 Santa Monica Blvd., (U.S. 66) HOLLYWOOD, Calif.
Near all Movie and TV Studios and Sunset Night Club Strip.

810 HOME

20TH CENTURY FOX PHOTO

6A-H1972

"Approved by All Motorists"

RADIO CITY MOTOR HOTEL

Radio City Tourist Motel, 1319 Tamarind Ave., Hollywood, Calif.
(At 5900 Block Sunset Blvd. - Between U. S. 101 and 66)

Santa MONICA CALIFORNIA

California Beaches

SANTA MONICA CALIFORNIA

UNITED STATES POSTAGE
1½ CENTS 1½

Mr. Sandy Burchfield
Rockford
Illinois
1511. Latham St.

Classic travel poster promoting California's coast.

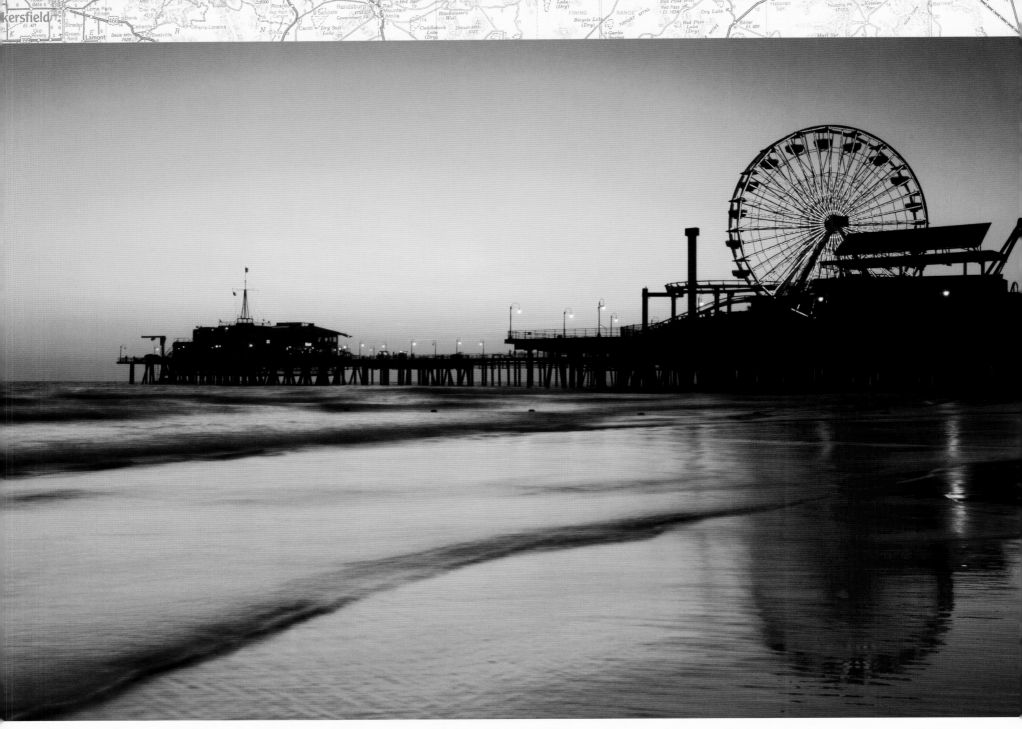

The neon-lit ferris wheel on Santa Monica's Municipal Pier glows over the waves and beach at sunset. *Chris Sargent/Shutterstock*

Wm. Tell Motel and Apts.
2509 Santa Monica Blvd., Santa Monica, Cal.
on U. S. 66
Will Rogers Highway

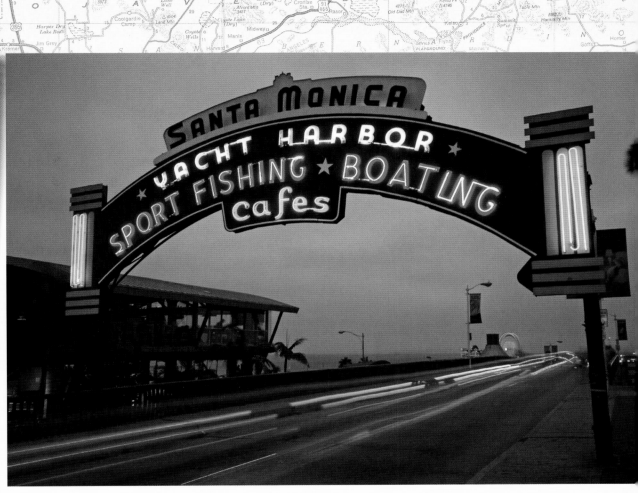

335 OVERLOOKING BEACH HOMES AND BEACH, SANTA MONICA, CALIFORNIA

MUNICIPAL PIER IN BACKGROUND

The terminus of Route 66 was the Municipal Pier at Santa Monica stretching out into the glories of the Pacific Ocean.

The welcome sign at the end of the Route 66: Santa Monica's Municipal Pier. *Michael Rickard/Shutterstock*

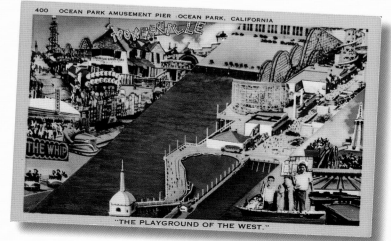

400 OCEAN PARK AMUSEMENT PIER ·OCEAN PARK, CALIFORNIA

"THE PLAYGROUND OF THE WEST."

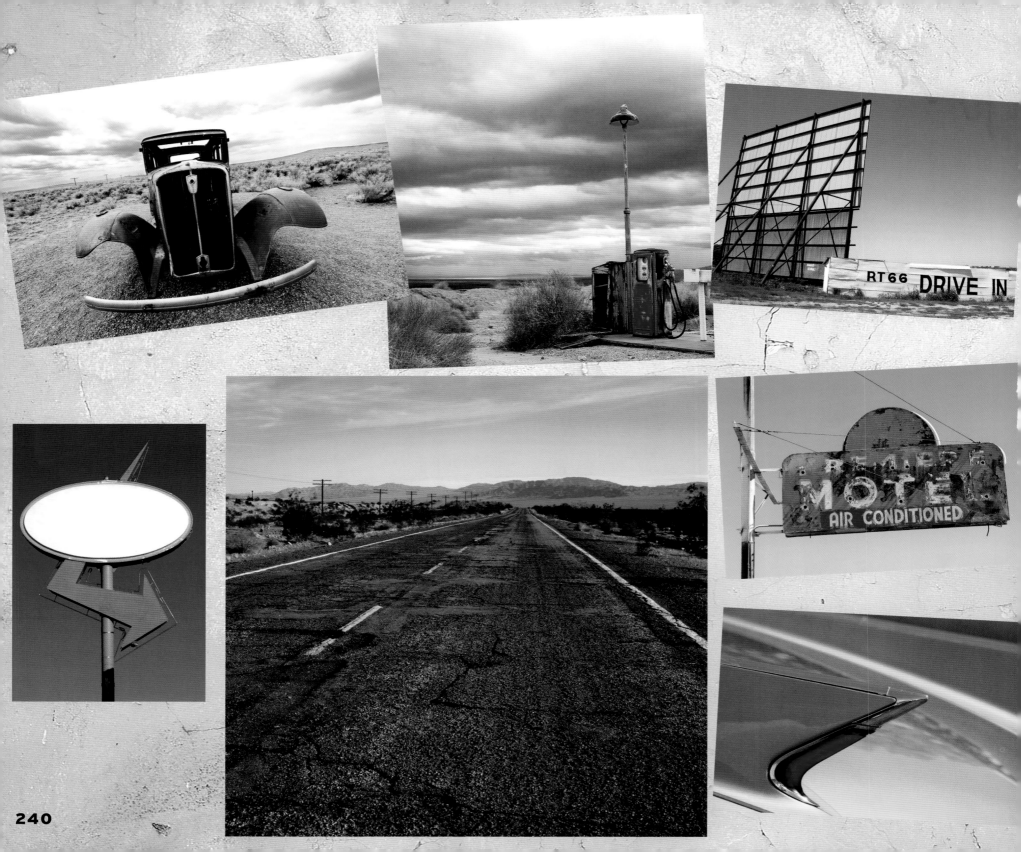